Show Time

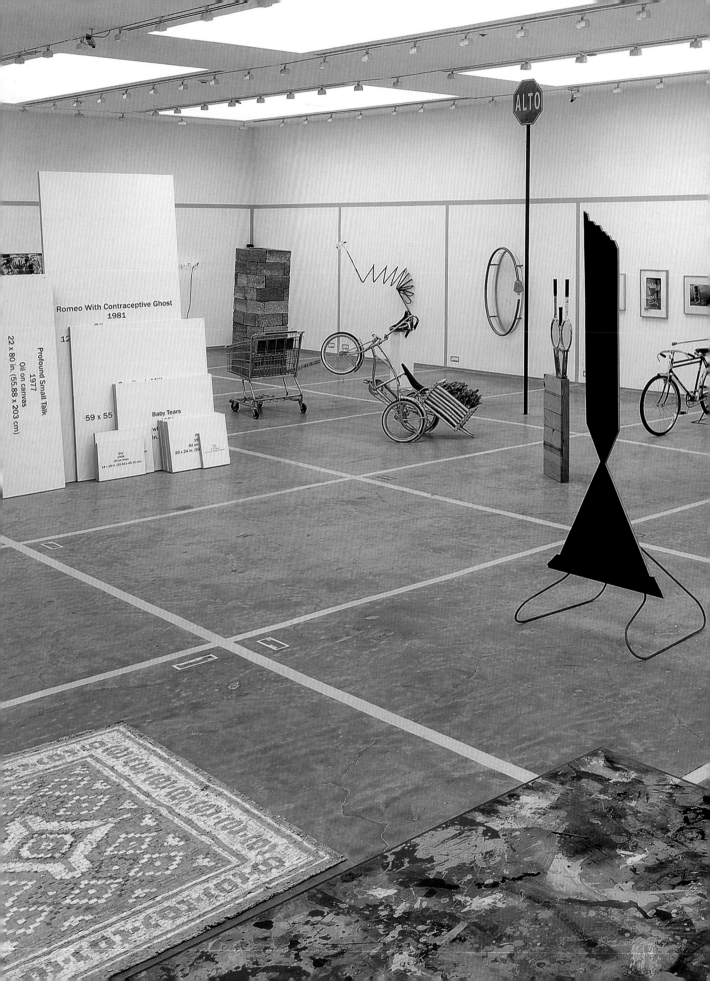

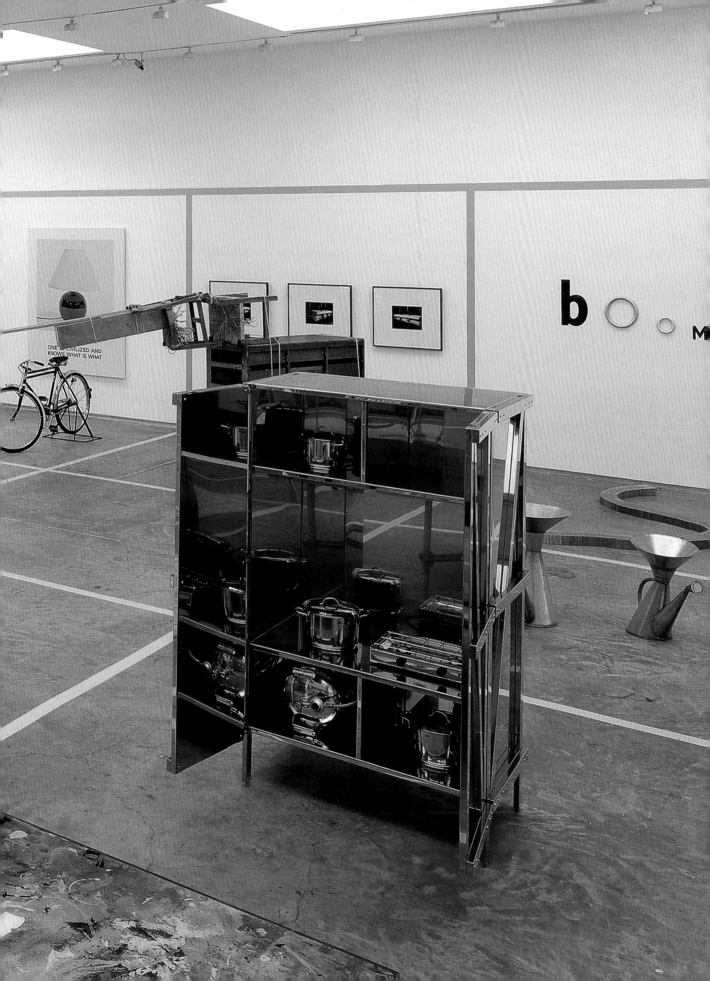

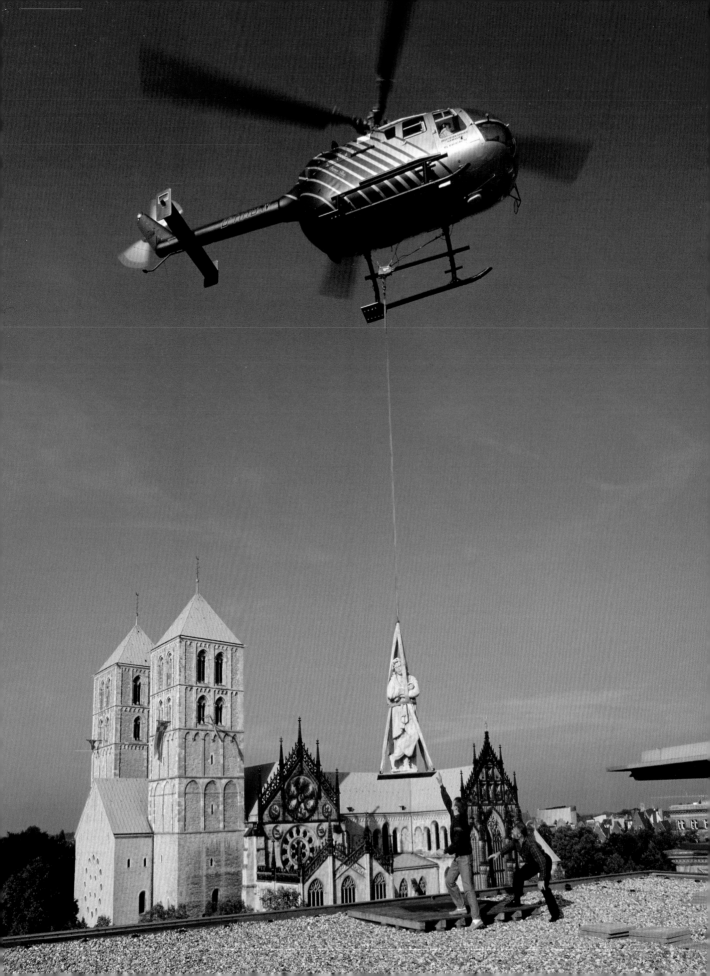

Show Time

The 50 Most Influential Exhibitions
of Contemporary Art

Jens Hoffmann

With 202 illustrations, 187 in colour

Thames & Hudson

About the Author

Jens Hoffmann is an exhibition maker and writer based in New York. He is Deputy Director and Head of Exhibitions and Public Programs at The Jewish Museum, New York. He has curated and co-curated a number of large-scale exhibitions, including the 2nd San Juan Triennial (2009), the 12th Istanbul Biennial (2011), and the 9th Shanghai Biennial (2012).

Show Time is dedicated to the pioneering work of **Harald Szeemann**

On the cover: Aomori Museum of Art, Aomori, Japan, view of the Aleko Hall. Architect Jun Aoki & Associates. Photo View Pictures Ltd/Superstock
pp.2–3: Installation view, An Unruly History of the Readymade, Fundación/Colección Jumex, Mexico City, Mexico, 2008–9
p.4: Ayşe Erkmen, *Sculptures on Air*, 1997, installation for Sculpture Projects Münster 97, Münster, Germany, 1997

First published in the United Kingdom in 2014 by Thames & Hudson Ltd, 181A High Holborn, London WC1V 7QX

Show Time:
The 50 Most Influential Exhibitions of Contemporary Art
© 2014 Jens Hoffmann

Editorial assistance and picture research by Joanna Szupinska-Myers and Dane Jensen

Designed by Fraser Muggeridge studio

British Library Cataloguing-in-Publication Data
A catalogue record for this book is available from the British Library

ISBN 978-0-500-23911-7

Printed and bound in China by C&C Offset Printing Co. Ltd

To find out about all our publications, please visit **www.thamesandhudson.com**. There you can subscribe to our e-newsletter, browse or download our current catalogue, and buy any titles that are in print.

Contents

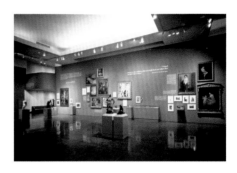

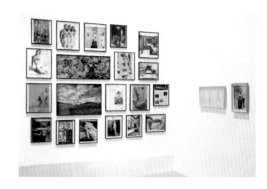

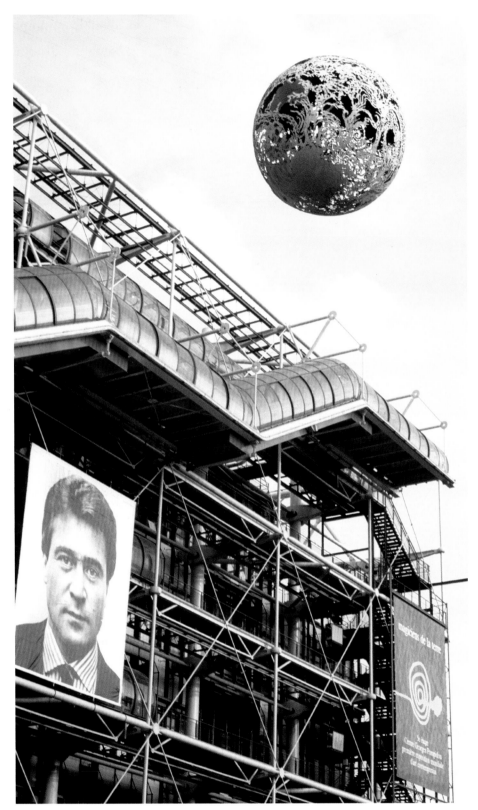

Braco Dimitrijević, *The Casual Passer-by I Met at 3.59 pm, Paris*, 1989 (below left) and
Neil Dawson, *Globe*, 1989 (above right), installation view from Magiciens de la Terre,
Centre Georges Pompidou, Paris, France, 1989

Introduction: Changing Exhibitions

Since the early 1990s, exhibition making and curating have undergone a dramatic change. From practices that revolved mostly around the conservation, interpretation, and display of objects in museum collections, they have become truly creative professions. Curators are increasingly inserting their subjectivity into the underlying ideas they present in their shows, and the presentations themselves are becoming ever more diverse in form and content. Some unforgettable and inspiring exhibitions have resulted.

In the last two decades, curating has come to be regarded as a professional practice in its own right rather than as a sub-discipline of art history. This new role for the curator is being nurtured by the establishment of an increasing number of formal curatorial education programs at universities, colleges, and art schools, as well as numerous publications—both books and dedicated journals—exploring a wide set of questions on curating. For this reason, many of the significant exhibition makers of the recent past did not enter the field via the traditional route of an art history education, and the current period is characterized by a broader dialogue between fine art and other disciplines. It is characterized as well by closer relationships between artists and curators, a strong theorization of the art context, and a clearer conceptualization of the role of the curator. The art world has become globalized, the international biennial has emerged as the ultimate exhibition format of our time, and the biennial curator is now an all-important arbiter of global art trends and tastes.

Show Time looks into the recent history of exhibition making by examining 50 key exhibitions of contemporary art from the late 1980s to today. These are the shows that truly changed the course of the discipline and contributed to a more complex understanding of what exhibition making means. They represent the most innovative efforts by some of the most risk-taking curators. All of them have altered the way we understand curatorial practice and its relationship to the world at large. Many investigated social issues and politics, and interrogated in various ways the sociopolitical engagement of the artists included. They clearly acknowledged the changes taking place in an increasingly multicultural world. They brought to the fore new sets of questions about our identities as human beings. In varied ways, they transformed how art and the public interrelate. *Show Time* is thus not only a document of the evolution of the profession

of curating—an analysis of an important history—but also a bold proposition for the future of exhibition culture.

Exhibitions have come to be understood more and more as vehicles for intellectual, cultural, social, and political investigation and expression. Those discussed in *Show Time* have constructively (re)activated the potential of art to look beyond the limits of traditional art history and what we may call "the art world". Their significance lies in how they engage with everyday experiences, reflect on globalization and post-Cold War political realities, connect not only with artists and audiences but also with other disciplines such as theater, architecture, literature, and even science, and privilege the production and distribution of knowledge. These bold exhibitions crossed boundaries, experimented, innovated.

In recent years, curatorial formats unrelated to exhibition making—public programs, education courses, publications, and so on—have gained in popularity. There is a general shift afoot in which the term "curating" is no longer exclusive to the process of making exhibitions, but can be deployed when no exhibition takes place at all, with art and curatorial concepts reaching the public via books, conferences, or screenings. In contemporary usage, the very word "curator" has become diluted to the point where it is simply about taste making and choosing in any context: for instance the selection of music by a DJ in a club, or of food on the menu in a restaurant. Some curators maintain that innovation in the field can only happen if we abandon traditional notions of what an exhibition is and seek more "flexible" forms of presentation. But *Show Time* takes as its fundamental premise the fact that the exhibition remains the primary place to encounter art, that there is a huge diversity of exhibition formats available, and that there is still much more to explore.

It is impossible for any field truly to progress without understanding its own past. All of the recent changes in curatorial work—the dramatic and radical expansions and redefinitions—have triggered much reflection. The proliferation of conferences, books, articles, and graduate programs devoted to curatorial studies are all part of a self-referential impulse—a desire to understand where the field of curating is coming from and where it is heading. An important part of this is the undertaking of a methodical examination of historically important exhibitions. There have been several noteworthy efforts along these lines, but they have mostly been undertaken by art historians focusing on exhibitions as they relate to the oeuvre of an artist or the evolution of an artistic movement. *Show Time* is distinct from these efforts in its essentially curatorial point of view, with the shows being selected from the perspective of someone working in the field, and with its emphasis on the form and function of exhibitions.

Several publications related to the history of exhibitions have been released in recent years. These include Bruce Altshuler's two books *Salon to Biennial:*

Exhibitions That Made History 1863–1959 (2008) and *Biennials and Beyond: Exhibitions That Made History 1962–2002* (2013), which encompass a wide range of exhibitions starting from the first Salon des Refusés in Paris in 1863 and ending with documenta 11 in 2002. These books chronologically track the progression of art history through exhibitions, and include historical texts such as exhibition reviews. There is also the *Exhibition Histories* series published by Afterall Books, which provides a highly detailed analysis of certain significant shows, such as Op Losse Schroeven (1969), When Attitudes Become Form (1969), The Third Havana Biennial (1989), and Magiciens de la Terre (1989), through new texts and historical documents.

Recent books on curating in general are even more numerous. A few examples include *A Brief History of Curating* (2008), Hans Ulrich Obrist's collected interviews with curators, and two books released in 2012 that attempt to survey the spectrum of curatorial practices today: *Thinking Contemporary Curating* by Terry Smith and *The Culture of Curating and the Curating of Culture(s)* by Paul O'Neill. Operating in productive dialogue with these publications, the unique aim of *Show Time* is to serve as a guidebook through a more recent history of exhibitions, presented by a practicing curator, and supported by some rarely seen, and previously lost, material and images.

Exhibitions, just like artworks, do not emerge from nowhere. They appear in particular moments, under their own sets of historical conditions. The art historian T.J. Clark wrote in the opening chapter of his 1973 book *Image of the People* that in its best form art history should be about "the connecting links between artistic form, the available systems of visual representation, the current theories of art, other ideologies, social classes, and more general historical structures and processes." This is also the perfect condensation of what exhibitions themselves, and a history of exhibitions, should aim to accomplish. *Show Time* organizes a history that addresses innovations in curating both formally and in terms of their broader cultural context and relevance.

This book has its origins in exhibition[2], a 2001 show and conference presented at the International Artists Studio Program in Sweden, which I developed together with students from the curatorial program of Konstfack—University College of Arts, Crafts, and Design in Stockholm. exhibition[2] was an exhibition of exhibitions. It evolved out of a desire to engage curatorial students with the recent history of exhibitions while giving them an opportunity to organize an exhibition and conference. We decided collectively which exhibitions we wanted to investigate, looking specifically for innovative shows that introduced new ideas and processes for making a display. The final 12 exhibitions, some of which are included in this book, were Magiciens de la Terre, Paris, 1989; Sonsbeek 93, Arnhem, 1993; The 1993 Whitney Biennial,

New York; do it, various venues, 1994–ongoing; NowHere, Humlebæk, 1996; documenta X, Kassel, 1997; Cities on the Move, Vienna, 1997; the 2nd Johannesburg Biennial, 1997; Sensation: Young British Artists from the Saatchi Collection, London, 1997; the 24th São Paulo Biennial, 1998; and Laboratorium, Antwerp, 1999. The students conducted interviews with the curators and some of the artists who were included, wrote texts on specific aspects of the exhibitions, and tracked down related visual materials, which ranged from featured artworks to reviews in the press, TV programs, and even merchandise.

A key finding of our undertaking was that group exhibitions have become the vehicles for creative expression authored by curators. This has only really become clear over the last couple of decades. Since the postmodern crises of the 1980s, curators have become much more aware of their voices and authorial roles in making exhibitions, and more self-conscious in relation to the field of curating as a whole. In other words, as curating has become a creative act in its own right, the group show has become the favored medium. Other identifiable trends have included the emergence of new and innovative exhibition models, in particular an emphasis on the large-scale thematic or historical group exhibition; an increase in overview shows of emerging artists; and the explosion of the biennial.

There are various reasons why *Show Time* focuses on exhibitions made since 1990. The year 1989 was the end of the Cold War and the beginning of the globalization of the art world, which continues today at a rapid rate. One of the major starting points of the latter phenomenon, as most curators would probably agree, was the iconic Magiciens de la Terre organized by Jean-Hubert Martin in Paris in 1989. This show set off a series of responses and conversations, prompting the curatorial community to reflect on established practices and develop radical new ones. Additionally, the first formal curatorial program was founded at the Ecole du Magasin in 1987, quickly followed by Bard College's Center for Curatorial Studies in 1990 and the Royal College of Art's Curating Contemporary Art course in 1992. A first wave of compendiums of curatorial essays was released in the 1990s, including Bernd Klüser and Katharina Hegewisch's *Die Kunst der Ausstellung* (1991), Reesa Greenberg, Bruce W. Ferguson, and Sandy Nairne's *Thinking About Exhibitions* (1996), and Mary Anne Staniszewski's *The Power of Display: A History of Exhibition Installations* (1998).

Show Time does not present its exhibitions chronologically, but instead in thematic clusters that illustrate particular ideas and directions. The chapters encapsulate the different exhibition forms that have been most groundbreaking, and most relevant for considering exhibition making today. Each chapter includes a brief overview and between five and eight exemplary exhibitions. (While all the exhibitions fit clearly into their categories, most of them could have been placed

in other chapters as well.) There are full details for each show—dates, location(s), curators, contributing artists, catalogue information—which for some of the lesser-known exhibitions had previously been thought lost to history. The entry for each exhibition also includes installation shots (some of which are published here for the first time), catalogue covers, floor plans, and images of promotional materials such as posters and invitations.

The book begins with "Beyond the White Cube," an exploration of exhibitions in public space, from traditional sculpture shows to citywide biennials to community-based social practice exhibitions that unfolded over long periods of time. The second chapter is entitled "Artists as Curators as Artists," and examines projects by artists who were intervening in collections as acts of institutional critique, or treating the exhibition as an artistic medium. "Across the Fields and Beyond the Disciplines" surveys exhibitions that merged art with content from other fields such as architecture, science, and the mass media. The fourth chapter, "New Lands," deals with exhibitions that attempted global surveys of contemporary art and culture, including the landmark Magiciens de la Terre and several others that developed as direct or indirect responses to it. "Biennial Years" looks at the ever-increasing role of the international art biennial, which has been crucial in forming the now-pervasive image of the roving international curator. "New Forms" takes stock of exhibitions that attempted to rejuvenate or even overthrow certain well-known exhibition formats: group shows, biennials, and collections. The seventh chapter, "Others Everywhere," focuses on exhibitions that dealt with issues related to race, nationality, class, gender, and sexual orientation. "Tomorrow's Talents Today" identifies exhibitions that were formative to certain artist groups or affiliations, such as Nicolas Bourriaud's Traffic, which was highly important to artists associated with what was subsequently termed "relational aesthetics." The book ends with "History," a series of exhibitions that set a new art-historical agenda through a greater consideration of female and non-Western artists as well as previously underrepresented art forms such as performance and conceptual work.

The exhibitions included in this book were selected from a very long list, eventually pared down on the basis of which were the most groundbreaking, or the most characteristic of a certain type of practice. As wide a range of curatorial practices as possible within each thematic group has been represented, in terms of the individual curator's method and style; the size and scale of the exhibition; the artists included; the location, institution type, and issues addressed; and other qualifications that are perhaps less easily articulated. I did not include any of my own curated exhibitions, but I did want to discuss those that I experienced personally and that have since proved relevant to the development of my practice, as well as to those of many others. The resulting list, while thorough, is not intended as the final word, and certainly not as a dismissal of any

exhibition that was not included. In a way, it reflects curatorial methodology itself, part of which is about sorting art and information into categories, and part of which is simply subjective and open to interpretation.

Readers with even a casual interest in exhibition histories will know some of the exhibitions in *Show Time*, for instance Okwui Enwezor's documenta 11. Other shows, such as Laboratorium (1999), curated by Hans Ulrich Obrist and Barbara Vanderlinden in Antwerp, or Global Conceptualism: Points of Origin, 1950s–1980s at the Queens Museum in 1999, are more like cult classics of curating. Some exhibitions were included on the basis of their formal innovation, such as Obrist's do it, an ongoing exhibition of artists' instructions that can take place anywhere in the world; others, such as Sensation (1997), are here because of the discussion they generated or their impact in the art world and beyond.

Show Time includes very few museum shows from the United States, which is perhaps an indication of a general lag in curatorial innovation in the American art world, cuts in public funding, increases in private interests, or all of the above. Several curators—Enwezor, Obrist, Dan Cameron, Thelma Golden, Paul Schimmel—are represented more than once. What may be most striking, however, is how truly international the survey is. While the majority of the exhibitions took place in Europe and North America, several were in South America, Africa, Asia, and the Middle East, and almost all were international in scope. *Show Time* thus demonstrates the truly global nature of the art world that has developed since 1989, and the importance of curators in bringing about this tectonic shift.

Harem #3, objects from the collection of the artist Mike Kelley,
installation view from Mike Kelley: The Uncanny, MUMOK,
Vienna, Austria, 2004

Beyond the White Cube

Sculpture Projects
Münster

Places with
a Past:
New Site-
Specific Art
in Charleston

inSITE

Sonsbeek 93

Culture in Action

Prospect.1
New Orleans

Rosângela Rennó, *Guerrero* portrait from the *United States* series,
1997, installation view from inSITE97, various sites in San Diego,
USA, and Tijuana, Mexico, 1997

Beyond the White Cube

One of the most marked developments in curating over the past 20 years has been the increased production and discussion around exhibitions and curatorial projects that take place outside the walls of the museum in public space. What Brian O'Doherty termed the "white cube" of the gallery in 1976 began to be seen by a set of artists and curators as restrictive, even antithetical, to their work and larger goals. Through various developments both within and outside the art world, artists and curators were more aware of the ideological implications of the gallery setting and in turn became interested in situating their work in public places, and in bringing in individuals and communities traditionally marginalized by the institution. This has often taken the form of research-oriented projects that connect with various publics and evolve over time, resulting in works that share authorship with host communities. Following the lead of artists, curators began to take further interest and initiative in producing exhibitions in spaces outside the white-cube environment. Working in public space allowed new possibilities to develop projects in a context, with specific audiences, and to address timely historical, social, or political issues where they occurred, expanding the curator's creative purview.

Some exhibitions, such as Sculpture Projects Münster and Sonsbeek 93, considered new forms of public art and engaged in the ongoing debate on the value of art in public space. Many of the most influential of these exhibitions beyond the white cube attempted more direct addresses toward social and political engagement, including Mary Jane Jacob's groundbreaking exhibitions Culture in Action and Places with a Past. Subsequent exhibitions inflected with greater political imperatives included inSITE, a series of exhibitions that took place along the US–Mexican border, and Prospect.1 New Orleans, an exhibition developed in response to the aftermath of Hurricane Katrina. The curators of these shows sought to make tangible connections between the world of art and the realm of society at large.

Sculpture Projects Münster

1977, 1987, 1997, and 2007
Various sites in Münster, Germany

Martin Boyce, *We Are Still and Reflective*,
Sculpture Projects Münster 07, 2007

Sculpture Projects Münster is considered a pioneer among art programs contextualized in urban and public spaces. It began in response to a local controversy in the mid-1970s over the placement of a public sculpture made by George Rickey in the town of Münster, Germany. The debate swelled to the point where the whole notion of modern art itself was under attack. In response, the curators Klaus Bussmann and Kasper König organized Sculpture Projects Münster in 1977 with the intention to educate and foster a critical dialogue about the merits of modern art and sculpture, from Auguste Rodin to the contemporary moment. The project grew beyond this original plan and has turned into a regular public exhibition organized every 10 years—thus far, in 1987, 1997, and 2007—that showcases a variety of art installed throughout Münster.

Sculpture Projects Münster is known for large and ambitious installations and a diverse range of media. Numerous artists are commissioned to create site-specific works in various locations throughout the city. The three curators of the 2007 exhibition— Brigitte Franzen, Kasper König, and Carina Plath— referred to the overall series as a "long-term study" of how artists can explore and engage with the

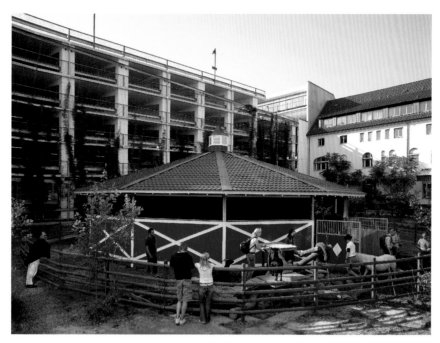

Mike Kelley, *Petting Zoo*, Sculpture Projects Münster 07, 2007

public sphere, and how these explorations may change over time.

Given the general trend today toward shrinkage of both public spaces and budgets for public art projects, the curators and organizers (all of whom have worked for the Westphalian State Museum of Art and Cultural History) see this project as an increasingly necessary one. In order to amplify the dialogue over how public space is perceived and utilized, all of the Sculpture Projects Münster exhibitions have emphasized an educational component. For instance, in 2007, 302 public tours were offered (including some for the deaf and disabled) as well as 40 different events such as panel discussions, art outreach programs and classes, and published guides in various media, including a children's book.

While the notion of art in the public sphere has changed radically over the decades toward more socially engaged and relational involvements with communities, Sculpture Projects Münster has continued to hold onto a more traditional idea of outdoor sculpture in an intriguing and unique manner. Through the project, artists have the opportunity to create works on a scale that has

become increasingly difficult to fund and produce. Another unique component is the relationship to the picturesque city of Münster, whose population now fully embraces the event and understands it as part of the city's identity.

modulorbeat (Marc Günnewig and Jan Kampshoff), *switch+*, information center, Sculpture Projects Münster 07, 2007

Exhibition Title
Sculpture Projects Münster 77

Organizer
Westphalian State Museum
of Art and Cultural History

Curators
Klaus Bussmann
Kasper König

Dates
July 3 – November 13, 1977

Location
Various sites in Münster,
Germany

Publication
Klaus Bussmann and Kasper
König, eds., *Skulptur:
Ausstellung in Münster,*

*Westfälisches Landesmuseum
für Kunst und Kulturgeschichte,
Schlossgarten, Universität,
Aasee, 3. Juli – 13. November
1977 (Katalog 1: Die Entwicklung
der abstrakten Skulptur im 20.
Jahrhundert und die autonome
Skulptur der Gegenwart;
Katalog II: Projektbereich),
Landschaftsverband Westfalen-
Lippe und Stadt, Münster, 1977*

Artists
Carl Andre
Michael Asher
Joseph Beuys
Donald Judd
Richard Long
Bruce Nauman
Claes Oldenburg
Ulrich Rückriem
Richard Serra

Exhibition Title
Sculpture Projects Münster 87

Organizer
Westphalian State Museum
of Art and Cultural History

Curators
Klaus Bussmann
Kasper König

Dates
June 14 – October 4, 1987

Location
Various sites in Münster,
Germany

Publication
Klaus Bussmann and Kasper
König, eds., *Skulptur Projekte
in Münster, 1987: Katalog zur*

*Ausstellung des Westfälischen
Landmuseums für Kunst und
Kulturgeschichte in der Stadt
Münster, DuMont, Cologne,
1987*

Artists
Dennis Adams
Carl Andre
Giovanni Anselmo
Siah Armajani
Richard Artschwager
Michael Asher
Stephan Balkenhol
Lothar Baumgarten
Joseph Beuys
George Brecht
Daniel Buren
Scott Burton
Eduardo Chillida
Thierry de Cordier
Richard Deacon

Paweł Althamer, *Path / Scieżka*, 2007, Sculpture Projects Münster 07, 2007

Luciano Fabro
Robert Filiou
Ian Hamilton Finlay
Fischli & Weiss
Katharina Fritsch
Isa Genzken
Ludger Gerdes
Dan Graham
Rodney Graham
Hans Haacke
Keith Haring
Ernst Hermanns
Georg Herold
Jenny Holzer
Rebecca Horn
Shirazeh Houshiary
Thomas Huber
Donald Judd
Hubert Kiecol
Per Kirkeby
Harald Klingelhöller
Jeff Koons
Raimund Kummer
Ange Leccia
Sol LeWitt
Mario Merz
Olaf Metzel
François Morellet
Reinhard Mucha
Matt Mullican
Bruce Nauman
Maria Nordmann
Claes Oldenburg
Nam June Paik
A.R. Penck
Guiseppe Penone
Hermann Pitz
Fritz Rahmann
Ulrich Rückriem
Reiner Ruthenbeck
Thomas Schütte
Richard Serra
Susana Solano
Ettore Spalletti
Thomas Struth
Richard Tuttle
Franz West
Rémy Zaugg

Exhibition Title
Sculpture Projects
Münster 97

Organizer
Westphalian State Museum
of Art and Cultural History

Curators
Klaus Bussmann
Kasper König

Dates
June 22 – September 28,
1997

Location
Various sites in Münster,
Germany

Publication
Klaus Bussmann, Kasper König,
and Florian Matzner, eds.,
*Contemporary Sculpture.
Projects in Münster 1997*, Verlag
Gerd Hatje, Stuttgart, 1997

Artists
Kim Adams
Carl Andre
Michael Asher
Georg Baselitz
Alighiero e Boetti
Christine Borland
Daniel Buren
Janet Cardiff
Maurizio Cattelan
Eduardo Chillida
Stephen Craig
Richard Deacon
Mark Dion
Stan Douglas
Maria Eichhorn
Ayşe Erkmen
Fischli & Weiss
Isa Genzken
Paul-Armand Gette
Jef Geys
Douglas Gordon
Dan Graham
Marie-Ange Guilleminot
Hans Haacke
Raymond Hains
Georg Herold
Thomas Hirschhorn
Rebecca Horn
Huang Yong Ping
Bethan Huws
Fabrice Hybert
Ilya Kabakov
Tadashi Kawamata
Martin Kippenberger
Per Kirkeby
Jeff Koons
Svetlana Kopystiansky

Sol LeWitt
Atelier van Lieshout
Olaf Metzel
Reinhard Mucha
Maria Nordman
Claes Oldenburg /
 Coosje van Bruggen
Gabriel Orozco
Tony Oursler
Nam June Paik
Jorge Pardo
Hermann Pitz
Marjetica Potrč
Charles Ray
Tobias Rehberger
Ulrich Rückriem
Allen Ruppersberg
Reiner Ruthenbeck
Kurt Ryslavy
Karin Sander
Thomas Schütte
Richard Serra
Roman Signer
Andreas Slominski
Yutaka Sone
Diana Thater
Bert Theis
Rirkrit Tiravanija
Eulàlia Valldosera
herman de vries
Lawrence Weiner
Franz West
Rachel Whiteread
Elin Wikström /
 Anna Brag
Wolfgang Winter /
 Berthold Hörbelt
Jeffrey Wisniewski
Andrea Zittel
Heimo Zobernig

Exhibition Title
Sculpture Projects Münster 07

Organizer
Westphalian State Museum
of Art and Cultural History

Curators
Brigitte Franzen
Kasper König
Carina Plath

Dates
June 16 – September 30,
2007

Location
Various sites in Münster,
Germany

Publication
Brigitte Franzen, Kasper
König, and Carina Plath,
eds., *Sculpture Projects
Münster 07*, Walther König,
Cologne, 2007

Artists
Pawel Althamer
Michael Asher
Nairy Baghramian
Guy Ben-Ner
Guillaume Bijl
Martin Boyce
Jeremy Deller
Elmgreen &
 Dragset
Hans-Peter Feldmann
Dora García
Isa Genzken
Dominique
 Gonzalez-Foerster
Tue Greenfort
David Hammons
Valérie Jouve
Mike Kelley
Suchan Kinoshita
Marko Lehanka
Gustav Metzger
Eva Meyer &
 Eran Schaerf
modulorbeat
 (Marc Günnewig /
 Jan Kampshoff)
Deimantas Narkevicius
Bruce Nauman
Maria Pask
Manfred Pernice
Susan Philipsz
Martha Rosler
Thomas Schütte
Andreas Siekmann
Rosemarie Trockel
Silke Wagner
Mark Wallinger
Clemens von
 Wedemeyer
Annette Wehrmann
Pae White

Places with a Past: New Site-Specific Art in Charleston

May 24 – August 4, 1991
Various sites in Charleston, South Carolina, USA

Exhibition guide

Places with a Past: New Site-Specific Art in Charleston was an exhibition curated by Mary Jane Jacob that took place at a number of public sites throughout Charleston, South Carolina, in 1991. The intention was to invite artists to work within the urban context of Charleston, mainly in historic locations, in a way that would both suit the works of art and call attention to the city's rich history. These kinds of public urban exhibitions were already occurring frequently in Europe (such as Sculpture Projects Münster), but Places with a Past was the first of its type in the United States, moving into new territory not only with its site-specific character but also with its ambition to participate in broad sociopolitical discourses, which the European exhibitions did not do. It was part of the larger Spoleto Festival USA, an annual arts event that has taken place every spring in Charleston since 1977. The festival usually focuses on the performing arts—music, dance, theater, and opera—and thus Places with a Past was unique for the festival and for the city of Charleston.

Jacob invited 23 international artists to work in situations of their choosing, encouraging them to develop new projects or adapt existing works in reaction to each site's cultural, historical, and

Opposite: Ronald Jones, *Untitled (This representation of George N. Barnard's stereograph South Carolina Cherubs (after Raphael), Charleston, S.C., c.a. 1874–75, is a remembrance of Denmark Vesey's righteous rebellion. Vesey, a freed black man, planned the liberation of Charleston's slaves at the Hampstead congregation of the Emanuel African Methodist Episcopal Church in 1822. And though the insurrection was put down only hours before it was to unfold across the city, Vesey's spirit of revolt against injustice was an expression of the promise of civil rights in a free society.)*, 1991

Following pages: David Hammons, *America Street*, 1991

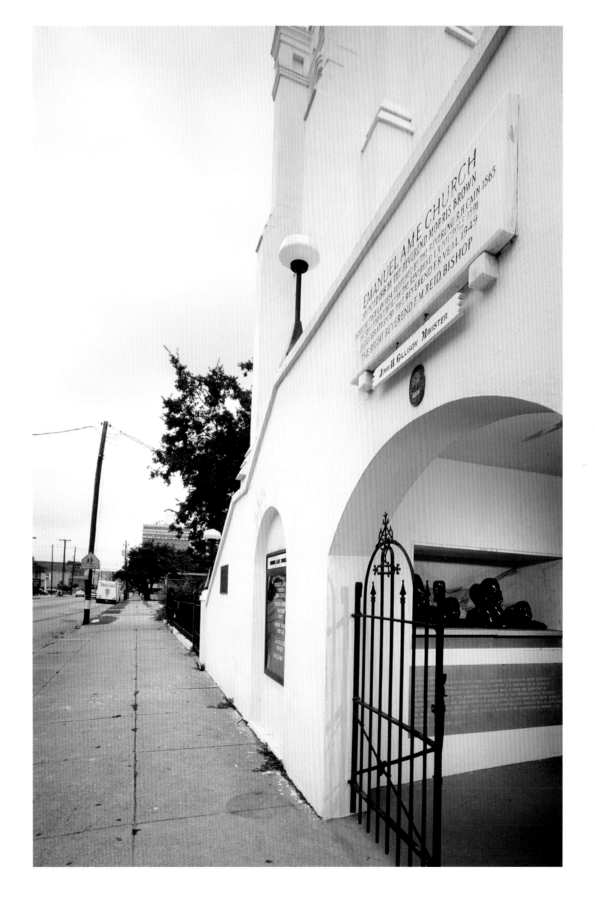

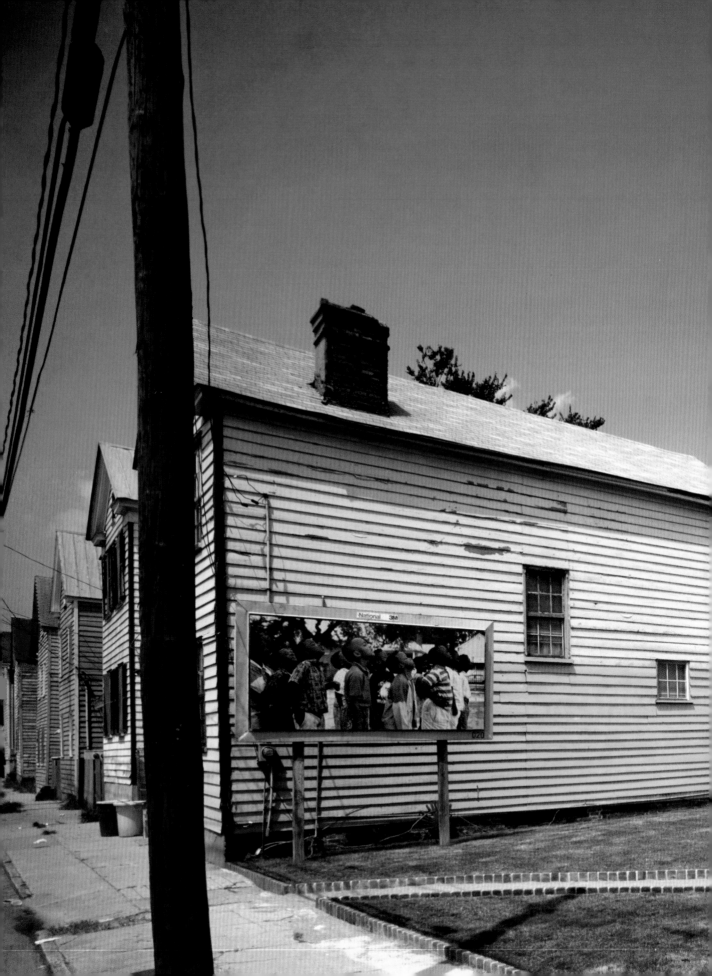

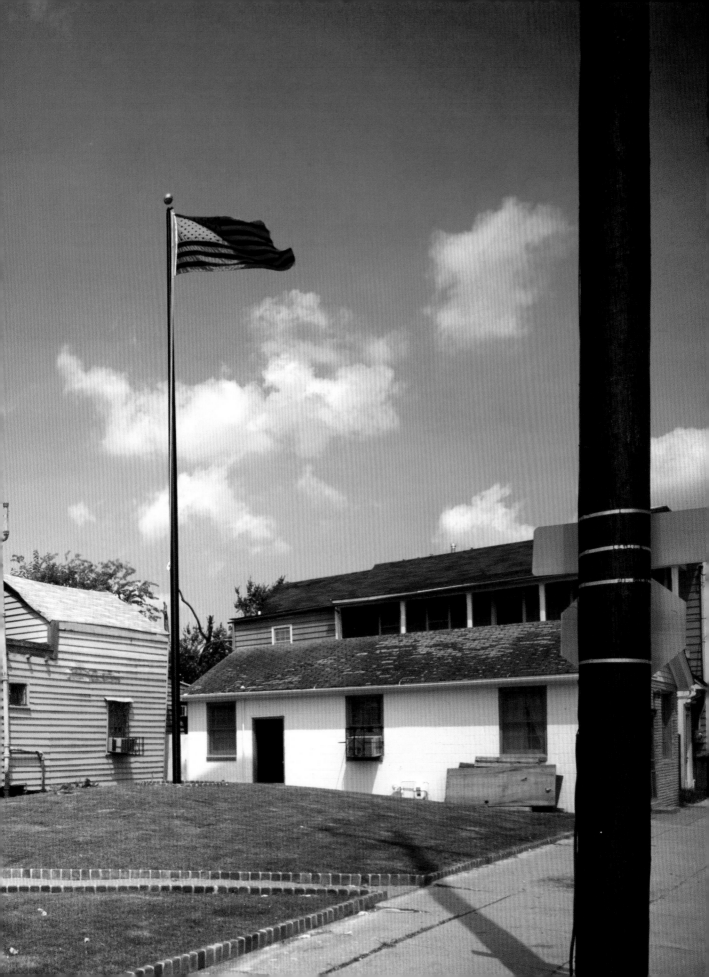

Charleston was the bridge between the works of art and the audience. When there are no doors and admissions are taken away, the audience changes. When an exhibition goes to the public, art may be encountered unwittingly. Places with a Past, while a profound artistic statement rather than a social manifesto, dealt with issues that directly touch one's daily life. As with all great art, it drew its meaning from human experience, and turned its temporal and spatial particularity into a universal experience.

Mary Jane Jacob, "Making History in Charleston," in Mary Jane Jacob, ed., *Places with a Past: New Site-Specific Art at Charleston's Spoleto Festival*, Spoleto Festival USA and Rizzoli International Publications, New York, 1991.

aesthetic specificities. The project was funded by the National Endowment for the Arts and various private sources, which meant that the artists enjoyed significant resources and time to realize their ideas. Many chose sites that were overtly "old": a former jailhouse, dilapidated residences, an old pump house. Themes deeply embedded in Charleston's historical fabric such as slavery, religion, and the military arose repeatedly. Most artists ended up working with sites and histories that were outside the city's established, canonical history; they were interested in giving voice to stories rarely heard. This approach dovetailed perfectly with Jacob's curatorial interests: she was, and still is, well known for projects that take place outside traditional gallery spaces and involve non-traditional or historically marginalized audiences and venues.

Places with a Past was open for visitors to experience in any way they chose, but bicycling and walking were encouraged as the best methods with which to engage with the artwork. Organized walking tours were available. The event was extremely well received and has repeatedly been called one of the most influential exhibitions of the 1990s by curators and critics alike.

Exhibition Title
Places with a Past: New
Site-Specific Art in Charleston

Organizer
Spoleto Festival USA

Curator
Mary Jane Jacob

Dates
May 24 – August 4, 1991

Location
Various sites in Charleston,
South Carolina, USA

Publication
Mary Jane Jacob, ed.,
*Places with a Past: New
Site-Specific Art at Charleston's
Spoleto Festival*, Spoleto
Festival USA and Rizzoli
International Publications,
New York, 1991

Artists
Christian Boltanski
Chris Burden
James Coleman
Houston Conwill /
 Estella Conwill Majozo /
 Joseph De Pace /
Kate Ericson /
 Mel Ziegler
Ian Hamilton Finlay
Gwylene Gallimard /
 Jean-Marie Mauclet

Antony Gormley
Ann Hamilton
David Hammons
Ronald Jones
Narelle Jubelin
Liz Magor
Elizabeth Newman
Joyce Scott
Cindy Sherman
Lorna Simpson /
 Alva Rogers
Barbara Steinman

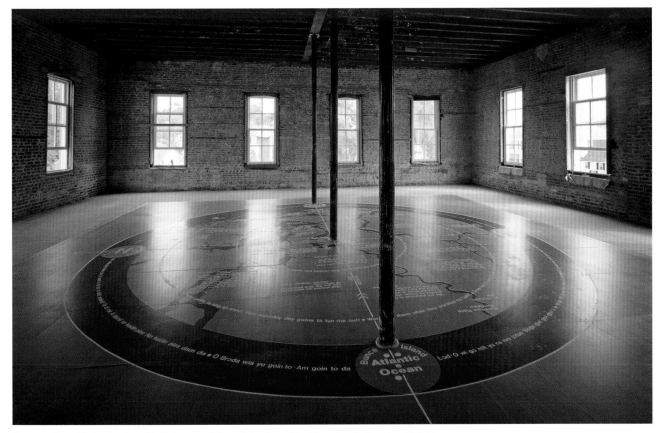

Houston Conwill, Estella Conwill Majozo, and Joseph De Pace, *The New Charleston* (detail), 1991

inSITE

1992, 1994, 1997, 2000–1, and 2005
Various sites in San Diego, USA,
and Tijuana, Mexico

inSITE is a bi-national exhibition sited in the border region between San Diego in the United States and Tijuana in Mexico, installed at various locations in each country simultaneously. There have been five editions since its founding (in 1992, 1994, 1997, 2000–1 and 2005), but it is unclear whether another will be held. Ernest Silva and Mark Quint of the nonprofit artist collective Installation founded the project, but it soon grew into a much more expansive endeavor that involved numerous people and organizations.

inSITE focused on social and political issues related to the border, specifically immigration and the shifting of jobs and workers back and forth, especially since the North American Free Trade Agreement of 1994 between the United States and Mexico (and Canada). By commissioning programs and projects, inSITE got artists and cultural producers from both countries to work together. In addition, starting with inSITE97, there was a related two-year residency program for artists to undertake research and create work. The artists led public tours and participated in organized talks with immigration officers and human rights groups to further the public's understanding of the region's social and political realities.

The inSITE exhibitions were well funded, and thus tended to be extremely ambitious and executed on a grand scale in a wide variety of media. Installations and performances were spread throughout the region, and organized tours enabled visitors to move freely across the border to view the work. In an attempt to avoid being just another biennial blockbuster and speaking only to the international art elite, inSITE sought directly to involve and influence the local communities of the border region. Extracurricular events such as lectures, classes, and screenings focused on education and community building, and much of this programming took place in local schools and universities. Dozens of art institutions, nonprofit organizations and corporate sponsors were involved in putting on the events in both countries, making inSITE a very successful idealistic effort.

Each inSITE exhibition generated an enormous amount of press coverage, since its content was so politically charged and its scale not unlike that of a regular biennial exhibition. It also attracted a wide and diverse audience, operating as it did across borders and nationalities in such a populous region. It received less attention from followers of contemporary art, however, who viewed it as an alternative, and political, event in contrast to the more mainstream biennial circuit.

In order to go from Tijuana to San Diego without crossing the Mexico/USA border, I will follow a perpendicular route away from the fence and circumnavigate the globe heading 67° SE, NE, and SE again until meeting my departure point.
The items generated by the journey will attest to the fulfillment of the task. The project will remain free and clear of all critical implications beyond the physical displacement of the artist.

Para viajar de Tijuana a San Diego sin cruzar la frontera entre México y los Estados Unidos, tomaré una ruta perpendicular a la barda divisoria. Desplazándome 67° SE, luego hacia el NE y de nuevo hacia el SE, circunnavegaré la Tierra hasta llegar al punto de partida.
Los objetos generados por el viaje darán fe de la realización del proyecto, mismo que quedará libre de cualquier contenido crítico más allá del desplazamiento físico del artista.

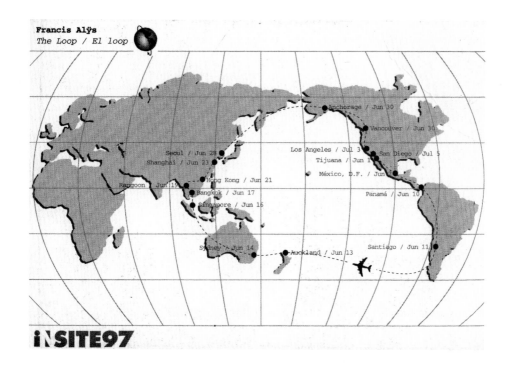

Francis Alÿs, *The Loop*, ephemera
of an action, inSITE97, 1997

Exhibition Title
inSITE92

Organizer
Installation Gallery, San Diego

Curators
Committee

Dates
August 7 – November 28, 1992

Location
Various sites in San Diego,
USA, and Tijuana, Mexico

Publication
Sally Yard, ed., *inSITE92*,
Installation Gallery,
San Diego, 1992

Artists
Wick Alexander
Ben Anderson
Patsy Babcock
Cora Boyd
Carmela Castrejón Diego
Cipriano
Johnny Coleman
Chuck Collings
Laura Crouch
Joyce Cutler-Shaw
Adolfo Davila
Steve DePaoli
Lewis DeSoto
Mary Louise Donovan
Larry Dumlao
Amanda Farber
Anthony Gormley
Judit Hersko
Steve Ilott
Jay Johnson
David Jurist
Nina Katchadourian
Jean Lowe
James Luna
Kim MacConnel
Eva Montville
Ming Mur-Ray
Anna O'Cain
Marcia Olson
Cheryl Lynn Parry
Patricia Patterson
Ellen Phillips
Liss Platt
Melba Price
Brent Riggs
Ray David Rogers
Ulf Rollof
Daphne Ruff
Leslie Samuels
Deborah Small
Melissa Smedley
Michael Soriano
Luis Stand

Jason Tannen
Noboru Tsubaki
Olav Westphalen
Nanette Yannuzzi-Macias

Exhibition Title
inSITE94: A Binational Exhibition
of Installation
and Site-Specific Art

Organizer
Installation Gallery, San
 Diego, in conjunction with:
Museum of Contemporary
 Art, San Diego
Department of Culture
 of the City of Tijuana
Instituto de Cultura
 de Baja California
Consejo Nacional para la Cultura
 y las Artes de Mexico Centro
 Cultural Tijuana Instituto
 Nacional de Bellas Artes,
 Tijuana

Curators
Committee

Dates
September 25 – October 30, 1994

Location
Various sites in San Diego,
USA, and Tijuana, Mexico

Publication
Sally Yard, ed., *inSITE94*,
Installation Gallery,
San Diego, 1995

Artists
Carlos Aguirre
Terry Allen
José Bedia
Carol Bing
Alvaro Blancarte
Border Art Workshop /
 Taller de Arte Fronterizo
Lee Boroson
David Beck Brown
Sheldon Brown
Chris Burden
Rimer Cardillo
Carmela Castrejón Diego
Albert Chong
Johnny Coleman
Cooperativa Mexicali
Abraham Cruzvillegas
Joyce Cutler-Shaw
Mark Alice Durant
Felipe Ehrenberg
En-Con-Traste
Helen Escobedo
Anya Gallaccio

Andy Goldsworthy
José Miguel González Casanova
Mathieu Gregoire
Silvia Gruner
Diego Gutiérrez
Yolanda Gutiérrez
Mildred Howard
Estela Hussong
Enrique Ježik
Rolf Julius
David Jurist
Allan Kaprow
Nina Karavasiles
Nina Katchadourian
Nina Katchadourian /
 Steven Matheson / Mark Tribe
Janet Koenig / Greg Sholette
Mario Lara / Barbara Sexton
Gabriela López Portillo
Jean Lowe
Kim MacConnel
Nanette Yannuzzi-Macias /
 Melissa Smedley
Luis Moret
Anne Mudge
Ming Mur-Ray
Dennis Oppenheim
Oscar Ortega
Pepón Osorio
John Outterbridge
Graciela Ovejero
Marta Palau
Patricia Patterson
Marcos Ramírez ERRE
Ulf Rollof
Nancy Rubins
Roberto Salas
Roman de Salvo
Michael Schnorr
Ernest Silva
Jim Skalman
Deborah Small
Buzz Spector
Sofía Táboas
Eloy Tarcisio
Robert Therrien
Val Valgardson
Eugenia Vargas
VITAL SIGNS
Olav Westphalen
Susan Yamagata
Yukinori Yanagi

Exhibition Title
inSITE97

Organizer
Installation Gallery, San Diego

Curators
Jessica Bradley
Olivier Debroise
Ivo Mesquita
Sally Yard

Dates
September 26* –
November 30, 1997
* Conversations, lectures,
 and some community
 engagement projects
 began in March 1997

Location
Various sites in San Diego,
USA, and Tijuana, Mexico

Publication
Sally Yard, ed., *inSITE97:
Private Time in Public
Space / Tiempo Privado
en Espacio Publico*,
Installation Gallery,
San Diego, 1997

Artists
Eduardo Abaroa
Vito Acconci
Kim Adams
Francis Alÿs
Fernando Arias
David Avalos
Judith Barry
Rebecca Belmore
Miguel Calderón
Tony Capellán
Chicano Park Artists
 Task Force
Gonzalo Díaz
Helen Escobedo
Manolo Escutia
Iran do Espírito Santo
Christina Fernandez
Andrea Fraser
Thomas Glassford
Quisqueya Henríquez
José Antonio
 Hernández-Diez
Louis Hock
Spring Hurlbut
Doug Ischar
David Lamelas
Ken Lum
Liz Magor
Anna Maria Maiolino
Rubén Ortiz-Torres
Patricia Patterson
Marcos Ramírez ERRE
Rosângela Rennó
Miguel Rio Branco
Betsabeé Romero
Daniela Rossell
Allan Sekula
Gary Simmons
Lorna Simpson
Deborah Small
Melanie Smith
Einar & Jamex de la Torre
Pablo Vargas Lugo
Nari Ward

→

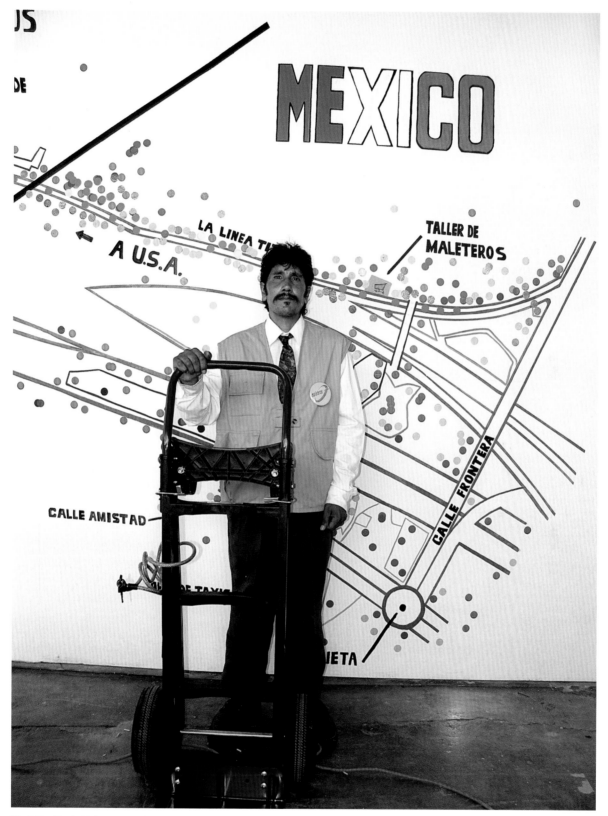

Mark Bradford, *Maleteros*, social engagement project for inSITE_05, 2005

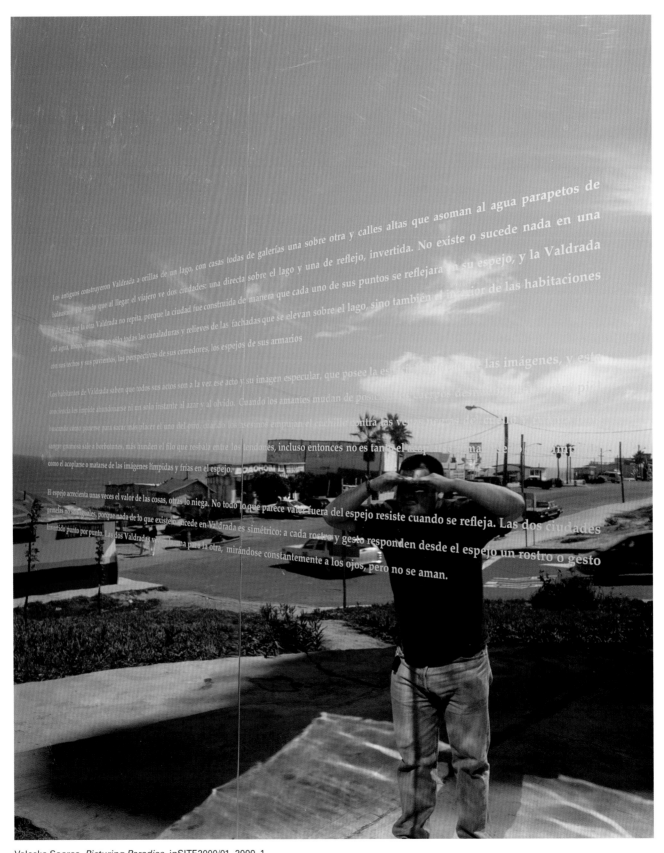

Valeska Soares, *Picturing Paradise*, inSITE2000/01, 2000–1

Community Engagement Projects

Border Art Workshop /
 Taller de Arte Fronterizo
Sheldon Brown
Carmen Campuzano
Amanda Farber
Octavio Hernández
Fran Ilich
Alfonso Lorenzana /
 Francisco Morales
Danielle Michaelis
Ugo Palavicino
RevolucionArte
Roberto Salas
Genie Shenk
Ernest Silva /
 Alberto Caro Limón
Glen Wilson
Cindy Zimmerman

Exhibition Title
inSITE2000/01: New
Contemporary Art Projects
for San Diego – Tijuana

Organizer
Installation Gallery,
San Diego

Executive Directors
Carmen Cuenca
Michael Krichman

Curators
Susan Buck-Morss
Ivo Mesquita
Osvaldo Sánchez
Sally Yard

Dates
October 13, 2000 –
February 25, 2001

Location
Various sites in San Diego,
USA, and Tijuana, Mexico

Publication
Osvaldo Sánchez and
Cecilia Garza, eds.,
*inSITE2000/01: Fugitive Sites/
Parajes fugitivos*, Installation
Gallery, San Diego, 2002

Artists
Carlos Amorales
Gustavo Artigas
Judith Barry
Alberto Caro Limón

Jordan Crandall
Arturo Cuenca
Mauricio Dias /
 Walter Riedweg
Mark Dion
Silvia Gruner
Diego Gutiérrez
Jonathan Hernández /
 FUSSIBLE /
 ToroLab
Alfredo Jaar
Komar & Melamid
Allan McCollum
Íñigo Manglano-Ovalle
Mônica Nador
Ugo Palavicino
Héctor Pérez
Armando Rascón
Roman de Salvo
Lorna Simpson
Valeska Soares
Meyer Vaisman
Jeffrey Vallance
Glen Wilson
Krzysztof Wodiczko

Exhibition Title
inSITE_05

Organizer
Installation Gallery,
San Diego

Artistic Director
Osvaldo Sánchez

Curators

*Farsites: Urban Crisis
and Domestic Symptoms
in Recent Contemporary Art*
Adriano Pedrosa

Conversations
Sally Yard

Scenarios
Ute Meta Bauer (Mobile
 Transborder Archive)
Hans Fjellestad (Ellipsis)
Mark Tribe (Tijuana Calling)

Associate Curators
Donna Conwell
Tania Ragasol

Dates
August 26* – November 13, 2005
* Conversations and lectures
 began November 3, 2003

Location
Various sites in San Diego,
USA, and Tijuana, Mexico

Publications
Adriano Pedrosa, ed., *inSITE_05:
 Farsites / Sitios distantes*,
 San Diego Museum of Art,
 San Diego, 2005
Osvaldo Sánchez and Donna
 Conwell, eds., *inSITE_05:
 [Situational] Public:
 Interventions, Scenarios*,
 Installation Gallery,
 San Diego, 2006

Artists

Interventions: Bypass
Allora & Calzadilla
Felipe Barbosa /
 Rosana Ricalde
Mark Bradford
Bulbo
Teddy Cruz
Christopher Ferreria
Thomas Glassford &
 José Parral
Maurycy Gomulicki
Gonzalo Lebrija
João Louro
Rubens Mano
Josep-Maria Martín
Itzel Martínez del Cañizo
Aernout Mik
Antoni Muntadas
Paul Ramírez Jonas
R_Tj-SD Workshop
SIMPARCH
Javier Téllez
Althea Thauberger
Judi Werthein
Måns Wrange

*Farsites: Urban Crisis
and Domestic Symptoms in
Recent Contemporary Art*
Franz Ackermann
Francis Alÿs
Juan Araujo
Dora Longo Bahia
Gabriele Basilico
Mark Bradford
Carlos Bunga
Pedro Cabrita Reis
Eloisa Cartonera
Franklin Cassaro
Marcelo Cidade
Eduardo Consuegra
Rochelle Costi
José Dávila

Iran do Espírito Santo
Etcétera
Didier Fiuza Faustino
Marcius Galan
Carlos Garaicoa
Kendell Geers
Robert Gober
Felix Gonzalez-Torres
Johan Grimonprez
Cao Guimarães
Jonathan Hernández
Guillermo Kuitca
Geraldine Lanteri
Leonilson
Armin Linke
Rita McBride
Jorge Macchi
Rubens Mano
Marepe
Julie Mehretu
Rivane Neuenschwander
Henrik Olesen
Catherine Opie
Gabriel Orozco
Damián Ortega
Fernando Ortega
Marjetica Potrč
Pedro Reyes
Doris Salcedo
Dean Sameshima
Silke Schatz
Gregor Schneider
Melanie Smith
Sean Snyder
Thomas Struth
Taller Popular de Serigrafía
Ana Maria Tavares
Armando Andrade Tudela
Susan Turcot
Adriana Varejão
Hector Zamora

Scenarios
Iván Díaz-Robledo
Ricardo Dominguez /
 Coco Fusco
Damon Holzborn
Fran Ilich
Liisa Lounila
Angel Nevarez /
 Alex Rivera
Magaly Ponce
Anna-Marie Schleiner /
 Luis Hernandez
Ricardo Miranda Zuniga

Sonsbeek 93

June 5 – September 26, 1993
Various sites in Arnhem, The Netherlands

Sonsbeek 93 was held in Arnhem, The Netherlands, in 1993 as part of an ongoing series focusing on art in the public sphere, which had been taking place since the late 1940s in the city's Sonsbeek Park. Curated by Valerie Smith, Sonsbeek 93 involved 38 international artists and artist groups, who were asked to submit project proposals based on their responses to the city of Arnhem. Located in the eastern part of the Netherlands, very near the German border, Arnhem has a long and rich history. It was the site of a fierce battle during World War II, in which German divisions defeated British troops attempting to seize Berlin; Sonsbeek 93 took place just before the 50th anniversary of this event.

Smith invited artists to comment through their work on the history of the city and specific aspects of its environment. Installations and projects were executed in diverse locations: a park, a home for the elderly, a prison, marshes on the border of the city, a restaurant. Since the works were created specifically for the chosen sites, many of them took forms that radically diverged from the artists' previous work. For instance the artist Mike Kelley made his first foray into the sphere of exhibition making by curating a show that revolved around the Freudian notion of the uncanny (see pp.68–9).

Not all of the proposed projects were executed. Some were not finished for various reasons but still remained on view to visitors. What made Sonsbeek 93 unlike most contemporary international exhibitions—and quite antithetical to the typical sleek and elegantly packaged biennials of today—was its intentional open-endedness, its emphasis on process, and its embrace of the failed and the unrealized. In this sense, Sonsbeek 93 diverged from earlier iterations of the exhibition series, which were more formal in their presentations, particularly the previous edition curated by Saskia Bos, which Smith felt was too polished and static.

Accompanying the exhibition was a 300-page catalogue containing Smith's notes, her correspondence with the artists, and the art proposals that she received, including those that were ultimately unrealized. In keeping with the open-ended concept, it did not include any critical or theoretical writings about the exhibition or the work. Instead, readers (like visitors to the show) were left to draw conclusions based on their own, necessarily partial, experiences of Sonsbeek 93.

Alighiero e Boetti, *Autoritratto (Self-Portrait)*, animated sculpture, 1993

Mirosław Bałka, *211 x 179 x 125*, installed outside the Moscowa
Cemetery, Arnhem, 1993

Exhibition Title
Sonsbeek 93

Curator
Valerie Smith

Dates
June 5 – September 26, 1993

Location
Various sites in Arnhem,
The Netherlands

Publication
Jan Brand, Catelijne de
Muynck, and Valerie Smith,
eds., *Sonsbeek 93*, Snoeck-
Ducaju & Zoon, Ghent, 1993

Artists
Mario Airó
Paweł Althamer
Art Orienté Objet
Fareed Armaly*
Michael Asher
Christina Assmann
Mirosław Bałka
Blue Funk
Alighiero e Boetti
Jean-Baptiste Bruant
Tom Burr
Maurizio Cattelan*
Thierry de Cordier*
Patrick Corillon
Stephan Dillemuth
Mark Dion
Kate Ericson / Mel Ziegler

Pepe Espaliú
Anna Gudjónsdóttir /
 Till Krause
Ann Hamilton
Ken Hardy
Irene & Christine Hohenbüchler
Zuzanna Janin
Kamagurka
Mike Kelley
John Körmeling
Liz Larner /
 Susan Narduli
Yuri Leiderman
Mark Manders
Annette Messager
Juan Muñoz
Jan van de Pavert
Vong Phaophanit

Keith Piper
Marc Quinn
Allen Ruppersberg
Eran Schaerf
Andreas Siekmann
subREAL*
Lawrence Weiner
R.W. van de Wint
Rémy Zaugg

* Included in catalogue but
did not participate in show

See p.69 for the list of artists
included in Mike Kelley: The
Uncanny, which formed part
of Sonsbeek 93

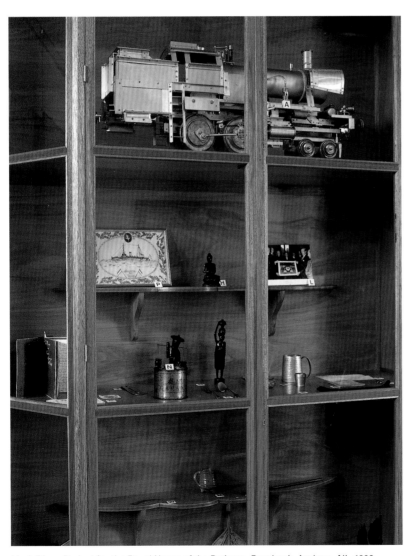

Mark Dion, *Project for the Royal Home of the Retirees, Bronbeek, Arnhem, NL*, 1993

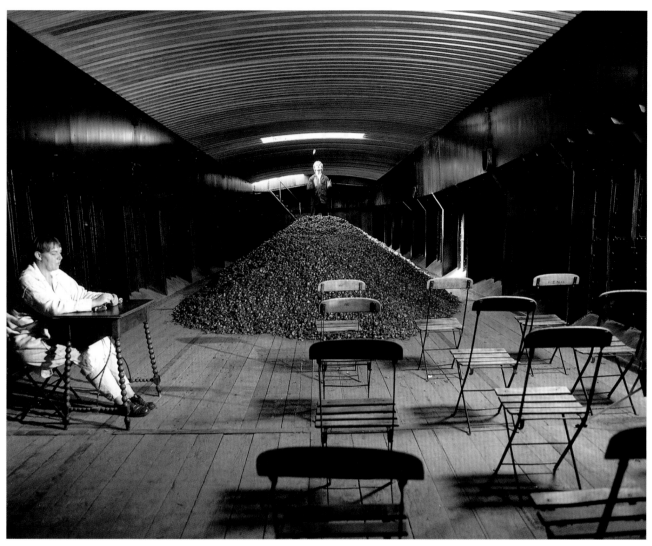

Ann Hamilton, *attendance*, 1993, installation/performance
photographed by Yves Paternoster

Culture in Action

May – September 1993
Various sites in Chicago, Illinois, USA

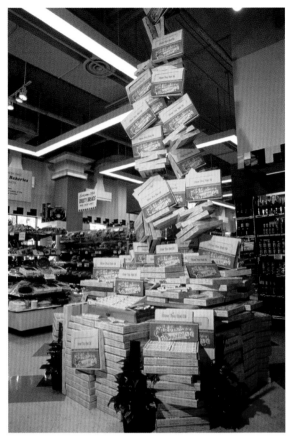

Simon Grennan and Christopher Sperandio, *We Got It!*, 1993

As part of a citywide effort to integrate art projects with members of underserved communities, the curator Mary Jane Jacob organized Culture in Action, a two-year-long undertaking in Chicago from 1991 to 1993. Artists from various locations across the United States—including Simon Grennan and Chrisopher Sperandio, Iñigo Manglano-Ovalle, Robert Peters, and the artist group Haha, all of whom were already based in Chicago—and local citizens collaboratively researched and developed projects relating to what they considered the pressing social and political issues of the time, such as AIDS, homelessness, racism, and illiteracy. Eight different projects were organized, each focusing on a separate issue and directly engaging with various marginalized communities. The work in Culture in Action culminated in dematerialized temporary projects such as a communal garden, a dinner party, a candy bar, courses for high-school students, and interactive sculptures. The long periods of research and engagement that laid the foundation for creating these projects had as much (or more) impact as their end results.

Exhibition catalogue

Jacob's intention was to explore how art projects can directly impact diverse publics, broadening the experience of art beyond the constraints of

Exhibition Title
Culture in Action

Organizer
Sculpture Chicago

Curator
Mary Jane Jacob

Dates
Culture in Action was developed over long periods of discussion and work with communities starting in 1991, and was launched as a public event in May 1993, continuing through September 1993

Location
Various sites in Chicago, Illinois, USA

Publication
Mary Jane Jacob, Michael Brenson, and Eva M. Oldson, eds., *Culture in Action: A Public Art Program of Sculpture Chicago*, Bay Press, Seattle, 1995

Artists
Mark Dion / The Chicago Urban Ecology Action Group
Kate Ericson / Mel Ziegler / A Resident Group of Ogden Courts Apartments
Simon Grennan / Christopher Sperandio / The Bakery, Confectionery and Tobacco Workers' International Union of America Local No. 552
Haha and Flood: A Volunteer Network for Active Participation in Healthcare
Suzanne Lacy / A Coalition of Chicago Women

Iñigo Manglano-Ovalle / Street-Level Video
Daniel J. Martinez / The West Side Three-Point Marchers
Robert Peters / Mushroom Pickers, Ghosts, Frogs, and other "Others"

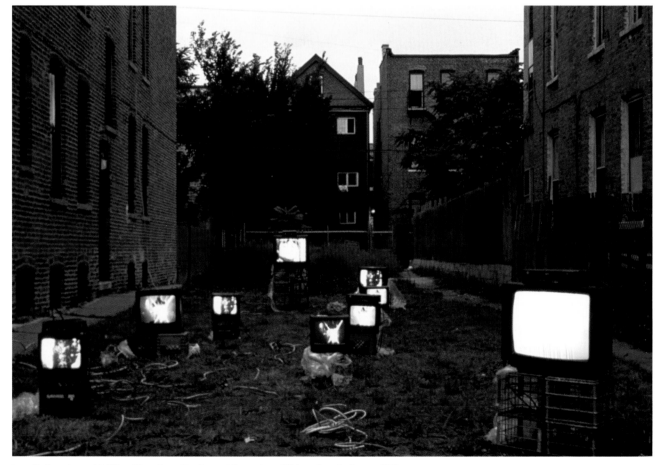

Installation view with Iñigo Manglano-Ovalle and Street Level Video, *Rest In Peace*, 1993

the museum world. Further, she wanted to create a bottom-up instead of a top-down system of production; in other words, the art was conceived and created by the communities themselves in conversation with the artists as opposed to the then-prominent scenario in which official organizations plopped decontextualized, readymade objects or projects into communities. Jacob sought to find ways to sustain the relationships that were being built between the artists, communities, and audience members. The artists and artist groups spent a great deal of time before the exhibition proper familiarizing themselves with the issues relevant to the communities.

Five-hour bus tours were offered for members of the public who wished to engage deeply with the work and the participants, and to appreciate what had been achieved. It should be noted, however, that the primary audience intended for the project was the participant communities, and not outside visitors (and certainly not the mainstream art world). Education played a major role in Culture in Action, but the exhibition was not didactic in the usual "museum education" sense. Rather, education was woven into every aspect of the organizational premise. Although not all the projects were meant to create solutions for the social problems they addressed, some of them did indeed have long-term positive effects. Culture in Action not only shifted the art world's notions about the role of exhibitions, but it also had a significant impact on the real lives of many Chicagoans.

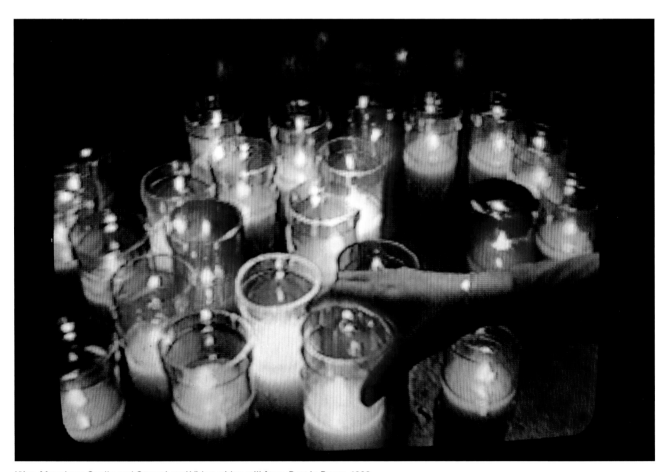

Iñigo Manglano-Ovalle and Street Level Video, video still from *Rest In Peace*, 1993

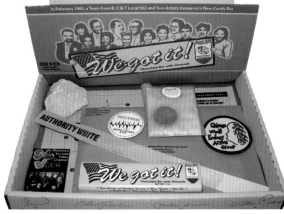

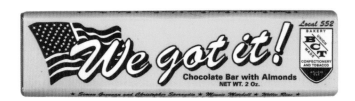

Participants' Souvenir Box (re-employed *We Got It!* retail display box featuring mementos contributed by participating artists). Clockwise from top left: display view of box; Mark Dion, student badge; Suzanne Lacy, chunk from limestone boulder monuments; Simon Grennan and Christopher Sperandio, candy bar; and Haha, condom

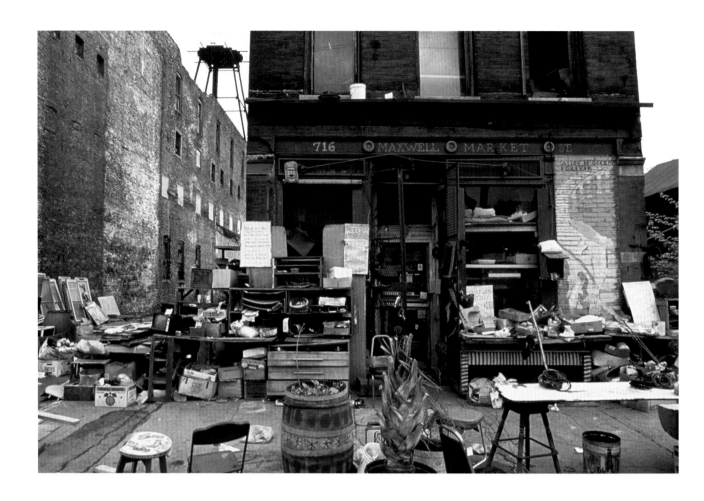

Above and opposite: Maxwell Street Market, Chicago, 1993
(now defunct), site for Daniel J. Martinez's parade *Consequences
of a Gesture* and installation *100 Victories/10,000 Tears*, 1993

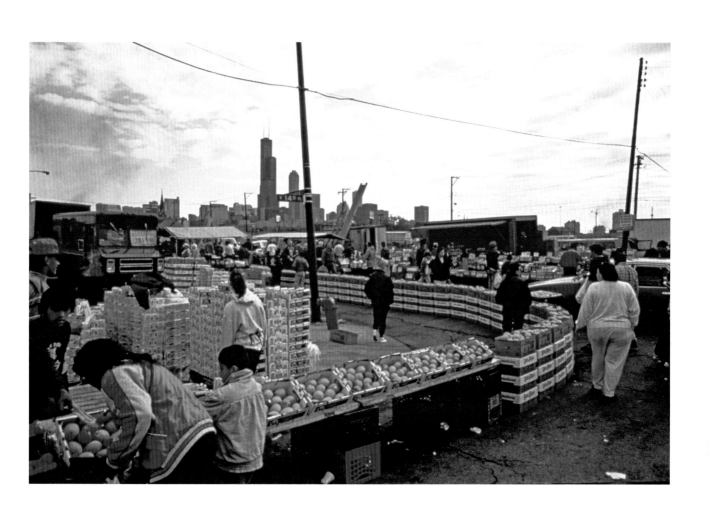

Prospect.1 New Orleans

November 1, 2008 – January 18, 2009
Contemporary Arts Center and various other sites
in New Orleans, USA

Prospect.1 New Orleans was the first New Orleans international biennial. It was launched and curated by Dan Cameron, and it came at an apt time for the city, which was going through the process of rebuilding after the (natural and political) devastation of Hurricane Katrina, that had hit in 2005. Cameron wrote in his statement of intent that Prospect New Orleans would contribute to the revitalization of New Orleans by spurring tourism and bringing international attention to the city's vibrant visual arts community.

> Though it is generally known that the majority of the city's population is both poor and black, the mass media was as unprepared as the government to record, interpret, or otherwise cope with the realities that faced thousands of families.

Dan Cameron, "A Biennial for New Orleans," in Dan Cameron, ed., Barbara J. Bloemink, Lolis Elie, and Claire Tancons, *Prospect.1 New Orleans*, PictureBox, New York, 2008.

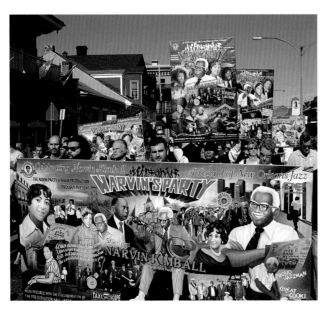

Navin Rawanchaikul and Tyler Russell, *Narvin's Party*, painting series being carried in the Jazz Funeral for Narvin Kimball organized for Prospect.1 New Orleans' Opening Day, 2008

This first installment of the biennial opened in 2008 and featured 81 international artists, including 10 who were from, or working in, the state of Louisiana. The exhibition was located in 24 different venues in various areas of New Orleans, from art and museum spaces such as the Contemporary Arts Center and the New Orleans Museum of Art to alternative spaces, including Harrah's Casino and Battle Ground Baptist Church. Although there was no explicit theme, the city's context and recent history were so "thick" (as the art critic Steven Stern put it) that they greatly conditioned the reading of the art, whether or not a particular work was meant to be site-specific. Many artworks sought to insert themselves into the social life of a particular community. For instance, Mark Bradford built a sculptural installation, organized a benefit auction, and hosted a massive crawfish boil.

Katharina Grosse, *Untitled*, installation, 2008

Exhibition catalogue

Cameron sought to couch Prospect New Orleans as a player in the international biennial scene, alongside those in Venice and São Paulo. His project was as much about bringing international attention to the local culture of New Orleans as about putting together a comprehensive and challenging contemporary art exhibition. To attract the attention he thought the biennial deserved, he made it the largest exhibition in the history of the United States in terms of the number of participating artists. Overall, Prospect.1 New Orleans was applauded by a wide range of critics as a thought-provoking first biennial that was deeply immersed in the life of its home city.

Until Katrina turned New Orleans
into an international center for
thinking outside the box, the
possibility that a city could
become an important home
to contemporary art without
building a major new museum
seems not to have occurred
to any of the country's mayors
or city councils.

Dan Cameron, "A Biennial for New Orleans," in Dan
Cameron, ed., Barbara J. Bloemink, Lolis Elie, and
Claire Tancons, *Prospect.1 New Orleans*, PictureBox,
New York, 2008.

Mark Bradford, *Mithra*, installation, 2008

Exhibition Title
Prospect.1 New Orleans

Organizer
U.S. Biennial, Inc.

Curator
Dan Cameron

Dates
November 1, 2008 –
January 18, 2009

Location
24 sites in New Orleans,
USA, including:
Battleground Baptist Church
Contemporary Arts Center
The George and Leah
 McKenna Museum
 of African American Art
Harrah's Casino
L9
Louisiana Art Works
New Orleans Jazz &
 Heritage Foundation
New Orleans Museum
 of Art
Newcomb Art Gallery
Studio at Colton

Publication
Dan Cameron, ed.,
Barbara J. Bloemink,
Lolis Elie, and Claire
Tancons, *Prospect.1
New Orleans*, PictureBox,
New York, 2008

Artists
Allora & Calzadilla
Ghada Amer
El Anatsui
Janine Antoni
Alexandre Arrechea
Luis Cruz Azaceta
John E. Barnes, Jr.
Sanford Biggers
Willie Birch
Monica Bonvicini
Mark Bradford
Candice Breitz
Cai Guo Qiang
Cao Fei
Francis Cape
Chen Chien-Jen
Adam Cvijanovic
Jose Damasceno
Anne Deleporte
Leandro Erlich
Skylar Fein

Roy G. Ferdinand, Jr.
Tony Fitzpatrick
Gajin Fujita
Rico Gatson
Katharina Grosse
Trenton Doyle Hancock
Victor Harris &
 Fi Yi Yi
Arturo Herrera
Jacqueline Humphries
Isaac Julien
William Kentridge
Lee Bul
Kalup Linzy
Srdjan Loncar
Rafael Lozano-Hemmer
Deborah Luster
McCallum & Tarry
Jorge Macchi
Dave McKenzie
Shawne Major
Nalini Malani
Josephine Meckseper
Julie Mehretu
Aernout Mik
Beatriz Milhazes
Tatsuo Miyajima
Yasumasa Morimura
Zwelethu Mthethwa
Wangechi Mutu

Shirin Neshat
Marcel Odenbach
Kaz Oshiro
Miguel Palma
Perejaume
Pierre et Gilles
John Pilson
Sebastian Preece
Navin Rawanchaikul /
 Tyler Russell
Rosângela Rennó
Pedro Reyes
Robin Rhode
Stephen G. Rhodes
Nadine Robinson
Clare E. Rojas
Kay Rosen
Malick Sidibe
Amy Sillman
Nedko Solakov
Jackie Sumell
SUPERFLEX
Fiona Tan
Pascale Marthine Tayou
Fred Tomaselli
Jannis Varelas
Xavier Veilhan
Paul Villinski
Nari Ward
Xu Bing

Leandro Erlich, *Window and Ladder— Too Late for Help*, installation, 2008

Artists
as
Curators
as
Artists

Freeze

The Brooklyn
Museum
Collection:
The Play of the
Unmentionable

Mining the
Museum:
An Installation
by Fred Wilson

The Museum
as Muse:
Artists Reflect

Mike Kelley:
The Uncanny

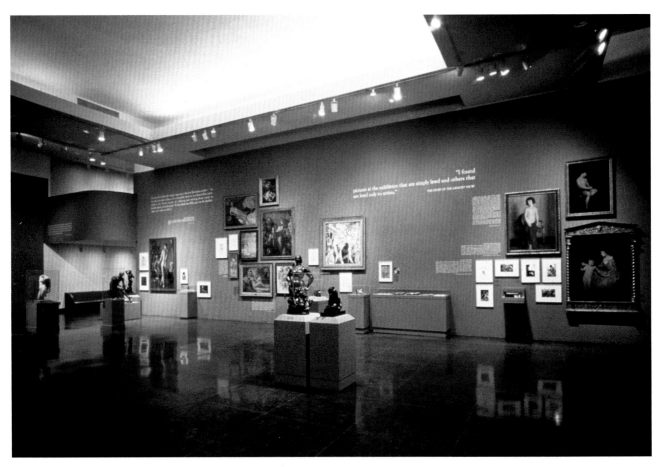

Installation view, The Brooklyn Museum Collection: The Play of the
Unmentionable, The Brooklyn Museum, New York, USA, 1990

Artists as Curators as Artists

Conceiving exhibitions, and particularly collections, has always seemed to be a source of inspiration for artists. Since Marcel Duchamp's International Surrealist Exhibition held at the Galerie des Beaux-Arts in Paris in 1938, artists' interests in organizing shows has grown and developed in several ways. The one that best serves as an exemplary precursor for many subsequent artist-curated exhibitions is Andy Warhol's Raiding the Icebox, a show of the collection of the Rhode Island School of Design's gallery that took place in 1970. Following Warhol's path, the artists who curated the exhibitions described in this book have frequently looked at existing collections and modes of display, but in evolving and varied ways. Joseph Kosuth's The Play of the Unmentionable and Fred Wilson's Mining the Museum are two now-iconic exhibitions in which the artists selected and arranged objects in a museum collection in order to highlight controversial themes and ideas, including politics, censorship, or, in Wilson's case, the troubling history of race relations in the United States. These reinventions of collections by artists came out of the Institutional Critique movement—a form of art practice that examined how art institutions condition the perception and creation of artworks— and were considered cutting-edge in their moment. The current prevalence of such shows in museums, however, has been criticized in recent years as a method for curators to avoid rehanging their own institutional collections, leaving this difficult responsibility to the artist's subjective eye. In the best cases, these exhibitions are able to reflect contemporary concerns and issues through historical works, leaving audiences to ponder the role of the museum as a guardian of culture.

Of course, intervention into the museum collection is not the only format for the artist-curated show. Just as Duchamp organized the International Surrealist Exhibition in the 1930s, artists have continued to self-organize exhibitions of their own work and that of their peers, as in the case of Freeze in 1988, which helped launch the careers of the Young British Artists. Some artists, for instance Mike Kelley with his show The Uncanny, use the exhibition as a medium to further their conceptual and artistic development. These exhibitions position a range of objects from many sources to articulate a gesture or mood put forward by the artist.

Freeze

6 August – 29 September 1988, in three parts
Port Authority Building, Surrey Docks,
London, UK

Freeze was co-organized by a number of art students in 1988, but the one most credited with realizing the project has been Damien Hirst, who was then 23 years old and a student at Goldsmiths College in London. He and 15 of his fellow students installed their works in a large, abandoned Port Authority building. The venue was empty and available due to the economic recession that the UK was experiencing at the time; in fact, the space had already been used to host a number of exhibitions by young emerging artists, enabling them to initiate their own projects and gain public exposure.

The title, Freeze, refers to Mat Collishaw's controversial photographic lightbox—one of the works in the show—portraying a close-up image of a bullet hole in a human skull. The reference is to the ability of a photograph to freeze a moment in time. Sponsored by the London Docklands Development Corporation and Olympia & York, the exhibition was accompanied by a catalogue whose high production values significantly helped raise the profile of the show. The whole enterprise had a strong professional veneer, but it was not all about careerism and public relations, as many believe today. As one of the teachers at Goldsmiths

Freeze is eighties art, not in the sense that it parades the most uncontested talents of its generation, but rather in the sense that it forms a quintessential eighties composite.

Ian Jeffrey, "Platonic Tropics," in Damien Hirst, ed., *Freeze*, E.G.A., Brighton, 1988.

Exhibition Title
Freeze

Curator
Damien Hirst

Dates
6 August – 29 September 1988,
in three parts

Location
Port Authority Building,
Surrey Docks, London, UK

Publication
Damien Hirst, ed., *Freeze*,
E.G.A., Brighton, 1988

Artists
Steven Adamson
Angela Bulloch
Mat Collishaw
Ian Davenport
Dominic Denis*
Angus Fairhurst
Anya Gallaccio
Damien Hirst
Gary Hume
Michael Landy

Abigail Lane
Sarah Lucas
Lala Meredith-Vula
Stephen Park
Richard Patterson
Simon Patterson
Fiona Rae

* Included in catalogue but
 did not participate in show

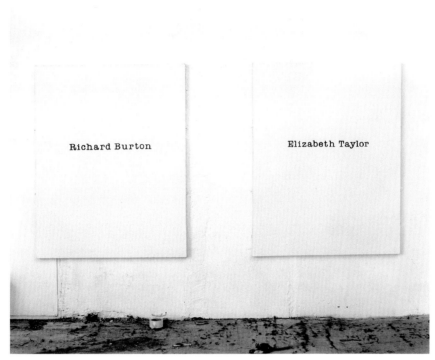

Simon Patterson, *Richard Burton / Elizabeth Taylor*, 1987

College, Michael Craig-Martin, commented, "People have said that Freeze was about making money, but it wasn't. Nobody could have bought Damien's spot painting ... [*Row* and *Edge* were both painted directly on the wall in the third part of Freeze]. It was about being young, about being excited about what [they] were doing, and getting people to see their work."

Freeze generated an enormous amount of interest in the participating artists, even though only one artwork was sold and the show was not widely reviewed. Charles Saatchi, the powerful advertising guru and art collector who was known at the time for bestowing international fame on young artists practically overnight, first met Hirst and his peers at Freeze, and several of the group went on to show at Saatchi's gallery and sell work into his collection. Although we cannot credit a single exhibition for putting the so-called Young British Artists, or YBAs, on the map, Freeze certainly played an important role in the instigation of the phenomenon.

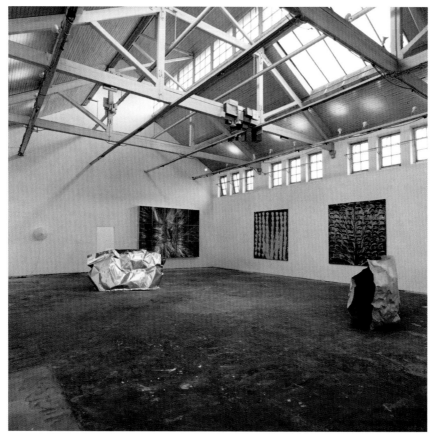

Installation view

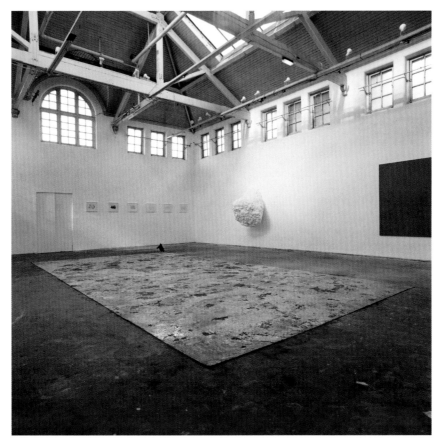

Installation view with a floor sculpture by Anya Gallaccio

The Brooklyn Museum Collection: The Play of the Unmentionable

Installation view with wall texts

September 27 – December 31, 1990
Brooklyn Museum, New York, USA

The artist Joseph Kosuth curated the exhibition The Brooklyn Museum Collection: The Play of the Unmentionable as a temporary installation in 1990. It was part of the Brooklyn Museum's Grand Lobby series, which was dedicated to inviting artists to install experimental projects without any constraints dictated by a curator. Instead, the curators at the museum acted as supporters and facilitators.

The Play of the Unmentionable dealt with how art has been censored in different cultures and throughout the ages. Kosuth teamed up with several of the museum's curators and Max Moerman, a graduate student in religious studies at Stanford University, to select and display 100 artworks drawn from the museum's collections—including African, Middle Eastern, Classical, Asian, and Prints and Drawings—that had been at some time censored by public officials or religious institutions. Several had been on permanent display elsewhere in the museum, and instead of temporarily installing other pieces in their place, notices were posted stating that they had been moved to the Grand Lobby.

The Play of the Unmentionable was arranged salon-style and organized into several distinct categories, such as the female and male nude, the child nude, religious and political controversies, and questions surrounding propriety in artistic representation. Once installed, unexpected connections and configurations became apparent. A large amount of written information, authored or chosen by Kosuth, accompanied the works in the form of labels and wall texts, giving the exhibition the didactic feeling of a cultural-history display.

> If art is to be more than expensive decoration, you have to see it as expressing other kinds of philosophical and political meaning.

Joseph Kosuth and Randall Short, "An Artist Who Sees the Frame First: An Interview with Joseph Kosuth," *The Play of the Unmentionable: An Installation by Joseph Kosuth at the Brooklyn Museum*, The New Press in association with the Brooklyn Museum, New York, 1992.

Exhibition Title The Brooklyn Museum Collection: The Play of the Unmentionable **Organizer** Brooklyn Museum, New York, USA	**Curator** Joseph Kosuth **Dates** September 27 – December 31, 1990 **Location** Brooklyn Museum, New York, USA	**Publication** Joseph Kosuth and David Freedberg, *The Play of the Unmentionable: An Installation by Joseph Kosuth at the Brooklyn Museum*, The New Press in association with the Brooklyn Museum, New York, 1992	**Artists** Various artworks and artifacts from the Brooklyn Museum collection

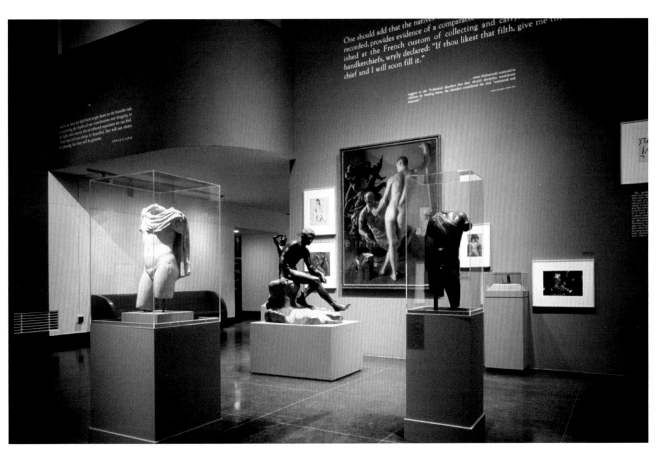

Installation view of sculptural works

Supporting the project was the National Endowment for the Arts, which at the time was embroiled in political upheaval for its support of so-called controversial artists and exhibitions, including The Play of the Unmentionable. The show also received many positive reviews from critics for tackling, as the *New York Times* critic Roberta Smith worded it, "issues that are both imminently topical and as old as time." It attracted such huge crowds that its run was extended for an additional month past the planned closing date, and it remains the only exhibition ever devoted to an overview of censored art on such a large scale. The Play of the Unmentionable started a trend that continues today, in which museums ask artists to "interpret" historical collections in order to address the challenge of contemporizing them.

Mining the Museum: An Installation by Fred Wilson

April 3, 1992 – February 28, 1993
Maryland Historical Society, Baltimore, USA

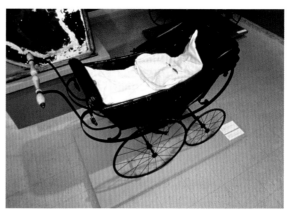

Modes of Transport, 1770–1910. Baby carriage, *c.*1908, maker unknown; hood, 20th century, maker unknown

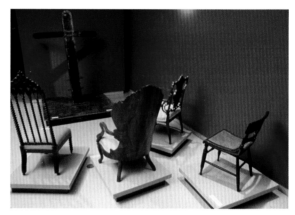

Cabinetmaking, 1820–1960. From left: side chair, *c.*1840–60, maker unknown; whipping post, date unknown, maker unknown; J.H. Belter, armchair, *c.*1855; armchair, *c.*1896, maker unknown; side chair with logo of Baltimore Equitable Society, *c.*1820–40, maker unknown

Art museums—and of course also museums of science, natural history, and so on—have long been perceived by the public as neutral sites that display authoritative, coherent historical narratives. Since the 1970s, however, a movement of artists operating under the banner of Institutional Critique has sought to question and unmask the apparent neutrality of museums by exposing how their functions are very much driven by particular ideological interests and value systems. In 1992, Mining the Museum: An Installation by Fred Wilson at the Maryland Historical Society in Baltimore investigated how museums, knowingly or unwittingly, exclude minority groups and their histories and cultures from their collections and exhibitions. While Mining the Museum was not technically curated by Wilson, his involvement with the Maryland Historical Society was sufficiently curatorial to justify its inclusion in this chapter.

As an artist-in-residence for a year prior to the show, Wilson extensively studied the art, artifacts, and archives at the historical society and discovered many items related to suppressed minority histories in the United States. Treating the works in the collection as what he called

> Behind their often-cavernous halls of cultural relics, museums are places where sacrosanct belief systems are confirmed on the basis of hierarchies valuing one culture over another.

Lisa G. Corrin, "Mining the Museum: Artists Look at Museums, Museums Look at Themselves," in Lisa G. Corrin, ed., *Mining the Museum: An Installation by Fred Wilson,* The Contemporary, Baltimore, and The New Press, New York, 1994.

Exhibition Title
Mining the Museum:
An Installation by Fred Wilson

Installed by
Fred Wilson

Curators
Lisa G. Corrin
Jennifer Goldsborough

Dates
April 3, 1992 –
February 28, 1993

Location
Maryland Historical Society,
Baltimore, USA

Publication
Lisa G. Corrin, ed., *Mining the Museum: An Installation by Fred Wilson*, The Contemporary, Baltimore, and The New Press, New York, 1994

Artists
Various artworks and artifacts from the Maryland Historical Society's collection, mostly anonymous, selected by Fred Wilson

"raw materials," he deconstructed and rearranged them in a way that exposed how the museum systematically represented (or, more often, failed to represent) histories of African Americans and Native Americans. Many of the objects that Wilson used had never been displayed before, thus giving them a new life outside the storage shelves.

Mining the Museum occupied an entire floor and was divided into a sequence of eight rooms. The walls were painted particular colors to symbolize different themes. Using such strategies as installing sound recordings, projecting images onto canvases and objects, juxtaposing text with objects in the collection, and manipulating the atmosphere with various lighting techniques, the exhibition created a jarring effect that forced the viewer to reflect critically on resurrected or untold histories. These histories were already latent in the objects before Wilson's artistic and curatorial intervention, and he brought them to light through the particular staging of the show.

Mining the Museum received great critical acclaim and was visited by a diverse audience. In fact, it attracted more visitors to the venue than had cumulatively attended since its founding in 1844. The exhibition made a lasting impact on the Maryland Historical Society, which subsequently became more open to other histories, and Wilson's artistic–curatorial approach was taken up as an international phenomenon. Museums and cultural producers are operating in ever more self-conscious and self-reflexive ways with respect to how they tell history, and they frequently cite Mining the Museum as a specific inspiration.

Metalwork, 1793–1880. Silver vessels in Baltimore Repoussé style, 1830–80, maker unknown; slave shackles, *c.*1793–1872, made in Baltimore, maker unknown

Truth Trophy and Pedestals. From left: empty pedestals labeled Harriet Tubman, Frederick Douglas, and Benjamin Banneker; globe, *c.*1913; acrylic mounts, *c.*1960s; Shobal Vail Clevenger, *Henry Clay*, *c.*1870; artist unknown, *Napoleon Bonaparte*, *c.*1850; C. Hennecke & Co, *Andrew Jackson*, *c.*1870

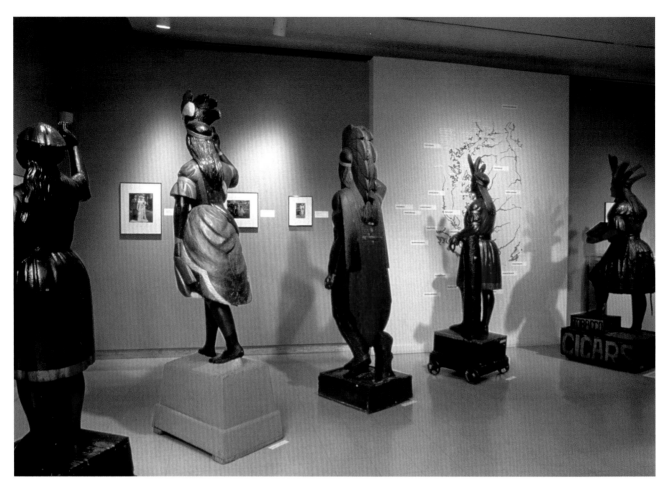

Installation view, *Portraits of Cigar Store Owners*, folk sculptures by
John Philip Yeager (except second from right: artist unknown), *c.*1870s

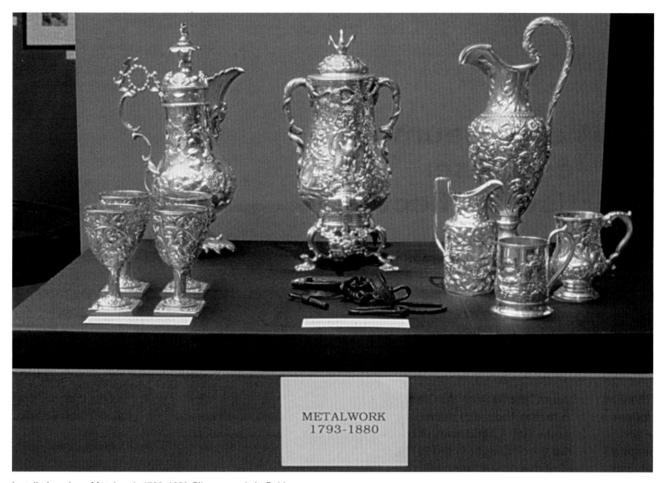

Installation view, *Metalwork, 1793–1880*. Silver vessels in Baltimore
Repoussé style, 1830–80, maker unknown; slave shackles, *c.*1793–
1872, made in Baltimore, maker unknown

The Museum as Muse: Artists Reflect

March 14 – June 1, 1999
The Museum of Modern Art, New York, USA

General Idea (AA Bronson, Felix Part, and Jorge Zontal),
The Boutique from the 1984 Miss General Idea Pavillion, 1980

The word "museum" stems from the Greek word *museion*, which means "house of the muses," a shrine for the nine Greek goddesses of creative inspiration. Since the onslaught in the 1970s of Institutional Critique, these "shrine-like" associations have been persistently questioned. It is now an accepted idea that museums, by perpetuating their own status as authoritative venues for the interpretation and display of art to the public, often conceal the ideological and political hierarchies that are very much embedded in the processes of deciding what is worthy of inclusion (or deserves exclusion).

The Museum as Muse: Artists Reflect, a 1999 exhibition curated by Kynaston McShine at the Museum of Modern Art in New York, set out with the explicit aim to present "a broad-based, international survey of works about museums and their practices and policies." McShine undertook a study of every aspect of the museum's functions, from its administrative programs to its public policies, curators' roles, and exhibition strategies. The process of unveiling this complex underbelly took many different forms in the 188 works by 59 artists that visitors experienced. The show included painting, sculpture, photography, installation, audio,

Barbara Bloom, *The Reign of Narcissism*, 1988–89

Exhibition Title
The Museum as Muse:
Artists Reflect

Organizer
The Museum of Modern Art,
New York, USA

Curator
Kynaston McShine

Dates
March 14 – June 1, 1999

Location
The Museum of Modern Art,
New York, USA

Publication
Kynaston McShine, ed.,
*The Museum as Muse:
Artists Reflect*, The Museum
of Modern Art, New York, 1999

Artists
Vito Acconci
Eve Arnold
Art & Language
Michael Asher
Lothar Baumgarten
Barbara Bloom
Christian Boltanski
Marcel Broodthaers
Daniel Buren
Sophie Calle
Janet Cardiff
Henri Cartier-Bresson
Christo
Joseph Cornell
Jan Dibbets
Lutz Dille
Mark Dion
Herbert Distel
Marcel Duchamp
Kate Ericson / Mel Ziegler
Elliott Erwitt
Roger Fenton
Robert Filliou
Larry Fink
Fluxus
Günther Förg
Andrea Fraser
General Idea (AA Bronson /
 Felix Part / Jorge Zontal)
Hans Haacke
Richard Hamilton
Susan Hiller
Candida Höfer
Komar & Melamid
Louise Lawler
Jean-Baptiste Gustave Le Gray
Jac Leirner
Zoe Leonard
Sherrie Levine
El Lissitzky
Allan McCollum
Christian Milovanoff
Vik Muniz
Claes Oldenburg
Dennis Oppenheim
Charles Willson Peale
Hubert Robert
Edward Ruscha
David Seymour
Robert Smithson
Thomas Struth
Hiroshi Sugimoto
Charles Thurston Thompson
Stephen Thompson
Jeff Wall
Gillian Wearing
Christopher Williams
Fred Wilson
Garry Winogrand

video, and performance. Dada and neo-Dada gestures were generously represented, and Marcel Duchamp's puns and jokes regarding art institutions clearly played a major inspirational role. A few works from the 1800s were included, and five new pieces were commissioned. The Museum as Muse was accompanied by an illustrated catalogue that included artists' writings on their personal thoughts about museums. The emphasis was therefore not only on the museum's inner functions, but also on its relationships with artists as told from the latter's point of view.

The exhibition sparked many questions, even accusations, from critics. Some felt that it was nothing more than a forum for artists to vent their hostility toward museums, with respect to particular policies, for instance, or ways of handling artworks. There was also the inevitable question of whether artists' criticisms could possibly have any teeth in this context, given the institutional embrace. In other words, how can Institutional Critique, when absorbed and displayed by the very institutions it questions, not serve on some level as self-aggrandizing and self-congratulatory on the part of the object of the supposed criticism?

Mark Dion, *The Great Chain of Being*, 1998

Mike Kelley:
The Uncanny

June 5 – September 26, 1993
Gemeentemuseum, Arnhem, The Netherlands
and "re-staged" at Tate Liverpool, UK,
February 20 – May 3, 2004, MUMOK, Vienna,
Austria, July 17 – November 1, 2004,
and the 8th Gwangju Biennial, South Korea,
September 3 – November 7, 2010

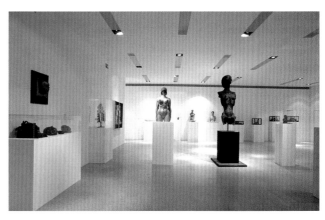

Installation view with sculptural works

Installation view

Exhibition Title
Mike Kelley: The Uncanny

Curators
Achim Hochdörfer
Mike Kelley

Dates
June 5 – September 26, 1993
(as an exhibition within
Sonsbeek 93)

Location
Gemeentemuseum, Arnhem,
The Netherlands

**Locations and Dates of
"Re-staged" Versions**
Tate Liverpool, UK
 (supported by the
 Henry Moore Foundation,
 UK), February 20 – May 3,
 2004
MUMOK (Museum Moderner
 Kunst Stiftung Ludwig Wien),

Vienna, Austria,
 July 17 – November 1, 2004
8th Gwangju Biennial: 10,000
 Lives, South Jeolla, South
 Korea, September 3 –
 November 7, 2010

Publications
Mike Kelley, ed., *The Uncanny*,
 Gemeentemuseum, Arnhem,
 1993
Mike Kelley, John C. Welchman,
 and Christoph Grunenberg,
 Mike Kelley: The Uncanny,
 Walther König, Cologne, 2004

Artists
Eva Aeppli
Cynthia "Plaster Caster"
 Albritton
John de Andrea
Francesco Antommarchi
Art Orienté Objet
Dean Barrett
Hans Bellmer

Nayland Blake
Jonathan Borofsky
Marcel Broodthaers
Kristian Burford
Reg Butler
Jake & Dinos Chapman
Jacques Charlier
Christo
Bryan Crockett
Salvador Dalí
John Davies
Keith Edmier
Ian English
Judy Fox
Christiana Glidden
Robert Gober
Nancy Grossman
Duane Hanson
Damien Hirst
Steve Hodges
John Isaacs
Allen Jones
Edward Kienholz
Robert Knight
Jeff Koons

Tetsumi Kudo
Herbert List
Sarah Lucas
Paul McCarthy
Tony Matelli
John Miller
Ron Mueck
Matt Mullican
Bruce Nauman
Siegfried Neuenhausen
Dennis Oppenheim
Tony Oursler
Malcom Poynter
Thom Puckey
Marc Quinn
Charles Ray
Richard Rush Studio, Chicago
Karl Schenker
Cindy Sherman
Laurie Simmons
Paul Thek
Gavin Turk

Mike Kelley: The Uncanny was originally
a small show curated by the artist Mike Kelley
for Sonsbeek 93. It reappeared in 2004, reworked
and with additions, at Tate Liverpool and at
MUMOK in Vienna, and in 2010 as part of the
8th Gwangju Biennial, South Korea.

Sigmund Freud defined "the uncanny" as an
instance or object that is simultaneously familiar
and foreign to the beholder, provoking ambivalent
and unsettling feelings. In his famous 1919 essay
"The Uncanny," he illustrates the notion by making
reference to the doll Olympia in E.T.A. Hoffmann's
story "The Sandman" (1816), which Freud says
resembles a living human being in an unfamiliar
way. Taking this notion as the starting point
for organizing an exhibition, Kelley displayed
mannequin-related artworks: medical dolls,
taxidermied animals, anatomical waxworks, sex
dolls, religious statues, ventriloquists' dummies,
hyperrealistic sculptures, pagan figurines, and
so on. He exhibited photographic images of some
objects and artworks for which he was not able
to arrange loans. He also displayed photographs
of taboo and grotesque imagery, such as a police
photograph of someone who had accidently
killed himself during autoerotic asphyxiation,

and representations of sexually transmitted diseases.
Thus, on top of estrangement and intimacy, the
viewer also at times felt shock, disgust, and curiosity.

The exhibition experimented with combining high
and low, serious and light, avant-garde and kitsch.
It was not reducible to a fine art experience because
it was not organized on aesthetic principles and was
more like a survey of a collection of cultural artifacts
and objects than an art show meant to be judged on
the basis of the quality of each individual work. But
it was also much more than an uncritical display
of kitsch, since it provoked turbulent emotions and
reactions. It was a cabinet of curiosities, a sadistic
collection of things over which to muse, and a
subset of some of the inspirational source material
underlying Kelley's own creative practice.

Across the Fields and Beyond the Disciplines

High & Low:
Modern Art
and Popular
Culture

Cities on the
Move:
Contemporary
Asian Art on
the Turn of the
21st Century

Laboratorium

What If:
Art on the
Verge of
Architecture
and Design

Century City:
Art and Culture
in the Modern
Metropolis

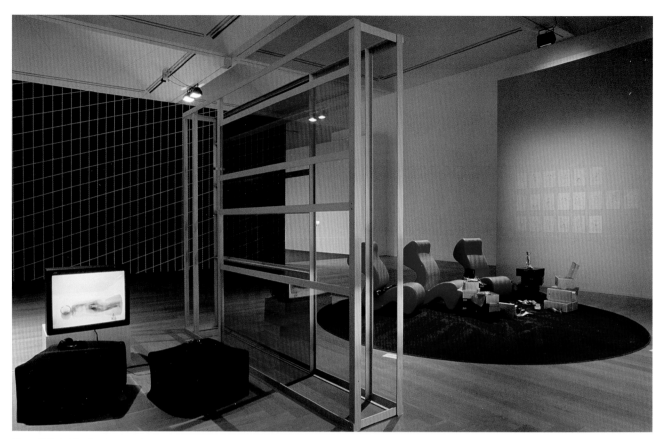

Liam Gillick, *Big Conference Centre Limitation Screen,* 1998, and *Big Negotiation Screen*, 1998 (center) and Sylvie Fleury, *Spring Summer 2000*, 2000, installation (right), installation view from What If: Art on the Verge of Architecture and Design, Moderna Museet, Stockholm, Sweden, 2000

Across the Fields
and Beyond the Disciplines

The exhibitions in this section reveal interdisciplinary connections between contemporary art and science, technology, architecture, urbanism, and material culture. There are many reasons behind curators' increased interest in other fields, but one of the main ones is directly related to globalization and new technologies that allow for greater interconnectivity across the world between people, places, and ideas. This new interconnectivity has brought about significant increases in exchange between the contemporary art centers, historically located in Western Europe and the United States, and new hubs in Asia, Africa, and Latin America, in terms of artistic, economic, and cultural development. Both the traveling exhibition Cities on the Move and Tate Modern's Century City were attempts to display geographically specific art and culture within the framework of the new globalism.

The proliferation of technologies such as the internet in the 1990s also led to deeper thinking about the relationship between art and technology. Some curators began to conceive of the exhibition site as a laboratory in which artists could experiment with innovative ideas. Laboratorium was one of the first exhibitions to explore the concept of experimentation as a shared nexus point between science and art, seeking commonalities among the research methodologies and production styles of artists and scientists. Other exhibitions— such as What If: Art on the Verge of Architecture and Design and High & Low: Modern Art and Popular Culture—explored relationships between art, material culture, and related fields of architecture and design, breaking with the formal divide between "high" and "low" art that was taken for granted during much of the 20th century.

Through all these tendencies, a strong contingent of curators emerged who examined new places, methodologies, and fields in exhibitions in order to foster new perspectives on contemporary art and culture. Within this interdisciplinary boom of the 1990s, the legacy of postmodernism is palpable. Traditional art-historical categories and diachronic timelines were being abandoned for a more synchronic view of art as the product of a matrix of broader cultural influences.

High & Low: Modern Art and Popular Culture

October 7, 1990 – January 15, 1991
The Museum of Modern Art, New York, USA,
and touring

Our goal is to examine the transformations through which modern painters and sculptors have made new poetic languages by reimagining the possibilities in forms of popular culture; and, as a corollary, to acknowledge the way those adaptations in modern art have often found their way back into the common currency of public visual prose.

Kirk Varnedoe and Adam Gopnik, "Coda," in *High & Low: Modern Art and Popular Culture*, The Museum of Modern Art, New York, 1990.

The 1991 the Museum of Modern Art in New York hosted the exhibition High & Low: Modern Art and Popular Culture with the intention of uncovering the impact of "low" popular culture on "high" modernist art. The curators, Kirk Varnedoe and Adam Gopnik, brought together more than 250 works by over 50 modernist artists (from the Parisian avant-gardes to the contemporary moment) as well as an array of commercial productions, from advertisements to graffiti, comics, and signage. Highly influenced by postmodern thinking, the exhibition was one of the first large-scale explorations of the relationship between popular culture and modern art to take place in a museum setting.

The show was organized into five themes: the influence of mass culture on Cubism, the role of advertising in the development of artists such as Aleksandr Rodchenko, the impact of the caricature on painters like Philip Guston, the influential part played by graffiti and "public writings" for artists including Cy Twombly and Jean Dubuffet, and the importance of comics in the works of Pop artists such as Roy Lichtenstein. The show had two catalogues: a "visual" (low) catalogue presented the artworks within their thematic groups, and an "intellectual" (high) catalogue introduced supplementary readings to accompany the artworks and mass-cultural material.

High & Low was massively popular, drawing large crowds and receiving much critical attention. Some declared the exhibition a breath of fresh air, opening up the museum to connections between different forms of culture. MoMA had always had a design department, but objects from that part of the museum's collection had never been shown in dialogue with painting, for example, before this exhibition. Others disdained High & Low as arbitrary in its selection of works, and reductive of the real historical tensions that have existed between the realm of avant-garde art and popular culture, artificially glossing over their differences and placing them into a harmonious relation that never existed. High & Low subsequently traveled to the Art Institute of Chicago and the Museum of Contemporary Art, Los Angeles, where it was received more favorably.

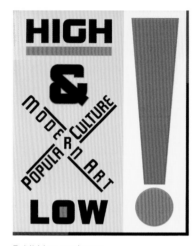

Exhibition catalogue

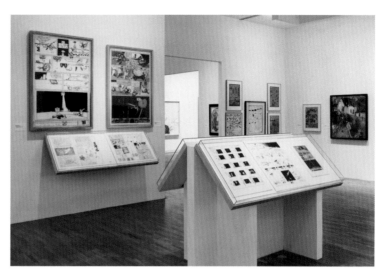

Installation view

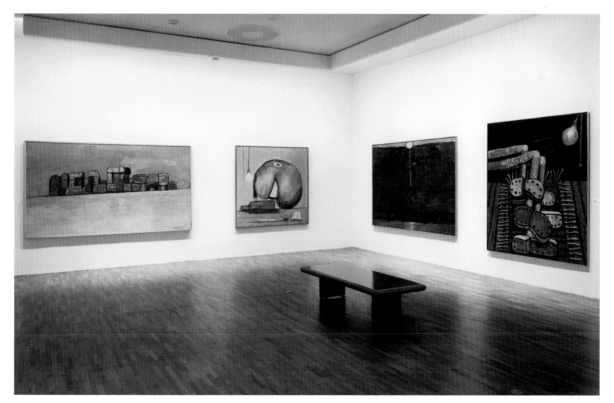

Installation view of works by Philip Guston

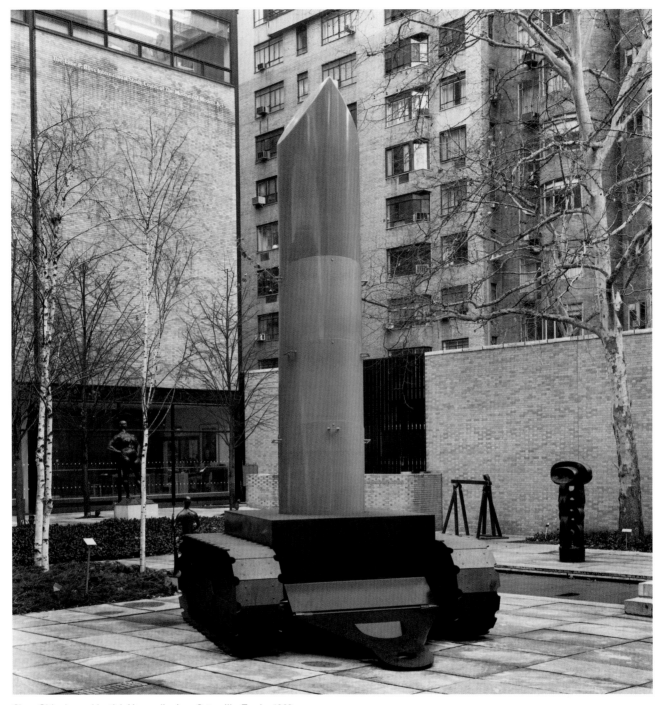

Claes Oldenburg, *Lipstick (Ascending) on Caterpillar Tracks*, 1969

Exhibition Title
High & Low: Modern Art
and Popular Culture

Organizer
The Museum of Modern Art,
New York, USA

Curators
Adam Gopnik
Kirk Varnedoe

Dates
October 7, 1990 –
January 15, 1991

Location
The Museum of Modern Art,
New York, USA

Tour Locations and Dates
The Art Institute of Chicago,
 Chicago, Illinois, USA,
 February 20 – May 12, 1991
Museum of Contemporary Art,
 Los Angeles, California, USA,
 June 21 – September 15, 1991

Publications
Kirk Varnedoe and Adam
 Gopnik, *High & Low: Modern
 Art and Popular Culture*,
 The Museum of Modern Art,
 New York, 1990
Kirk Varnedoe and Adam
 Gopnik, eds., *Modern Art
 and Popular Culture:
 Readings in High & Low*,
 The Museum of Modern Art,
 New York, 1990

Artists
Giacomo Balla
Constantin Brancusi
Georges Braque
Brassaï
Joseph Cornell
Robert Crumb
Stuart Davis
Robert Delaunay
Jean Dubuffet
Marcel Duchamp
Max Ernst
Öyvind Fahlström
Lyonel Feininger

Gamy
Juan Gris
Philip Guston
Raymond Hains
Richard Hamilton
Raoul Hausmann
George Herriman
Hannah Höch
Jenny Holzer
Hugo Inderau, Cologne
Jess
Jasper Johns
Jeff Koons
Fernand Léger
Roy Lichtenstein
E.V. Lucas / George Morris
Winsor McCay
René Magritte
Joan Miró
Gerald Murphy
Elizabeth Murray
O'Galop
Claes Oldenburg
Meret Oppenheim
Francis Picabia
Pablo Picasso
Cedric Price

Robert Rauschenberg
Man Ray
Aleksandr Rodchenko
James Rosenquist
Mimmo Rotella
Edward Ruscha
Kurt Schwitters
Saul Steinberg
Luise Straus-Ernst
Antoni Tàpies
Cy Twombly
Jacques de la Villeglé
Andy Warhol
William Whiteley

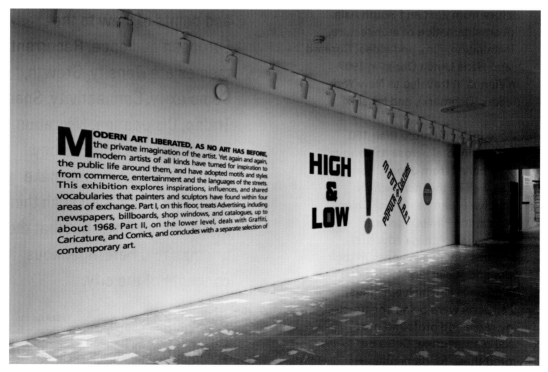

Installation view with explanatory wall text and graphics

Cities on the Move: Contemporary Asian Art on the Turn of the 21st Century

November 26, 1997 – January 18, 1998
Secession, Vienna, Austria,
and touring

Cities on the Move: Contemporary Asian Art on the Turn of the 21st Century was the first exhibition in the West to focus on contemporary art and architecture from East and South Asia. It was a forceful amalgamation of architecture, performance, installation, film, and video. Curated by Hou Hanru and Hans Ulrich Obrist in 1997 at Secession in Vienna, it traveled to New York, London, Humlebæk (Denmark), and Helsinki.

Cities on the Move included more than 150 artists and architects in total across its various incarnations. They hailed from Japan, Korea, and Singapore as well as the increasingly dynamic and creative urban centers of China, Indonesia, Malaysia, the Philippines, and Thailand. At the time, all of these countries were undergoing tremendous changes in their economic, urban, and social landscapes due to the accelerating pace at which buildings, highways, and airports were being constructed, accompanied by rapid and profound post-totalitarian social restructuring. Cities on the Move mirrored these fundamental transformations, giving Western audiences a vivid sense of the intensity and creative chaos of contemporary Asian metropolises.

Cities on the Move displayed the work of numerous artists who were scarcely known in Europe and the United States but extremely successful in Asia. It did this on a previously unseen scale, with highly innovative displays and installations. This made a significant contribution to the art boom in Asia. The show also radically reconsidered the concept of a touring exhibition by dramatically changing from venue to venue. Each iteration was almost an entirely new exhibition, reflecting the ongoing research of the two curators, which continued while the exhibition was on tour.

The exhibition endeavors to shed some light on the incredibly dynamic architecture and art scenes of these cities which are mostly unknown in Europe, and will try to introduce more than one hundred different positions and points of view to the European audience. Recurrent themes are Density, Growth, Complexity, Connectivity, Speed, Traffic, Dislocation, Migration, Homelessness and Ecology. The different positions make clear that there is no such thing as an "Asian City" but that there are manifold heterogeneous concepts of the city.

Hou Hanru and Hans Ulrich Obrist, "Cities on the Move," in Hou Hanru and Hans Ulrich Obrist, eds., *Cities on the Move*, Hatje Cantz, Ostfildern-Ruit, 1998.

Surasi Kusolwong, *Freedom of Choice (£1 Each)*, installation, 1999

Exhibition catalogue

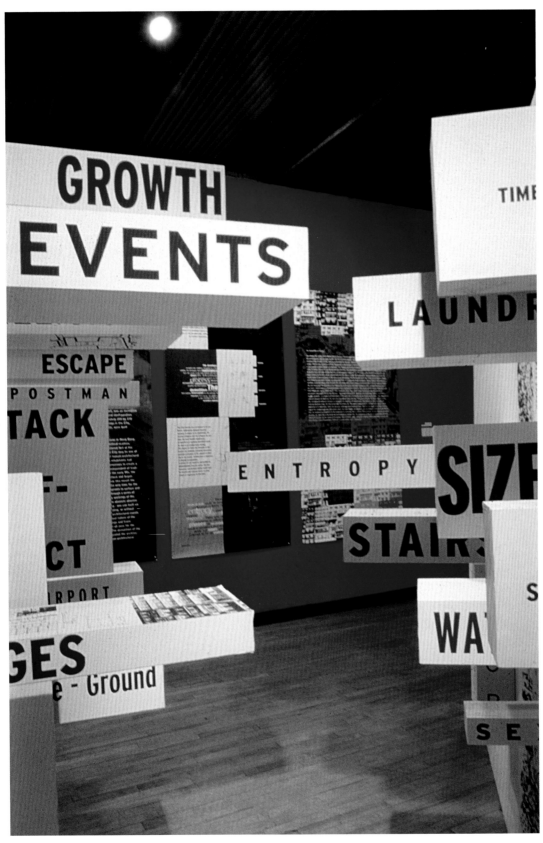

Aaron Tan, *Kowloon Walled City*, 1999

Exhibition Title
Cities on the Move:
Contemporary Asian Art on
the Turn of the 21st Century

Curators
Hou Hanru
Hans Ulrich Obrist

Dates
November 26, 1997 –
January 18, 1998

Location
Secession, Vienna, Austria

Tour Locations and Dates
CAPC, Bordeaux, France,
 June 4 – August 30, 1998
P.S.1 Contemporary Art Center,
 New York, USA, October 8,
 1998 – January 10, 1999
Louisiana Museum of Modern
 Art, Humlebæck, Denmark,
 January 29 – April 21, 1999
Hayward Gallery, London, UK,
 May 13 – June 27, 1999
Kiasma Museum of
 Contemporary Art, Helsinki,
 Finland, November 5 –
 December 19, 1999

Publication
Hou Hanru and Hans Ulrich
Obrist, eds., *Cities on the Move*,
Hatje Cantz, Ostfildern-Ruit, 1998

Artists*
Arahmaiani
Nobuyoshi Araki
Cai Guo Qiang
Chang Yung Ho
Chen Shao Xiong
Chen Zhen
Chi Ti-Nan
Choi Jeong-Hwa
Charles Correa
Heri Dono
Edge (Michael Chan /
 Gary Chang)
Geng Jianyi
Simryn Gill
Hanayo Itsuko
Harvard Project
Itsuko Hasegawa
David d'Heilly / Kayoko Ota
Herzog & de Meuron
Richard Ho
Oscar Ho Hing-Kay
Ho Siu Kee
Tao Ho
Takashi Homma
Huang Chin-Ho
Huang Yong Ping
Arata Isozaki
Toyo Ito
Sumet Jumsai
Chitti Kasemkitvatana
Eric Khoo
Kiyonori Kikutake
Jinai Kim
KNTA
Aglaia Konrad

Koo Jeong-A
Rem Koolhaas
Kisho Kurokawa
Surasi Kusolwong
Lee Bul
Liang Ju-Hui
Liew Kung Yu
Lim Kim Hai
Lin Yilin
Ken Lum
Greg Lynn
Fumihiko Maki
Fiona Meadows /
 Frédéric Nantois
Sohn-Joo Minn
Rudi Molacek
Mariko Mori
Takashi Murakami
Matthew Ngui
Tsuyoshi Ozawa
Ellen Pau
Navin Rawanchaikul /
 Rirkrit Tiravanija
Kazuyo Sejima
Seung H-Sang
Shen Yuan
Shi Yong
Judy Freya Sibayan
Marintan Sirait / Andar Manik
Yutaka Sone
Soo-Ja Kim
Sarah Sze
Aaron Tan
Fiona Tan
Takahiro Tanaka
Tay Kheng Soon

Chandraguptha Thenuwara
Ting Toy King
Tsang Tsou-Choi
Wang Du
Wang Jianwei
Wang Jun-Jieh
Wong Hoy-Cheong
Wong & Ouyang Associates
Choi Wook
Xu Tan
Riken Yamamoto
Miwa Yanagi
Ken Yeang
Yin Xiuzhen
Zhan Wang
Zhang Peili
Zheng Guogu
Zhou Tiehai
Zhu Jia

* List includes only those artists
 and architects featured in the
 exhibition's first incarnation
 in Vienna, Austria

Laboratorium

June 27 – October 3, 1999
Provinciaal Museum voor Fotografie
and various sites in Antwerp, Belgium

The 1999 exhibition Laboratorium was an interdisciplinary project that involved collaborations between artists and scientists in Antwerp, Belgium, looking specifically at what unites them in terms of working processes—as the exhibition statement proposed, artists and scientists share a spirit of "imagination and experimentation"—and in terms of their respective sites of production, namely the studio and the laboratory. Over the summer of that year, a group of scientists and artists met regularly with the two curators, Hans Ulrich Obrist and Barbara Vanderlinden, to formulate the core ideas for the exhibition and the events around it.

The resulting show, presented at the Provinciaal Museum voor Fotografie in Antwerp, offered visitors an overview of laboratory concepts and an installation of images, texts, and objects in the space, where the organizers had set up offices for themselves as a kind of curatorial laboratory. At workstations in the exhibition space, visitors could carry out experiments of their own. Various other workstations were dispersed throughout the city, mostly in abandoned office buildings. Each of these laboratories had a specific theme, such as a "laboratory of doubt," a "cognitive science laboratory," a "highway for choreographic

investigation," an "existing artist studio," and the "first laboratory of Galileo." As Obrist recalled, "We declared the whole city of Antwerp a lab." Bruce Mau's *Book Machine* gave the audience a chance to witness the making of the enormous catalogue for the show. Each day new pages were sent via fax from the designer's studio in Toronto to Antwerp, where they were displayed to the public.

Laboratorium started as a discussion that involves questions such as: What is the meaning of laboratories? What is the meaning of experiments? When do experiments become public and when does the result of an experiment reach public consensus? Is rendering public what happens inside the laboratory of the scientist and the studio of the artist a contradiction in terms? These and other questions are being offered in this interdisciplinary project that starts with the "workplace" where the artists and the scientists experiment and work freely.

Hans Ulrich Obrist and Barbara Vanderlinden, "Laboratorium," in Hans Ulrich Obrist and Barbara Vanderlinden, eds., *Laboratorium*, DuMont, Cologne, 2001.

Exhibition Title
Laboratorium

Curators
Hans Ulrich Obrist
Barbara Vanderlinden

Dates
June 27 – October 3,
1999

Location
Provinciaal Museum
voor Fotografie and
various sites in Antwerp,
Belgium

Publication
Hans Ulrich Obrist and
Barbara Vanderlinden, eds.,
Laboratorium, DuMont,
Cologne, 2001

Artists
Agency
Mark Bain
Lewis Baltz
Oladélé Ajiboyé Bamgboyé
Thomas Bayrle
Wiebe E. Bijker
Daniel Buren
James Lee Byars
Johannes Cladders
Harry Collins
Anne Daems
Tacita Dean
Vinciane Despret
Souleymane Bachir Diagne
Lionel Esteve
Jan Fabre
Harun Farocki
Hans-Peter Feldmann
Fischli & Weiss
Michel François /
 Erwan Mahéo

Peter Galison
Frank Gehry
Liam Gillick
Joseph Grigely
Carsten Höller
In situ production
Henrik Plenge Jakobsen
Caroline A. Jones
Alexander Kluge
Koo Jeong-A
Rem Koolhaas
Hans-Werner Kroesinger
Laboratoire Agit-Art
Pierre Laszlo
Bruno Latour
Xavier Le Roy
Armin Linke
Adam Lowe
Ken Lum
Jean-Charles Masséra
Bruce Mau
Jonas Mekas

Gustav Metzger
Jean-Luc Moulène
Matt Mullican
Jacques Ninio
Gabriel Orozco
Panamarenko
Marko Peljhan
Research Group
 Oldenburg
Jason Rhoades
Israel Rosenfield
Martha Rosler
Rupert Sheldrake
Luc Steels
Isabelle Stengers
Meg Stuart
Tomoko Takahasi
Rosemarie Trockel
Francisco J. Varela
Wang Jian Wei
Lawrence Weiner
David Western

Bruno Latour, *Theatre of Proof*, 1999

Carsten Höller, *Laboratorium of Doubt*, 1999

With support from Antwerp city officials, part of the exhibition was an official "open lab day" in which the public was invited to tour science labs around the city. In addition, the theorist, sociologist and science historian Bruno Latour was invited to curate what he called "tabletop experiments" in which famous historical scientific experiments such as those by Louis Pasteur were re-enacted for the public to witness.

It is difficult to fully assess Obrist's and Vanderlinden's intentions for the program, given its open-ended nature and broad reach in terms of participants, events, and disciplines. Laboratorium was certainly a continuation of Obrist's interdisciplinary interests and specifically his involvement with the relationship between art and science that began with his project Art & Brain in 1995 (co-organized with Ernst Pöppel).

What If:
Art on the Verge of Architecture and Design

May 6 – September 3, 2000
Moderna Museet, Stockholm, Sweden

What If: Art on the Verge of Architecture and Design, held at the Moderna Museet, Stockholm, in 2000, attempted to address how art practice has been influenced by the related fields of design and architecture. As the curator Maria Lind wrote in the exhibition catalogue, "Artists cannibalize these kindred disciplines for formalistic purposes and in order to reflect and question the concrete, designed reality that surrounds us."

There were 30 artists involved in the project, including Liam Gillick—widely known for blurring the boundaries between fine art and architecture—who organized (or "filtered," in Lind's terminology) the layout of the space. The exhibition was arranged so that artworks, furniture, designed objects, and models were shown in different sections, with some consolidated tightly together. This layout made it difficult for viewers to move physically through the exhibition space. Some parts of the gallery were densely filled with objects, while others were mostly empty. Lind likened the arrangement to the modernist grid, or a cityscape.

Boxed exhibition publication designed by Pae White

Dominique Gonzalez-Foerster, *Brasilia Hall*, 2000

There were no wall labels identifying the pieces; viewers were supplied with a map that helped aid their navigation through Gillick's labyrinth, enhancing the sense of traveling or strolling, much like the 19th-century flaneurs who mused over the bustling spectacle of Parisian city life. Invited to reflect on the aesthetics of designed objects and architectural elements outside of the works' normal functional environment, visitors were transformed into modern-day flaneurs. The art critic Ina Blom noted that the exhibition brought out the "fantastic" and "surreal" aspects of design and architecture.

Besides the exhibition, there were two other facets of the programming that Lind considered equally important: a publication, which was meant to function as an integral part of the exhibition, and a series of symposia—called "listen-ins"—where the public could hear artists, architects, designers, and city planners talk about various subjects related to the show.

Above and above right: details from the exhibition catalogue

Exhibition Title
What If: Art on the Verge
of Architecture and Design

Curators
Maria Lind, "filtered" by Liam
Gillick

Dates
May 6 – September 3, 2000

Location
Moderna Museet,
Stockholm, Sweden

Publication
The publication was
simultaneously an artwork
by Pae White, with the
invitation, essays, floor
plan, artist pages, and other
documentation printed on
A3 posters, each folded in
half and placed in a blue
and yellow box

Artists
Lotta Antonsson
Miriam Bäckström

Martin Boyce
Nathan Coley
Jason Dodge
Elmgreen & Dragset
Maria Finn
Sylvie Fleury
Liam Gillick
Dominique Gonzalez-Foerster
Jim Isermann
Gunilla Klingberg
Jim Lambie
Rita McBride
Sarah Morris
N55

Hajnal Németh
Olaf Nicolai
Jorge Pardo
Philippe Parreno
Elizabeth Peyton
Tobias Rehberger
Gerwald Rockenschaub
Pia Rönicke
Simon Starling
SUPERFLEX
Apolonija Šušteršič
Rirkrit Tiravanija
Pae White
Andrea Zittel

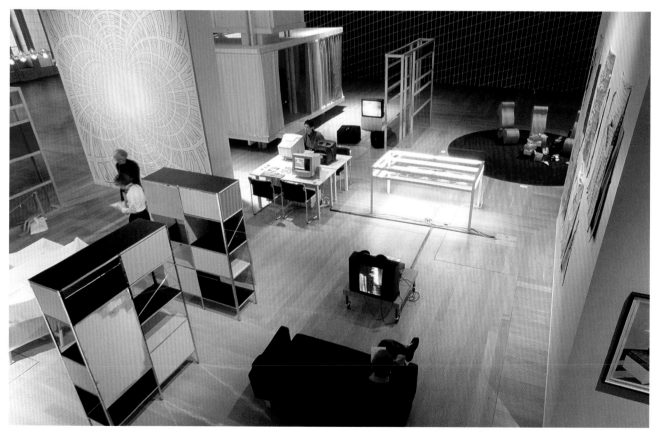

Installation view

Century City: Art and Culture in the Modern Metropolis

February 1 – April 29, 2001
Tate Modern, London, UK

The 2001 exhibition Century City: Art and Culture in the Modern Metropolis, curated by Iwona Blazwick at Tate Modern in London, tapped into one of the key elements of modernity: the rapid development and proliferation of metropolitan areas. During the 20th century, mostly due to industrialization and growth in commerce, rural populations migrated en masse to the cities. With this economic change, new social formations also irrevocably transformed individual and cultural subjectivity; the setting of the metropolis defined cultural movements and offered a ceaseless encounter with the new. Within the arena of the metropolis, it was inevitable that different cultures would hybridize and clash, old social structures would die and new ones would form, while ideas and aesthetics were exchanged and appropriated. Century City sought to address the dizzying plurality and quantity of art produced in the context of modern urbanity.

The exhibition featured an array of works in various media from nine cities: not only the "usual suspects" of Paris, New York, Vienna, Moscow, and London, but also Bombay/Mumbai, Lagos, Rio de Janeiro, and Tokyo. The curatorial statement for the exhibition called these cities cultural "crucibles for innovation" whose distinct designs and expressions speak to

"wider global tendencies" felt universally. Twelve guest curators were invited to select and arrange the works in the show; each city was paired with one curator, and each curator was assigned a particular period of time (for example, 1905–15 in Paris).

Century City was not limited to fine art. There were billboards (in the Bombay/Mumbai section), posters (in the Moscow section), and other forms of popular cultural material throughout the exhibition. Much attention was given to the products of the avant-garde movements of the West, since these groups played a major role in defining the visual culture of metropolitan life in the first half of the 20th century.

The city is a medium for the modern. It is a paradox of the metropolis that its scale and heterogeneity can generate an experience both of unbearable invisibility and liberating anonymity; of alienating disconnectedness, indeed impotence; and of the possibility of unbound creativity.

The picturing of modern urban life represents a powerful strand in the art and culture of twentieth-century art.

Iwona Blazwick, "Century City," in Iwona Blazwick, ed., *Century City: Art and Culture in the Modern Metropolis*, Tate Publishing, London, 2001.

Exhibition Title
Century City: Art and Culture
in the Modern Metropolis

Curators
Michael Asbury /
 Paulo Venancio Filho
Lutz Becker
Iwona Blazwick
Richard Calvocoressi /
 Keith Hartley
Emma Dexter
Okwui Enwezor / Olu Oguibe
Serge Fauchereau
Geeta Kapur /
 Ashish Rajadhyaksha
Donna De Salvo
Reiko Tomii

Dates
February 1 – April 29, 2001

Location
Tate Modern, London, UK

Publication
Iwona Blazwick, ed., *Century
City: Art and Culture in the
Modern Metropolis*, Tate
Publishing, London, 2001

Artists
Vito Acconci
Chinua Achebe

ACHTYRKO
Auguste Agero
Adebisi Akanji
Akasegawa Genpei
Navjot Altaf
Peter Altenberg
Guillaume Apollinaire
Alexander Archipenko
Eugène Atget
Léon Bakst
Balkrishna Art
BANK
Bruno Barbey
Sally Barker
Georgina Beier
Anatoli Belsky
Lynda Benglis
Alexandre Benois
Henry Bond / Liam Gillick
Tord Boontje
Sonia Boyce
Constantin Brancusi
Georges Braque
Trisha Brown
Roberto Burle Marx
Sérgio Camargo
Josef Carl
Amílcar de Castro
Auguste Chabaud
Marc Chagall
Hussein Chalayan
Ilya Chashnik / Nikolai Suetin
Giorgio de Chirico
City Racing

J.P. Clark
Lygia Clark
Le Corbusier
Melanie Counsell
Keith Coventry
Joseph Csaky
James Cubitt & Partners
Milton Dacosta
Girish Dahiwale
Leon Damas
Nils Dardel
Aleksandr Deineka
Robert Delaunay
Sonia Delaunay
Jeremy Deller
André Derain
Design Cell KRVIA
Tom Dixon
Mikhail Dlugatch
Atul Dodiya
Kees van Dongen
Marcel Duchamp
Raymond Duchamp-Villon
Raoul Dufy
Mary Beth Edelson
Albin Egger-Lienz
Aleksandra Ekster
Cyprian Ekwensi
Vasili Elkin
Paul Elliman
Tracey Emin
Erhabor Emokpae
Ben Enwonwu
Jacob Epstein

Esteichov
Jason Evans
Angus Fairhurst
Roger de la Fresnaye
Sigmund Freud
Otto Freundlich
Pyotr Galadchev
Aleksei Gan
Pablo Gargallo
Marcel Gautherot
Richard Gerstl
Albert Gleizes
Natalia Gontcharova
Nancy Graves
Juan Gris
Isaac Grünewald
Guerrilla Art Action Group
Ferreira Gullar
Shilpa Gupta
Auguste Herbin
Eva Hesse
Hikosaka Naoyoshi
Hirano Kōga /
 Oyobe Katsuhito /
 Kushida Mitsuhiro
Damien Hirst
Nancy Holt
Hori Kosai
Horikawa Michio
Gary Hume
M.F. Husain
Reima Husain / Owais Husain
Rummana Hussain
Boris Ignatovich →

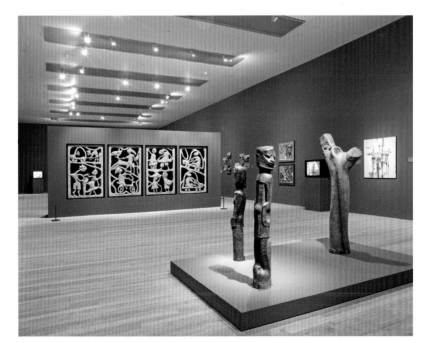

Installation view from Century City: Lagos 1955–1970

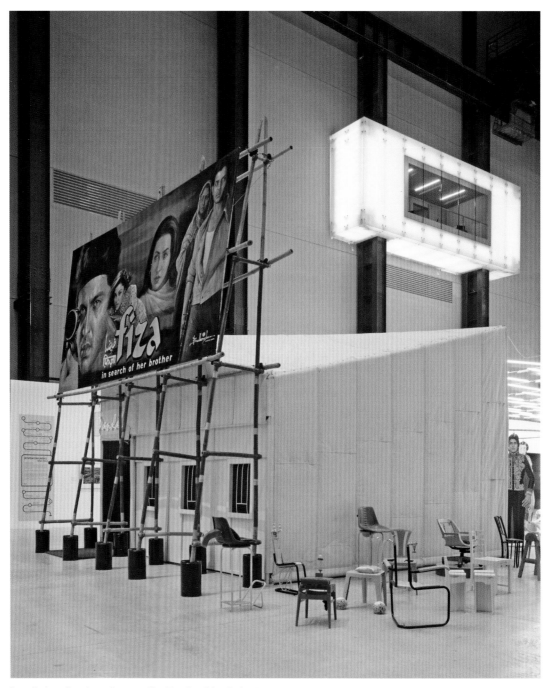

Installation view from Century City: Bombay/Mumbai 1992–2001

Imprint 93
INVENTORY
Runa Islam
Isozaki Arata
Max Jacob
Antonio Carlos Jobim
Joan Jonas
Jitish Kallat
Sen Kapadia
Michail Kaufman
Bhupen Khakhar /
 Vaman Rao Khaire
Ivan Kliun
Gustav Klucis /
 Valentina Kalugina
Nick Knight
Azuri Kodshak
Vincent Akwete Kofi
Taki Kōji /
 Nakahira Takuma
Oskar Kokoschka
Koshimizu Susumu
Karl Kraus
François Kupka
Kusama Yayoi
Duro Ladipo
Michael Landy
Henri Laurens
Anton Lavinsky
Jacob Lawrence
Mark Leckey
Sarah Lucas
Lee Ufan
Fernand Léger
Wilhelm Lehmbruck
Peter Lewis
Jacques Lipchitz

El Lissitzky
Adolf Loos
Sarah Lucas
Nalini Malani
Kasimir Malevich
Louis Marcoussis
Robert Mapplethorpe
Filippo Marinetti
Albert Marquet
Henri Matisse
Matsuzawa Yutaka
Gordon Matta-Clark
Vladimir Mayakovsky
Tyeb Mehta
Konstantin Melnikov
Jean Metzinger
Grigori Miller
Mary Miss
Amedeo Modigliani
Peter Moore
Robert Morris
Vera Ignatevna Mukhina
Kausik Mukhopadhyay
Robert Musil
Hayley Newman
Malangatana Ngwenya
Oscar Niemeyer
Nosepaint–Beaconsfield
Chris Ofili
Hélio Oiticica
José Oiticica Filho
J.D. "Okhai" Ojeikere
Uche Okeke
Christopher Okigbo
Yoko Ono
Bruce Onobrakpeya
Dennis Oppenheim

Oyobe Katsuhito with
 Hosoe Eikō / Gōda Sawako
Lygia Pape
Swapan Parekh
Janette Parris
Jules Pascin
Anand Patwardhan
Sudhir Patwardhan
Simon Periton
Francis Picabia
Pablo Picasso
Adrian Piper
Liubov Popova
Nicolai Prusakov
Nikoai Punin
Hans Purrmann
Pushpamala N.
Ashish Rajadhyaksha
Affonso Eduardo Reidy
Marc Riboud
Faith Ringgold
Diego Rivera
Aleksandr Rodchenko
Donald Rodney
Henri Rousseau
Ibrahim Salahi
Sharmila Samant
Egon Schiele
Arthur Schnitzler
Sekine Nobuo
Elrms Semenova
Gino Severini
Ketaki Sheth
Sudarshan Shetty
Aleksandr Shukhov
Dayanita Singh
Raghubir Singh

Robert Smithson / Nancy Holt
Antonia Sofronova
Amadeo de Souza-Cardoso
Wole Soyinka
Johnny Spencer
Sarah Staton
Leopold Survage
Stenberg Brothers
Varvara Stepanova
Nikolai Suetin
Vivan Sundaram
Sooni Taraporevala
Vladimir Tatlin
Solomon Telingater
Juergen Teller
Wolfgang Tillmans
Gavin Turk
Keith Tyson
UNDERCURRENTS
Uno Akira
Aleksandr Vesnin
Konstantin Vialov
Jacques Villon
Maurice de Vlaminck
Otto Wagner
Herwarth Walden
Mark Wallinger
Andy Warhol
Gillian Wearing
Franz Weissmann
Rachel Whiteread
Hannah Wilke
Ludwig Wittgenstein
Yamanaka Nobuo
Yamashita Kikuji
Yokoo Tadanori
Ossip Zadkine

Exhibition catalogue

New Lands

Magiciens
de la Terre

Cocido y Crudo

2nd
Johannesburg
Biennial:
Trade Routes –
History and
Geography

The Short
Century:
Independence
and Liberation
Movements
in Africa,
1945–1994

After the Wall:
Art and
Culture in
Post-Communist
Europe

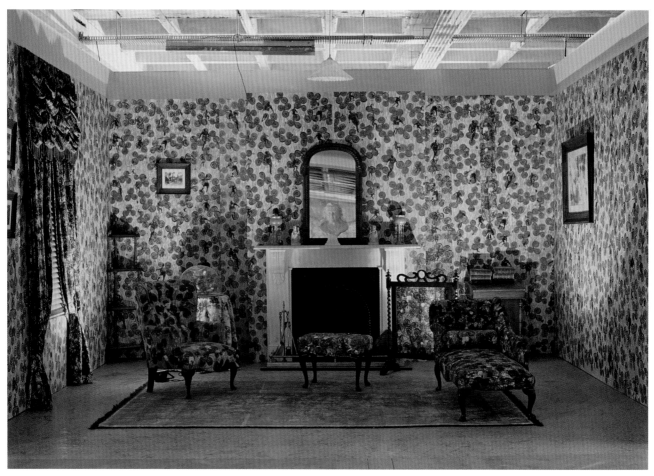

Yinka Shonibare, *Victorian Philanthropist's Parlour*, 1996–97,
installation view from the 2nd Johannesburg Biennial: Trade
Routes – History and Geography, Johannesburg and Cape Town,
South Africa, 1997

New Lands

The basic premise behind this book is to examine innovations in curatorial practice since 1990. While there are a number of reasons for selecting this particular year, one essential justification relates to the consideration of exhibition history as a discursive field in and of itself. Jean-Hubert Martin's 1989 exhibition Magiciens de la Terre is in many ways the starting point for this publication and easily one of the most influential exhibitions in recent decades in terms of its effect on curators and exhibition history. Magiciens de la Terre was one of the first large-scale group shows to include art on a markedly global scale, giving equal emphasis and treatment to art from around the world. Considered groundbreaking at the time for its attempt at a de-hierarchized global survey, its horizontal treatment of a variety of work made in extremely different contexts and intended for very different purposes led to criticism that Hubert's achievement was largely un-theorized and culturally insensitive. A new generation of curators discussed, debated, and experimented with the types of exhibitions that could be developed in response to the increasing realities of global contemporary art.

While Dan Cameron's Cocido y Crudo was explicitly defined as a response to Magiciens de la Terre, other curators have explored the exhibition's legacy less specifically and directly in favor of more overarching considerations. Standing out among this generation of curators is Okwui Enwezor, who has been singularly focused on understanding globally interconnected histories and politics, for instance in the 2nd Johannesburg Biennial and The Short Century: Independence and Liberation Movements in Africa, 1945–1994. The 1990s also saw the dissolution of the Soviet Union, leading to an increase in interest (among Westerners) in art from Eastern Europe. David Elliott's After the Wall: Art and Culture in Post-Communist Europe was among the first exhibitions to explore that formerly uninvestigated terrain.

Magiciens de la Terre

May 18 – August 14, 1989
Centre Georges Pompidou and
La Grande Halle, Parc de la Villette,
Paris, France

Magiciens de la Terre took place in the summer of 1989 at the Centre Georges Pompidou and Parc de la Villette in Paris. The curator, Jean-Hubert Martin, intended it as a counterargument to the ethnocentric, colonial mindset of Western contemporary art discourses at the time. He was directly reacting against the exhibition "Primitivism" in 20th Century Art: Affinity of the Tribal and the Modern, organized by the Museum of Modern Art in New York in 1984, which he believed epitomized prevailing exclusionary and myopic discourses, and ignored the particular qualities and contexts of the "primitive" artworks on display, such as the ritual use value of objects in the belief systems of their makers. Magiciens de la Terre was also a critique of the Paris Biennial, in which artworks and representatives of specific countries were selected based on France's own culture, thus strengthening its hegemonic image of itself while marginalizing most art hailing from non-Western countries.

Martin's solution involved the inclusion of equal numbers of artworks from the "marginal" (Africa, Latin America, Asia, and Australia) parts of the world alongside the "centers" (the United States and Western Europe). He chose the works based on his own judgment and taste, well aware that his selections exemplified (and were conditioned by) his Western point of view. He realized that while the premise of his categorization represented a big step forward in thinking, it somewhat contradicted his intention to be inclusive. For all practical purposes, in other words, he knew that his show was still marginalizing the "primitive" works as "Other" or "peripheral," but he nevertheless believed that an authentically global exhibition using a framework that would help Western visitors better understand non-Western artworks would help prod the rest of the art world toward a more inclusive model. The show included 100 works in total, 50 in each category. Martin traveled extensively for his research and hired a team of art experts in each region, thus creating a model for the ways in which many international curators now operate.

Magiciens de la Terre generated much criticism among reviewers, artists, and the public, whose main complaint was that the selection of artworks appeared haphazard, and that the organizational premise seemed to overwhelm the aesthetic qualities of the objects. But today, Martin's attempt to introduce outside perspectives to Western art discourses and to take a more horizontal, as opposed to hierarchical, approach to global artistic practices is acknowledged as a problematic but milestone moment in exhibition history. While Magiciens de la Terre did not align itself with postcolonial theory, unlike many other exhibitions throughout the 1990s, it was one of the first to take a step toward integrating outside artists into the Western-dominated platform of the exhibition space, attempting to look at and understand art on a global scale on some kind of equal level.

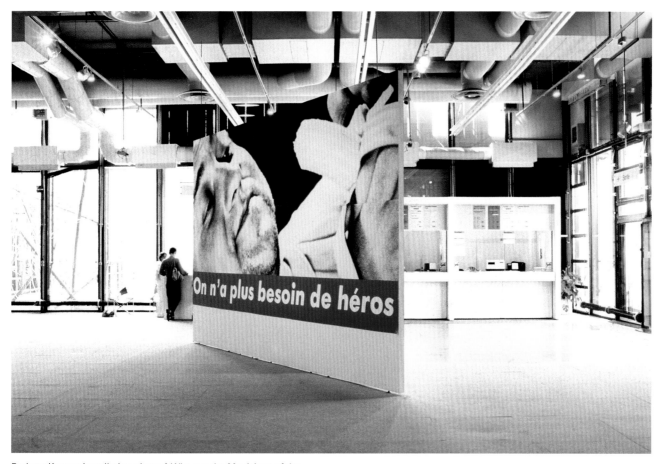

Barbara Kruger, installation view of *Who are the Magicians of the Earth?*, Centre Georges Pompidou, 1989

Jangarh Singh Shyam, installation view of *Paintings of legendary
figures and monsters, coated on two walls of earth*, La Grande Halle,
Parc de la Villette, 1989

Exhibition Title
Magiciens de la Terre

Organizers
Le Musée national d'art
 moderne—Centre Georges
 Pompidou
La Grande Halle—La Villette

Curator
Jean-Hubert Martin

Conceptual Committee
Jan Debbaut
Mark Francis
Jean-Louis Maubant

Dates
May 18 – August 14, 1989

Locations
Centre Georges Pompidou,
 Paris, France
La Grande Halle, Parc de la
 Villette, Paris, France

Publication
Jean-Hubert Martin, ed.,
Magiciens de la Terre, Editions
de Centre Pompidou, Paris, 1989

Artists
Marina Abramović
Dennis Adams
S.J. Akpan
Jean-Michel Alberola
Dossou Amidou
Giovanni Anselmo
Rasheed Araeen

Nuche Kaji Bajracharya
John Baldessari
José Bédia
Joe Ben, Jr.
Jean-Pierre Bertrand
Gabriel Bien-Aimé
Alighiero e Boetti
Christian Boltanski
Erik Boulatov
Louise Bourgeois
Stanley Brouwn
Frédéric Bruly Bouabré
Daniel Buren
James Lee Byars
Seni Camara
Mike Chukwukelu
Francesco Clemente
Marc Couturier
Tony Cragg
Enzo Cucchi
Cleitus Dambi /
 Nick Dumbrang /
 Ruedi Wem
Neil Dawson
Bowa Devi
Maestre Didi
Braco Dimitrijević
Efiaimbelo
John Fundi
Julio Galán
Moshe Gershuni
Enrique Gómez
Dexing Gu
Hans Haacke
Rebecca Horn
Shirazeh Houshiary
Yongping Huang
Alfredo Jaar
Nera Jambruk

Ilya Kabakov
Tatsuo Kawaguchi
On Kawara
Alselm Kiefer
Bodys Isek Kingelez
Per Kirkeby
John Knight
Agbagli Kossi
Barbara Kruger
Paulosee Kuniliusee
Kane Kwei
Boujemaâ Lakhdar
Georges Liautaud
Felipe Linares
Richard Long
Esther Mahlangu
Karel Malich
Jivya Soma Mashe*
John Mawandjul
Cildo Meireles
Mario Merz
Miralda
Tatsuo Miyajima
Norval Morrisseau
Juan Muñoz
Henry Munyaradzi
Claes Oldenburg /
 Coosje Van Bruggen
Nam June Paik
Wesner Philidor
Sigmar Polke
Temba Rabden*
Ronaldo Pereira Rego
Chéri Samba
Sarkis
Twins Seven Seven
Raja Babu Sharma
Jangarh Singh Shyam
Nancy Spero

Daniel Spoerri
Hiroshi Teshigahara
Yousuf Thannoon
Lobsang Thinle /
 Lobsang Palden /
 Bhorda Sherpa
Cyprien Tokoudagba
Ulay
Ken Unsworth
Chief Mark Unya /
 Nathan Emedem
Patrick Vilaire
Acharya Vyakul
Jeff Wall
Lawrence Weiner
Krzysztof Wodiczko
Jimmy Wululu
Jack Wunuwun
Jie Chang Yang
Aboriginal community
 of Yuendumu
 (Francis Jupurrurla Kelly /
 Frank Bronson
 Jakamarra Nelson /
 Neville Japangardi Poulson /
 Paddy Jupurrurla Nelson /
 Paddy Japaljarri Sims /
 Paddy Japaljarri Stewart /
 Towser Jakamarra Walker)
Zush

* Included in catalogue but
 did not participate in show

to the 1989 exhibition Magiciens de la Terre, which claimed to have been the most authentic "global art" exhibition to date because of its broad presentation of artworks from around the world. The critical response to Magiciens fueled Cameron's theory that expansive international exhibitions should become obsolete.

Cocido y Crudo

December 14, 1994 – March 6, 1995
Museo Nacional Centro de Arte Reina Sofía,
Madrid, Spain

[E]ven the most meaningful intercultural contacts must be made with full awareness of the risk they run: that the moment may very well exhaust itself of significance before anyone is truly satisfied.

Dan Cameron, "Cocido y Crudo," in
Dan Cameron, ed., *Cocido y Crudo*,
Museo Nacional Centro de Arte Reina
Sofía, Madrid, 1995.

Cocido y Crudo ("The Raw and the Cooked") was curated by Dan Cameron at the Museo Nacional Centro de Arte Reina Sofia in Madrid in 1995. It included a total of 55 artists from 20 different countries working in a diverse range of media, including video, photography, painting, and performance-based work. Cameron intended the show as a response to what he saw as a general curatorial movement since the 1980s away from the independently organized group show, which many believed to have exhausted itself as a form. Specifically, Cocido y Crudo was a response

The show's title referenced the seminal book by the anthropologist Claude Lévi-Strauss about the shared structural elements of myths throughout the world. Inspired by Lévi-Strauss's mission to discover similarities and universalities across cultures, Cocido y Crudo attempted to frame its diverse works as simultaneously local and universal—their shared qualities transcending the specificities of the individual artists' identities, sexual preferences, and socioeconomic origins. This approach was quite opposed to the method of Magiciens de la Terre, which in various ways reified the artists' "otherness" by relying heavily on their places of origin as an organizational principle.

Cocido y Crudo generated a great deal of controversy and much negative criticism in Spanish newspapers. All of the educational events linked to the show were canceled, and some artists' works were even censored. Cameron later lamented, "The project that consumed three years of my life had been thrown into the dustbin of the history of Spanish art."

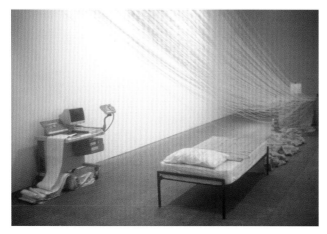

Janine Antoni, *Slumber*, 1993

Exhibition Title
Cocido y Crudo

Organizer
Museo Nacional Centro de Arte
Reina Sofía, Madrid, Spain

Curator
Dan Cameron

Dates
December 14, 1994 –
March 6, 1995

Location
Museo Nacional Centro de Arte
Reina Sofía, Madrid, Spain

Publication
Dan Cameron, ed., *Cocido y Crudo*, Museo Nacional Centro de Arte Reina Sofía, Madrid, 1995

Artists
Afrika (Sergei Bugaev)
Janine Antoni
Stefano Arienti
Sadie Benning
Xu Bing
Pedro Cabrita Reis
Geneviève Cadieux
Victoria Civera
Juan Dávila
Wim Delvoye
Mark Dion
Eugenio Dittborn
Willie Doherty
Lili Dujourie
Marlene Dumas
Jimmie Durham
Maria Eichhorn
Sylvie Fleury
Renée Green
Mona Hatoum
José Antonio Hernández-Diez
Gary Hill

Damien Hirst
David Horan
Narelle Jubelin
KCHO (Alexis Leiva Machado)
Bodys Isek Kingelez
Martin Kippenberger
Igor Kopystiansky
Svetlana Kopystiansky
Mariusz Kruk
Eva Lofdahl
Rogelio López Cuenca
Petr Lysáček
Paul McCarthy
Marlene McCarty
Tatsuo Miyajima
Pedro Mora
Juan Luis Moraza
Yasumasa Morimura
Jean-Baptiste Ngetchopa
Marcel Odenbach
Gabriel Orozco
Vong Phaophanit
Pierre et Gilles

Keith Piper
Rosângela Rennó
Faith Ringgold
Allen Ruppersberg
Doris Salcedo
Julia Scher
Kiki Smith
Rirkrit Tiravanija
Sue Williams
Fred Wilson

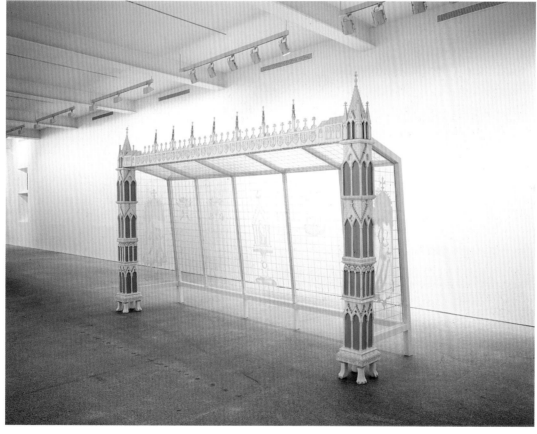

Wim Delvoye, *Madrid*, 1994

2nd Johannesburg Biennial: Trade Routes – History and Geography

October 12 – December 12, 1997
Various sites in Johannesburg and Cape Town, South Africa

Trade Routes – History and Geography was the title of the 2nd Johannesburg Biennial, held in 1997 at various venues around Johannesburg and Cape Town. Organized by the Nigerian-born American curator and art historian Okwui Enwezor, it consisted of six exhibitions at six different venues, each organized by an independent international curator: Colin Richards, Octavio Zaya, Gerardo Mosquera, Kellie Jones, Hou Hanru, Yu Yeon Kim, and Mahen Bonetti.

South Africa dismantled its racist policy of apartheid in 1990 and held its first multiracial elections in 1994. The first Johannesburg Biennale took place in 1995, with that edition following the traditional mode of inviting international artists to represent their home countries. With Trade Routes Enwezor wanted to counter this paradigm, and also to underline Johannesburg and Cape Town as being part of a broader paradigm shift in the "restless," globalized 20th century. Enwezor consciously withheld the artists' places of origin in the exhibition signage and catalogue, hoping to break the barriers implied by nationality, which he believed invite reductive interpretations of artworks and fuel anachronistic ideologies. He also announced that he wanted to avoid the "very limited enclosure of Eurocentrism."

Much as South Africa had opened its political structures to include those who had been marginalized, Enwezor sought to create an exhibition that would increase the visibility of, and open up new possibilities of interpretation for, contemporary works that had been muted or excluded when globalization was in its infant historical stages.

Trade Routes also tasked itself with creating a visible history of globalization by looking into how cultures fuse and diverge over time. For instance, the section curated by Octavio Zaya, called Alternative Currents, took as its premise the ways in which local subjectivities rub against the overarching discourses of globalization such as postcolonialism and multiculturalism in a particular region or country.

Only about 20 percent of the artists in Trade Routes actually showed in the formally designated exhibition spaces. Others employed billboards, gardens, and other outdoor settings. Despite the international attention that Trade Routes was receiving, the government forced the exhibition to close early, purportedly due to financial problems and low local attendance. Since then, there has not been another Johannesburg Biennial, but its legacy has been vital to the development of the contemporary art scene in South Africa.

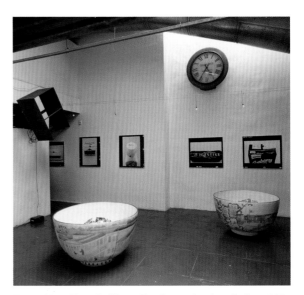

Huang Yong Ping, *Da Xian—The Doomsday*, installation, 1997

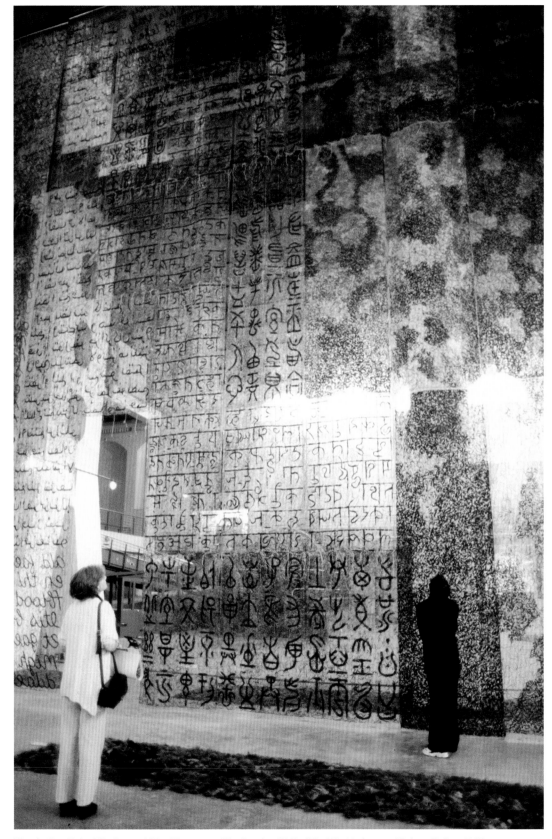

Wenda Gu, *United Nations—Africa Monument: The Praying Wall of The World*, site-specific installation, 1997

Exhibition Title
2nd Johannesburg
Biennial: Trade Routes –
History and Geography

Organizer
AICA: Africus Institute
for Contemporary Art,
a project of the Greater
Johannesburg
Metropolitan Council

Artistic Director
Okwui Enwezor

Curators
Mahen Bonetti
Hou Hanru
Kellie Jones
Yu Yeon Kim
Gerardo Mosquera
Colin Richards
Octavio Zaya

Dates
October 12 –
December 12, 1997

Location
Various sites in Johannesburg
and Cape Town, South Africa

Publication
Okwui Enwezor, ed.,
*Trade Routes: History and
Geography — 2nd Johannesburg
Biennale 1997*, The Greater
Johannesburg Metropolitan
Council, South Africa, and
the Prince Claus Fund for
Culture and Development,
The Netherlands, 1997

Artists

Alternating Currents
Georges Adéagbo
Ghada Amer
Oladélé Ajiboyé Bamgboyé
Wayne Barker
Mario Benjamin
Bili Bidjocka
Gordon Bleach

Andries Botha
Tania Bruguera
Cho Duck-Hyun
Jeannette Christensen
Viyé Diba
Moustapha Dimé
Eugenio Dittborn
Stan Douglas
Olafur Eliasson
Touhami Ennadre
Coco Fusco
Kendell Geers
Félix González-Torres
Renée Green
Wenda Gu
Hans Haacke
Kay Hassan
Carl Michael von Hausswolff /
 Leif Elggren
Juan Fernando Herrán
Pierre Huyghe
Isaac Julien
Y.Z. Kami
Seydou Keita
Suchan Kinoshita
Joachim Koester
Abdoulaye Konate
Vivienne Koorland
Igor Kopystiansky
Svetlana Kopystiansky
Atta Kwami
Marc Latamie
Los Carpinteros
Ken Lum
Steve McQueen
Esko Männikkö
Pat Mautloa
Salem Mekuria
William Miko
Milagros de la Torre
Santu Mofokeng
Zwelethu Mthetwa
Shirin Neshat
Rivane Neuenschwander
Olu Oguibe
Antonio Olé
Gabriel Orozco
Pepón Osorio
Ouattara Watts
Malcolm Payne
Marko Peljhan
Vong Phaophanit
Rona Pondick

Ernesto Pujol
Jo Ractliffe
Rosângela Rennó
Sophie Ristelhueber
Peter Robinson
Juan Carlos Robles
Joachim Schönfeldt
Teresa Serrano
Yinka Shonibare
Penny Siopis
Abdourahmane Sissako
Peter Spaans
Beat Streuli
Hiroshi Sugimoto
Vivan Sundaram
Sam Taylor-Wood
Pascal Marthine Tayou
Diana Thater
Nestor Torrens
Carlos Uribe
Eulalia Valldosera
Sergio Vega
Jeremy Wafer
Mark Wallinger
Carrie Mae Weems
Sue Williamson

Graft
Allan Alborough
Siemon Allen
Bridget Baker
Candice Breitz
Pitso Chimzima
Angela Ferreira
Maureen de Jager
Anton Karstel
Moshekwa Langa
Antoinette Murdoch
Johannes Phokela
Tracey Rose
Sluice
Marlaine Tosoni
Sandile Zulu

Important and Exportant
Willem Boshoff
Frédéric Bruly Boubaré
Sophie Calle
David Hammons
David Medalla
Cildo Meireles
Ana Mendieta
Adam Nankervis

Life's Little Necessities
Zarina Bhimji
Maria Magdalena Campos-Pons
Silvia Gruner
Veliswa Gwintsa
Glenda Heyliger
Wangechi Mutu
Bernadette Searle
Lorna Simpson
Melanie Smith
Valeska Soares
Jocelyn Taylor
Fatimah Tuggar
Pat Ward Williams

Hong Kong, Etc.
Roderick Buchanan
Andreas Gursky
Arni Haraldsson
Huang Yong Ping
Bodys Isek Kingelez
Feng Mengbo
Ellen Pau
Keith Piper
Rivka Rinn
Fiona Tan
Zhu Jia

Transversions
Sabin Bitter / Helmut Weber
Montien Boonma
Luca Buvoli
Diller & Scofidio
Stephen Hobbs
Alfredo Jaar
Michael Joo
William Kentridge
Les Levine
Choong Sup Lim
Dennis Oppenheim
Osvaldo Romberg
Shazia Sikander
Gary Simmons
Hale Tenger
Minette Vári
Xu Bing
Young-Jin Kim

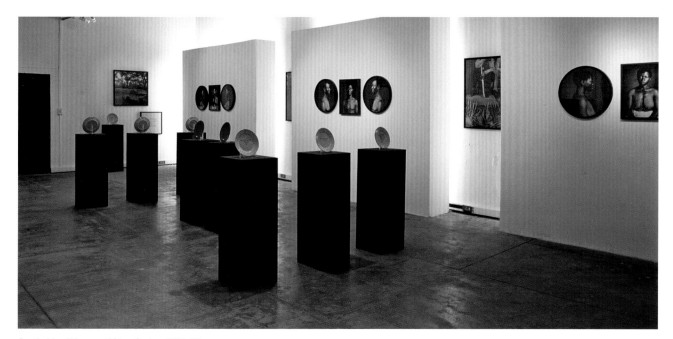

Carrie Mae Weems, *Africa Series*, 1991–93

The Short Century: Independence and Liberation Movements in Africa, 1945–1994

February 15 – April 22, 2001
Museum Villa Stuck, Munich, Germany,
and touring

The Short Century: Independence and Liberation Movements in Africa, 1945–1994 was curated by Okwui Enwezor in 2001 and originally presented at the Museum Villa Stuck in Munich. It subsequently traveled to Berlin, Chicago, and New York. The exhibition's ultimate goal was to introduce the world to African modernist art production since the end of World War II, and to redress the scant attention given to the continent in the dominant discourse of world art history. The Short Century was in fact the first major survey to examine the cultural identities that arose from Africa's liberation movements (1945 and 1994 mark the beginning and the end of the African nations' struggle for independence).

The breadth of this attempt was enormous. Enwezor included a slew of practices beyond the categories of the fine arts, dividing the show into seven distinct sections that included multiple disciplines: modern and contemporary art, film, photography, architecture/space, graphics, music/recorded sound, and literature and theater. He further connected all of these disparate forms of production to a historical framework, paying particular attention to the cultural expressions of the various liberation and freedom movements coming out of Africa. For instance, one of his curatorial methods was to juxtapose art with images of political events, drawing (some said forcing) relationships between art production and the social context and history in which they were embedded. Other strategies involved displaying colonial and anti-colonial propaganda, ranging from posters to film, which were borrowed from national and private collections specifically for the exhibition. More than 50 artists were included, most of them hailing from Africa.

The Short Century included many educational facets such as a 400-page catalogue with commissioned essays and commentaries as well as original texts: historical manifestos, pamphlets, and resolutions on the African liberation movements. Further, each venue in which the show was presented hosted numerous panel discussions and public programs. The Short Century received a great deal of positive feedback from critics, who noted the nobility of its attempt to introduce the world to African culture and the challenging and educational experience it offered to American and European viewers. The critic Justin Hoffman said the exhibition provided "a starting point for future analyses." In all, Enwezor can be credited for jump-starting this much-needed re-evaluation of African art history in the postcolonial context.

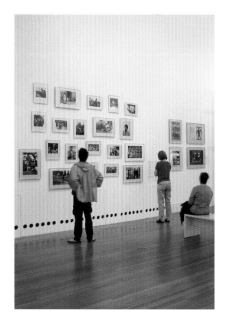

Installation view

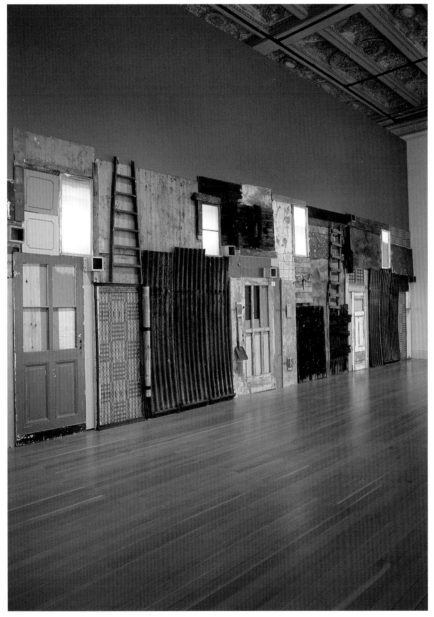

António Olé, *Margem da Zona Limite*, 1994/2001

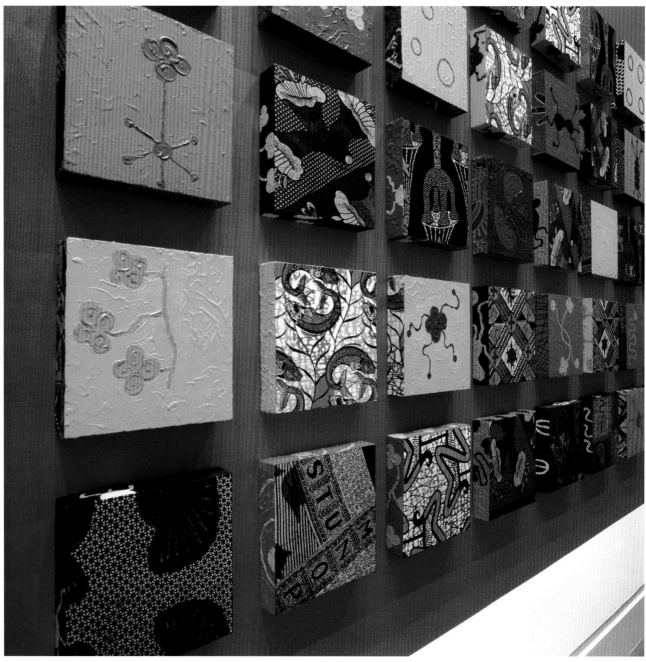

Yinka Shonibare, *100 Years* (detail), 2000

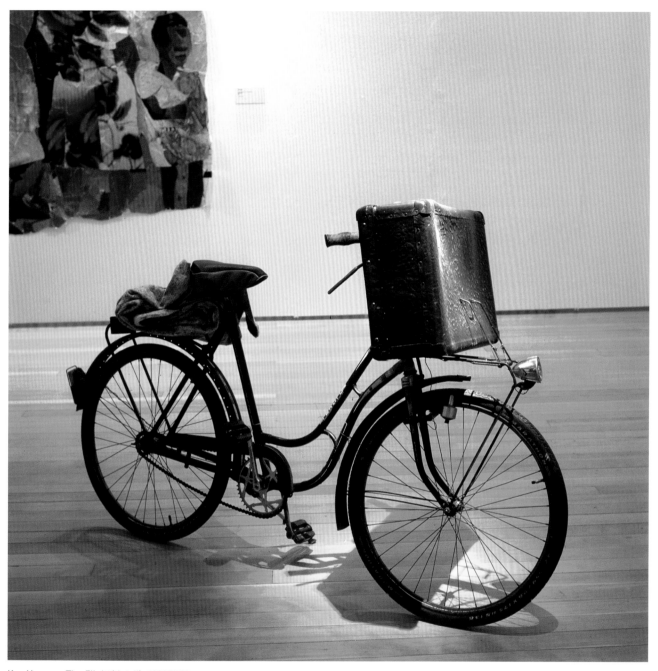

Kay Hassan, *The Flight* (detail), 1995/2001

Exhibition Title
The Short Century:
Independence and Liberation
Movements in Africa, 1945–1994

Organizer
Museum Villa Stuck, Munich

Curator
Okwui Enwezor

Co-curators
Rory Bester
Lauri Firstenberg
Mark Nash
Chika Okeke

Dates
February 15 – April 22, 2001

Location
Museum Villa Stuck, Munich,
Germany

Tour Locations and Dates
Martin-Gropius-Bau, Berlin
 (coordinated by Haus der
 Kulturen der Welt, Berlin),
 May 18 – July 29, 2001

Museum of Contemporary Art,
 Chicago, September 8 –
 December 30, 2001
P.S.1 Contemporary Art Center,
 New York, February 10 –
 May 5, 2002

Publication
Okwui Enwezor, ed., *The Short
Century: Independence and
Liberation Movements in Africa,
1945–1994*, Prestel and Museum
Villa Stuck, Munich, 2001

Artists
Georges Adéagbo
Jane Alexander
Ghada Amer
Oladélé Ajiboyé Bamgboyé
Georgina Beier
Zarina Bhimji
Alexander "Skunder"
 Boghossian
Willem Boshoff
Frédéric Bruly Bouabré
Ahmed Cherkaoui
Gebre Kristos Desta
Uzo Egonu
Ibrahim Mohammed El-Salahi

Erhabor Ogieva Emokpae
Touhami Ennadre
Benedict Chukwukadibia
 Enwonwu
Dumile Feni (Mslaba)
Samuel Fosso
Kendell Geers
David Goldblatt
Kay Hassan
Kamala Ishaq
Gavin Jantjes
Isaac Julien
Marion Kaplan
Kaswende
Seydou Keïta
William Kentridge
Bodys Isek Kingelez
Vincent Kofi
Rachid Koraïchi
Sydney Kumalo
Moshekwa Langa
Christian Lattier
Ernest Mancoba
Santu Mofokeng
Zwelethu Mthethwa
John Ndevasia Muafangejo
Thomas Mukarobgwa
Iba Ndiaye
Malangatana Ngwenya

Amir Nour
Demas Nwoko
Uche Okeke
Antonio Olé
Ben Osawe
Ricardo Rangel
Marc Riboud
Gerard Sekoto
Twins Seven Seven
Yinka Shonibare
Malick Sidibé
Gazbia Sirry
Lucas Sithole
Cecil Skotnes
Pascale Marthine Tayou
Tshibumba Kanda Matulu
Ouattara Watts
Sue Williamson

That Africa was a staging ground for some of the most important questions of postwar politics and society, and that these questions made a crucial impact on identity, modernity, freedom, subjectivity, ethics, and culture, can no longer be debated. The more salient question arising from this exhibition is: "What is African and what is Africa to us?"

Okwui Enwezor, "The Short Century: Independence
and Liberation Movements in Africa, 1945–1994,
An Introduction," in Okwui Enwezor, ed., *The Short
Century: Independence and Liberation Movements
in Africa, 1945–1994*, Prestel and Museum Villa Stuck,
Munich, 2001.

Tshibumba Kanda Matulu, *The History of Zaire Series* (detail), 1973–74

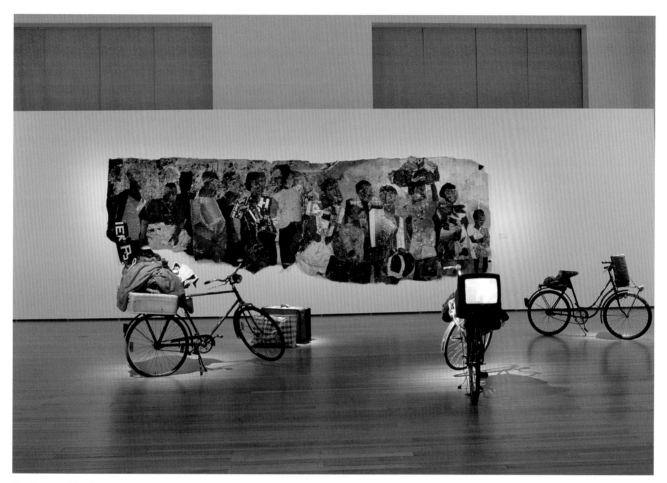

Kay Hassan, *The Flight*, 1995/2001

After the Wall: Art and Culture in Post-Communist Europe

October 16, 1999 – January 16, 2000
Moderna Museet, Stockholm, Sweden,
and touring

The fall of the Berlin Wall in 1989, followed by the collapse of the Soviet Union in 1991, drastically changed the course of world history, tipping global society toward an era that Francis Fukuyama colorfully tagged as "the end of history" in the 1990s. Capitalism became the systematically unchallenged economic order, and Eastern Europe and Russia unabashedly adopted its structures. Any alternative to capitalism—which official European and Soviet Communism had offered before this tipping point—now seemed irrelevant, or overly utopian and ungrounded in political reality.

To address the impact of this dramatic social, political, and historical upheaval in Eastern and Central Europe and the former Soviet Union, Bojana Pejić, David Elliot, and Iris Müller-Westermann organized artworks from these regions in the exhibition After the Wall: Art and Culture in Post-Communist Europe. Held in 1999–2000, the show was a historical retrospective of recent times,

Installation view with Olga Tobreluts, *Antique Models*, 1998 (left) and Frank Thiel, *The "Friedrich Engels" Guards Regiment*, 1990 (right)

Exhibition Title
After the Wall: Art and Culture
in Post-Communist Europe

Organizer
Moderna Museet, Stockholm

Curators
Bojana Pejić
David Elliott
Iris Müller-Westermann

Dates
October 16, 1999 –
January 16, 2000

Location
Moderna Museet,
Stockholm, Sweden

Tour Locations and Dates
Museum of Contemporary
 Art Foundation Ludwig,
 Budapest, Hungary,
 June 15 – August 27, 2000
Hamburger Bahnhof, Berlin,
 Germany, October 1, 2000 –
 February 4, 2001

Publication
Bojana Pejić and David Elliott,
eds., *After the Wall: Art and
Culture in Post-Communist
Europe*, Moderna Museet,
Stockholm, 1999

Artists
Jovan âekiç
David âern
Jifií âernick

AES+F
Arvids Alksnins /
 Peteris Kimelis /
 Dzintars Licis /
 Martins Ratniks
Tatyana Antoshina
Breda Beban / Hrvoje Horvatic
Emese Benczúr
Luchezar Boyadjiev
Veronika Bromová
Violeta Bubelyte
Attila Csörgö
C.U.K.T.
Danica Dakic
Plamen Dejanoff /
 Swetlana Heger
Iskra Dimitrova
Lilia Dragnev / Lucia Macari
Róza El-Hassan
Miklós Erhardt / Dominic Hislop
Vadim Fishkin
Gunda Förster
Gints Gabrans / Ines Pormale
Lyudmila Gorlova
Cosmin Gradinaru
Marina Grzinic
Georgy Gurjanov
Jusuf Hadïifejzoviä
Besnik Haxhilliari
Georg Herold
Edi Hila
IRWIN
Sanja Ivekovic
Zuzanna Janin
Piotr Jaros
Inessa Josing
Kai Kaljo
Keti Kapanadze
Kristof Kintera
Iosif Kiraly

Tomasz Kizny
Artur Klinow
Sergey Kozhemyakin
Katarzyna Kozyra
Rassim Kristev
Miroslav Kulchitsky
Oleg Kulik
Zofia Kulik
Giedrius Kumetaitis /
 Mindaugas Ratavicius
Antal Lakner
Yuri Leiderman
Dominik Lejman
Vitaly Levchenya
Via Lewandowsky
Zbigniew Libera
Maja Licul
Tanya Lieberman
LN Women League Project
Nikolos Lomaschwili
Calin Man
Milovan Markovic
Dalibor Martinins
Boris Mikhailov / Sergej Bratkow
 / Sergej Solonskij
Galina Moskaleva
Igor Moukhin
Kriszta Nagy
Deimantas Narkevićius
Zoran Naskovski
Ilona Nemeth
Olaf Nicolai
Audrius Novickas
Roman Ondák
Marko Peljhan
Dan Perjovschi
Ulf Puder
Franc Purg
Egle Rakauskaite
Koka Ramishwili

Mindaugas Ratavicius
Neo Rauch
Peter Rónai
Robert Rumas
Anri Sala
Aidan Salakhova
Azat Sargsyan
Arsen Savadov /
 Oleksandr Kharchenko
Igor Savchenko
Tilo Schulz
Yevgeny Semionov
Juriy Senchenko
Kalin Serapionov
Nebojša Šerić Šhoba
Anatolij Shuravlev
Liina Siib
Harutyun Simonyan
Konstantin Skotnikov
Nedko Solakov
Mladen Stilinovic
subREAL
Agnes Szépfalvi
Balint Szombathy
Simonas Tarvydas
Frank Thiel
Olga Tobreluts
Rasa Todosijevic
Slaven Tolj
Milica Tomiç
Jaan Toomik
Igor Tosevski
Vasyly Tsagolov
Zaneta Vangeli
Mark Verlan / Pavel Braila
Katefiina Vincourova
Weekend Art
Yevgeny Yufit
Anita Zabilevska
Artur Żmijewski

including 127 works by artists from 23 different countries, with media ranging from painting to film, photography, and video. The works were all made within the period that began with Perestroika (the economic and political "restructuring" of the Soviet Union under Mikhail Gorbachev) and ended with the fall of the Berlin Wall. The exhibition was organized into four sections that spoke to specific topics under the umbrella theme of post-Communism: "Social Sculpture," "Re-Inventing the Past," "Questioning Subjectivity," and "Genderscapes."

Overall, the works expressed a sense of loss, and an ambivalence toward their subject matter— a confusion of identity accompanied by an uneasy

inability to cope with political upheaval and the new social, political, and economic order. After the Wall subsequently traveled to Budapest and Berlin. It received mixed reviews, especially in Germany, where memories of East and West persisted and brought ideological baggage to some people's readings of the show. But in general, After the Wall was applauded as a well-organized and original survey of the art created under these new conditions, and for shedding light on the changing tides of European and Russian cultures directly affected by the fall of Communism.

Following pages: Zofia Kulik, *From Siberia to Cyberia*, 1999

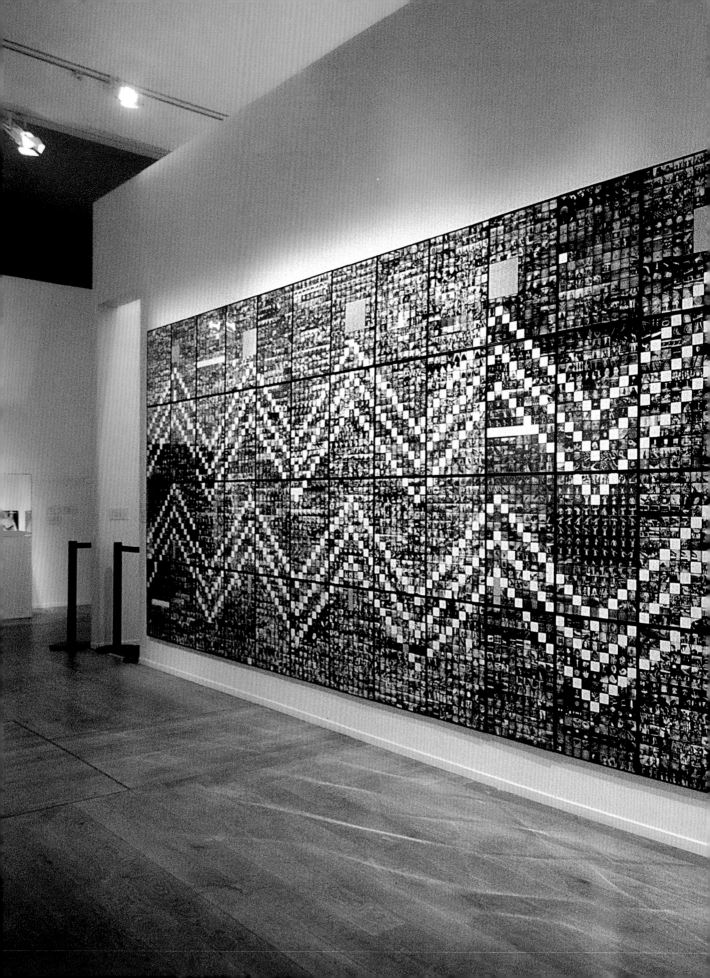

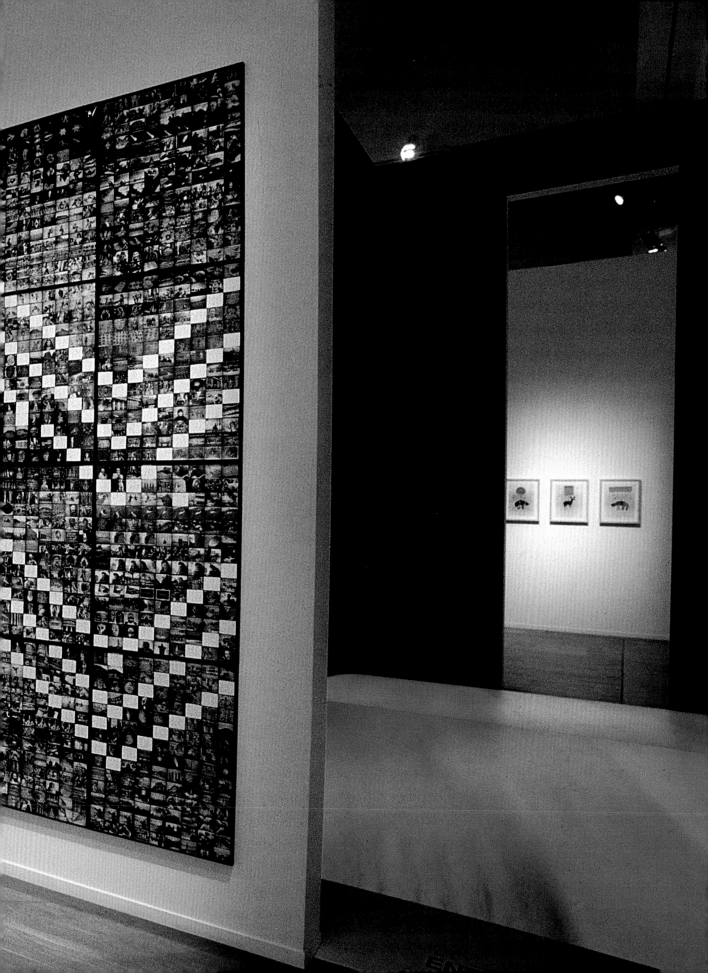

Biennial
Years

Manifesta 1–9:
European
Biennial of
Contemporary Art

documenta X

24th São Paulo
Biennial

documenta 11

7th Lyon
Biennial:
C'est arrivé
demain
(It Happened
Tomorrow)

4th Berlin
Biennial for
Contemporary
Art: Of Mice
and Men

9th
International
Istanbul Biennial:
Istanbul

dOCUMENTA (13)

Robert Kuśmirowski, *Wagon*, 2006, installation view from the 4th
Berlin Biennial for Contemporary Art: Of Mice and Men, KW Institute
for Contemporary Art and various sites along Augustrasse, Berlin,
Germany, 2006

Biennial Years

If one exhibition format has dominated curatorial practice and its history over the past 20 years, it is undoubtedly the biennial. This type of large-scale international show has its origins in the late 19th century, and in the second half of the 20th century it proliferated globally and grew exponentially in prominence. Biennials are important mainly because of their role as international meeting points in an increasingly dispersed art world; they are stages upon which sprawling, citywide international exhibitions are seen by vast audiences. They are also a means by which cities without traditional museum infrastructures can boost cultural tourism and become hugely more relevant to outside artists, curators, and collectors. Significantly, biennials have also served as launching points for the careers of many independent curators, since their temporary and project-driven nature allows for more creativity and latitude in developing curatorial concepts and themes than traditional museum exhibitions.

Documenta, which takes place every five years in Kassel, Germany, has become the most prominent arena for this style of curatorship, due in large part to the legacy of Catherine David's documenta X and Okwui Enwezor's documenta 11, which had highly authored curatorial themes and platforms. The 24th São Paulo Biennial was notable for chief curator Paulo Herkenhoff's ambitious undertaking to understand the past 400 years of art through the curatorial theme of anthropophagy (cannibalism). The biennial as a curatorial form perhaps reaches its infrastructural and ideological pinnacle with Manifesta, the roving, pan-European biennial, which was founded with the idealistic aim to become a site of communication and exchange across that continent. Other curators have explored different approaches to the biennial format, creating smaller, more intimate gestures reflecting on urban contexts and environments, and on relationships and connections among artists; examples of this include the 9th International Istanbul Biennial, the 7th Lyon Biennial, and the 4th Berlin Biennial.

Manifesta 1–9: European Biennial of Contemporary Art

1996, 1998, 2000, 2002, 2004, 2008, 2010, and 2012
Various sites throughout Europe

Manifesta is a pan-European biennial, with each edition presented in a different city. A phenomenon of the newly unified, post-Berlin Wall Europe, Manifesta was created to encourage cultural exchange among the European nations. To date there have been eight Manifesta shows, in Rotterdam, the Netherlands (1996), Luxembourg (1998), Ljubljana, Slovenia (2000), Frankfurt, Germany (2002), Donostia – San Sebastian, Spain (2004), Trentino – Alto Adige, South Tyrol, Italy (2008), Murcia, Spain (2010), and Genk, Belgium (2012). The 2006 edition, planned for Nicosia, Cyprus, was canceled three months prior to its opening.

Manifesta began in 1996 as a Dutch initiative with the support of various other national governments and ministers of culture. That edition was held at 16 different museums and 36 other public locations in Rotterdam, culminating in a massive, citywide event. The five curators selected more than 70 international artists, mostly from European countries, to exhibit. Over time, Manifesta has developed a vast network of young and emerging art professionals, who for each edition organize various platforms, programs, and events.

A central committee, the International Foundation Manifesta, envisions future endeavors and provides organizational support for all the Manifesta projects.

One of the groundbreaking aspects of Manifesta is its emphasis on collaboration. Artists, curators, and local government representatives all work closely together to realize the projects from the ground up. It also involves an extensive training program on the practical aspects of the organizational process. This was especially true of Manifestas 2, 3, and 4, in which each time, 30 selected students were formally brought on board to learn about all aspects of the production.

Manifesta, its ancillary features (educational programs, panel discussions, publications), and its collaborators and sponsors all continue to expand with each new edition. The 2008 edition in Italy attracted more than 100,000 visitors and involved more than 200 artists from around the world. This popularity is echoed in the media. Manifesta receives more press coverage than almost any other international art event and is often praised by critics for its prodigious ambitions and experimental fearlessness. As a cutting-edge art exhibition and a hub for Europe's contemporary cultural and intellectual productions, Manifesta epitomizes the collective aspirations of the European continent in the 21st century.

Maurizio Cattelan, *Untitled*, installation view from Manifesta 2, Luxembourg, 1998

Exhibition Title
Manifesta 1

Organizer
Foundation European Art
Manifestation

Curators
Rosa Martinez
Viktor Misiano
Katalyn Neray
Hans Ulrich Obrist
Andrew Renton

Dates
June 9 – August 19, 1996

Location
Various sites in Rotterdam,
The Netherlands

Publication
Katalyn Neray, Rosa Martinez,
Viktor Misiano, Andrew Renton,
and Hans Ulrich Obrist, eds.,
*Manifesta 1: Rotterdam, the
Netherlands, 9 June – 19 August
1996*, Foundation European Art
Manifestation, Rotterdam, 1996

Artists
Martin Beck
Patrick van Caeckenbergh
Mat Collishaw
Rogelio López Cuenca
Maria Eichhorn
Róza El-Hassan
Olafur Eliasson
Entertainment & Co
Ayşe Erkmen
Vadim Fishkin
Bernhard Fuchs
Tamara Grcic
Joseph Grigely
Douglas Gordon
Tommi Grönlund /
 Petteri Nisunen
Marie-Ange Guilleminot
Dmitri Gutov
Jitka Hanzlová
Carl Michael von Hausswolff
Christine Hill
Carsten Höller
Huang Yong Ping
Fabrice Hybert
IRWIN
Siraj Izhar
Henrik Plenge Jacobsen
Robert Jankuloski
Piotr Jaros
Koo Jeong-A
Ivana Keser
Suchan Kinoshita
Renée Kool
Pavel Kopriva

Oleg Kulik / Mila Bredikhina
Yuri Leiderman
Tracy Mackenna
Esko Männikkö
Eva Marisaldi
Jenny Marketou
Roger Meintjes
Regina Möller
NEsTWORK
Petteri Nisunen
Maurice O'Connell
Roman Ondák
Valeri Podoroga
Tadej Pogačar (P.A.R.A.S.I.T.E.)
Mathias Poledna
Liza May Post
Luca Quartana
Tobias Rehberger
Gerwald Rockenschaub
Arsen Savadov
Pit Schulz
Georgy Senchenko
Nedko Solakov
Soo-Ja Kim
subREAL
János Sugár
Sam Taylor-Wood
Kathy Temin
Hale Tenger
Wolfgang Tillmans
Rirkrit Tiravanija
Jaan Toomik
Didier Trenet
Rosemarie Trockel
Mette Tronvoll
Uri Tzaig
Paco Vacas
Eulàlia Valldosera
Lydia Venieri
Susann Walder
Catherine Yass

Exhibition Title
Manifesta 2

Organizer
The Ministry of Culture
of Luxembourg

Curators
Robert Fleck
Maria Lind
Barbara Vanderlinden

Dates
June 28 – October 11, 1998

Location
Various sites in Luxembourg,
Luxembourg

Publication
Robert Fleck, Maria Lind, and
Barbara Vanderlinden, *Manifesta

*2: Biennale européenne d'art
contemporain, Luxembourg,*
Agence luxembourgeoise
d'action culturelle and Casino
Luxembourg-Forum d'art
contemporain, Luxembourg, 1998

Artists
Eija-Liisa Ahtila
Kutlug Ataman
Orla Barry
Emese Benczúr
Christine Borland
Eriks Bozis
Maurizio Cattelan
Alicia Framis
Dora García
Dr. Galentin Gatev
Dominique Gonzalez-Foerster
Félix González-Torres
Carsten Höller
Pierre Huyghe
Sanja Ivekovic
Inessa Josing
Kristof Kintera
Elke Krystufek
Peter Land
Maria Lindberg
Michel Majerus
Bjarne Melgaard
Deimantas Narkevicius
Fanni Niemi-Junkola
Honoré d'O
Boris Ondreicka
Tanja Ostojic
Marko Peljhan
Dan Perjovschi
Franz Pomassl
Antoine Prum
Tobias Rehberger
Jeroen de Rijke / Willem de Rooij
Bojan Sarcevic
Eran Schaerf
Tilo Schulz
Nebojša Šerić Šhoba
Ann-Sofi Sidén
Andreas Slominski
Sean Snyder
Apolonija Šušteršič
Sarah Sze
Bert Theis
Piotr Uklánski
Gitte Villesen
Richard Wright

Exhibition Title
Manifesta 3: Borderline
Syndrome, Energies of Defence

Curators
Francesco Bonami
Ole Bouman
Maria Hlavajová
Kathrin Rhomberg

Dates
June 23 – September 24, 2000

Location
Various sites in Ljubljana,
Slovenia

Publication
Francesco Bonami,
Ole Bouman, Maria Hlavajová,
and Kathrin Rhomberg,
*Manifesta 3: Borderline
Syndrome, Energies of Defence*,
International Foundation
Manifesta, Ljubljana, 2000

Artists
Adel Abdessemed
Pawel Althamer
Maja Bajević
Simone Berti
Ursula Biemann
Roland Boden
Agnese Bule
Phil Collins
Joost Conijn
Josef Dabernig
Colin Darke
Elmgreen & Dragset
FAT (Sean Griffiths, Charles
 Holland, and Sam Jacob)
Urs Fischer
Nayia Frangouli /
 Yane Calovski
Marcus Geiger
Amit Goren
Veli Granö
gruppo A12
Pravdoliub Ivanov
Ivana Jelavic
Daniel Jewesbury
Šelja Kameric
Ian Kiaer
Rasmus Knud /
 Søren Andreasen
Koo Jeong-A
Edward Krasinski
Darij Kreuh
Denisa Lehocká
Alexander Melkonyan
Matthias Müller
Paul Noble
Anton Olshvang
Roman Ondák
Anatoly Osmolovsky
Adrian Paci
Manfred Pernice
Diego Perrone
Susan Philipsz
Marjetica Potrč
Arturas Raila
Anri Sala
Bülent Şangar
Sanna Sarva
Tomo Savić-Gecan →

Schie 2.0 (Jan Konings /
 Ton Matton / Lucas Verweij)
Ene-Liis Semper
Stalker
Simon Starling
Škart (Dragan Protic /
 Mileta Postic / Tijana Moraca /
 Peter de Bruyne /
 Djordje Balmazovic)
Nika Špan
Nasrin Tabatabai
Sarah Tripp
Francisco Tropa
Joëlle Tuerlinckx
Sisley Xhafa
Jasmila Žbanic
Gregor Zivic

Exhibition Title
Manifesta 4

Curators
Iara Boubnova
Nuria Enguita Mayo
Stéphanie Moisdon Trembley

Dates
May 25 – August 25, 2002

Location
Various sites in Frankfurt,
Germany

Publication
Iara Boubnova, Martin Fritz,
and Stéphanie Moisdon
Trembley, eds., and Nuria
Enguita Mayo, *Manifesta 4:
European Biennial of
Contemporary Art*, International
Foundation Manifesta, Hatje
Cantz, Ostfildern-Ruit, 2002

Artists
0100101110101101.org
Halil Altindere
Daniel García Andújar
Apsolutno
Ibon Aranberri
Olivier Bardin
Yael Bartana
Massimo Bartolini
Elisabetta Benassi
Marc Bijl
Pierre Bismuth
Bleda y Rosa
Bless
Lionel Bovier
Luchezar Boyadjiev
Jasper van den Brink
Fernando Bryce
Gerard Byrne
The Construction &
 Deconstruction Institute

Roberto Cuoghi
Jonas Dahlberg
Kathy Deepwell
Dagmar Demming
Branislav Dimitrijević
Esra Ersen
Jon Mikel Euba
Jeanne Faust
João Fernandes
Zlatan Filipovic
Finger
Christoph Fink
Nina Fischer / Maroan El Sani
Dirk Fleischmann
Andreas Fogarasi
Luke Fowler
Andrea Geyer
Alonso Gil
Lyudmila Gorlova
Davide Grassi
Pia Greschner
Igor Grubic
Anna Gudmundsdottir
Alban Hajdinaj
Lise Harlev
Institut für Kulturanthropologie
 und Europäische Ethnologie
Jens Hoffmann with Natascha
 Sadr Haghighian / Tino Sehgal
Takehito Koganezawa
Erden Kosova
Andreja Kuluncic
Antal Lakner
Franck Larcade
Anton Litvin
Gintaras Makarevicius
Ján Mancuska
Líja Marcinkevica
Mathieu Mercier
Suzana Milevska
Gianni Motti
Ivan Moudov
Oliver Musovik
Olivier Nottellet
OHIO Photomagazine
Maria Papadimitriou
Florian Pumhösl
Tobias Putrih
Radek Group
Sal Randolph
Revolver Archiv für
 aktuelle Kunst
Gianni Romano
ROR (Revolutions on Request)
Pia Rönicke
rraum-rraum02-ideoblast
Natascha Sadr Haghighian
Hedwig Saxenhuber
Hans Schabus
Tino Sehgal
Kalin Serapionov
Bruno Serralongue
Erzen Shkololli
Sancho Silva
Monika Sosnowska

Laura Stasíulytë
Mika Taanila
Nomeda / Gediminas Urbonas
Edin Vejselovic Edo
wemgehoertdiestadt
Måns Wrange
Haegue Yang
Jun Yang
Zapp
Artur Żmijewski

Exhibition Title
Manifesta 5

Curators
Massimiliano Gioni
Marta Kuzma

Dates
June 11 – September 30, 2004

Location
Various sites in Donostia–San
Sebastian, Spain

Publication
Marta Kuzma and Massimiliano
Gioni, *With All Due Intent:
Manifesta 5: European Biennial
of Contemporary Art*, Manifesta
5, Centro Internacional de
Cultura Contemporánea, and
Actar, Barcelona, 2004

Artists
Bas Jan Ader
Victor Alimpiev /
 Sergey Vishnevsky
Huseyin Alptekin
Micol Assaël
Sven Augustijnen
Zbynûk Baladrán
John Bock
Michaël Borremans
Sergey Bratkov
Carlos Bunga
Duncan Campbell
Cengis Çekil
Illya Chichkan /
 Kyrill Protsenko
Jan de Cock
Angela de la Cruz
D.A.E. (Peio Aguirre /
 Leire Vergara)
Jeremy Deller
Andrea Faciu
Iñaki Garmendia
Geert Goiris
Kim Hiorthøy
Laura Horelli
Külli Kaats
Johannes Kahrs
Leopold Kessler
Mark Leckey

Maria Lusitano
Mark Manders
Asier Mendizabal
Boris Mikhailov
Office of Alternative Urban
 Planning (Verónica Arcos /
 José Arnaud / Sannah Belzer /
 Sebastián Khourian /
 Claudia Strahl /
 Mónica Villate /
 Constanze Zehi)
Oksana Pasaiko
Anu Pennanen
Garrett Phelan
Kirsten Pieroth
Paola Pivi
Marc Quer
Daniel Roth
Michael Sailstorfer
Silke Schatz
Markus Schinwald
Conrad Shawcross
Eyal Sivan / Michel Khleifi
Hito Steyerl
Misha Stroj
Patrick Tuttofuoco
Vangelis Vlahos
Gillian Wearing
Amelie von Wulffen
Cathy Wilkes
Yevgeniy Yufit
Olivier Zabat
David Zink Yi
Darius Ziura

Exhibition Title
Manifesta 6 (canceled)

Curators
Mai Abu ElDahab
Anton Vidokle
Florian Waldvogel

Planned Dates
September 23 –
December 17, 2006

Location
Nicosia, Cyprus

Exhibition Title
Manifesta 7

Curators
Adam Budak
Anselm Franke / Hila Peleg
Raqs Media Collective

Dates
July 19 – November 2, 2008

Location
Various sites in South Tyrol, Italy

Publications

Adam Budak, Anselm Franke, Hila Peleg, and Raqs Media Collective, *Companion: Manifesta 7: European Biennial of Contemporary Art*, Silvana Editoriale, Milan, 2008

Adam Budak, Anselm Franke, Hila Peleg, and Raqs Media Collective, *Manifesta 7: Index*, Silvana Editoriale, Milan, 2008

Adam Budak, Anselm Franke, Hila Peleg, and Raqs Media Collective, *Manifesta: 7 Scenarios*, Silvana Editoriale, Milan, 2008

Artists

David Adjaye
Nader Ahriman
Airswap
Alterazioni Video
Azra Aksamija
Maria Thereza Alves /
 Jimmie Durham /
 Michael Taussig
Shahid Amin
Michelangelo Antonioni
Knut Åsdam
Tamy Ben-Tor
David Benewith
Bernadette Corporation
Stefano Bernardi

Hélène Binet
Margrét H. Blöndal
Botto e Bruno
Kristina Braein
Brave New Alps
Harold de Bree
Attila Bruni
Michal Budny
BURGHARD
Yane Calovski
Beth Campbell
Fabio Campolongo
CandidaTV
Nina Canell
Andrea Caranti
Libia Castro & Ólafur Ólafsson
Adriana Cavarero
Marcos Chaves
Claire Fontaine
Marcus Coates
Peter Coffin
contemporary culture index
Neil Cummings &
 Marysia Lewandowska
Curatorlab
Keren Cytter
Oskar Dawicki
Jeremiah Day
Evelina Deicmane
Rä Di Martino
Dictionary of War
Nico Dockx
Brigid Doherty

Mladen Dolar
Andreas Duscha
Latifa Echakhch
Miklós Erhardt &
 Little Warsaw
Igor Eskinja
Tim Etchells
etoy.CORPORATION
fabrics interseason
Famed
Harun Farocki
Anna Faroqhi
Omer Fast
Didier Fiuza Faustino
Ivana Franke
Peter Friedl
Yona Friedman
Matthew Fuller
Martino Gamper
Francesco Gennari
Jan Gerber & Sebastian Lutgert
Ranu Ghosh
Karø Goldt
Larry Gottheim
Stefano Graziani
Renée Green
Jos de Gruyter /
 Harald Thys
Rupali Gupte & Prasad Shetty
João Maria Gusmão &
 Pedro Paiva
Anawana Haloba /
 Francesca Grilli

Ant Hampton
Graham Harwood
Florian Hecker
Heide Hinrichs
Nikolaus Hirsch &
 Michel Müller
Hiwa K
Hannes Hoelzl
Tom Holert /
 Claudia Honecker
Karl Holmqvist
Heidrun Holzfeind
Emre Hüner
Hannah Hurtzig
Il Funambolo
Runa Islam
Ricardo Jacinto
Helen Jilavu
Timo Kahlen
Sanjay Kak
Karl Kels
Zilvinas Kempinas
Anne-Mie van Kerckhoven
Ragnar Kjartansson
Barbora Klímová
Daniel Knorr
Joachim Koester
Chris Kondek
Andree Korpys /
 Markus Löffler
Milena Kosec
Reinhard Kropf &
 Siv Helene Stangeland →

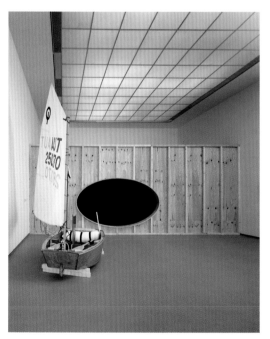

Hans Schabus, *Forlorn*, 2002, and *Another Try for a Room for "Western,"* 2002, installation view from Manifesta 4, Frankfurt, Germany, 2002

Exhibition catalogue, Manifesta 9, 2012

Anders Krueger
Adam Leech
Sonia Leimer
Lawrence Liang
Deborah Ligorio
Charles Lim Yi Yong
m-city
Kuehn Malvezzi
Teresa Margolles
Renzo Martens
Daria Martin
Christian Mayer
Thomas Meinecke
Angela Melitopoulos
Xisco Mensua
Miks Mitrevics
Monipodio
Valérie Mréjen
Rabih Mroué
Andreas Müller
Christian Philipp Müller
Sina Najafi
Rosalind Nashashibi
Glen Neath
The Next Enterprise
Olaf Nicolai
Walter Niedermayr
Margareth Obexer
Luigi Ontani
Open Anonymous Society
Anna Ostoya
Jorge Otero-Pailos

Pacquée
Davide de Paoli
Chiara Parisi
Ewa Partum
Gianni Pettena
Martin Pichlmair
Piratbyrån
Falke Pisano / Will Holder
Jaime Pitarch
Paolo Plotegher
Andrea Polato
Prof. Bad Trip
Publink
Philippe Rahm
Ria
Bernd Ribbeck
Alain Robbe-Grillet
Pietro Roccasalva
Roee Rosen
Pamela Rosenkranz
Arundhati Roy
Christoph Ruckhäberle
Natascha Sadr Haghighian
Saskia Sassen
Jeffrey T. Schnapp
Florian Schneider
Martina Schullian
Kateřina Šedá
Gianluca &
 Massimiliano de Serio
Helena Sidiropoulos
Janek Simon

Dayanita Singh
Eyal Sivan
Michael Snow
Enrico Spanu
Kamen Stoyanov
Josef Strau
Meg Stuart
Melati Suryodarmo
Jörgen Svensson
Javier Tellez
TEUFELSgroup
Hansa Thapliyal
Althea Thauberger
Eugenio Tibaldi
Adrien Tirtiaux
Krist Torfs
Luca Trevisani
Tatiana Trouvé
Christopher Turner
Uqbar Foundation
Alexander Vaindorf
Ricardo Valentim
Jochem Vanden Ecker
Elvira Vannini
Nico Vascellari
Barbara Visser
Danh Vo
Johannes Vogl
Klaus Weber
Eyal Weizman
Judi Werthein
Guido van der Werve

Stephen Willats
Anna Witt
Richard Wright
Zafos Xagoraris
Matsuko Yokokoji
Saadi Yousef
ZimmerFrei
Darius Ziura

Exhibition Title
Manifesta 8

Curators
Alexandria Contemporary
 Arts Forum
Chamber of Public Secrets
Tranzit.org

Dates
October 9, 2010 –
January 9, 2011

Location
Murcia, Spain

Publication
*Manifesta 8: la Bienal Europea
de Arte Contemporáneo, región
de Murica, España en diálogo
con el norte de Africa*, Silvana
Editoriale, Milan, 2010

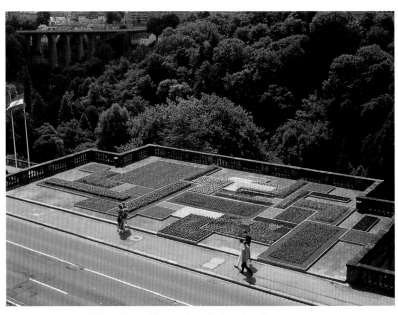

Tobias Rehberger, *Within View of Seeing*, installation view from
Manifesta 2, Luxembourg, 1998

Artists

AA (The Arts Assembly)
The Action Mill
AGM 10
Mounira Al Solh
Basma AlSharif
Abed Anouti
Esref Armagan
Backbench
Babi Badalov
Gonzalo Ballester
Neil Beloufa
Erick Beltrán
Lene Berg
Michael Paul Britto
Pablo Bronstein
Brumaria
Igor & Ivan Buharov
Ergin Cavusoglu
Banu Cennetoglu /
 Shiri Zinn
Filipa César
Boris Charmatz
Loulou Cherinet
Heman Chong
Common Culture
Céline Condorelli
Danilo Correale
Kajsa Dahlberg
Cristina David
Stephan Dillemuth
Willie Doherty
Juan Downey
Anders Eiebakke
Sherif El-Azma
Aida Eltorie
Alfonso Escudero
Marcelo Expósito &
 Verónica Iglesia
Carla Filipe
Simon Fujiwara
Alexandra Galkina
Melanie Gilligan
Laurent Grasso
Ryan Gander
Thierry Geoffroy (Colonel)
Khaled Hafez
Nav Haq
Karl Holmqvist
Ralf Homann
Sung Hwan Kim
Incubator for a Pan-African
 Roaming Biennial
Ann Veronica Janssens
Jeleton
Adela Jušic
Mahmoud Khaled
Hassan Khan
Mathieu Kleyebe Abonnenc /
 Sarah Maldoror
Irene Lucas & Christoph Euler
Erlea Maneros Zabala
Suhail Malik
Ana Martínez & Ricardo Moreno
Rosell Meseguer

Metahaven
Darius Miksys
The MoCHA Sessions
Nástio Mosquito
Charles Mudede
Kenny Muhammad &
 Adam Carrigan
Ángel Nevárez &
 Valerie Tevere
n.e.w.s. (Renée Ridgway /
 Rick van Amersfoort)
Fay Nicolson
nOFFICE
Lorraine O'Grady
The Otolith Group
Bouchra Ouizguen
Olivia Plender
Nada Prlja
Wanda Raimundi-Ortiz
Red76
Ariel Reichman
Jasper Rigole
Pedro G. Romero / Archivo F.X.
Emily Roysdon
María Ruido
David Rych
Nikolaus Schletterer
Ruti Sela
Massimiliano &
 Gianluca de Serio
Catarina Simao
Alexandre Singh
Jean-Marc Superville Sovak
Take to the Sea
Michael Takeo Magruderm
Mariusz Tarkawian
Stefanos Tsivopoulos
Tomáš Vanek
Martin Vongrej
Tris Vonna-Michell
Tanja Widmann
Wooloo
Raed Yassin

Exhibition Title

Manifesta 9: The Deep
of the Modern

Curator

Cuauhtémoc Medina

Dates

June 2 – September 30, 2012

Location

Genk, Limburg, Belgium

Publication

Cuauhtémoc Medina,
Dawn Ades, and Katerina
Gregos, *Manifesta 9:
The Deep of the Modern:
A Subcyclopaedia*, Silvana
Editoriale, Milan, 2012

Artists

2012 Architects &
 Refunx
Grigori Alexandrov
Lara Almarcegui
Leonid Amalrik,
 Dmitri Babichenko &
 Vladimir Polkovnikov
Carlos Amorales
Roger Anthoine
Alexander Apóstol
The Ashington Group
Bernd & Hilla Becher
Beehive Design Collective
Oliver Bevierre
Rossella Biscotti
George Bissill
Christian Boltanski
Irma Boom &
 Johan Pijnappel
Bill Brandt
Marcel Broodthaers
Janet Buckle
Zdeněk Burian
Edward Burtynsky
Ben Cain
Duncan Campbell
Alberto Cavalcanti
CINEMATEK
 (The Royal Belgian
 Film Archive)
Claire Fontaine
Emile Claus
Rev. Francis William Cobb
Norman Cornish
Nemanja Cvijanović
Gilbert Daykin
Jeremy Deller
Charles Demuth
Manuel Durán
Ecomusée Bois-du-Luc
Max Ernst
Federal Police Archive,
 Brussels, Belgium
Tomaž Furlan
Kendell Geers
Goldin+Senneby
Rocco Granata
Eva Gronbach
Igor Grubic
Jan Habex
Thomas Harrison Hair
David Hammons
Tony Harrison
Nicoline van Harskamp
Josef Herman
Robert Heslop
Emre Hüner
IRWIN
Joris Ivens &
 Henri Storck
Jota Izquierdo
Maryam Jafri
Magdalena Jitrik
Kevin Kaliski

Mikhail Karikis &
 Uriel Orlow
Willy Kessels
Oliver Kilbourn
Aglaia Konrad
Nicolas Kozakis &
 Raoul Vaneigem
Erik van Lieshout
Richard Long
Maximilien Luce
Manuel Luque
Don McCullin
Tom McGuinness
Oswaldo Maciá
Don McPhee
John Martin
Frans Masereel
Michael Matthys
Constantin Meunier
vzw Mijn-Verleden
 (Mijndepot Waterschei)
Marge Monko
Museum van de
 Mijnwerkerswoning
 (Museum of the
 Miner's House)
Arthur Munby
Haifeng Ni
Nederlands Mijnmuseum
 (Dutch Mine Museum)
Georg Wilhelm Pabst
Keith Pattison
Henry Perlee Parker
Pierre Paulus de Châtelet
Raqs Media Collective
William Rittase
Rijksarchief (State Archive),
 Hasselt, Belgium
William Heath Robinson
Roumeliotis Family
Bea Schlingelhoff
Lina Selander
Kuai Shen
Robert Smithson
Praneet Soi
Joseph Stella
Suske & Wiske
 (Standaard Uitgeverij,
 Antwerp, Belgium)
Graham Sutherland
Denis Thorpe
Ante Timmermans
Yan Tomaszewski
Jan Toorop
Ana Torfs
Turkish Union,
 Beringen, Belgium
Maarten Vanden Eynde
Antonio Vega Macotela
Bernar Venet
Georges Vercheval
Katleen Vermeir &
 Ronny Heiremans
Visible Solutions LLC
Paolo Woods

documenta X

June 21 – September 28, 1997
Various sites in Kassel, Germany

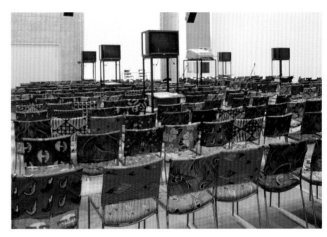

Franz West, *Docu-Chairs*, installation, 1997–2003

Documenta is presented every five years in Kassel, Germany, and each edition runs for 100 days. It began in 1955, initiated by the artist and curator Arnold Bode and the art historian Werner Haftmann, who wanted to introduce the public to modernist abstract artists from the first half of the 20th century. While they did not set out with the intention to start a series, Documenta has since become one of the largest international blockbuster art events in the world, drawing hundreds of thousands of visitors and serving as a major showcase for cutting-edge contemporary artists.

Curated by Catherine David, the first female curator in the history of the series, documenta X took place in 1997. David invited over 140 artists to exhibit in various locations across Kassel, from shop windows to museums to public areas. Her organizational concept was based on her neologism "retroperspective," which she defined as an attempt to articulate the goals of past artists through contemporary artworks—to see, in other words, how unfinished business from the past is inherited and made manifest in artistic practices today. Artists such as Marcel Broodthaers and Joseph Beuys were touchstones for documenta X; David attempted to articulate their artistic strategies

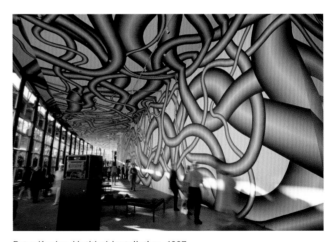

Peter Kogler, *Untitled*, installation, 1997

Exhibition Title
documenta X

Organizers
Documenta and Museum
Fridericianum, Kassel

Curator
Catherine David

Dates
June 21 – September 28, 1997

Location
Various sites in Kassel, Germany

Publications
Catherine David and Jean-
François Chevrier, *Politics-
Poetics: documenta X—
the book*, Hatje Cantz,
Ostfildern-Ruit, 1997
Paul Sztulman, Catherine David,
and Jean-François Chevrier,
documenta X: Short Guide,
Hatje Cantz, Ostfildern-Ruit,
1997

Artists
Robert Adams
Paweł Althamer
Archigram
Archizoom Associati
Art & Language
Aya & Gal Middle East
Oladélé Ajiboyé Bamgboyé
Lothar Baumgarten
Catherine Beaugrand
Samuel Beckett
Blank & Jeron
Marcel Broodthaers
Heath Bunting
Charles Burnett
Jean-Marc Bustamante

Cabelo
Lygia Clark
James Coleman
Collective (La Ciutat
de la Gent)
Stephen Craig
Jordan Crandall
Daniele Del Giudice
Stan Douglas
Ed van der Elsken
Bruna Esposito
Walker Evans
Aldo van Eyck
Öyvind Fahlström
Patrick Faigenbaum
Harun Farocki
Feng Mengbo
Fischli & Weiss
Peter Friedl
Holger Friese
Liam Gillick
Gob Squad
Jean-Luc Godard
Heiner Goebbels
Dorothee Golz
Dan Graham
Toni Grand
Hervé Graumann
Johan Grimonprez
Johan Grimonprez /
Herman Asselberghs
Ulrike Grossarth
Hans Haacke
Raymond Hains
Richard Hamilton
Richard Hamilton /
Ecke Bonk
Siobhán Hapaska
Carl Michael von Hausswolff
Michal Heiman
Jörg Herold
Christine Hill
Christine &
Irene Hohenbüchle

Carsten Höller /
Rosemarie Trockel
Edgar Honetschläger
Felix S. Huber / Philip Pocock /
Florian Wenz / Udo Noll
Hybrid WorkSpace
Jackson Pollock Bar
Jodi
Mike Kelley /
Tony Oursler
Mike Kelley /
Tony Oursler /
Diedrich Diederichsen
William Kentridge
Martin Kippenberger
Joachim Koester
Peter Kogler
Aglaia Konrad
Rem Koolhaas
Hans-Werner Kroesinger
Suzanne Lafont
Sigalit Landau
Maria Lassnig
Jan Lauwers
Jozef Legrand
Antonia Lerch
Helen Levitt
Geert Lovink
Chris Marker
Kerry James Marshall
Christoph Marthaler /
Anna Viebrock
Steve McQueen
Gordon Matta-Clark
Jana Milev
Mariella Mosler
Jean-Luc Moulène
Reinhard Mucha
Christian Philipp Müller
Matt Mullican
Antonio Muntadas
Matthew Ngui
Carsten Nicolai
Olaf Nicolai

Stanislas Nordey
Hélio Oiticica
Gabriel Orozco
Adam Page
Marc Pataut
Raoul Peck
Marko Peljhan
Michelangelo Pistoletto
Lari Pittman
Emilio Prini
Stefan Pucher
Radio Mentale
David Reeb
Gerhard Richter
Liisa Roberts
Anne-Marie Schneider
Jean-Louis Schoellkopf
Thomas Schütte
Michael Simon
Abderrahmane Sissako
Alison & Peter Smithson
Aleksandr Sokurov
Nancy Spero
Erik Steinbrecher
Meg Stuart
Hans Jürgen Syberberg
Slaven Tolj
Tunga
Uri Tzaig
Danielle Vallet Kleiner
Vito Acconci Studio
Martin Walde
Jeff Wall
Wang Jianwei
Marijke van Warmerdam
Lois Weinberger
Franz West
Garry Winogrand
Eva Wohlgemuth /
Andreas Baumann
Penny Yassour
Lilian Zaremba
Andrea Zittel
Heimo Zobernig

via contemporary practices. The main theme that was tackled was the relationship between art and politics. The show is credited with introducing postcolonial considerations to the German art world, which until that point had focused mostly on art from NATO countries. An extraordinarily ambitious schedule of programming beyond the exhibition itself was included, with the events given nearly equal importance to the art on display. Numerous lectures, panel discussions, and the performing arts program Theater Skizzen added a critical discourse to the show's dynamic. Many of these activities were part the program "100 Days—100 Guests," a platform for encounters and exchanges between audience members and invited speakers. The major themes introduced in "100 Days—100 Guests" dealt with the ramifications of the development of modernism in non-Western cultures, the notion of identity, and what constitutes the universal. Also under the auspices of documenta X, a series of radio, internet, and television performances were broadcast for the duration of the exhibition, and documented on CD-ROM. Indeed, one of the recurring criticisms of documenta X was the scarcity of more traditional forms of art, namely painting and sculpture, in favor of new media and event-based programming.

24th São Paulo Biennial

October 3 – December 13, 1998
Pavilhão Ciccillo Matarazzo,
Parque Ibirapuera, São Paulo, Brazil

Maria Martins, *La femme a perdu son ombre / The Woman Has Lost Her Shadow*, 1964

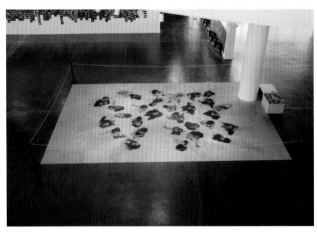

Allora & Calzadilla, *Charcoal Dance Floor*, 1998

The 24th São Paulo Biennial was held in 1998. The venue, Pavilhão Ciccillo Matarazzo, covers more than 33,000 square meters, and the show involved more than 270 international artists and 10 curators operating under the direction of chief curator Paulo Herkenhoff and adjunct curator Adriano Pedrosa. The artworks spanned the last 400 years and were selected to elaborate on the theme of anthropophagy—more commonly known as cannibalism. Herkenhoff's inspiration came from Oswald de Andrade's 1928 *Manifesto Antropófago*. De Andrade, a poet and writer from São Paulo, employed anthropophagy in his text as a metaphor for how Brazilian culture consumes, or "ingests," elements of foreign cultures and makes them part of its own hybridized identity.

The biennial was divided into four thematic segments: "National Representations," showcasing traditional approaches in Brazilian art; "Brazilian Contemporary Art"; "Roterios" (Routes), a section considering globalization; and "Historical Nucleus," which brought previously unseen historical works to Brazil. Many of the contemporary artists worked in non-traditional media that supported (sometimes literally) the cannibalistic theme: not just images and sculptures of body parts, but actual body parts and fluids, dead animals, and mutilated flesh. There were also many interactive works, one of the most popular being a small ice rink constructed by Danish artist Olafur Eliasson.

Exhibition Title
24th São Paulo Biennial

Chief Curator
Paulo Herkenhoff

Adjunct Curator
Adriano Pedrosa

Curators
Bart de Baere
Rina Carvajal
Lorna Ferguson
Maaretta Jaukkuri
Vasif Kortun
Awa Meite
Ivo Mesquita
Louise Neri
Apinan Poshyananda
Ami Steinitz

Dates
October 3 –
December 13, 1998

Location
Pavilhão Ciccillo Matarazzo,
Parque Ibirapuera, São Paulo,
Brazil

Publication
Paulo Herkenhoff and Adriano
Pedrosa, eds., *XXIV Bienal de
São Paulo*, Fundação Bienal de
São Paulo, Brazil, 1998

Artists
Mario Abreu
Halil Actindere
Mark Adams
Georges Adéagbo
Regina Aguilar
Carlos Aguirre
Vicente Albán
Allora & Calzadilla
Hüseyin Bahri Alptekin
Fernando Alvim
Francis Alÿs
Jean André

Claudia Andujar
Oswald de Andrade Filho
Arnaldo Antunes
Nobuyoshi Araki
Michael Asher
Chant Avedissian
Mirosław Bałka
Arthur Barrio
Moisés Barrios
Leonora de Barros
Mario Benjamin
Candice Breitz
Ernest Breleur
Pedro Cabrita Reis
Waltércio Caldas
Sérgio Camargo
Haroldo de Campos
Carlos Capelán
Janet Cardiff
Valia Carvalho
Lourdes de Castro
Mutlu Cerkez
Chieh Jen Chen
Albert Chong

Dadang Christanto
Sandra Cinto
Soly Cissé
Nicola Costantina
Rochelle Costi
Michael Craig-Martin
Iftikhar & Elizabeth Dadi
Juan Davilla
Jean Baptiste Debret
Antonio Dias
Cícero Dias
Maurício Dias &
 Walter Riedweg
Rineke Dijkstra
Honoré d'O
Arturo Ducloss
Roza El-Hassan
Sandra Eleta
Olafur Eliason
Touhami Ennadre
Sylvie Fleury
Andrea Fraser
Hilmar Fredriksen
Iole de Freitas →

Installation view with Gabriel Orozco, *La DS*, 1993 (left) and Arthur Omar, *Antropologia da face
gloriosa—A grande muralha (Anthropology of the Glorious Face—The Great Wall)*, 1973–98 (right)

Founded in 1951, the São Paulo Biennial is the second-oldest biennial in the world (the Venice Biennale is the oldest, having started in 1895) and it is one of the most important art events in the southern hemisphere. São Paulo was not always a global cultural capital, but after World War II, and particularly since the 1960s, it has been gaining much more attention from the international art world, thanks in large part to its biennial. This particular edition carved a space for Brazil on the global cultural map not only by taking on a provocative theme, but also by demonstrating how Brazilian culture had already been in dialogue with, and drawn inspiration from, international art movements over the last four centuries. The 24th São Paulo Biennial is today cited as being among the most important biennials of the 20th century.

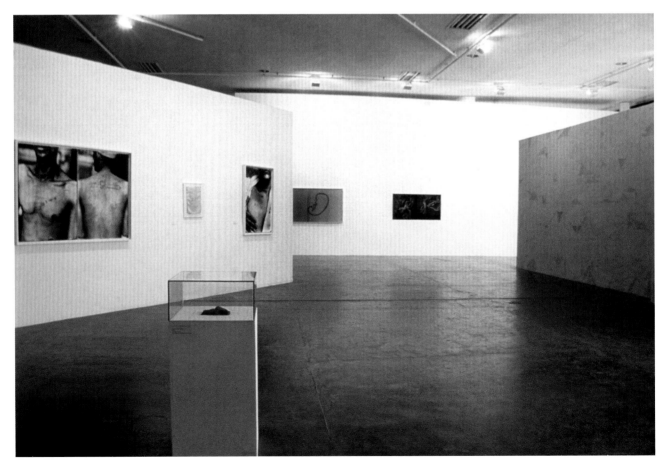

Installation view with Artur Barrio, *Livro de carne / Book of Meat*, 1978 (center left)

Carlos Garaico
Anna Bella Geiger
General Idea (AA Bronson /
 Felix Part / Jorge Zontal)
Yehoshua Glotman
Vincent van Gogh
Zvi Goldstein
Rubem Grilo
Victor Grippo
Carmela Gross
Abigail Hadeed
Elias Heim
Choi Jeong Hwa
Ing K
Francis Jupurrurla Kelly
William Kentridge
Ahmed Makki Kante
Seydou Keita
Abdoulaye Konaté
Joseph Kpobly
Elke Krystufek
Mischa Kuball
Oleg Kulik
Toshihiro Kuno
Moshekwa Langa
Wesley Duke Lee
Leonilson
Sherrie Levine
Laura Lima
Martin Lopez
Geoff Lowe
Ken Lum
Leena Luostarinen
Ivens Machado
José Joaquín Magón
Brian Maguire
Anna Maria Maiolino
Mark Manders
Iñigo Manglano-Ovalle
Esko Männikkö
Antonio Manuel
Jenny Marketou
Zivko Marusic
Henri Matisse
Cildo Meireles
Bjarne Melgaard
Beatriz Milhazes
Jean-François Millet
Maurizio Mochetti
Tracey Moffatt
Priscilla Monge
Thomas Mulcaire
Vik Muniz
Johan Muyle
Emmanuel Nassar

Ernesto Neto
Rivane Neuenschwander
Maurice O'Connell
Tomie Ohtake
Hélio Oiticica
Arthur Omar
Gabriel Orozco
Nazareth Pacheco
Nam June Paik
Lygia Pape
Luis Paredes
Luo Brothers (Luo Wei Bing /
 Luo Wei Dong / Luo Wei Guo)
Judy Pfaff
Jackson Pollock
Danilo di Prete
Raul Quintanilla
Khalil Rabah
Markus Raetz
Nuno Ramos
Rosângela Rennó
José Resende
Miguel Rio Branco
Glauber Rocha
Doris Salcedo
Bulent Sangar
Mira Schendel
Katie van Scherpenberg
Daniel Senise
Ann-Sofie Sidén
Maleck Sidibe
Walter Silveira
Regina Silvera
Jan Sluijters
Courtney Smith
Valeska Soares
Antoni Socías
Soo-Ja Kim
Pierrick Sorin
Edgard de Souza
Manit Sriwanichpoom
José Antonio Suarez
Cecilio Thompson
Milica Tomic
Francisco Tropa /
 Lourdes Castro
Tunga
Delson Uchoa
Meyer Vaisman
Adriana Varejão
Diego Veintimilla
Jeff Wall
Franz West
Xu Jiang
Moico Yaker

**Núcleo Histórico /
Historical Nucleus**

Artists
Josef Albers
Aleijadinho (Antonio
 Francisco Lisboa)
Tarsila do Amaral
Pedro Américo
Hans Arp
Francis Bacon
Ignácio Maria Barreda
Hércules Barsotti
Hans Bellmer
Valère Bernard
Max Bill
William Blake
Raul Bopp
Louise Bourgeois
Victor Brecheret
Theodore de Bry
Jean-Baptiste Carpeaux
Flávio de Carvalho
Emiliano di Cavalcanti
Blaise Cendrars
Francisco das Chagas (o Cabra)
Paul Chenavard
Lygia Clark
CoBrA
Manuel Inácio da Costa
Salvador Dalí
Eugéne Delacroix
Paul Delaroche
Louis-Jean Desprez
Antonio Dias
Theo van Doesburg
Albert Eckhout
Max Ernst
Lucio Fontana
Heinrich Füssli
Théodore Géricault
Alberto Giacometti
Vincent van Gogh
Oswaldo Goeldi
Francisco de Goya
Alberto da Veiga Guignard
Mona Hatoum
Eva Hesse
José Teófilo de Jesus
Ferdinand van Kessel
Jan van Kessel
Yves Klein
Guillermo Kuitca
Yayoi Kusama
Jean de Léry

Glenn Ligon
Richard Lohse
René Magritte
Kazimir Malevich
Anita Malfatti
Piero Manzoni
Maria Martins
André Masson
Roberto Matta
Cildo Meireles
Ernest Meissonier
Piet Mondrian
Michel de Montaigne
Vicente do Rego Monteiro
Gustave Moreau
Edvard Munch
Bruce Nauman
Ismael Néri
Hans Nöbauer
Hélio Oiticica
Dennis Oppenheim
Alejandro Otero
Tony Oursler
Wolfgang Paalen
Francis Picabia
Sigmar Polke
Frans Post
Auguste Raffet
Robert Rauschenberg
Armando Reverón
Gerhard Richter
Auguste Rodin
Nigel Rolfe
Félicien Rops
Robert Ryman
Mira Schendel
Lasar Segall
David Alfaro Siqueiros
Robert Smithson
Jesús Rafael Soto
Hans Staden
Thomas Struth
Pierre Subleyras
André Thévet
Joaquin Torres-García
George Vantongerloo
Alfredo Volpi
Friedrich Vordemberge-
 Gildewart

documenta 11

June 8 – September 15, 2002
Various sites in Kassel, Germany

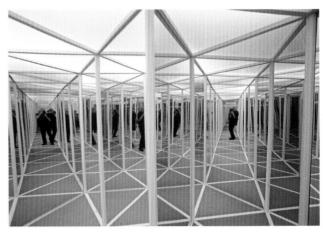

Ken Lum, *Mirror Maze With 12 Signs of Depression*, 2002

Documenta, staged every five years, has long been regarded as one of Europe's foremost stages for the "next big thing" in contemporary art. It is heavily steeped in European culture, since its original mandate was to reinvigorate culture in postwar Germany; it is always takes place in Kassel, Germany, the city of its founding. For the 100 days it was on view in 2002, Documenta 11, curated by Okwui Enwezor, was a truly global show—a traveling international symposium and exhibition on art, politics, and culture.

John Bock in collaboration with Jochen Dehn, Knut Klasen, and Marc Aschenbrenner, *Gribbohm II b*, 2002

Compared to its predecessors, the exhibition was radically geographically expanded, with most of the 120-plus artists hailing from areas outside Western metropolises. Enwezor worked with a team of six co-curators (Carlos Basualdo, Ute Meta Bauer, Susanne Ghez, Sarat Maharaj, Mark Nash, and Octavio Zaya) and the exhibition was divided into five sections, or "platforms." The main platform was based in Kassel and housed most of the object-based artworks. Documentary and documentary-style films, some feature-length, played a major role. The other four platforms were spread across Berlin, St. Lucia, Vienna, New Delhi, and Lagos. They all had topical titles—"Democracy Unrealized," "Experiments with Truth: Transitional Justice and the Processes of Truth and Reconciliation," "Créolité and Creolization," and "Under Siege: Four African Cities—Freetown, Johannesburg, Kinshasa, Lagos"—and consisted of multiple panel discussions, lectures, and other educational events. Enwezor claimed that he was uninterested in showcasing "optical manifestations" and instead wanted to create "a public sphere where ideas that do not lend themselves easily to optical representation can be articulated."

Most of the criticisms voiced the suspicion that the intellectual dialogue took precedence over the art. Enwezor, for his part, shrugged off such claims as predicated on outmoded ideas of artworks as merely objects for display.

Exhibition Title
documenta 11

Organizer
Documenta and Museum
Fridericianum, Kassel

Curator
Okwui Enwezor

Co-curators
Carlos Basualdo
Ute Meta Bauer
Susanne Ghez
Sarat Maharaj
Mark Nash
Octavio Zaya

Dates
June 8 – September 15, 2002

Location
Various sites in Kassel,
Germany, including:
Museum Fridericianum
documenta-Halle
KulturBahnhof
BALi-Kino
Binding-Brauerei
Orangerie
Auerpark
Innenstadt/Nordstadt

Additional "Platforms"
Platform1: Democracy
 Unrealized, Vienna, Austria,
 March 15 – April 20, 2001, and
 Berlin, Germany, October
 9–30, 2001
Platform2: Experiments with
 Truth: Transitional Justice and
 the Processes of Truth and
 Reconciliation, New Delhi,
 India, May 7–21, 2001
Platform3: Créolité and
 Creolization, St. Lucia,
 January 12–16, 2002
Platform4: Under Siege: Four
 African Cities—Freetown,
 Johannesburg, Kinshasa,
 Lagos, Lagos, Nigeria, March
 15–21, 2002

Publications
Okwui Enwezor, ed.,
 Documenta11_Platform5:
 Catalogue, Hatje Cantz,
 Stuttgart, 2002
Okwui Enwezor, ed.,
 Documenta11_Platform5:
 Ausstellung/Exhibition—
 Kurzführer/Short Guide,
 Hatje Cantz, Stuttgart, 2002
Okwui Enwezor, ed., *Democracy*
 Unrealized: Documenta11_
 Platform1, Hatje Cantz,
 Stuttgart, 2002
Okwui Enwezor, ed.,
 Experiments with Truth:
 Transitional Justice and
 the Processes of Truth and
 Reconciliation: Documenta11_
 Platform2, Hatje Cantz,
 Stuttgart, 2002
Okwui Enwezor, ed.,
 Créolité and Creolization:
 Documenta11_Platform3,
 Hatje Cantz, Stuttgart,
 2002
Okwui Enwezor, ed.,
 Under Siege: Four African
 Cities—Freetown,
 Johannesburg, Kinshasa,
 Lagos: Documenta11_
 Platform4, Hatje Cantz,
 Stuttgart, 2002

Artists
Georges Adéagbo
Ravi Agarwal
Eija-Liisa Ahtila
Chantal Akerman
Gaston A. Ancelovici
Fareed Armaly /
 Rashid Mashawari
Michael Ashkin
Asymptote Architecture
Kutlug Ataman
The Atlas Group (Walid Raad)
Julie Bargmann /
 Stacy Levy
Artur Barrio
Bernd & Hilla Becher
Zarina Bhimji
Black Audio Film Collective

John Bock with Jochen Dehn /
 Knut Klasen / Marc
 Aschenbrenner
Ecke Bonk
Frédéric Bruly Bouabré
Louise Bourgeois
Pavel Brăila
Stanley Brouwn
Tania Fernandéz Bruguera
Luis Camnitzer
James Coleman
Constant
Hanne Darboven
Destiny Deacon
Stan Douglas
Cecilia Edefalk
William Eggleston
Maria Eichhorn
Touhami Ennadre
Feng Mengbo
Chohreh Feyzdjou
Yona Friedman
Meschac Gaba
Giuseppe Gabellone
Carlos Garaicoa
Kendell Geers
Isa Genzken
Jef Geys
David Goldblatt
Leon Golub
Dominique Gonzalez-Foerster
Renée Green
Victor Grippo
Le Groupe Amos
Jens Haaning
Mona Hatoum
Thomas Hirschhorn
Candida Höfer
Craigie Horsfield
Huit Facettes
Pierre Huyghe
Igloolik Isuma Productions
Sanja Iveković
Alfredo Jaar
Joan Jonas
Isaac Julien
Amar Kanwar
On Kawara
William Kentridge
Johan van der Keuken
Bodys Isek Kingelez
Ben Kinmont

Svetlana & Igor Kopystiansky
Ivan Kožarić
Andreja Kulunčić
Glenn Ligon
Ken Lum
Steve McQueen
Mark Manders
Fabian Marcaccio
Cildo Meireles
Jonas Mekas
Annette Messager
Ryuji Miyamoto
Santu Mofokeng
Multiplicity
Juan Muñoz
Shirin Neshat
Gabriel Orozco
Olumuyiwa Olamide Osifuye
Ulrike Ottinger
Ouattara Watts
Park Fiction
Manfred Pernice
Raymond Pettibon
Adrian Piper
Lisl Ponger
Pere Portabella
Raqs Media Collective
Alejandra Riera /
 Doina Petrescu
Dieter Roth
Doris Salcedo
Seifollah Samadian
Gilles Saussier
Allan Sekula
Yinka Shonibare
Andreas Siekmann
Simparch
Lorna Simpson
Eyal Sivan
David Small
Fiona Tan
Pascale Marthine Tayou
Jean-Marie Teno
Trinh T. Minh-Ha
tsunamii.net
Joëlle Tuerlinckx
Luc Tuymans
Nomeda & Gediminas Urbonas
Jeff Wall
Nari Ward
Cerith Wyn Evans
Yang Fudong

7th Lyon Biennial: C'est arrivé demain (It Happened Tomorrow)

September 18, 2003 – January 4, 2004
Institut d'Art Contemporain, Villeurbanne,
Musée d'Art Contemporain de Lyon,
Musée des Beaux-Arts de Lyon,
Le Rectangle, and La Sucrière, Lyon, France

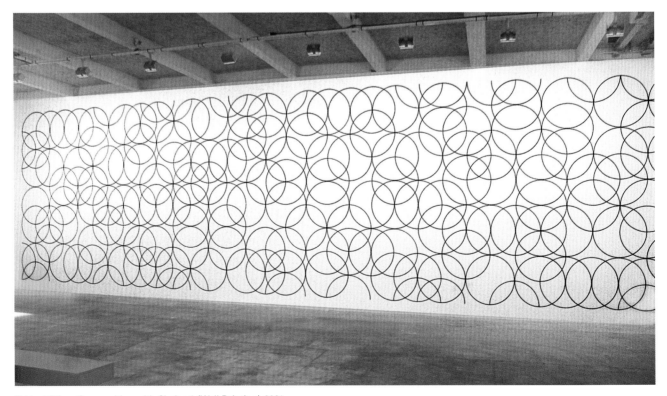

Bridget Riley, *Composition with Circles 2 (Wall Painting)*, 2001

Exhibition Title
7th Lyon Biennial: C'est arrivé demain (It Happened Tomorrow)

Organizer
Les Biennales de Lyon

Artistic Director
Thierry Raspail

Curators
Le Consortium – Xavier Douroux, Franck Gautherot and Éric Troncy
Anne Pontégnie and Robert Nickas

Dates
September 18, 2003 –
January 4, 2004

Locations
Institut d'Art Contemporain, Villeurbanne
Musée d'Art Contemporain de Lyon
Musée des Beaux-Arts de Lyon
Le Rectangle
La Sucrière

Publication
Biennale d'art contemporain de Lyon 2003: "C'est arrivé demain," Les presses du réel, Dijon, 2003

Artists
Vito Acconci
John Armleder
David Askevold
Christian Boltanski with
 Jean Kalman /
 Franck Krawczyk /
 Ryoko Sekiguchi
Martin Boyce
Eamon Brown
Maurizio Cattelan
Jeong Hwa Choi
Larry Clark
Dan Coombs
Yayoi Deki
Trisha Donnelly
Jim Drain
Katharina Fritsch
Giuseppe Gabellone
Piero Gilardi
Bruno Gironcoli
Daan van Golden
Dominique Gonzalez-Foerster
Rodney Graham
Robert Grosvenor
Trenton Doyle Hancock
Mark Handforth
Tim Head
Carsten Höller
Pierre Huyghe
Jay-Jay Johanson
Mike Kelley
Frederick Kiesler
Yayoi Kusama
Bertrand Lavier
Len Lye
Claude Lévêque
Paul McCarthy
Didier Marcel
Eva Marisaldi
Gustav Metzger
Olivier Mosset
Dave Muller
Albert Oehlen
Jorge Pardo
Philippe Parreno
Steven Parrino
Ara Peterson
Florian Pumhösl
Bridget Riley
Ugo Rondinone
Sara Rossi
Ed Ruscha
Hiraki Sawa
Lily van der Stokker
Catherine Sullivan
Betty Tompkins
Xavier Veilhan
Dan Walsh
Gary Webb
Franz West
Christopher Wool

C'est arrivé demain (It Happened Tomorrow) was the title of the 2003 Lyon Biennial, held in five different locations in Lyon, France. It was directed by Thierry Raspail, who invited several curators to collaborate in the endeavor: Le Consortium founders Xavier Douroux, Franck Gautherot, and Eric Troncy, along with Robert Nickas and Anne Pontégnie. More than 60 artists working from the 1920s to the present were included. The five venues were art museums and galleries spread across the city: La Sucrière (the main venue, an old sugar factory), the Musée d'Art Contemporain, Institut d'Art Contemporain, Le Rectangle, and the Musée des Beaux-Arts de Lyon.

The title was inspired by the 1944 film of the same name by René Clair about a journalist who begins to receive the following day's newspaper—giving him the advantage of knowing the future before his peers—and one day sees his own picture in the obituary section. The poster for the exhibition, designed by M/M Paris, who had a unique impact on the graphic design of exhibitions in France during the 1990s, used the typeface from the 1985 Hollywood movie *Back to the Future*, about a teenager who travels from the 1980s to the 1950s. Like both films, C'est arrivé demain sought to investigate the (mostly recent) past to try to alter the direction of the future. A statement in the catalogue asked, "If the future is programmed, can we stop it from happening?"

C'est arrivé demain did not focus solely on recent works by the featured artists, but displayed a particular timespan for each artist. Further, Raspail considered all the works on display open-ended and not final in their intention and execution. He wanted to distinguish the Lyon Biennial from current trends in major biennials by treating it as an exposition rather than an exhibition, meaning that the artwork would take precedence over the exhibition (or curator). Also distinguishing this from other biennials was the fact that the curators decided to resist curating a global overview with monumental artworks from all corners of the world. Instead, they treated the project like any other large group exhibition, focusing their selections on Western European and American artists and relatively traditional media. Many critics praised the show's scale and modesty, and appreciated the clever title; there were few negative reviews.

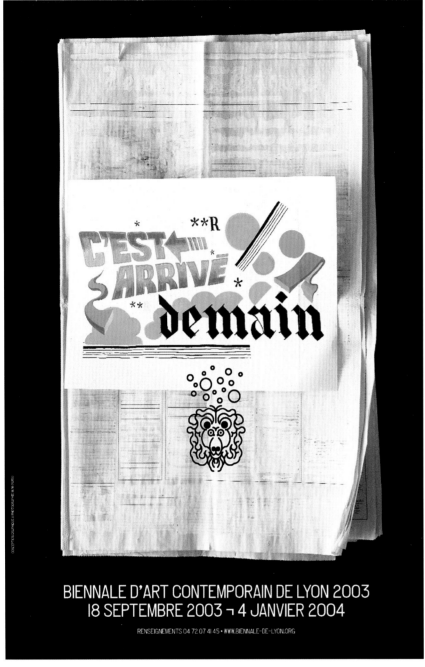

Exhibition poster

Mike Kelley and Paul McCarthy, *Sod and Sodie Sock Comp. O.S.O.*, installation detail, 1998

4th Berlin Biennial for Contemporary Art: Of Mice and Men

March 25 – June 5, 2006
KW Institute for Contemporary Art and various sites along Augustrasse, Berlin, Germany

The 4th Berlin Biennial was a 10-week show in 2006 consisting of a series of art exhibits, events, and publications. Entitled Of Mice and Men, it was curated by the trio Maurizio Cattelan, Massimiliano Gioni, and Ali Subotnick (founders of the Wrong Gallery) and organized by KW Institute for Contemporary Art. It involved over 80 international artists and artist groups working in a variety of media and art forms, and was presented in 12 different venues that stretched down a single street, the Auguststrasse in Berlin's Mitte district. As opposed to a traditional "white cube" gallery space, these sites represented real daily life and ranged from private apartments to offices, a church, a cemetery, and (most notably) an abandoned Jewish school for girls. The exhibition statement declared that the show sought to "bring together artworks that deal with a looming sense of loss, a threatening atmosphere of personal insecurity, and collective anxiety."

Paul McCarthy, *Bang-Bang Room*, installation, 1992

[Of Mice and Men] is an exhibition about life, but as observed through its simplest elements: You are born, you live, and then you die. Except that life never proceeds so linearly: it jumps and skips; it takes wrong turns; it is illuminated by sudden flashes. Echoing this pace, the exhibition proceeds in a nonlinear fashion, with digressions, spreading out into the buildings along the street as if following the threads of memory or the seductions of chance. Of Mice and Men is an exhibition that opens up elective affinities and unexpected associations, recurring moods and tensions.

Maurizio Cattelan, Massimiliano Gioni, and Ali Subotnick, "Of Mice and Men," in Maurizio Cattelan, Massimiliano Gioni, and Ali Subotnick, eds., *Von Mäusen und Menschen / Of Mice and Men: 4. Berlin Biennale für Zeitgenössische Kunst / 4th Berlin Biennial for Contemporary Art*, Hatje Cantz, Ostfildern-Ruit, and KW Institute for Contemporary Art, Berlin, 2006.

There were three publications: the exhibition guide, which mapped out and explained the venues and artists; a book that included double-page spreads of works by the participating artists collaged together with historical images and objects, and *Checkpoint Charley*, a publication that compiled images of works by more than 700 artists, representing the curators' research. A series of activities were held in the 18 months leading up to the exhibition, and the curators organized a "guerilla franchise" called "Gagosian Gallery, Berlin"—a play on the name of the commercial Gagosian gallery network—that staged a new exhibition every four weeks. In addition, *Zitty* magazine published interviews between the show's curators and artists working in Berlin.

What made Of Mice and Men stand out was the enormous attention to detail in the installation, the show's unpretentious yet powerful presentation, and the excellent selection of works. The curators dispensed, for better or worse, with the idea that a biennial must include a representative artist from every corner of the planet. The focus was less on political correctness than on creating something cohesive and elegant, yet disturbing.

Private view invitation card, with an image from Aneta Grzeszykowska, *Album*, 2005

Kris Martin, *Mandi III*, installation, 2003

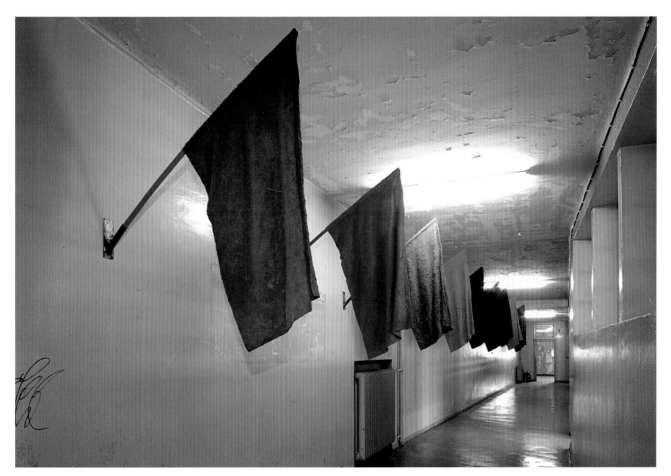

Pravdoliub Ivanov, *Territories*, installation, 1995/2003

Exhibition Title
4th Berlin Biennial
for Contemporary Art:
Of Mice and Men

Organizer
KW Institute for Contemporary
Art, Berlin

Curators
Maurizio Cattelan
Massimiliano Gioni
Ali Subotnick

Dates
March 25 – June 5, 2006

Location
KW Institute for Contemporary
Art and various sites along
Augustrasse, Berlin, Germany

Publications
Maurizio Cattelan, Massimiliano
Gioni, and Ali Subotnick, eds.,
*Von Mäusen und Menschen /
Of Mice and Men: 4. Berlin
Biennale für Zeitgenössische
Kunst / 4th Berlin Biennial for
Contemporary Art*, Hatje
Cantz, Ostfildern-Ruit, and KW
Institute for Contemporary
Art, Berlin, 2006

Maurizio Cattelan, Massimiliano
Gioni, and Ali Subotnick,
eds., *Checkpoint Charley*,
4th Berlin Biennial for
Contemporary Art and KW
Institute for Contemporary
Art, Berlin, 2006

Artists
Tomma Abts
Viktor Alimpiev
Paweł Althamer
Kai Althoff /
 Lutz Braun
Ulf Aminde
Micol Assaël

Roger Ballen
Thomas Bayrle
Michael Beutler
Michaël Borremans
Bouchet
Berlinde de Bruyckere
Tobias Buche
Anthony Burdin
Mircea Cantor
Bruce Conner
Benjamin Cottam
Martin Creed
Oliver Croy /
 Oliver Elser
Roberto Cuoghi
Tacita Dean

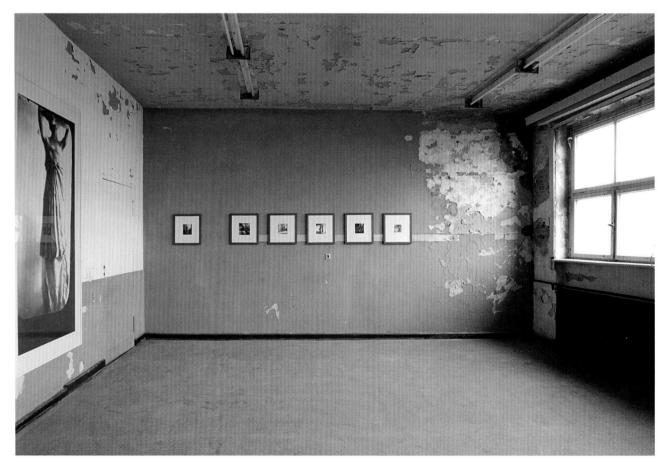

Installation view with prints by Francesca Woodman, 1972–80

Jeremy Deller
Nathalie Djurberg
Gino de Dominicis
Trisha Donnelly
Marcel van Eeden
Saul Fletcher
Roland Flexner
Felix Gmelin
Aneta Grzeszykowska
Sebastian Hammwöhner /
 Dani Jakob /
 Gabriel Vormstein
Rachel Harrison
Pravdoliub Ivanov
Sergej Jensen
Dorota Jurczak

Tadeusz Kantor
Ian Kiaer
Christopher Knowles
Robert Kuśmirowski
Klara Liden
Erik van Lieshout
Paul McCarthy
Corey McCorkle
Ján Mančuška
Mike Mandel /
 Larry Sultan
Mark Manders
Kris Martin
Michaela Meise
Matthew Monahan
Otto Mühl

Bruce Nauman
Cady Noland
Damián Ortega
Diego Perrone
Susan Philipsz
Jorge Queiroz
Reynold Reynolds /
 Patrick Jolley
Ricarda Roggan
Aïda Ruilova
Anri Sala
Markus Schinwald
Michael Schmidt
Thomas Schütte
Norbert Schwontkowski
Tino Sehgal

Shirana Shahbazi
Steven Shearer
Florian Slotawa
Christiana Soulou
Jaan Toomik
Paloma Varga Weisz
Gillian Wearing
Clemens von Wedemeyer /
 Maya Schweizer
Andro Wekua
Cathy Wilkes
Francesca Woodman
Thomas Zipp

Front and back of the invitation to the opening party

9th International Istanbul Biennial: Istanbul

September 16 – October 30, 2005
Various sites in Istanbul, Turkey

The 9th International Istanbul Biennial, presented in 2005, had a simple and self-referential title: "Istanbul". The curatorial statement declared that the title "refers both to the real urban location and to the imaginative charge that this city represents for the world. Istanbul as a metaphor, as a prediction, as a lived reality, and an inspiration, has many stories to tell, and the biennial will attempt to tap directly into this rich history and possibility." It was curated by Charles Esche and Vasif Kortun, with assistants Esra Sarigedik and November Paynter, and it included more than artists and artist groups. Half of them lived and worked in Istanbul for six months prior to the show, while the remaining half made their works elsewhere around the world. The intention of this was to heighten the sense of Istanbul both as a site and as an imaginative space.

The curators used several venues throughout the city: Deniz Palas Apartments, the Garanti Building, Antrepo no. 5, a tobacco warehouse, the Bilsar Building, Platform Garanti Contemporary Art Center, and the Garibaldi Building—all sites that they believed represented "common references to everyday life." The locations were centered in Beyoğlu, the city's nightclub district, and were within walking distance of one another. Indeed,

the pedestrian's journey between the spaces was intended to be part of the overall art-viewing experience.

Much of the art was site-specific, relying heavily on Istanbul's characteristics as the context, thus reflecting the biennial's name and theme. Beyond the art exhibitions, a major component was the "Positionings Programme" that consisted of artist lectures as well as the offices of a local magazine, which opened itself up as a discussion site and put on display an archive of contemporary art books.

Some critics remained skeptical about the intentions of the biennial's theme, claiming that any biennial is already mostly a promotion of its city for tourists. Responding to this charge in an interview, Esche said, "If you go with any kind of plan focused just on how to get tourists to come here, then you wouldn't do an art exhibition You'd build a beach [But] I wouldn't deny that that's a byproduct."

Lukas Duwenhögger, *Sunday Afternoon*, 2002

Michael Blum, *A Tribute to Safiye Behar*, installation, 2005

Exhibition Title
9th International Istanbul
Biennial: Istanbul

Organizer
iksv—Istanbul Kültür Sanat
Vakfı (Istanbul Foundation
for Culture and Arts)

Curators
Charles Esche
Vasıf Kortun

Dates
September 16 –
October 30, 2005

Location
Various sites in Istanbul, Turkey,
including:
Antrepo no. 5
Bilsar Building
Deniz Palas Apartments
Garanti Building
Garibaldi Building

Platform Garanti Contemporary
Art Center
Tobacco Warehouse

Publications
Charles Esche and Vasıf Kortun,
eds., *Biennial Guide*, iksv—
Istanbul Kültür Sanat Vakfı,
Istanbul, 2005
Charles Esche and Vasıf Kortun,
eds., *Art, City and Politics in
an Expanded World: Writings
from the 9th International
Istanbul Biennial*, iksv—
Istanbul Kültür Sanat Vakfı,
Istanbul, 2005

Artists
Hüseyin Alptekin
Paweł Althamer
Halil Altındere
Yochai Avrahami
Yael Bartana
Otto Berchem
Johanna Billing

Michael Blum
Daniel Bozhkov
Pavel Büchler
Phil Collins
Smadar Dreyfus
Lukas Duwenhögger
Maria Eichhorn
Gardar Eide Einarsson
Hala Elkoussy
Jon Mikel Euba
Jakup Ferri
Flying City
Luca Frei
Erik Göngrich
gruppo A12
Hatice Güleryüz
Daniel Guzman
IRWIN
Chris Johanson
Y.Z. Kami
Karl-Heinz Klopf
Servet Koçyiğit
Yaron Leshem
David Maljkovic
Oda Projesi

Ahmet Öğüt
Paulina Ołowska
Silke Otto-Knapp
Serkan Özkaya
Şener Özmen
Ola Pehrson
Dan Perjovschi
Khalil Rabah
Mario Rizzi
RUANGRUPA
Solmaz Shahbazi
Wael Shawky
Ahlam Shibli
Sean Snyder
Nedko Solakov
SUPERFLEX /
 Jens Haaning
Pilvi Takala
Alexander Ugay
Alexander Ugay /
 Roman Maskalev
Axel John Wieder /
 Jesko Fezer
Tintin Wulia
Cerith Wyn Evans

Paulina Ołowska, *Le Shoe*, 2005 (floor) and Lukas Duwenhögger, *Sunday Afternoon*, 2002 (center above)

Servet Koçyiğit, *Blue Side Up*, installation, 2005

dOCUMENTA (13)

June 9 – September 16, 2012
Various sites in Kassel, Germany, Banff, Canada,
Kabul and Bamiyan, Afghanistan, and
Alexandria and Cairo, Egypt

From its center at the Museum Fridericianum in the heart of Kassel, Germany, dOCUMENTA (13) radiated out into the city and its environs. There were also outposts in Kabul and Bamiyan, Afghanistan, and satellite events in Cairo and Alexandria in Egypt, and in Banff, Canada. Paintings, sculptures, photographs, installations, films, performances, lectures and seminars—the work of over 220 artists from more than 50 countries—were the many arms of what Christov-Bakargiev envisioned as a living and breathing organism. Her holistic, sprawling exhibition examined the principal themes of being "on stage," "under siege," "in a state of hope," and "on retreat." dOCUMENTA (13) was also a celebration of creativity, discovery, and the persistence of human expression, with emphasis on the artistic gesture and its cultural relevance. Art and the world shared the same stage, thoughtfully choreographed to provide both a provocative challenge and the rare gift of wonder.

Brian Jungen, *Dog Run*, installation, 2012

Since its inception in 1955 as a forum for exhibiting "degenerate" artwork that had been banned by the Nazis, Documenta has gained a reputation as a sprawling, concept-driven exhibition free from the demands of the art market. The most recent iteration, dOCUMENTA (13), opened in summer 2012. Its director, Carolyn Christov-Bakargiev, took on an ambitious and unprecedented scale of production, multiplicity of disciplines, and convergence of concepts.

dOCUMENTA (13) in Kassel is intentionally uncomfortable, incomplete, nervously lacking— at every step, one needs to know that there is something fundamental that is not known, that is invisible and missing— a memory, an unresolved question, a doubt.

Carolyn Christov-Bakargiev, in Carolyn Christov-Bakargiev, Chus Martínez, and Franco Berardi, *Documenta 13: The Book of Books*, dOCUMENTA (13) and Hatje Cantz, Ostfildern-Ruit, 2012.

On the ground floor of the Fridericianum, a persistent artificial breeze moved visitors through the historic building thanks to Ryan Gander's intervention *I Need Some Meaning I Can Memorize (The Invisible Pull)* (2012). Lining one of the galleries were postcard-sized paintings of 900 apples and pears by the Bavarian pastor and pomologist (fruit scientist) Korbinian Aigner (1885–1966), who while

Exhibition Title
dOCUMENTA (13)

Artistic Director
Carolyn Christov-Bakargiev

**Head of Department
and Core Agent**
Chus Martínez

Agents
Leeza Ahmady
Bassam El Baroni
Jill Bennett
Iwona Blazwick
Geoff Cox
Nikola Doll
Alanna Heiss
Sofía Hernández Chong Cuy
Sunjung Kim
Adam Kleinman
Koyo Kouoh
Joasia Krysa
Marta Kuzma
Raimundas Malasauskas
Hans Ulrich Obrist
Lívia Páldi
Hetti Perkins
Sarah Rifky

Pascal Rousseau
Eva Scharrer
Jakob Schillinger
Kitty Scott
Chiara Vecchiarelli
Andrea Viliani

Dates
June 9 – September 16, 2012

Location
Various sites in Kassel,
Germany, Banff, Canada, Kabul
and Bamiyan, Afghanistan, and
Alexandria and Cairo, Egypt

Publications
*100 Notes— 100 Thoughts:
Documenta Series*,
dOCUMENTA (13) and Hatje
Cantz, Ostfildern-Ruit, 100
publications in 2011–12
Carolyn Christov-Bakargiev,
Chus Martínez, and Franco
Berardi, *Documenta 13: The
Book of Books*, dOCUMENTA
(13) and Hatje Cantz,
Ostfildern-Ruit, 2012
Carolyn Christov-Bakargiev,

Documenta 13: The Logbook,
dOCUMENTA (13) and Hatje
Cantz, Ostfildern-Ruit, 2012
Carolyn Christov-Bakargiev,
Guillermo Faivovich, and
Nicolás Goldberg, *Documenta
13: The Guidebook*,
dOCUMENTA (13) and Hatje
Cantz, Ostfildern-Ruit, 2012

Artists
Lida Abdul
Bani Abidi
Etel Adnan
Korbinian Aigner
Vyacheslav Akhunov
Barmak Akram
Khadim Ali
Allora & Calzadilla
Maria Thereza Alves
Francis Alÿs
Ayreen Anastas
AND AND AND
Ida Applebroog
Mohammad Yusuf Asefi
Doug Ashford
Tarek Atoui
Kader Attia
Julie Ault

Alexandra Bachzetsis
Nanni Balestrini
Amy Balkin
Judith Barry
Massimo Bartolini
Gianfranco Baruchello
Ahmed Basiony
Thomas Bayrle
Jérôme Bel
Gordon Bennett
Rossella Biscotti
Manon de Boer
Alighiero e Boetti
Anna Boghiguian
Carol Bove
Kristina Buch
Andrea Büttner
Gerard Byrne
CAMP (Shaina Anand /
 Sanjay Bhangar /
 Ashok Sukumaran)
Janet Cardiff &
 George Bures Miller
Emily Carr
Mariana Castillo Deball
Paul Chan
Kudzanai Chiurai
Constant
Daniel Gustav Cramer →

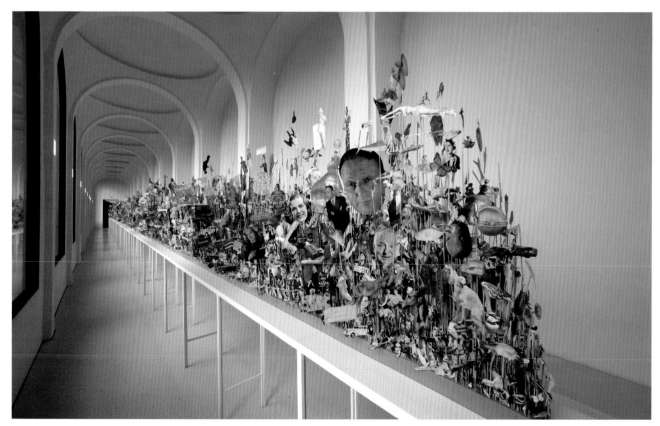

Geoffrey Farmer, *Leaves of Grass*, installation, 2012

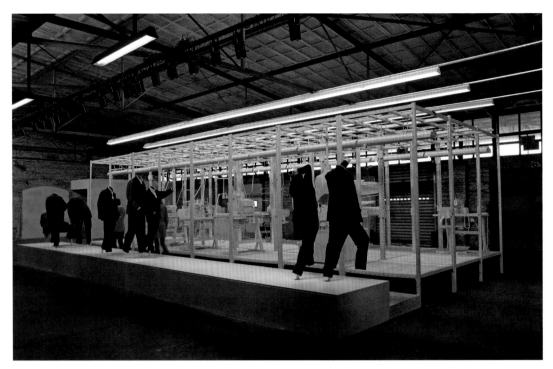

István Csákány, *Ghost Keeping*, installation, 2012

Installation view

Critical Art Ensemble
Abraham Cruzvillegas
István Csákány
Attila Csörgő
Antoni Cumella
Salvador Dalí
Tacita Dean
Mark Dion
Thea Djordjadze
Willie Doherty
Trisha Donnelly
Sam Durant
Jimmie Durham
e-flux (Julieta Aranda /
 Anton Vidokle)
Haris Epaminonda
Cevdet Erek
Guillermo Faivovich &
 Nicolás Goldberg
Matias Faldbakken
Geoffrey Farmer
Omer Fast
Lara Favaretto
Ceal Floyer
Llyn Foulkes
Abul Qasem Foushanji
Chiara Fumai
Rene Gabri
Ryan Gander
Dora García
Mario Garcia Torres
Fernando García-Dory
Theaster Gates
Jeanno Gaussi
Mariam Ghani
Simryn Gill
Julio González
Tue Greenfort
Zainab Haidary
Fiona Hall
Florian Hecker
Tamara Henderson
Susan Hiller

Horst Hoheisel
Judith Hopf
Khaled Hourani /
 Amjad Ghannam /
 Rashid Masharawi
Pierre Huyghe
Sanja Ivekovic
Emily Jacir
Toril Johannessen
Joan Jonas
Brian Jungen
Brian Jungen /
 Duane Linklater
Rudolf Kaesbac
Robin Kahn /
 The National Union of
 Women from Western Sahara
Masood Kamandy
Amar Kanwar
William Kentridge
Hassan Khan
Erkki Kurenniemi
Adriana Lara
Dinh Q Lê with
 Vu Giang Huong / Quang Tho /
 Huynh Phuong Dong /
 Nguyen Thu /
 Truong Hieu / Phan Oanh /
 Nguyen Toan Thi /
 Duong Anh / Minh Phuong /
 Kim Tien / Quach Phong /
 Nguyen Thanh Chau
Jolyon Leslie
Gabriel Lester
David Link
Maria Loboda
Mark Lombardi
Aníbal López
Renata Lucas
Marcos Lutyens /
 Raimundas Malašauskas /
 Sissel Tolaas
Goshka Maçuga

Anna Maria Maiolino
Nalini Malani
Raimundas Malasauskas
Man Ray
Maria Martins
Francesco Matarrese
Fabio Mauri
Julie Mehretu
John Menick
Gustav Metzger
Lee Miller
Aman Mojadidi
MOON Kyungwon &
 JEON Joonho
Gareth Moore
Giorgio Morandi
Rabih Mroué
Zanele Muholi
Christian Philipp Müller
M.A. Numminen
Shinro Ohtake
Rahraw Omarzad
Roman Ondák
Füsun Onur
The Otolith Group
Christodoulos Panayiotou
Giuseppe Penone
Claire Pentecost
Susan Philipsz
Pratchaya Phinthong
Sopheap Pich
Lea Porsager
Michael Portnoy
Margaret Preston
Seth Price
Ana Prvacki
Walid Raad
Michael Rakowitz
Araya Rasdjarmrearnsook
Doreen Reid Nakamarra
Pedro Reyes
Gunnar Richter
Stuart Ringholt

Ruth Robbins &
 Red Vaughan Tremmel
Juana Marta Rodas &
 Julia Isidrez
Paul Ryan
Hannah Ryggen
Aase Texmon Rygh
Natascha Sadr Haghighian
Anri Sala
Charlotte Salomon
Issa Samb
Ines Schaber
Tino Sehgal
Albert Serra
Tejal Shah
Wael Shawky
Zolaykha Sherzad
Nedko Solakov
Song Dong
Alexandra Sukhareva
Mika Taanila
Mohsen Taasha
Javier Téllez
Warwick Thornton
Warlimpirrnga Tjapaltjarri
Jalal Toufic
Rosemarie Trockel
Rattana Vandy
Nath Vann
Adrián Villar Rojas
Jeronimo Voss
Vu Giang Huong
Ian Wallace
Jessica Warboys
Clemens von Wedemeyer
Apichatpong Weerasethakul /
 Chaisiri Jiwarangsan
Lawrence Weiner
Yan Lei
Yang Haegue
Akram Zaatari
Zalmaï
Konrad Zuse

imprisoned for his anti-Nazi sermons developed several new species of apples. In the Neue Galerie unfolded Geoffrey Farmer's *Leaves of Grass* (2012), an intricate and engrossing installation resembling a field of grass made of cut-outs from 50 years of *Life* magazine. The prehistoric was also present, in the form of a display of eight ancient female figures called the Bactrian Princesses. Though small, they still possessed a bold and palpable presence.

Besides merely walking visitors through the annals of history, these works and numerous others in the exhibition spoke to the power of art to transform our perception. Tino Sehgal's *This Variation* (2012)

engaged and entranced visitors who entered a dark room, which soon erupted into a mysterious chorus of chanting, humming, chirping voices and writhing bodies. Beside a compost heap, Pierre Huyghe's fantastical and nightmarish installation *Untitled* (2011–12) featured a sculpture of a female reclining nude with a beehive for a head, a greyhound with a pink leg, and a garden of poisonous plants, opium poppies, and cannabis. In Pedro Reyes's *SANITORIUM* (2012) one could sign up for therapies ranging from Gestalt to primal screaming.

New
Forms

**This is the
Show and the
Show is Many
Things**

do it

NowHere

**50th Venice
Biennale:
Dreams and
Conflicts – The
Dictatorship
of the Viewer**

**28th São Paulo
Biennial:
In Living Contact**

**An Unruly
History of the
Readymade**

Henrietta Lehtonen, *Cafeteria and Park Island*, 1994, installation view
from This is the Show and the Show is Many Things, Museum of
Contemporary Art, Ghent, Belgium, 1994

New Forms

This section explores significant experimentation in exhibition-making over the past 20 years, looking at innovation within a variety of exhibition formats: group shows, biennials, and collection shows. The motivation for this new approach is frequently attributed to a desire to rethink institutions and the role of exhibitions, and often takes artists' projects, ideas, and movements as inspiration for curatorial experimentation. Hans Ulrich Obrist's do it began in 1993 as a series of conversations with two artists, Christian Boltanski and Bertrand Lavier, and took its form from instructional works by artists such as Yoko Ono and Alison Knowles. It was manifested as a compendium of artist's instructions and as a generative and roving exhibition, which has taken place in innumerable forms on almost every continent.

The year following the launch of do it, Bart de Baere organized This is the Show and the Show is Many Things, an evolving exhibition-cum-artist's studio that focused on the creative process and collaborations between artists. Other exhibitions involved the process itself less directly, but were certainly inspired by artists and movements. An Unruly History of the Readymade, curated by Jessica Morgan for the Jumex Collection in 2008, took the Duchamp-inspired readymade as its content as well as its conceptual and organizational premise.

Collaboration and the inclusion of multiple curatorial voices has also become a major source of innovation in exhibition making. In 2003, for the 50th Venice Biennale, Francesco Bonami called upon a team of nine collaborators to produce exhibitions and projects around their individual priorities and interests. Similarly, in 1996, Lars Nittve invited six curators to organize NowHere, a project at the Louisiana Museum of Modern Art in Humlebæk, Denmark. Both exhibitions demonstrated a desire for a pluralistic approach in which several voices and perspectives are regarded as equally valid. Sometimes, as in the case of the 28th São Paulo Biennial, experimentation in exhibition making has actually been viewed as necessary in the face of institutional restrictions or mandates.

This is the Show and the Show is Many Things

September 17 – November 27, 1994
Museum of Contemporary Art, Ghent, Belgium

This is the Show and the Show is Many Things was a 1994 exhibition curated by Bart de Baere at the Museum of Contemporary Art in Ghent, Belgium. The intention was to present a series of ongoing "conversations" among 13 artists. The art in the exhibition consisted of physical works, ephemeral interventions, and installations, all unified into a single exhibition that intentionally did not distinguish any one artist's individual work from the rest. Thus, the overall impression was both seamless and chaotic. There were no wall labels to define and pinpoint certain pieces, and incomplete works were scattered about—even in storage spaces. Artists continued to contribute to the exhibition over the two months of its run, and thus This is the Show was constantly in flux. Since the art never became final or static, the exhibition space was in many ways more like an artist's studio than a museum space.

Also on display, in a sense, were the processes of the artists as they worked through their collaborative efforts. According to De Baere, the exhibition was meant to stand apart from the "relational aesthetics" model that had defined much of the art of the 1990s, although in fact it relied quite heavily on the strategies of that model. The artists themselves became part of the exhibition, since viewers were invited to watch them arranging or installing their work, or meandering through the space. Sometimes viewers were invited to participate. Many of the works in the show were "user-friendly," inviting the audience to engage with them or even take parts home, but not every piece was meant to be interactive, and sometimes it was unclear which ones were only to be looked at and which could be touched. Thus, even though the viewer was welcomed to some degree as a participant, the experience of This is the Show and the Show is Many Things also inspired a sense of confusion, bewilderment, and mystification.

Exhibition Title
This is the Show and
the Show is Many Things

Curator
Bart de Baere

Dates
September 17 –
November 27, 1994

Location
Museum of Contemporary Art,
Ghent, Belgium

Publication
Bart de Baere, Pierre Giquel,
Ronald van de Sompel, and Dirk
Pültau, eds., *This is the Show
and the Show is Many Things*,
Museum of Contemporary Art,
Ghent, 1994

Artists
Louise Bourgeois
Anne Decock
Honoré d'O
Fabrice Hybert
Suchan Kinoshita
Henrietta Lehtonen
Mark Manders
Jason Rhoades
Maria Roosen
Claire Roudenko Bertin

Eran Schaerf
Luc Tuymans
Uri Tzaig

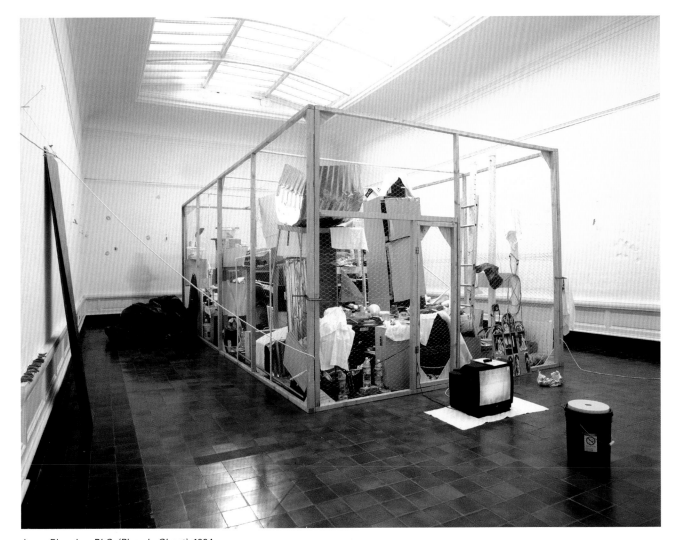

Jason Rhoades, *P.I.G. (Piece in Ghent)*, 1994

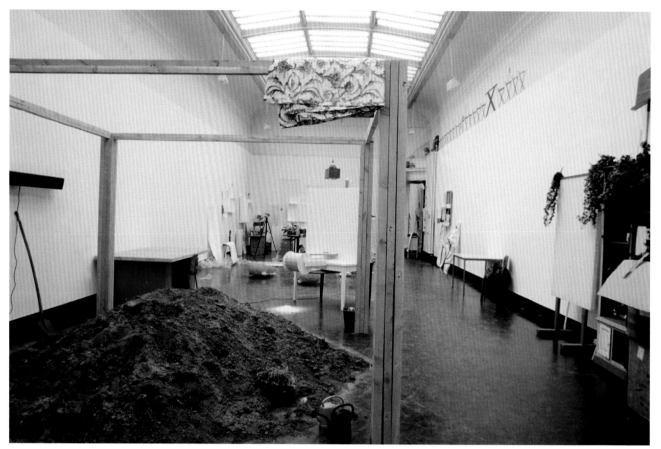

Anne Decock, *Hortus Conclusus*, 1994

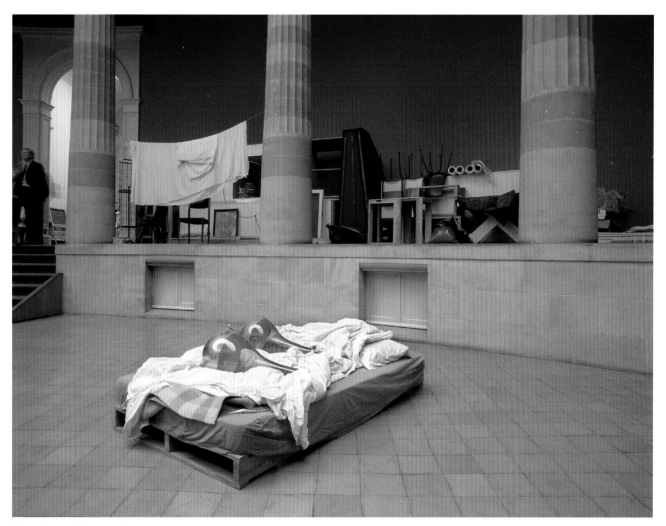

Maria Roosen, *Bed*, installation, 1994

do it

1994 – ongoing
Various locations and formats

Visitor writing a postcard, Joseph Grigely, *Do It Now*, 1997

Michelangelo Pistoletto, *Sculpture for Strolling*, Italy, 1996

Beginning in 1994, the curator Hans Ulrich Obrist organized an ongoing exhibition entitled do it to challenge the notion that a work of art or an exhibition had to be a singular, hermetically contained object or event. The initial idea arose during a conversation between Obrist and the artists Christian Boltanski and Bertrand Lavier about the incorporation of instructional procedures into artworks. Inspired by this, Obrist created an exhibition that would undergo various iterations in multiple venues, all based on sets of instructions submitted by different artists. Andreas Slominski's instruction, for example, asked the audience to use the seat of a bicycle as a lemon squeezer. The instructions are not the artworks, nor is do it about following rules; rather, viewers at each site receive the instructions, engage in independent decision-making processes, explore the possibilities of interpretation, and become the authors of new works. Today, as fresh iterations continue to take place around the world, do it is the longest-running exhibition ever. Its expansive and international scope also makes it one of the largest exhibitions in history. It has had at least 90 different iterations in Europe, the Americas, Asia, and Australia, its many different manifestations changing based on the location and interests of the people involved. It has been exhibited

Exhibition Title
do it

Curator
Hans Ulrich Obrist

do it consists of publications
(starting in 1993), exhibitions
(1994–2013), do it TV, and do it
Home, all curated by Obrist

DO IT – MUSEUM

**Additional Curators
and Coordinators**
Pamela Echeverría (Mexico City)
Virginia Perez (Costa Rica)
Kitti Chalthiraphant /
 Maymay Jumsai / Chitti
 Kasemkitvatana / Yanawit
 Kunchaethong / Surasi
 Kusolwong / Nopadoi
 Limwatanakul / Virapong
 Phadonsak / Waroot
 Phanyarachunn / Nattapak
 Phatanapromchai / Thatree
 Pokavanich / Sitticha
 Pratchayaratikul / Titapol
 Suwankusolsong (Bangkok)

Locations and Dates
Ritter Kunsthalle, Klagenfurt,
 Austria, September 30 –
 November 25, 1994
CCA Centre for Contemporary
 Arts, Glasgow, UK,
 June 22 – July 29, 1995
FRAC, Nantes, France, October
 28 – December 21, 1995
Institute of Modern Art,
 Brisbane, Australia,
 February 22 – March 23,
 1996
The Reykjavik Municipal Art
 Museum, Reykjavik, Iceland,
 February – May 1996
Centro Civico per l'Arte
 Contemporanea "La Grancia,"
 Siena, Italy, March 8 –
 March 23, 1996
Kunsthalle Helsinki
 Taidehalli, Helsinki,
 Finland, May 29 – August 11,
 1996
Espace Forde, Geneva,
 Switzerland, May 31 –
 July 7, 1996
Bangkok: Alliance Française,
 Bangkok, Thailand, October 5
 – November 2, 1996

Uppsala Konstmuseum,
 Uppsala, Sweden,
 November 9 – December 1,
 1996
Theatre de Chatelet, Paris,
 France, 1996
Sala Temporal de la Casa
 de Moneda, Bogotá,
 Colombia, 1997
Tallinna Kunstihoones, Thallin,
 Estonia, 1997
Nicolaj Contemporary Art
 Center, Copenhagen,
 Denmark, 1997
Edmonton Art Gallery, Alberta,
 Canada, April 11 – June 14,
 1998
Skuc Gallery, Ljubljana,
 Slovenia, 1998
Lawrence Wilson Art
 Gallery, University of
 Western Australia, Perth,
 February 9 – April 29,
 2001
Museo de Arte Carrillo Gil,
 Mexico City, Mexico,
 November 14, 2001 –
 February 10, 2002
San José, Costa Rica,
 November 2002

Publications
Hans Ulrich Obrist, ed., *do it*,
 AFAA (Association Française
 d'Action Artistique), Paris,
 1993
Hans Ulrich Obrist, ed., *do it*,
 The Reykjavik Municipal Art
 Museum, Reykjavik, 1996
Hans Ulrich Obrist, ed., *do it*,
 Zerynthia Associazione per
 l'Arte Contemporanea,
 Rome, 1996
Hans Ulrich Obrist, ed., *do it:
 Thai Version*, AFAA, Alliance
 Française de Bangkok,
 and Bangkok University,
 Bangkok, 1996
Hans Ulrich Obrist, ed., *do it*,
 Nicolaj Contemporary Art
 Center, Copenhagen, 1997
Hans Ulrich Obrist and Gregor
 Podnar, eds., *do it*, Galerija
 Škuc, Ljubljana, 1998
Hans Ulrich Obrist, ed.,
 do it, The University of
 Western Australia,
 Perth, 2001
Hans Ulrich Obrist, ed., *do it*,
 Museo de Arte Carrillo Gil,
 Mexico City, 2001 →

as physical shows, as an online exhibition, and as
a book. There is a philosophy of do it, a children's
do it, and an anti-do it. The only element that has
remained constant is the loose set of rules originally
laid down by Obrist, but even these are in continual
flux depending on where the show is presented.

In addition to the physical shows of do it, between
1995 and 1996 a series of short instructional video
clips by international artists was broadcast each
week on Australian national television. Obrist has
also collaborated with the online journal *e-flux* to
host do it (home version), an online compendium
of artists' writings, essays, interviews, and, of
course, instructional pieces; participants were
encouraged to upload photographs of the artworks
they created based on the instructions provided.
In 2004, e-flux published a do it book that included
168 instructions written by contemporary artists
and writers as well as the best responses from the
online community. The book was meant to serve as
a historical record of the various stages and forms

that do it had taken. do it was re-launched in
2013 in collaboration with Independent Curators
International, which organized its extensive tour in
the United States and Canada during the 1990s.

do it: the compendium, published by Independent
Curators International in 2013 to celebrate two
decades of do it shows

DO IT – ICI TOUR

Organizers
Independent Curators
International, New York, USA

Locations and Dates
Palo Alto Cultural Center,
Palo Alto, California, USA,
June 15 – July 27, 1997
Cranbook Art Museum,
Bloomfield Hills, Michigan,
USA, August 30 – October 26,
1997
Freedman Gallery, Albright
College, Reading,
Pennsylvania, USA,
January 23 – March 1, 1998
Surrey Art Gallery, Surrey,
British Columbia, Canada,
March 8 – May 24, 1998
Cantor Art Gallery, College
of the Holy Cross, Wooster,
Massachusetts, USA,
March 18 – April 19, 1998
Dunlop Art Gallery, Regina,
Saskatchewan, Canada,
May 9 – June 14, 1998
Lamont Gallery, Phillips Exeter
Academy, Exeter, New
Hampshire, USA, April 17 –
May 9, 1998
Salina Arts Center, Salina,
Kansas, USA, May 16 –
August 2, 1998
Boulder Museum of
Contemporary Art, Boulder,
Colorado, USA, June 12 –
August 30, 1998
Pittsburgh Center for the Arts,
Pittsburgh, Pennsylvania,
USA, September 4 –
November 1, 1998
Visual Arts Center, Boise State
University, Boise, Idaho,
USA, September 15 –
October 25, 1998
The Nickle Arts Museum,
The University of Calgary,
Alberta, Canada, September
25 – December 23, 1998
Institute of Contemporary Art,
Maine College of Art, Portland,
Maine, USA, November 12 –
December 18, 1998
The Morris Museum,
Morristown, New Jersey,
Noyes Museum, Oceanville,
New Jersey, Ben Shahn
Galleries, William Paterson
University, Wayne, New
Jersey, and Zimmerli Art
Museum, New Brunswick,
New Jersey, USA, January 10
– April 4, 1999

Museum of Art, Fort
Lauderdale, Florida, USA,
January 14 – April 2, 2000
Colorado State University,
Boulder, Colorado, USA,
March 24 – April 28, 2000
Memphis Brooks Museum of
Art, Memphis, Tennessee,
USA, April 23 – July 2, 2000
Scottsdale Museum of
Contemporary Art,
Scottsdale, Arizona, USA,
June 3 – August 26, 2000
Wriston Gallery, Lawrence
University, Appleton,
Wisconsin, USA,
September 29 –
November 5, 2000
Atlanta College of Art,
Atlanta, Georgia, USA,
October 12 – December 26,
2000
Maryland Institute, Baltimore,
Maryland, USA, November
17 – December 16, 2000
Soo Visual Arts Center,
Minneapolis, Minnesota,
USA, June 3 – July 29, 2001
York Arts Center, York,
Pennsylvania, USA,
October 4 – December 1,
2001
University of Toronto at
Scarborough, Toronto,
Ontario, Canada,
November 7 – December
14, 2001
Addison Art Gallery, Andover,
Massachusetts, USA,
September 28, 2001 –
January 6, 2002
Socrates Sculpture Park, New
York, USA, May 12 – July 7,
2013
Gund Gallery at Kenyon
College, Gambier, Ohio,
USA, May 12 – August 25,
2013
tranzit, Budapest, Hungary,
May 17 – June 21, 2013
MU artspace, Eindhoven,
The Netherlands, May 17
– July 19, 2013
Manchester Art Gallery,
Manchester, UK, July 5 –
September 22, 2013
Samek Art Gallery, Bucknell
University, Lewisburg,
Pennsylvania, USA,
September 16 –
December 12, 2013
Handwerker Gallery,
Ithaca College, New York,
USA, September 30 –
November 1, 2013

Publications
Hans Ulrich Obrist, ed.,
do it (ICI tour catalogue),
Independent Curators
International, New York, 1997
Hans Ulrich Obrist, ed., Bruce
Altshuler and Kate Fowle,
do it: the compendium,
Independent Curators
International, New York, 2013

Artists – MUSEUM and ICI TOUR
Various groups of artists,
including:
Carlos Amorales
John Baldessari
Michel Blazy
John Bock
Christian Boltanski
Iñaki Bonillas
Joan Brossa
Miguel Calderón
José León Cerrillo
Critical Art Ensemble
Minerva Cuevas
Diller & Scofidio
Jimmie Durham
Maria Eichhorn
Hans-Peter Feldmann
Claudia Fernández
Mario Garcia Torres
Paul-Armand Gette
Thomas Glassford
Dominique Gonzalez-Foerster
Félix González-Torres
Douglas Gordon
Dan Graham
Joseph Grigely
Ulrike Grossarth
HCRH
Maria Teresa Hincapié
Shere Hite
Jutta Høy
Fabrice Hybert
Mike Kelley
Alison Knowles
Koo Jeong-A
Surasi Kusolwong
Bertrand Lavier
LCM
Xavier Leroy
Sol LeWitt
Siobhan Liddell
Sylvère Lotringer
Eva Marisaldi
Chris Marker
Cildo Meireles
Annette Messager
Robert Morris
Yoko Ono
Damian Ortega
Fernando Ortega
Pepón Osorio
Michelangelo Pistoletto

Marjetica Potrč
Emilio Prini
Tadej Pogačar / P.A.R.A.S.I.T.E.
Pedro Reyes
Jason Rhoades
Pippilotti Rist
Jean-Jacques Rullier
Tino Sehgal
Rupert Sheldrake
Andreas Slominski
Bruce Sterling
Annika Ström
Rirkrit Tiravanija
Yasunao Tone
Francisco J. Varela
Anton Vidokle
Mart Viljus
Lawrence Weiner
Erwin Wurm

DO IT – TELEVISION

Organizer
Realized in cooperation with
Vienna's museum in progress

Iteration
Reykjavik, Iceland, 1996

Artists
Gilbert & George
Leon Golub
Damien Hirst
Shere Hite
Robert Jelinek
Ilya Kabakov
Jonas Mekas
Eileen Myles
Yoko Ono
Steven Pippin
Michelangelo Pistoletto
Michael Smith
Nancy Spero
Dave Stewart
Rirkrit Tiravanija
Lawrence Weiner
Erwin Wurm

Iteration
Uppsala, Sweden, 1996

Artists
Gilbert & George
Leon Golub
Damien Hirst
Shere Hite
Ilya Kabakov
Jonas Mekas
Eileen Myles
Yoko Ono
Steven Pippin
Michelangelo Pistoletto
Michael Smith
Nancy Spero

DO IT – HOME VERSION

Organizer
e-flux.com

Iteration
Reykjavik, Iceland, 1996

Publication
Hans Ulrich Obrist, ed.,
do it, e-flux, New York,
and Revolver, Frankfurt,
2004

Artists
Pablo Azul
John Baldessari
Amy E. Cohen /
 Francisco J. Varela
Jimmie Durham
Paul-Armand Gette

Liam Gillick
Félix González-Torres
Dan Graham
Ulrike Grossarth
Mona Hatoum
Noritoshi Hirakawa
Carsten Höller
Allan Kaprow
Christian Marclay
Chris Marker
David Medalla
Olaf Metzel
John Miller
Pepón Osorio
Nam June Paik /
 John McEvers
Jason Rhoades
Pipilotti Rist
Ugo Rondinone
Sam Samore
Thomas Schütte

Andreas Slominski
Diminik Steiger
Hugo Suter
Uri Tzaig

Iteration
Mexico City, Mexico,
2001

Artists
Marina Abramović
Dara Birnbaum
Liam Gillick
Leon Golub
Douglas Gordon
María Teresa Hincapié
Ben Kinmont
Pepón Osorio
Michelangelo Pistoletto
Pipilotti Rist
Rosemarie Trockel

SEMINAR

Event Title
Do It For/With Someone Else

Collaborators
Molly Nesbit
Stefano Boeri

Date
December 2002

Location
Istituto Universitario
di Architettura di Venezia,
Italy

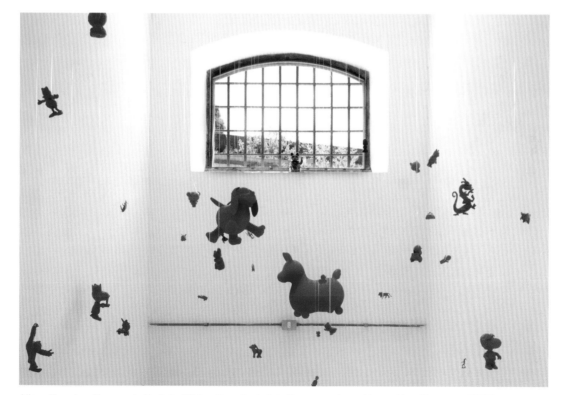

Alison Knowles, *Homage to Each Red Thing*, Espacio de Arte Contemporáneo, Montevideo, Uruguay, 1996/2011

NowHere

May 15 – September 8, 1996
Louisiana Museum of Modern Art,
Humlebæk, Denmark

NowHere took place at the Louisiana Museum of Modern Art in Humlebæk, Denmark, in 1996. Lars Nittve, the director of the museum, cleared the permanent collection galleries and invited six international curators to stage what he called a "mini-Documenta." The five different exhibitions they conceived involved more than 170 international artists and musicians, and each took a different theme and title. "Incandescent," curated by Laura Cottingham, focused on feminist practices and the status of women in the art world. "Get Lost" was an exhibit of video and installation art dealing with techno-culture and the mass media, curated by Anneli Fuchs and Lars Grambye. Bruce W. Ferguson's "Walking and Thinking and Walking" was about flux and instability, showing works related to constant movement. Curated by Iwona Blazwick, "Work in Progress" showcased process art since the 1960s. Finally, Ute Meta Bauer's simply titled "?" focused on the work of Joseph Beuys that had been on view in the museum as a way to question the institution and its mission.

Nittve intended NowHere to reflect on the zeitgeist of the 1990s. He claimed that cultural production and theory "can no longer rely on the idea of dominant tendencies or 'isms' ... to help us understand what we see happening in art." Very much influenced by postmodern diversity in discourse, Nittve's pluralistic organizing strategy opened up NowHere to multiple approaches, and avoided having any one single perspective dominate the show. Rather, each "mini-exhibition" spoke on its own. Once the works were installed, however, particular convergences and themes emerged. The layout of the Louisiana Museum was ideal for a show like this. It is a network of rooms and corridors that seem freely woven together, situated on a sprawling parkland that slopes toward a beach.

Installation view with Fareed Armaly, *Sign-System*, 1996, Fareed Armaly and Ute Meta Bauer, *? Character*, 1996, Regina Möller, *Poster*, 1996, and Fareed Armaly and Ute Meta Bauer, *? Character Trailers*, 1996

Chris Ofili, *The Chosen Ones—The Wall*, 1996

Exhibition Title
NowHere

Organizer
Lars Nittve

Curators
Ute Meta Bauer
Iwona Blazwick
Laura Cottingham
Bruce W. Ferguson
Anneli Fuchs & Lars Grambye

Dates
May 15 – September 8, 1996

Location
Louisiana Museum of Modern
Art, Humlebæk, Denmark

Publications
Henning Steen Hansen,
 ed., *NowHere*, Louisiana
 Museum of Modern Art,
 Humlebæk, 1996
Ute Meta Bauer, ed., *?* (series
 of 13 magazines), Louisiana
 Museum of Modern Art,
 Humlebæk, Summer 1996
 Guest editors:
 Issue 1: Konstanze Schäfer
 Issue 2: Regina Möller
 Issue 3: Linda Bilda
 Issue 4: Barbara Jung
 Issue 5: Judith Hopf
 Issue 6: Innen plus
 Issue 7: erreakzioa-reacción
 Issue 8: Übung am Phantom
 Issue 9: Network Orange
 Issue 10: Brigitte Braun /
 Aylın Çatal
 Issue 11: Ina Wudkte
 Issue 12: Michelle Nicol
 Issue 13: Yvonne P. Doderer

Artists
Marina Abramović
Vito Acconci
Eija-Liisa Ahtila
Francis Alÿs
Francis Alÿs /
 Laureana Toledo

Janine Antoni
Fareed Armaly
Ericka Beckman
Joseph Beuys
Ginny Bishton
Dominique Blain
August Blom
Barbara Bloom
Cosima von Bonin
Lizzie Borden
Roland Brener
Marcel Broodthaers
Sophie Calle
Janet Cardiff
Monica Carocci
Lizzie Corfixen
François Court-Payen
Neil Cummings
Neil Cummings /
 Marysia Lewandowska
Hanne Darboven
Lewis DeSoto
Diane DiMassa
Braco Dimitrijević
Willie Doherty
Stan Douglas
Cheryl Dunye
Maria Eichhorn
Annika Eriksson
VALIE EXPORT
Eric Fischl
Fischli & Weiss
Ava Gerber
Alberto Giacometti
Félix González-Torres
Renée Green
Joseph Grigely
Henrik Håkansson
Henrik Håkansson /
 Jean Louis Huhta
Mona Hatoum
Chris Hedegus /
 D.A. Pennebaker
Eva Hesse
Gary Hill
Susan Hiller
Kaoru Hirabayashi
Christine & Irene Hohenbüchler
Jenny Holzer
Imprint 93 with Paul Bloodgood /
 Pavel Büchler /
 Cabinet Gallery /

Billy Childish / City Racing /
 Matthew Collins /
 Martin Creed / Neil Cummings /
 Jeremy Deller / Peter Doig /
 Ceal Floyer / Matthew Higgs /
 Stewart Home / Alan Kane /
 Liebscher Lehanka /
 Hillary Lloyd / Colin Lowe /
 Thomas Nicolaou / Paul Noble /
 Simon Periton /
 Elizabeth Peyton /
 James Pyman /
 Maggie Roberts /
 Bob & Roberta Smith /
 Roddy Thomson /
 Jessica Voorsanger /
 Christopher Warmington /
 Stephen Willats
Jaki Irvine
Henrik Plenge Jakobsen
Jill Johnston & Ingrid Nyeboe
Lea & Pekka Kantonen
Emiko Kasahara
Mary Kelly
Poul Kjærholm
Mette Knudsen
Peter Kogler
Gunnar Krantz
Barbara Kruger
Yayoi Kusama
Peter Land
Hans Lauritsen
Ann Lislegaard
Charles Long /
 Stereolab
Poul Martinsen /
 Sten Baadsgaard
T. Kelly Mason
Muda Mathis
Ulrike Meinhof
Ute Meta Bauer /
 Fareed Armaly
Minimal Club
Mission Invisible
Ana Claudia Múnera
N55
Yurie Nagashima
Bruce Nauman
Senga Nengudi
Chris Ofili
Lorraine O'Grady
Johan Oja

Frants Pandal
Marta María Pérez Bravo
Raymond Pettibon
Cesare Pietroiusti
Howardena Pindell
Adrian Piper
Peter Pommerer
Linda Post
Flemming Quist Møller /
 Jannik Hastrup
Mark Rakatansky
Charles Ray
Gerhard Richter
Pipilotti Rist
Martha Rosler
E. Schnelder-Sørensen
Stephanie Smith /
 Edward Stewart
Michael Snow
Haim Steinbach
Jana Sterbak / Ana Torfs
Sturtevant
Talking Heads
Joëlle Tuerlinckx
Vroonen & Snauwaert
Andy Warhol
Gillian Wearing
Elin Wikström
Sue Williams
Jane & Louise Wilson
Lotte Wissum
Krzysztof Wodiczko
Lynne Yamamoto

DJs
Susan Bigdeli / DJ SHIER
Barbara Jung / DJ NURSE
Mo Loschelder / DJ MO
Ina Wudtke / DJ T-INA

Techno Events and CD
Multiplex with 2000 and one /
 As One / Blake Baxter /
 Mark Broom / Cai & Kong /
 Clatterbox / Dan Curtin /
 Elin / Gregory Fleckner /
 Peter Ford / Hal & Clair / Hell /
 Mo & Kotai / Patrick Pulsinger /
 Dr. Rockit / Solvpil / Stasis /
 Sterac / Tanja / Erdem Tunakan /
 Unknown Unit /
 Orlando Voorn

50th Venice Biennale: Dreams and Conflicts – The Dictatorship of the Viewer

June 15 – November 2, 2003
Various sites in Venice, Italy

Dreams and Conflicts – The Dictatorship of the Viewer was the title of the 50th Venice Biennale, organized and curated by Francesco Bonami in 2003. His curatorial strategy was to give nine curators— Carlos Basualdo, Daniel Birnbaum, Catherine David, Massimiliano Gioni, Hou Hanru, Hans Ulrich Obrist, Gabriel Orozco, Gilane Tawadros, and Igor Zabel— complete autonomy to conceive semi-independent smaller exhibitions based on their own interests, with Bonami curating an additional two of his own. The art historian Molly Nesbit and the artist Rirkrit Tiravanija were also involved.

It was a precarious period, only two years after 9/11 and the beginning of the wars in Iraq and Afghanistan. Bonami believed that the social phenomenon of globalization put individual identities in jeopardy, which in turn caused a romantic return to the "dimension of inner awareness" and thus a world where a panoply of voices reigned. Dreams and Conflicts sought to convey this by creating individual, intimate encounters, contrary to the overwhelming "bigness" of most international exhibitions and biennials.

More than 300 artists participated in the eleven sections, which among them addressed many different conceptual threads. For example, Catherine David's "Contemporary Arab Representations" dealt with how the Middle East is viewed from within the region, whereas Hou Hanru's "Zone of Urgency" ("Z.O.U.") manipulated the architecture of the exhibition space, forcing viewers to move over ramps, bridges, and staircases while looking at the art. The section that received the most attention was "Utopia Station," curated by the triad of Obrist, Nesbit, and Tiravanija. The last exhibition that most viewers encountered on their visit, "Utopia Station" was dependent upon audience participation, with lounge-like areas, a stage for talks and discussions and a communal garden that contextualized the art on display. It looked like anything but a traditional exhibition.

Although the show attracted 260,000 visitors, a record number compared to previous editions of the Venice Biennale, many critics found the curatorial premise weak and the exhibition poorly executed. These claims tended to center on the haphazardness of the numerous sections, the poor quality of the installation, and the biennial's inability to live up to its claims of independence. The curators had tried to avoid the mega-exhibition effect by breaking the show into sections spread over different locations, but many critics felt it nevertheless came off as overwhelming. But today, in light of subsequent biennials, Dreams and Conflicts is hailed as one of the most radical iterations in the history of the Venice Biennale, due to its experimental nature and multiplicity of curatorial voices.

History is an endless stream of dreams, generated by conflicts, and the endless stream of conflicts, is the tragic consequence of unrealized dreams I am for producing dreams that contain the madness of conflict.

Francesco Bonami, "I Have A Dream," in Francesco Bonami, ed., *Dreams and Conflicts: The Dictatorship of the Viewer – 50th Biennale di Venezia*, Skira, Milan, and Rizzoli International Publications, New York, 2003.

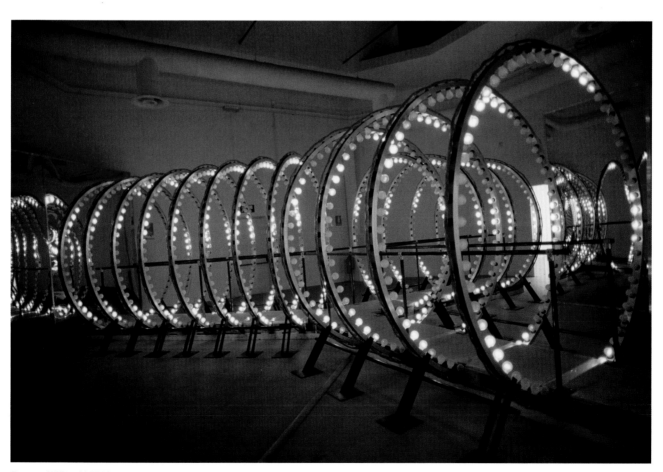

Carsten Höller, *Y*, 2003

Exhibition Title
50th Venice Biennale:
Dreams and Conflicts –
The Dictatorship of
the Viewer

Director
Francesco Bonami

Dates
June 15 – November 2, 2003

Location
Various sites in Venice, Italy

Publication
Francesco Bonami, ed.,
*Dreams and Conflicts: The
Dictatorship of the Viewer –
50th International Art Exhibition*,
Skira, Milan, and Rizzoli
International Publications,
New York, 2003

Curators and Sections

Title
Clandestine

Curator
Francesco Bonami

Location
Arsenale di Venezia

Artists
Etty Abergel
Avner Ben Gal
Mircea Cantor
Colin Drake
Enrico David
Flavio Favelli
Ghazel
Dryden Goodwin
Hannah Greely
Hakan Gürsoytrak
Michal Helfman
Eva Koch
Paulina Ołowska
Jorge Queiroz
Aïda Ruilova
Bojan Sarcevic
Dana Schutz
Doron Solomons
Monika Sosnowska
Cheyney Thompson
Jaan Toomik
Francisco Tropa
Tatiana Trouvé
Nobuko Tsuchiya
Magnus von Plessen
Amelie von Wulffen
Shizuka Yokomizo
Zheng Liu

Title
Contemporary Arab
Representations

Curator
Catherine David

Location
Arsenale di Venezia

Artists
Taysir Batniji
Tony Chakar
Bilal Khbeiz
Elias Khoury
Randa Shaath
Jalal Toufic
Paula Yacoub / Michel Lassarre

Title
Delays and Revolutions

Curators
Francesco Bonami
Daniel Birnbaum

Location
Italian Pavilion, Giardini

Artists
Franz Ackermann
Matthew Barney
Thomas Bayrle
Johanna Billing
Glenn Brown
Berlinde de Bruyckere
Maurizio Cattelan
Jonas Dahlberg
Tacita Dean
Sam Durant
Juan-Pedro Fabra Guemberena
Fischli & Weiss
Ceal Floyer
Giuseppe Gabellone
Ellen Gallagher
Isa Genzken
Carmit Gil
Felix Gimelin
Robert Gober
Amit Goren
Rodney Graham
Massimo Grimaldi
David Hammons
Kevin Hanley
Damien Hirst
Carsten Höller
Piotr Janas
Ian Kiaer
Dinh Q. Lê
Sarah Lucas
Lucy McKenzie
Kerry James Marshall
Helen Mirra
Rivane Neuenschwander
Cady Noland

Gabriel Orozco
Jennifer Pastor
Richard Prince
Carol Rama
Charles Ray
Tobias Rehberger
Shirana Shahbazi
Efrat Shvily
Rudolf Stingel
Rirkrit Tiravanija
Andy Warhol

Title
The Everyday Altered

Curator
Gabriel Orozco

Location
Arsenale di Venezia

Artists
Abraham Cruzvillegas
Jimmie Durham
Daniel Guzmán
Damián Ortega
Fernando Ortega
Jean-Luc Moulène

Title
Fault Lines: Contemporary
African Art and Shifting
Landscapes

Produced by
Forum for African Arts

Curator
Gilane Tawadros

Location
Arsenale di Venezia

Artists
Laylah Ali
Kader Attia
Samta Benyahia
Zarina Bhimji
Frank Bowling
Clifford Charles
Pitzo Chinzima
Rotimi Fani-Kayode
Hassan Fathy
Veliswa Gwintsa
Moshekwa Langa
Salem Mekuria
Sabah Naim
Moataz Nasr
Wael Shawky

Title
Individual Systems

Curator
Igor Zabel

Location
Arsenale di Venezia

Artists
Viktor Alimpiev
Pawel Althamer
Art & Language
Josef Dabernig
IRWIN
Luisa Lambri
Yuri Leiderman
Andrei Monastirsky
Pavel Mrkus
Roman Opałka
Marko Peljhan
Florian Pumhösl
Simon Starling
Mladen Stilinović
Nahum Tevet

Title
Interludes

Curator
Francesco Bonami

Location
Arsenale di Venezia

Artists
Darren Almond
Pawel Althamer
Pedro Cabrita Reis
Thomas Demand
Urs Fischer
Jeppe Hein
Sandi Hilal / Alessandro Petti
Gabriel Kuri
Damir Niksic
Mareaperto Onlus /
 Luca Guglietta
Alexandre Perigot
Paola Pivi
Piotr Uklanski

Title
The Structure of Survival

Curator
Carlos Basualdo

Assistant Curator
Stephanie Mauch

Location
Arsenale di Venezia

Artists
Caracas Group
Carolina Caycedo Sanchez
Alexandre da Cunha
Paola Di Bello
Yona Friedman
Gego
Fernanda Gomes →

Martha Rosler with students from the Konstfack, Stockholm, the Royal Academy, Copenhagen, and Yale, New Haven, and the FLEAS international collective, *space(ship)(station) Oleanna*, installation, 2003

Instead of each curator
attempting to contain the
complexity of the world
and weave the visions into a
curatorial interface, we focused
on drawing a map where each
curator was able to define his
or her view within a portion
and region of the exhibition.

Francesco Bonami, "I Have A Dream," in Francesco
Bonami, ed., *Dreams and Conflicts: The Dictatorship
of the Viewer – 50th Biennale di Venezia*, Skira, Milan,
and Rizzoli International Publications, New York, 2003.

Grupo de Arte Callejero
Rachel Harrison
José Antonio Hernández-Diez
Koo Jeong-A
Chris Ledochowski
Mikael Levin
Marepe
Cildo Meireles
Oda Projesi
Kaido Ole
Olumuyiwa Olamide Osifuye
Marjetica Potrč
Raqs Media Collective
Pedro Reyes
Andreas Siekmann / Alice
 Creischer
Robert Smithson
Meyer Vaisman
Dolores Zinny /
 Juan Maidagan

Title
Utopia Station

Curators
Molly Nesbit
Hans Ulrich Obrist
Rirkrit Tiravanija

Location
Arsenale di Venezia

Artists
Marina Abramović
Carla Accardi
Vito Acconci Studio
Franz Ackermann
Doug Aitken
Pawel Althamer
Amicale des Témoins
Anonymous
Arcagrup
Asymptote Architecture
Atelier van Lieshout
Yuri Avvakumov
Zeigam Azizov / Stuart Hall
John Baldessari
Matthew Barney
Thomas Bayrle
Dara Birnbaum
John Bock
Iñaki Bonillas
Ingrid Book / Carina Hedén
Ecke Bonk
Louise Bourgeois
Angela Bulloch
Bureau d'études
Pash Buzari
Jay Chung
Santiago Cirugeda
Tacita Dean
Luc Deleu
Jeremy Deller
Wilson Diaz / Marco Moretti
Diller & Scofidio

Nico Dockx
Trisha Donnelly
Jimmie Durham
Leif Elggren /
 Carl Michael van Hausswolff
Olafur Eliasson /
 Israel Rosenfield
Elmgreen & Dragset
Jan Fabre
Hans-Peter Feldmann
Peter Fend
Fischli & Weiss
Vadim Fishkin
Didier Fiuza Faustino
Alicia Framis
Yona Friedman
Future Systems
Isa Genzken
Matteo Ghidoni /
 Avanguardie Permanenti
Liam Gillick
John Giorno
Leon Golub
Tomislav Gotovac
Joseph Grigely
gruppo A12
Henrik Håkansson
Mathew Hale
Nikolaus Hirsch /
 Markus Weisbeck
Thomas Hirschhorn
Karl Holmqvist
Marine Hugonnier
Initiative Haubrich-Forum
Arata Isozaki
Janus Magazine
Sture Johannesson
John M. Johansen
Isaac Julien
Jean-Paul Jungmann /
 Tamas Zanko
Ilya & Emilia Kabakov
Gülsün Karamustafa
Jakob Kolding
Július Koller
Harmony Korine
Gyula Kosice
Lucien Kroll
Elke Krystufek
Gabriel Kuri
Bertrand Lavier
Kamin Lertchaiprasert
Simon Leung / Lincoln Tobier
Loo Jia Wen /
 Wong Hoy Cheong
M/M Paris
Steve McQueen
Enzo Mari
Bruce Mau Design / Institute
 without Boundaries
Jonas Mekas
Annette Messager
Gustav Metzger
Ayumi Minemura /
 Are You Meaning Company

M/M Paris / Philippe Parreno
Jonathan Monk
Multiplicity –
 Border Device(s) Project
Deimantas Narkevicius
Carsten Nicolai
Henrik Olesen /
 Kirsten Pieroth
Olof Olsson
Yoko Ono
Anatoli Osmolovski
Lygia Pape
Claude Parent
Manfred Pernice
Elizabeth Peyton
Michelangelo Pistoletto
Paola Pivi
Florian Pumhösl
Ma Qingyun
Radek
Raqs Media Collective
Tobias Rehberger
Pedro Reyes
David Robbins
François Roche
Pia Rönicke
Fernando Romero
ROR (Revolutions on Request)
Martha Rosler
Martha Rosler / FLEAS
Ed Ruscha
Natascha Sadr Haghighian
Anri Sala / Edi Rama
Tomas Saraceno
Markus Schinwald
Christoph Schlingensief
Carolee Schneeman
Allan Sekula
Thasnai Sethaseree
Shimabuku
Andreas Slominski
Patti Smith
Sean Snyder
Nancy Spero
Nedko Solakov
Yutaka Sone / Damon McCarthy
 / Eric Alloway / Henry Clancy
Luc Steels
SUPERFLEX
Supermoderno
Javier Téllez
Rirkrit Tiravanija
Rosemarie Trockel /
 Thea Djordjadze /
 Bettina Pousttchi
Uglycute
Agnès Varda
Anton Vidokle
Jacques Villeglé
Luca Vitone
Immanuel Wallerstein /
 Rirkrit Tiravanija
Lawrence Weiner
Wang Jian-Wei
Eyal Weizman

Franz West
Steven Willats
Pae White
Cerith Wyn Evans
Yang Fudong
Carey Young
Zerynthia (Association
 for Contemporary Art)
Andrea Zittel

Title
The Zone

Curator
Massimiliano Gioni

Location
A temporary space outside the
Italian Pavilion in the Giardini,
designed by gruppo A12, Milan

Artists
Alessandra Ariatti
Micol Assaël
gruppo A12
Anna de Manincor / ZimmerFrei
Diego Perrone
Patrick Tuttofuoco

Title
Z.O.U. – Zone of Urgency

Curator
Hou Hanru

Location
Arsenale di Venezia

Artists
Adel Abdessemed
Alfredo Juan Aquilizan
Maria Isabel Aquilizan
Atelier Bow-Wow
Atelier FCJZ /
 Young Ho Chang
Campement Urbain
Canton Express
Jota Castro
Shu Lea Cheang
Heri Dono
Gu Dexin
Huang Yong Ping
Joo Jae-Hwan
Sora Kim / Gimhongsok
Jun Nguyen-Hatsushiba
Surasi Kusolwong
Tsuyoshi Ozawa
Tadasu Takamine
Tsang Tsou-Choi
Wong Hoy Cheong
Yan Lei / Fu Jie
Yan Pei-Ming
Yang Zhenzhong
Zhang Peili
Zhu Jia

28th São Paulo Biennial: In Living Contact

October 26 – December 6, 2008
Pavilhão Ciccillo Matarazzo,
Parque Ibirapuera, São Paulo, Brazil

Javier Peñafiel, *Agenda do fim dos tempos drásticos / Journal of the End of the Drastic Times*, 2008 and Dora Longo Bahia, *Escalpo 5063 (Scalp 5063)*, 2008

The 28th São Paulo Biennial was held in 2008 at the Pavilhão Ciccillo Matarazzo. The curators, Ivo Mesquita and Ana Paula Cohen, chose more than 40 international artists (many from Brazil and other parts of Latin America) to take part. Entitled "In Living Contact", the exhibition offered a platform to observe and reflect on the culture of international biennials, using itself as a case study. The title came from an essay in the catalogue of the 1st São Paulo Biennial, in which the curator, Lourival Gomes Machado, wrote about the need for the biennial to be "in living contact" with the communities of Brazil and the art world at large.

Taking into consideration the subjects of history, politics, and economics as some of the driving factors that make biennials the mega-exhibitions they have become, In Living Contact charted out a critique of the biennial structure by including public events such as an open library and a conference series.

The curators were given only one year to plan the biennial, and a budget of $3.5 million (compared to the usual $12 million). As a way of dealing with these fiscal and organizational limitations, the curators decided to make the best of the situation

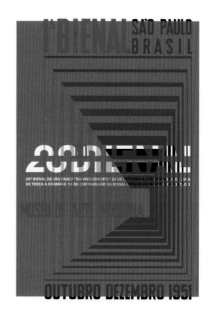

Exhibition poster

Exhibition Title
28th São Paulo Biennial:
In Living Contact

Curators
Ivo Mesquita
Ana Paula Cohen

Dates
October 26 – December 6,
2008

Location
Pavilhão Ciccillo
Matarazzo,Parque
Ibirapuera, São Paulo,
Brazil

Publication
Ivo Mesquita and Ana
Paula Cohen, *28th Bienal
de São Paulo: Guide*,
Fundação Bienal de São
Paulo, 2008

Artists
Marina Abramović
Eija-Liisa Ahtila
Vasco Araújo
Micol Assaël
assume vivid astro focus
Sarnath Banerjee
Erick Beltrán
Mabe Bethônico
Leya Mira Brander

Fernando Bryce
Rodrigo Bueno
Sophie Calle
Mircea Cantor
Iran do Espírito Santo
Ângela Ferreira
Fischerspooner
Peter Friedl
Israel Galván
Goldin+Senneby
O Grivo
Carsten Höller
Maurício Ianês
Joan Jonas
Armin Linke /
 Peter Hanappe
Dora Longo Bahia

Los Super Elegantes
Cristina Lucas
Allan McCollum
Rubens Mano
João Modé
Matt Mullican
Carlos Navarrete
Rivane Neuenschwander
Javier Peñafiel
Alexander Pilis
Paul Ramírez Jonas
Nicolás Robbio
Joe Sheehan
Gabriel Sierra
Valeska Soares
Vibeke Tandberg
Carla Zaccagnini

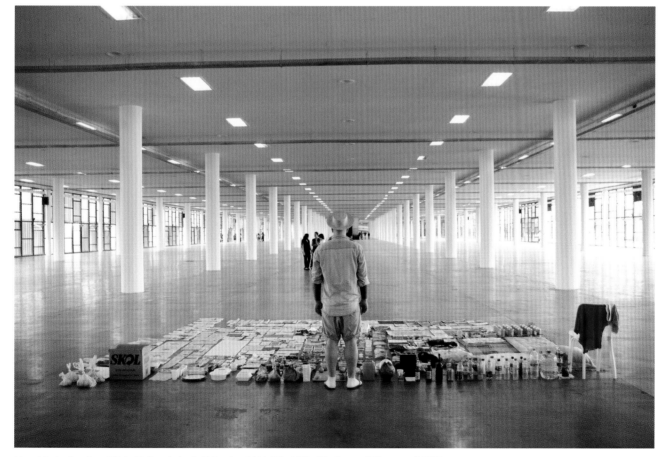

Maurício Ianês, *Sem Titulo (A Bondade de Estranhos) / Untitled (The Kindness of Strangers)*, 2008

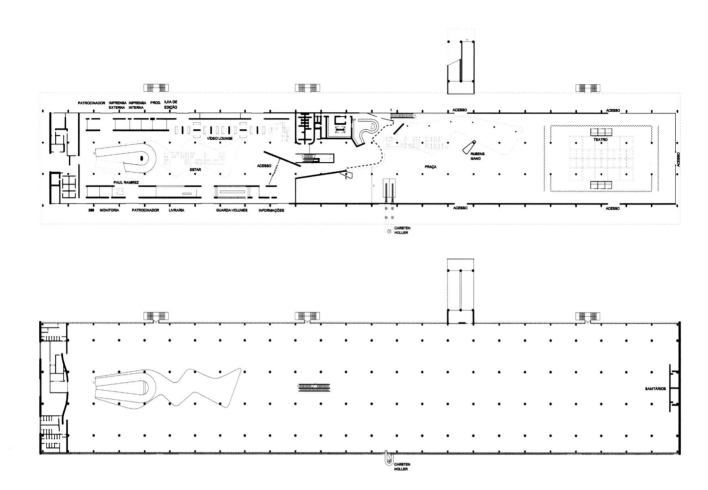

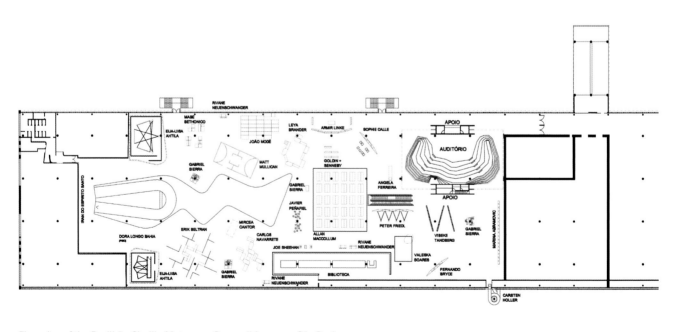

Floorplan of the Pavilhão Ciccillo Matarazzo, Parque Ibirapuera, São Paulo.
From top: the first, second, and third floor exhibition layouts

through a conceptual gesture that made their constraints transparent. The biennial was relatively barren of artworks, and it was separated into three radically different floors. The first floor was transformed into a public square with scheduled interdisciplinary events intended to facilitate social interactions. The second was left completely open— the "naked" section of the exhibition, so to speak— exposing the architectural structure and the physical qualities of the building. The third floor consisted of the exhibition, a library, and conference rooms.

This approach did not ward off skepticism, however, and controversy ensued even before the exhibition opened, mostly centering on the second-floor void. A renegade group known as the Pichadores sprayed graffiti all over this floor, protesting the curators' decision to leave it empty and allow the show to look so sparse.

Instead of trying to produce an all-encompassing and representative vision of the phenomenon of art today, it seems to be more important to sketch out specificities, and produce structural cartographies, setting in motion a process of investigative and critical, regular and systematic work that will keep pace with and productively account for movements and changes perceived within a given artistic circuit.

Ivo Mesquita and Ana Paula Cohen, "Introduction," in *28th Bienal de São Paulo: Guide*, Fundação Bienal de São Paulo, Brazil, 2008.

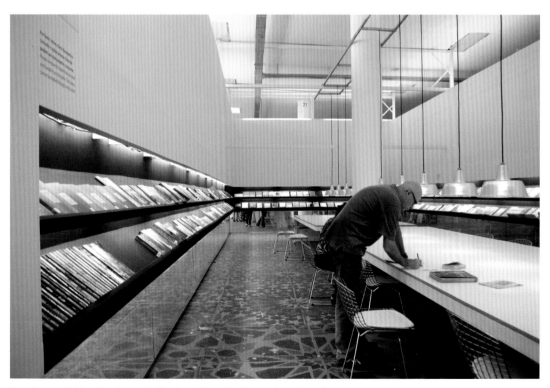

Dora Longo Bahia, *Escalpo 5063 (Scalp 5063)*, 2008, library view, third floor

An Unruly History of the Readymade

September 6, 2008 – March 6, 2009
Fundación/Colección Jumex,
Mexico City, Mexico

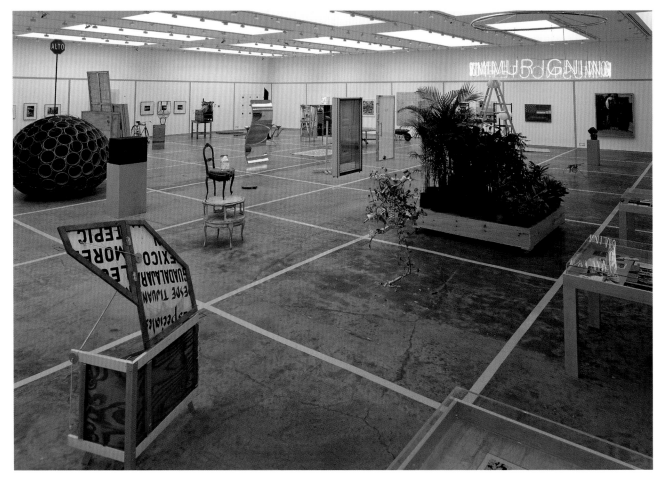

Installation view showing the yellow demarcations on the floor of the gallery space

Exhibition Title
An Unruly History
of the Readymade

Curator
Jessica Morgan

Dates
September 6, 2008 –
March 6, 2009

Location
Fundación/Colección Jumex,
Mexico City, Mexico

Publication
Jessica Morgan, ed.,
*An Unruly History of the
Readymade: Sixth Interpretation
of La Colección Jumex,*
Fundación/Colección Jumex,
Mexico City, 2008

Artists
Eduardo Abaroa
Allora & Calzadilla
Francis Alÿs

Carl Andre
John Baldessari
Mike Bidlo
Cezary Bodzianowski
Iñaki Bonillas
Mike Bouchet
Pedro Cabrita Reis
John Cage
Maurizio Cattelan
John Chamberlain
Marcelo Cidade
Claire Fontaine
Peter Coffin
Eduardo Costa
Abraham Cruzvillegas
Minerva Cuevas
Alexandre da Cunha
Jose Dávila
Stephen Dean
Marcel Duchamp
Elmgreen & Dragset
Urs Fischer
Fischli & Weiss
Dan Flavin
Ceal Floyer
Tom Friedman
Mario Garcia Torres

Thomas Glassford
Robert Gober
Félix González-Torres
Terence Gower
Daniel Guzmán
Mark Handforth
Philippe Hernandez
Damien Hirst
Jim Hodges
Carsten Höller
Roni Horn
Jonathan Horowitz
Jasper Johns
On Kawara
Martin Kippenberger
Jeff Koons
Joseph Kosuth
Gabriel Kuri
Louise Lawler
Gonzalo Lebrija
Jac Leirner
Sherrie Levine
Jorge Macchi
Marepe
Jason Meadows
Cildo Meireles
Beatriz Milhazes

Richard Moszka
Bruce Nauman
Gabriel Orozco
Damián Ortega
Richard Pettibone
Jack Pierson
Marjetica Potrč
Stephen Prina
Richard Prince
Robert Rauschenberg
Pedro Reyes
Vicente Rojo /
　　Octavio Paz
Marco Rountree Cruz
Regina Silveira
Gary Simmons
Rudolf Stingel
Sturtevant
Sofía Táboas
Rirkrit Tiravanija
Jacques Villeglé
Kelley Walker
Andy Warhol
Franz West
Christopher Williams
Cerith Wyn Evans
Gilberto Zorio

An Unruly History of the Readymade was a show of works from the Jumex Collection in Mexico City. Its aim was not simply to show selected readymade artworks, or to judge the included works against the standard of the great readymades of the 20th century, but rather to apply the principles of the readymade to the making of an exhibition. This application began at the very start, since curating a show for Jumex, or indeed for any circumscribed collection (in contrast to curating a loan-based exhibition) requires working with a "readymade" checklist, albeit in this case one that consists of more than 3,000 objects. The Jumex Collection has been the subject of multiple curators' foci, and a certain Duchampian "visual indifference" has come about with respect to the objects it contains, since many of them have been trotted out of storage year after year for various shows. Furthermore, this "readymade" selection of works exists in the context of the largest juice-production factory in Mexico. The stacked and crated artworks reside immediately next door to piled and wrapped pallets of Jumex juice, and it is difficult not to draw lines of comparison between the two. One pays for the other, and thus there is a certain interchangeability between the two entities

(how many juice pallets must be sold to buy one artwork crate?). There is also a remarkable visual correlation between product and artworks, given that many works in the collection, due to the overwhelming dominance of commercial culture in postwar art, actually resemble or are made out of products or product packaging.

The factory site provided an inspirational readymade environment for the exhibition. Works were installed in the Jumex gallery on a grid of eight by eight squares demarcated on the floor by the same yellow security lines that appear throughout the adjacent Jumex factory; in the factory they serve to guide the workers safely through the site. Each work was placed chessboard-style, in homage to Duchamp's favorite game, on one of the available squares, which continued up the walls for the hanging of the two-dimensional works. This mechanistic installation was continued in the placement of the works, which were presented chronologically according to creation date rather than according to any aesthetic, thematic, or art-historical criteria.

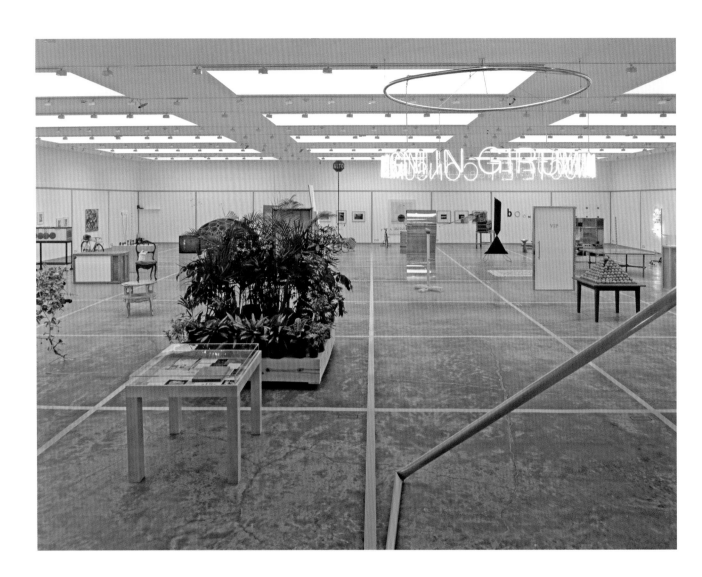

Above and opposite: Installation views with sculptural works

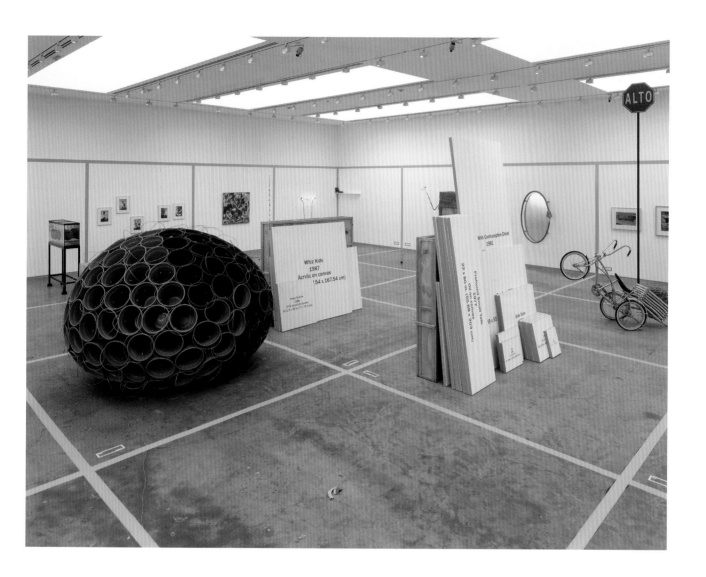

Others
Everywhere

The 1993
Whitney Biennial

In a
Different Light

31st Panorama
of Brazilian Art:
Mamõyguara
Opá Mamõ Pupé

11th
International
Istanbul Biennial:
What Keeps
Mankind Alive?

Phantom
Sightings:
Art After
the Chicano
Movement

Los Jaichackers (Julio Morales and Eamon Ore-Girón), *Migrant Dubs*, 2008, installation view from Phantom Sightings: Art After the Chicano Movement, Los Angeles County Museum of Art, California, USA, 2008

Others Everywhere

The United States in the 1990s was a hotbed of political debate, and many of the contested issues related to "identity politics," a catch-all term for matters that involve self-identified social groups, including those categorized by race, gender, class, national identity, and sexual orientation. The art world had become particularly embroiled in these issues in 1989 during controversies over National Endowment for the Arts (NEA) funding cuts stemming from a Robert Mapplethorpe exhibition at the Corcoran Gallery of Art in Washington, DC; the show had been funded in part by the NEA and included sexual imagery considered inappropriate by conservative politicians. The debates about the exhibition led directly to widespread discussions regarding the role of the museum as a site for displaying contemporary culture, and the place of the exhibition in investigating specific concerns and questions.

The 1993 Whitney Biennial was an early attempt to encapsulate issues related to identity politics; its curators selected works that dealt with controversial issues related to race, gender, and sexual orientation by a large number of artists who identified themselves with those categories. Other curators developed exhibitions that looked at identity as a core organizing principle. In 1995, the curator Lawrence Rinder and the artist Nayland Blake collaborated on In a Different Light, an exhibition that displayed a broad cross-section of queer artists and queer cultural influences from the 20th century. The 2008 exhibition Phantom Sightings: Art After the Chicano Movement was a large-scale traveling survey of an underrepresented group of Mexican–American artists. Curators internationally have used the exhibition format to problematize ideas of national identity—for instance the 31st Panorama of Brazilian Art: Mamõyguara Opá Mamõ Pupé ("Foreigners Everywhere"), organized by the Brazilian curator Adriano Pedrosa—or to reconsider quashed political movements, as in What, How and for Whom's 11th International Istanbul Biennial: What Keeps Mankind Alive?

The 1993 Whitney Biennial

February 24 – June 20, 1993
Whitney Museum of American Art,
New York, USA

Daniel J. Martinez, *Museum Tags: Second Movement (Overture) or Overture con Claque (Overture with Hired Audience Members)*, 1993

The 1993 Whitney Biennial at the Whitney Museum of American Art in New York was cited as a "watershed" show by the *New York Times* art critic Roberta Smith, and as the "most coherent biennial ever" by the critic Peter Schjeldahl. It also suffered a maelstrom of negative criticism, most of which accused it of being overly academic, aesthetically poor, and politically confused.

The Whitney Biennial was founded in 1932 as a means of showcasing the cutting edge of contemporary American art. The 1993 iteration was the first to take place under the museum directorship of David Ross, who was highly respected for supporting innovative contemporary art. Ross helped invigorate the proceedings by inviting artists and curators to show works that directly dealt with political and social issues in a much more explicit fashion than any previous edition. The result sparked in-depth conversations about the role of politics in art that are still hotly debated two decades later.

There were four curators: Elisabeth Sussman, Thelma Golden (the Whitney's first-ever African American curator), John Hanhardt and Lisa Philips. They selected a total of more than 150 works by 82 different artists. Quite controversially, the medium of painting was sidelined; the focus was on installation, video, and sculpture, with a particular emphasis on neo-conceptualist and political approaches. In addition to the Whitney's permanent film gallery on the second floor, two temporary video galleries were installed on the third and fourth floors, enabling the screening of a large volume of moving-image work. One of these, situated near the entrance of the museum, was George Holliday's amateur tape of the Rodney King beating that had sparked the Los Angeles riots the year before, thus opening up the show to work not created within the paradigm of fine art, and speaking directly to the exhibition's goal of broaching difficult political dialogue.

The curatorial statement declared an emphasis on artworks that "confront such dominant current issues as class, race, gender, sexuality, and the family." Other sociopolitical issues under consideration included Western imperialism and the mounting AIDS crisis. It was the most ethnically diverse Whitney Biennial to date. It also included a large number of women artists and artists who were openly gay.

Exhibition Title
The 1993 Whitney Biennial

Organizer
Whitney Museum
of American Art

Curators
Thelma Golden
John Hanhardt
Lisa Philips
Elisabeth Sussman

Dates
February 24 – June 20, 1993

Location
Whitney Museum of American
Art, New York, USA

Publication
Elisabeth Sussman, ed.,
1993 Biennial Exhibition,
Whitney Museum of
American Art, New York,
1993

Artists
Janine Antoni
Ida Applebroog

Charles Atlas
Matthew Barney
Sadie Benning
Camille Billops /
 James Hatch
Roddy Bogawa
Chris Burden
Peter Cain
Sophie Calle /
 Greg Shephard
Peter Campus
Christine Chang
Shu Lea Cheang
Maureen Connor
Julie Dash
Cheryl Dunye
Jimmie Durham
Jeanne C. Finley
Holly Fisher
Andrea Fraser
Miguel Gandert
Ernie Gehr
Robert Gober
Nan Goldin
Jean-Pierre Gorin
Renée Green
Michael Joaquín Grey /
 Randolph Huff
Gulf Crisis TV Project
Barbara Hammer

Gary Hill
George Holliday
William Jones
Mike Kelley
Karen Kilimnik
Byron Kim
Elizabeth LeCompte /
 The Wooster Group
Spike Lee
Zoe Leonard
Leone & Macdonald
Simon Leung
Glenn Ligon
Suzanne McClelland
Daniel J. Martinez
Donald Moffett
Christopher Münch
Not Channel Zero
Pepón Osorio
Raymond Pettibon
Jack Pierson
Lari Pittman
Lourdes Portillo
Mark Rappaport
Charles Ray
Jonathan Robinson
Alison Saar
Allan Sekula
Peter Sellars
Cindy Sherman

Gary Simmons
Lorna Simpson
Kiki Smith
Kiki Smith /
 David Wojnarowicz
Nancy Spero
Janice Tanaka
Julie Taymor
Francesc Torres
Trinh T. Minh-Ha
Willie Varela
Bill Viola
Marco Williams
Pat Ward Williams
Sue Williams
Fred Wilson
Kevin Wolff
Bruce Yonemoto /
 Norman Yonemoto /
 Timothy Martin

DANCENOISE
Kip Fulbeck
Marga Gomez
Guillermo Gómez-Peña /
 Coco Fusco
John Kelly
James Luna
Robbie McCauley
Mac Wellman

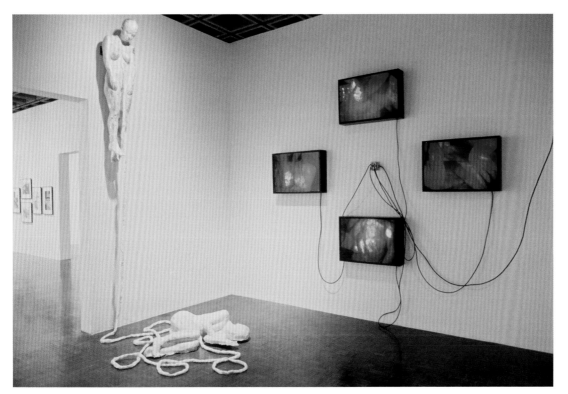

Installation view with Kiki Smith, *Untitled*, 1992–93 (left) and Kiki Smith with David Wojnarowicz, *Untitled*, 1980–92 (right)

In a Different Light

January 11 – April 9, 1995
University of California Berkeley Art Museum and
Pacific Film Archive, Berkeley, California, USA

What exactly is a lesbian or gay aesthetic sensibility? The 1995 exhibition In a Different Light at the University of California Berkeley Art Museum attempted to visualize an answer, acknowledging all along that that answer would be extraordinarily elusive and fluid. Curated by Lawrence Rinder with the artist Nayland Blake, the show included a wide range of artworks in multiple media produced over the preceding seven decades; in total there were more than 120 artists presenting over 200 works. It was the first attempt by a major museum to thematize an exhibition around how queer culture has been manifested in 20th-century American art. It surveyed artworks featuring gay and lesbian subject matter, and works that had been created by artists who identified as gay or lesbian (although the sexual preferences of individuals were never specified in the show or in the catalogue).

The curators organized their diverse survey into nine themes: Void, Self, Drag, Other, Couple, Family, Orgy, World, and Utopia. Works from historical avant-garde movements were touched upon as well, represented by several pieces of appropriation art from the 1980s, a large number of works produced in the 1970s as part of the feminist movement, and documentation of ephemeral actions by Fluxus artists in the 1950s

and 1960s. Precisely because the show was so sweeping in scope, visitors were made to realize the impossibility of pinning down what exactly constitutes gay, lesbian, or queer imagery. This ambiguity was purposeful, Rinder said, in order to make the exhibition "poetic, not polemic."

Overall, In a Different Light was praised by critics for creating a rich experience out of a subject that could easily have been presented in a narrow, myopic way. While the context in which the exhibition took place was exceptionally open to an endeavor like this, given the Bay Area's vibrant LGBT community, it was still a radical departure for a mainstream museum to undertake such a subject so openly and directly.

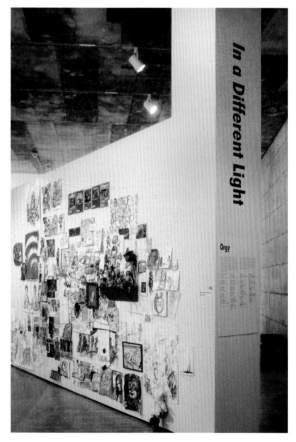

Installation view

Performance

In conjunction with the exhibition
In a Different Light
on view from January 11 through April 9, 1995

Stuart Sherman's Queer Spectacle

**Thursday
March 16
7:30 p.m.**

George Gund Theater and
museum galleries
Free

New York-based performance artist, film and
video maker, sculptor, and writer Stuart
Sherman presents media works in the George
Gund Theater at 7:30, followed by a solo
performance, *The Queer Spectacle*, at 8:00 in
the exhibition galleries.

Sherman offers a selection of whimsical,
cryptic, and queerly refreshing films and
videotapes, including *Piano Music, Me and
Joe, Pull,* and the premiers of *Don't Hang Up,
I'm Freezing,* and *Black and White & Grain.*

In *The Queer Spectacle* — described by
Sherman as "sex as idea, word, and object —
an exercise in self-identity" — the artist
manipulates objects on a TV tray to express,
humorously, poetically, and philosophically,
his personal experience as a gay man.

This Shared Voices project is made possible
through the Lila Wallace-Reader's Digest Fund
Museum Collections Accessibility Initiative.

Wheelchair accessible. To request disability-related
accommodations, please call: Voice-(510) 642-8344, or TDD-(510)
642-8734, Mondays-Fridays 9 am-5 pm. Please request
accommodations in order to assure the best possible arrangements.

UniversityArtMuseum PacificFilmArchive

2621 Durant Avenue, Berkeley
(between College Ave.& Bowditch St.)
For information call (510) 642-8344 weekdays 9-5

Public program flyer

Reading/Performance

In conjunction with the exhibition

In a Different Light

through April 9, 1995

**Sunday
April 2
2:30 p.m.**

George Gund Theater
Free with museum admission

Kevin Killian

reading *Cut*

Camille Roy

performing *The Rosy Medallions*

A pair of dramatic works by two Bay Area writers,
Kevin Killian and Camille Roy (AKA Megan
Adams) parallel themes in the exhibition.
Commissioned by the museum on the occasion of
In a Different Light, "Cut," the new play by Kevin
Killian, is a fantasia about a retrospective of
Alfred Hitchcock films organized by a local film
society. Killian is a playwright, novelist, and poet
whose forthcoming book is *Three Plays for San
Francisco Poet's Theater.*

Camille Roy presents a performance featuring parts of her recently published book *The
Rosy Medallions*, plus a new work. "Sex life, sex death — I don't have an opinion. I have
a waist and a knife instead." Roy is a writer and a performer of plays, poems and stories.

Education programs are funded in part by the
Margaret Calder Hayes Memorial Fund.

Wheelchair accessible. To request disability-related
accommodations, please call: Voice-(510) 642-8344, or TDD-(510)
642-8734, Mondays-Fridays 9 am-5 pm. Please request
accommodations in order to assure the best possible arrangements.

Illustrated: General Idle, *Baby Makes 3, 1984-89*

For information call
(510) 642-2358 weekdays 9-3

UniversityArtMuseum PacificFilmArchive

2626 Bancroft Way, Berkeley
(between College Ave.& Bowditch St.)

Public program flyer

University Art Museum and Pacific Film Archive

In a Different Light

January 11 - April 9, 1995

2626 Bancroft Way
Berkeley, CA.
510/642-0808

W, F, S, Su: 11 am - 5 pm
Th: 11 am - 9 pm
M, T: closed

Exhibition flyer

We can debate whether
identifiable gay or lesbian
sensibilities as such exist;
however, we certainly cannot
clarify the issue so long as
important artists remain
closeted—either by their
own or by others' efforts.

Lawrence Rinder, "An Introduction to In A Different
Light," in Nayland Blake, Lawrence Rinder, and Amy
Scholder, eds., *In A Different Light: Visual Culture,
Sexual Identity, Queer Practice*, City Lights Books,
San Francisco, 1995.

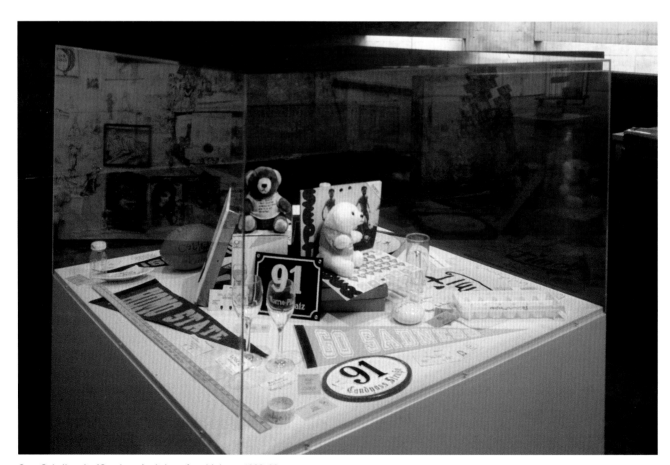

Cary S. Leibowitz (Candyass), vitrine of multiples, *c.*1988–93

Exhibition Title
In a Different Light

Curators
Nayland Blake
Lawrence Rinder

Dates
January 11 – April 9, 1995

Location
University of California Berkeley
Art Museum and Pacific Film
Archive, Berkeley, California,
USA

Publication
Nayland Blake, Lawrence
Rinder, and Amy Scholder,
eds., *In a Different Light:
Visual Culture, Sexual
Identity, Queer Practice*,
City Lights Books, San
Francisco, 1995

Artists
Vito Acconci
Kathy Acker
Amy Adler
Laura Aguilar
D-L Alvarez
Diane Arbus
Lyle Ashton Harris
Lutz Bacher
Judie Bamber
Lynda Benglis
Ross Bleckner
Louise Bourgeois
Romaine Brooks

Richmond Burton
Scott Burton
Jerome Caja
Judy Chicago
Arch Connelly
Dennis Cooper
Tee A. Corinne
Joseph Cornell
David Dashiell
John Defazio
Kate Delos
Charles Demuth
Diane Dimassa
Marcel Duchamp
David Dupuis
Nicole Eisenman
Sally Elesby
Vincent Fecteau
Tony Feher
Louise Fishman
General Idea
 (AA Bronson / Felix Part /
 Jorge Zontal)
Gilbert & George
John Giorno
Robert Gober
Nan Goldin
Jewelle Gomez
Tony Greene
Nancy Grossman
Jonathan Hammer /
 Linda Matalon
Harmony Hammond
Donna Han
Keith Haring
Lyle Ashton Harris
Marsden Hartley
Richard Hawkins
Geoffrey Hendricks

Eva Hesse
Scott Hewicker
David Hockney
Jim Hodges
Jenny Holzer
Roni Horn
Peter Hujar
Robert Indiana
Tyler Ingolia
Michael Jenkins
Jasper Johns
Larry Johnson
G.B. Jones
Deborah Kass
Mike Kelley
Karen Kilimnik
The Kipper Kids
Barbara Kruger
Suzanne Lacy
Thomas Lanigan-Schmidt
Kevin Larmon
Charles Ledray
Cary S. Leibowitz (Candyass)
Rudy Lemcke
Zoe Leonard
Sherrie Levine
Siobhan Liddell
Glenn Ligon
John Lindell
George Maciunas
Monica Majoli
Christopher Makos
Robert Mapplethorpe
Reginald Marsh
Marlene McCarty
McDermott & McGough
Kate Millett
Donald Moffett
Robert Morris

Ree Morton
Nicholas Mouffarege
Carrie Moyer
Peter Nagy
Claes Oldenburg
Catherine Opie
Alvin Orloff
Joel Otterson
Paul Pfeiffer
Jack Pierson
Lari Pittman
Richard Prince
J. John Priola
Pruitt & Early
Man Ray
Rex Ray
Brett Reichman
Hunter Reynolds
Betye Saar
Connie Samaras
Alan Saret
Carolee Schneemann
Collier Schorr
The Sex Pistols
Stuart Sherman
Jack Smith
Teresa A. Smith
Joan Snyder
Valerie Solanas
Pavel Tchelitchew
Carmelita Tropicana
David Tudor
Nicola Tyson
Andy Warhol
Simon Watson
Millie Wilson
David Wojnarowicz
Steve Wolfe
Martin Wong

31st Panorama of Brazilian Art: Mamõyguara Opá Mamõ Pupé

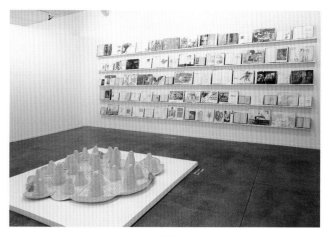

Pedro Reyes, *Sombrero colectivo*, 2004

October 4 – December 20, 2009
Museu de Arte Moderna de São Paulo,
Parque do Ibirapuera, São Paulo, Brazil

Mamõyguara Opá Mamõ Pupé was the name given
to the 31st Panorama of Brazilian Art held in 2009.
Curated by Adriano Pedrosa, the exhibition included
more than 30 artists and was hosted in the Museu
de Arte Moderna de São Paulo. This edition was
controversial because it included only artists
from outside Brazil, whereas previous Panoramas
had been specifically dedicated to showcasing
contemporary Brazilian art. The only other time
the exhibition had featured work by foreign artists
was in 2003, when the curator Gerardo Mosquera
had included just three.

The title of the exhibition was borrowed from a
work by the artist duo Claire Fontaine. It translates
as "foreigners everywhere" in the language of the
local Tupi Indians, who are alleged to have uttered
it in reaction to Portuguese explorers disembarking
in Brazil. As the curatorial statement of intent put
forth: "This Panorama is also a response to the
excessively domestic focus of the exhibitions
organized by most local institutions. There is a
need for international exhibitions curated for our
context." Many of the foreign artists created work
that spoke about Brazilian culture, art, or history
in some way. Much like Pedrosa's 24th São Paulo
Biennial a decade earlier, Mamõyguara Opá

Mamõ Pupé characterized Brazilian culture as open
and "cannibalistic," in that it systematically borrows
imagery and techniques from other cultures and
incorporates them into its own.

To accomplish the goal of bringing out the
"Brazil" in foreign art, eight artists were invited
to undertake a six-month residency. Contrary
to the usual intention of residencies, they were
asked not to create artwork during this time, but
rather to immerse themselves in the local culture
as much as possible in anticipation of the exhibition.
Visually, the show did not reflect the exotic view
of Brazil generally adopted by outsiders. Instead,
many of the artists focused heavily on formal
genres such as geometric abstraction, which
stems from the Neoconcretism movement of
the 1960s.

Despite all the controversy and hostility that
Mamõyguara Opá Mamõ Pupé generated,
a contingent of artists and educators defended
the exhibition, embracing its challenging
methodology.

Exhibition Title
31st Panorama of Brazilian Art:
Mamõyguara Opá Mamõ Pupé

Organizer
Museu de Arte Moderna
de São Paulo

Curator
Adriano Pedrosa

Dates
October 4 – December 20, 2009

Location
Museu de Arte Moderna de São
Paulo, Parque do Ibirapuera,
São Paulo, Brazil

Publication
Adriano Pedrosa, *Mamõyguara
Opá Mamõ Pupé. 31° Panorama
da Arte Brasileira*, Museu de
Arte Moderna de São Paulo,
2010

Artists
Franz Ackermann
Allora & Calzadilla
Armando Andrade Tudela
Juan Araujo
Alessandro Balteo Yazbeck /
 Eugenio Espinoza
Claire Fontaine
José Dávila
Simon Evans
Sandra Gamarra

Carlos Garaicoa
Dominique Gonzalez-Foerster
Nicolas Guagnini with
 Carla Zaccagnini /
 Nicolas Robbio /
 Pablo Siquier /
 Valdirlei Dias Nunes
Tamar Guimarães
Runo Lagomarsino
Luisa Lambri
Mateo López
Mauricio Lupini
Jorge Macchi
Jorge Pedro Núñez
Damián Ortega
Juan Pérez Aguirregoikoa
Marjetica Potrč
Pedro Reyes

Julião Sarmento
Gabriel Sierra
Sean Snyder
Tove Storch
SUPERFLEX
Adrián Villar Rojas
Cerith Wyn Evans

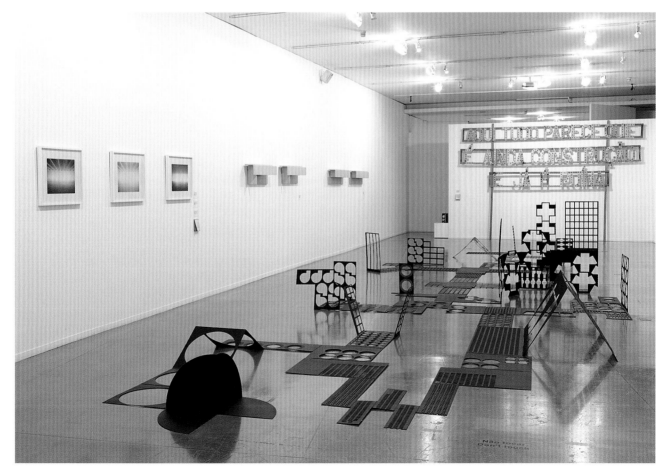

Installation view with Allora & Calzadilla, *Ruin*, 2006

11th International Istanbul Biennial: What Keeps Mankind Alive?

September 12 – November 8, 2009
Antrepo No. 3, Feriköy Greek School, and
Tobacco Warehouse, Istanbul, Turkey

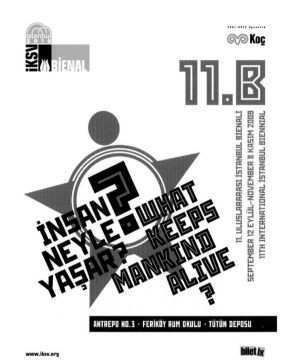

Exhibition poster

The 11th International Istanbul Biennial, presented in 2009, was titled What Keeps Mankind Alive? after a song from Bertolt Brecht's 1928 play *The Threepenny Opera*. Taking inspiration from Brecht's political and artistic motivations, the curators What, How and for Whom (WHW)—a nonprofit organization and curatorial collective from Zagreb, Croatia, that includes Ivet Curlin, Ana Dević, Natasa Ilić, and Sabina Sabolović—asked why Brecht's ambitions have fallen out of style. With the current triumph of neoliberal capitalism and the withering away of the Marxist Left as a viable political force, WHW believed the question of what keeps mankind alive to be even "more urgent and topical than when it was first posed by Brecht in 1928."

Inviting more than 70 international artists (many from Eastern Europe and Central Asia) to take part, the curators hoped to draw out the ways in which some of Brecht's artistic methods—collective creativity, epic theater, *Verfremdungseffkt* (estrangement effect), and art as a means for popularizing education—are evident in contemporary art practices. They did not take Brecht's methods too literally, but rather treated them openly, since they were interested in representing artworks that were politically committed in the same way that

Page from the accreditation booklet

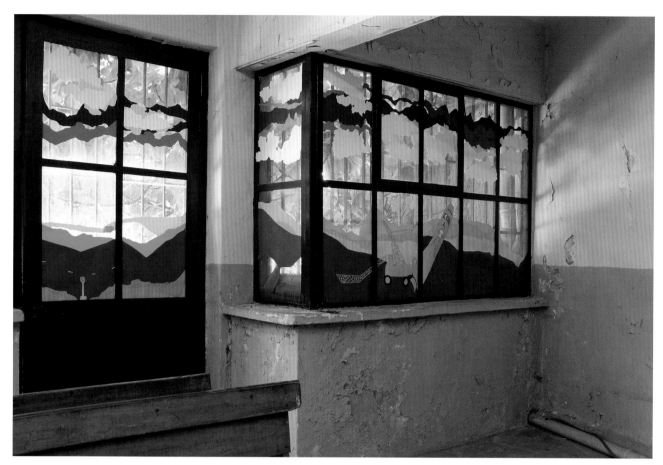

Lisi Raskin, *Control Room*, 2008

Brecht had been. All media were included, from montage to installation, photography, and drawing, but video played an especially large role. The exhibition was unabashedly pedagogical and activist, seeking to create a real political effect. In Marxian fashion, the curators exposed the mechanisms of the production of the biennial itself, for instance by publicizing the demographics of the artists and the costs associated with putting on the show.

What Keeps Mankind Alive? was located in three different venues, one being the biennial's usual warehouse space, Antrepo No. 3. The others were non-art venues: an old tobacco warehouse and Feriköy Greek School. Overall, the show received positive reviews for its ambitious attempt to merge art and politics as well as its uniqueness in challenging the normal structure and raison d'être of a biennial. Even though the curators were working

with delicate themes that normally provoke criticism—didactic art, political content and a lofty and dangerously overdetermined theme—they avoided many potential pitfalls.

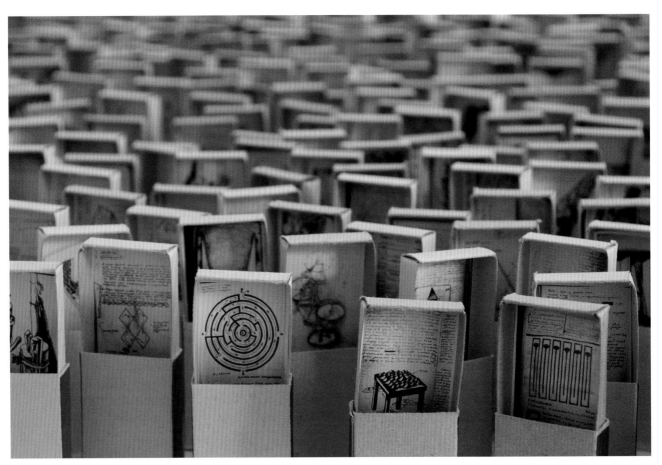

Vyacheslav Akhunov, *1m2* (detail), 2007

Exhibition Title
11th International Istanbul
Biennial: What Keeps
Mankind Alive?

Organizer
iksv—Istanbul Kültür Sanat
Vakfı (Istanbul Foundation
for Culture and Arts)

Curators
What, How and for Whom

Dates
September 12 –
November 8, 2009

Locations
Antrepo No. 3
Feriköy Greek School
Tobacco Warehouse

Publications
What, How and for Whom
and İlkay Baliç, eds., *11th
International Istanbul Biennial
Reader: What Keeps Mankind
Alive?*, iksv—Istanbul Kültür
Sanat Vakfı, Istanbul, 2009

What, How and for Whom
and İlkay Baliç, eds., *11th
International Istanbul Biennial
Guide*, iksv—Istanbul Kültür
Sanat Vakfı, Istanbul, 2009

Artists
Jumana Emil Abboud
Vyacheslav Akhunov
Mounira Al Solh
Nevin Aladağ
Hüseyin Bahri Alptekin
Doa Aly
Karen Andreassian
Yüksel Arslan
Zanny Begg
Lidia Blinova
Anna Boghiguian
KP Brehmer
Bureau d'études
Cengiz Çekil
Chto delat? (What is to
be done?)
Danica Dakić
Lado Darakhvelidze
Decolonizing.ps
(Sandi Hilal /
Alessandro Petti /
Eyal Weizman)

Natalya Dyu
Rena Effendi
Işıl Eğrikavuk
Etcétera
Hans-Peter Feldmann
Shahab Fotouhi
İnci Furni
Igor Grubić
Nilbar Güreş
Margaret Harrison
Sharon Hayes
Vlatka Horvat
Wafa Hourani
Hamlet Hovsepian
Sanja Iveković
Donghwan & Haejun Jo
Jesse Jones
Alimjan Jorobaev
Michel Journiac
KwieKulik
Siniša Labrović
David Maljković
Marwan
Avi Mograbi
Rabih Mroué
Aydan Murtezaoğlu /
Bülent Şangar
Museum of American Art,
Belgrade

Marina Naprushkina
Deimantas Narkevičius
Ioana Nemes
Wendelien van Oldenborgh
Mohammed Ossama
Erkan Özgen
Trevor Paglen
Nam June Paik
Marko Peljhan
Darinka Pop-Mitić
Lisi Raskin
María Ruido
Larissa Sansour
Hrair Sarkissian
Ruti Sela /
Maayan Amir
Canan Şenol
Société Réaliste
Tamás St. Auby
Mladen Stilinović
Jinoos Taghizadeh
Oraib Toukan
Vangelis Vlahos
Simon Wachsmuth
Artur Żmijewski

Newspaper explaining the exhibition's premise

Exhibition poster

Phantom Sightings: Art After the Chicano Movement

April 6 – September 1, 2008
Los Angeles County Museum of Art,
California, USA, and touring

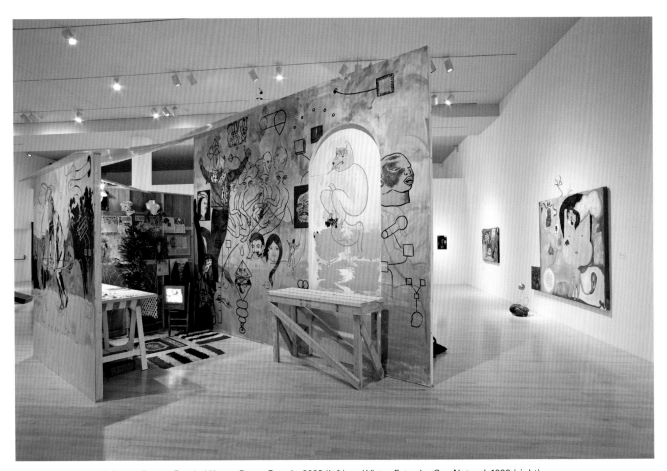

Installation view with Arturo Romo, *Rended House Drops Facade,* 2008 (left) and Victor Estrada, *Soy Natural,* 1992 (right)

Exhibition Title
Phantom Sightings:
Art after the Chicano Movement

Organizers
Los Angeles County Museum
of Art in conjunction with the
Chicano Studies Research
Center, UCLA

Curators
Howard N. Fox
Rita Gonzalez
Chon A. Noriega

Dates
April 6 –
September 1, 2008

Location
Los Angeles County Museum
of Art, California, USA

Tour Locations and Dates
Tamayo Museum of
 Contemporary Art, Mexico
 City, Mexico, October 16, 2008
 – January 11, 2009
Museo Alameda, San Antonio,
 Texas, USA, March 12 – June
 14, 2009
Phoenix Art Museum, Arizona,
 USA, July 25 – October 4,
 2009
Museo de Arte de Zapopan,
 Guadalajara, Jalisco, Mexico,
 November 6, 2009 – January
 31, 2010
El Museo del Barrio and The
 Americas Society, New York,
 USA, March 21 – June 6, 2010

Publication
Rita Gonzalez, Howard N. Fox,
and Chon A. Noriega, *Phantom
Sightings: Art after the Chicano
Movement*, University of
California Press, Berkeley,
California, 2008

Artists
Scoli Acosta
Asco
Margarita Cabrera
Juan Capistran
Carolyn Castaño
Alejandro Diaz
Adrian Esparza
Victor Estrada
Carlee Fernandez
Christina Fernandez
Harry Gamboa, Jr.
Gary Garay
Ken Gonzalez-Day
Gronk (Glugio Gronk Nicandro)
Danny Jauregui
Nicóla Lopez

Los Jaichackers (Julio César
 Morales & Eamon Ore-Giron)
Sandra de la Loza
Jim Mendiola
Delilah Montoya
Ruben Ochoa
Cruz Ortiz
Rubén Ortiz-Torres
Marco Rios
Arturo Romo
Shizu Salamando
Eduardo Sarabia
Patssi Valdez
Jason Villegas
Mario Ybarra, Jr.

Phantom Sightings: Art After the Chicano Movement was an international traveling exhibition curated by Rita Gonzalez, Howard N. Fox, and Chon A. Noriega in 2008, featuring more than 100 works in a variety of media by 30 different artists. A remark by the artist Harry Gamboa, Jr. that Chicano culture has been a kind of phantom presence in history, largely ignored and unrecognized by the mainstream, inspired the title. The Chicano movement and its accompanying art began to form in the 1960s and 1970s with Puerto Rican activism in New York. The movement emphasized political empowerment and ethnic pride over issues such as civil rights or immigration.

Phantom Sightings was unique in format compared to past shows looking at art originating from Mexican-American culture. Usually such art is treated as an identity or style, whereas Phantom Sightings focused attention on the conceptual strategies that the artists use to bring awareness to the public. It also focused on emerging artists from around the United States, many of whom do not consider themselves as working under a "Chicano art" label. The show included experimental works that incorporated performance, video, photography, and film, often capturing guerilla art interventions in public life such as culture jamming. For instance, Alejandro Diaz made an installation based on a public performance in which he had dressed in a white suit to look like a modern-day dandy and stood in front of Tiffany & Co. selling cardboard signs to exiting consumers with slogans such as "Mexican Wallpaper" or "Looking for Upper East Side lady with nice clean apt. (must have cable)." The exhibition became a much-needed introduction to the art production of a young generation of Mexican-American artists and their experiences in the United States.

> Phantom Sightings adjusts its thematic focus on artists whose practices evidence an awareness of street aesthetics as a transnational landscapes of signs and forms of address.
>
> Rita Gonzalez, "Phantom Sites: The Official, The Unofficial, and the Orifficial," in Rita Gonzalez, Howard N. Fox, and Chon A. Noriega, *Phantom Sightings: Art After the Chicano Movement*, University of California Press, Berkeley, California 2008.

Following pages: Installation view

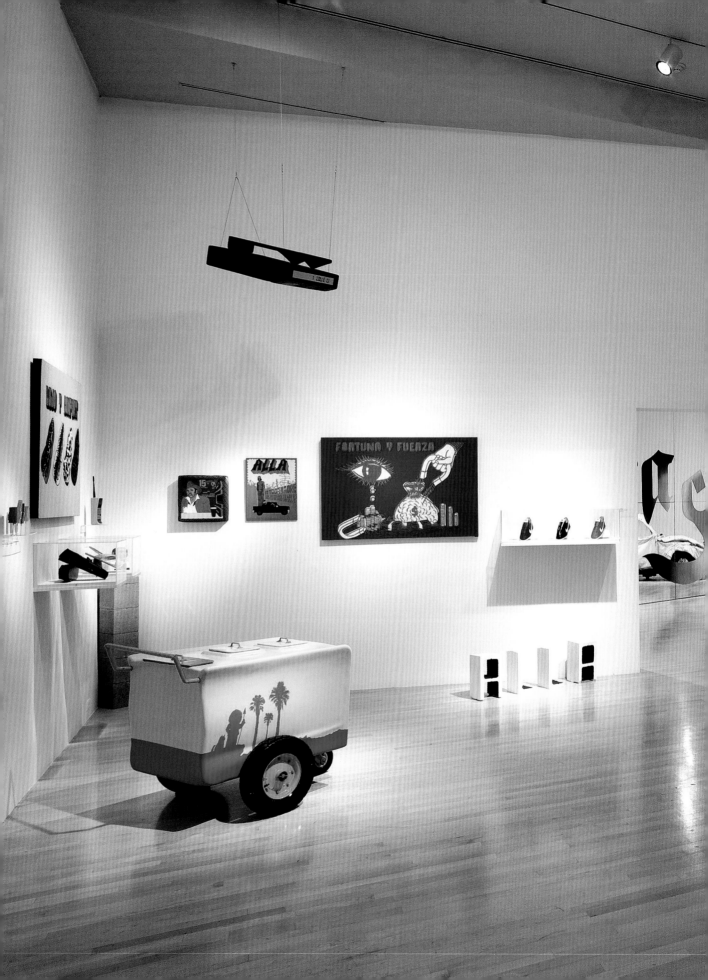

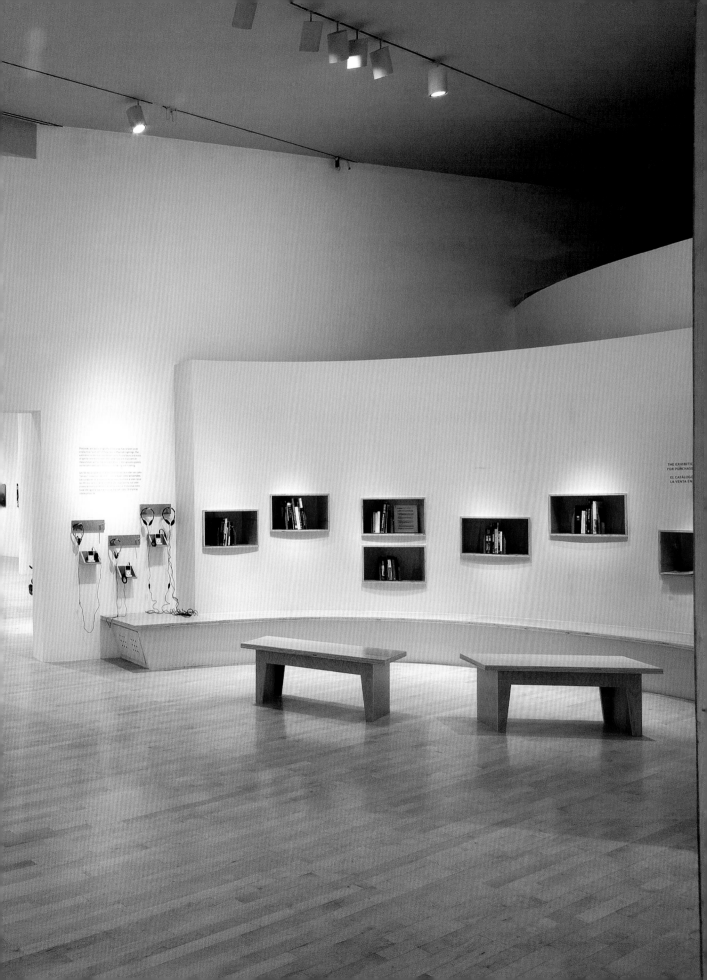

Tomorrow's Talents Today

No Man's Time

Helter Skelter:
L.A. Art
in the 1990s

Traffic

Sensation:
Young British
Artists from
the Saatchi
Collection

Freestyle

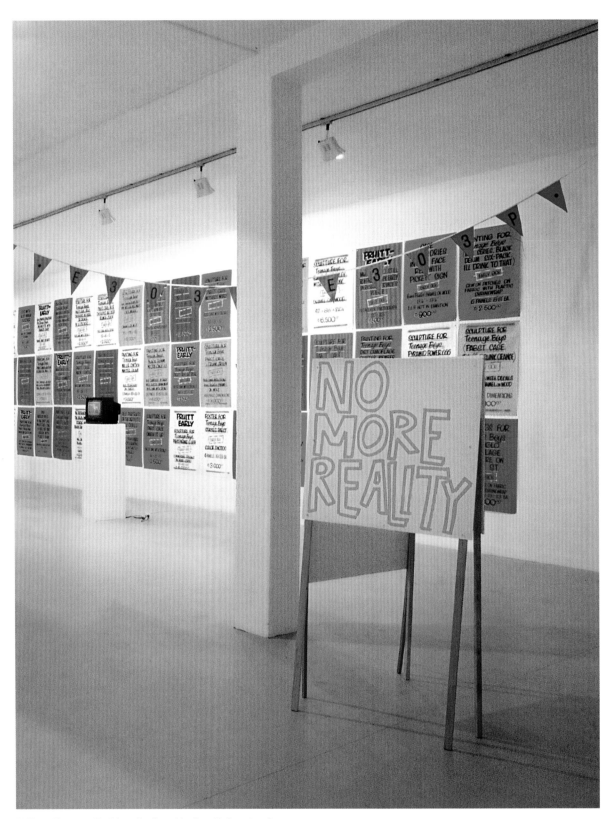

Philippe Parreno, *No More Reality*, 1991, installation view from
No Man's Time, Centre National d'Art Contemporain — Villa Arson,
Nice, France, 1991

Tomorrow's Talents Today

This section looks at exhibitions that have been noted as launching points that defined important groups or affiliations of artists over the last 20 years. Organizing shows according to an artistic group or "school" is one of the oldest and most prevalent curatorial approaches, originating in the Parisian salons of the 19th century. One of the main objectives has traditionally been to find and foster new artistic talents and place them in contextualized categories. While art in the late 20th century has been characterized as abandoning distinctive styles and movements in favor of a plurality of artistic voices and expressions, several movements still stand out, as defined by a number of influential exhibitions.

Éric Troncy's 1991 exhibition, No Man's Time at the Centre National d'Art Contemporain—Villa Arson in Nice, France, was a group exhibition of site-responsive, process-based works that resulted from one-month residencies by all the artists. This exhibition laid the groundwork for Nicolas Bourriaud's 1996 show Traffic at the CAPC Musée d'Art Contemporain in Bordeaux, and subsequently his influential text *Relational Aesthetics* (1998) that analyzed this new generation of young artists and their dedication to producing works that are situated somewhere between the exhibition site and the viewer. Sensation: Young British Artists from the Saatchi Collection, a traveling exhibition of the work of a group of artists known as the Young British Artists (YBAs), caused a stir in the late 1990s over the controversial aesthetics and tactics of the participants, particularly as received by American audiences at the Brooklyn Museum. Thelma Golden's 2001 exhibition Freestyle brought the term "post-black" into existence as an organizing principle for considering a new generation of African American artists whose work was less defined by identity politics than that of their forebears. Other influential exhibitions, such as Paul Schimmel's 1992 exhibition Helter Skelter: L.A. Art in the 1990s at The Museum of Contemporary Art, Los Angeles, have been organized around regional artistic scenes.

No Man's Time

July 6 – September 30, 1991
Centre National d'Art Contemporain—Villa Arson,
Nice, France

Installation view with Johan Muyle, *Oh!...La Barbe*, 1991

No Man's Time was held in 1991 at the Centre
National d'Art Contemporain—Villa Arson in Nice,
France. It was curated by Éric Troncy and Christian
Bernard, and included 22 artists working in a
wide range of media. An essential aspect of the
curators' organizational premise was to invite all
the participating artists to arrive a month early and
carry out residencies; the intention was to encourage
them to collaborate on their works. Troncy's diary and
notes from the residency period were later published
as the main components of the exhibition catalogue.

The theme involved a mixing of the "real" and the
"fantastical." This was posited as a response to the
historical events of the era: specifically the fall of
Communism in the Soviet Union and Eastern
Europe, an increasingly globalized market, and the
rise of neoliberal capitalism. At the time, the future
seemed open to many different possibilities,
and major new chapters of history were being
written. Reflecting this worldview, the No Man's
Time artists investigated process-based works in
performance, theater, and film. They experimented
with intermingling their works with their life activities
so that the division between the two would be blurred,
as the Fluxus artists did in the 1950s and 1960s with
their "happenings." While most of the works were

Philippe Parreno, *No More Reality*, 1991

Exhibition Title
No Man's Time

Curators
Christian Bernard
Éric Troncy

Dates
July 6 – September 30,
1991

Location
Centre National d'Art
Contemporain—Villa Arson,
Nice, France

Publication
Éric Troncy, *No Man's
Time*, Centre National
d'Art Contemporain—
Villa Arson, Nice,
1991

Artists
Richard Agerbeek
Henry Bond / Liam Gillick
BP
Angela Bulloch
Sylvie Fleury
Dominique Gonzalez-Foerster
Félix González-Torres
Manuel Ismora
Pierre Joseph
Karen Kilimnik
Richard Kongrosian

Aimee Morgana
Johan Muyle
Philippe Parreno
Raymond Pettibon
Pruitt & Early
Allen Ruppersberg
Jim Shaw
Lily van der Stokker
Xavier Veilhan

Guest Star
Martin Kippenberger

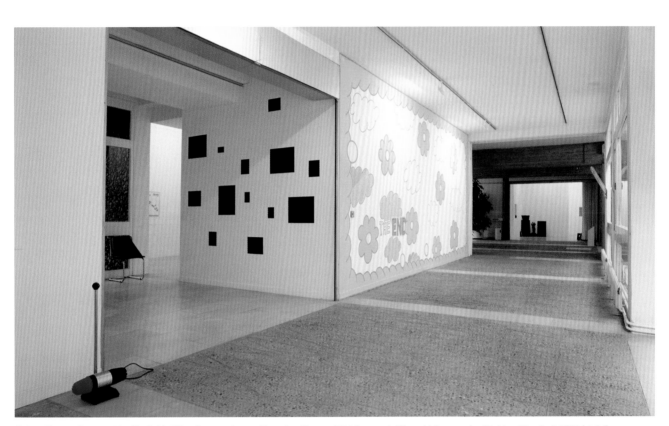

Sylvie Fleury, *Dusty*, 1991 (far left), Allen Ruppersberg, *Negative Space*, 1991 (center left), and Lily van der Stokker, *The End*, 1991 (right)

entirely devoid of political context and action, they were influenced by a particular political environment.

Very much in response to the Villa as a context, the final products were in many cases some kind of documentation of the process of building relationships with other artists and the space, framing these very site- and time-specific activities as the artistic medium itself. Troncy used a humorous metaphor in his diary to explain this communal and social aspect: "If one wanted to keep an image of No Man's Time and its preparation, it would without

doubt be that of a barbecue." This approach to art making and exhibiting was formalized and given a name—relational aesthetics—by the curator Nicolas Bourriaud, who specifically cited No Man's Time as formative to this kind of practice. It was the spark for a major international art movement based on open-ended, intersubjective relationships rather than discrete objects. No Man's Time brought together for the first time a group of artists, all of about the same age, who would during the 1990s collaborate and work together on a number of further occasions, most notably Bourriaud's Traffic in 1996.

Helter Skelter: L.A. Art in the 1990s

January 26 – April 26, 1992
The Museum of Contemporary Art, Los Angeles,
California, USA

Nancy Rubins, *Trailers and Hot Water Heaters*, installation, 1992

Helter Skelter: LA Art in the 1990s took place
at the Museum of Contemporary Art, Los Angeles,
in 1992 and included 16 artists who either hailed
from or were based in Los Angeles at the time.
The title refers to the apocalyptic war predicted
in the late 1960s by the serial killer Charles
Manson, who claimed that it would come about
as a result of racial tensions between black and
white communities. (Manson appropriated the
name from a 1968 Beatles song.) The exhibition's
curator, Paul Schimmel, intended this grim reference
to conjure what he called "the darker, angst-ridden
side of contemporary life" in Los Angeles as opposed
to the city's usual associations with sunny weather,
movies, and fun. He hoped to present the unique
quality of art produced by local artists in the 1990s
while also speaking more generally of the zeitgeist
of the late 20th century, which he believed to be
an overriding sense of doom and "psychological
alienation, dispossession, and disorder."

True to its sensational title, Helter Skelter
included a good deal of colorful, graphic—and
shocking—imagery, with loud, in-your-face sex and
violence. Most of the artworks borrowed in various
ways from pop-cultural sources such as cartoons,
pulp novels, rock music and even cult religions and

Not only do the works
presented address darkness
rather than light, but, taken
together, they show that L.A.
does have a culture of its own,
that its community is different
from others, and that, in this
case, "regional" art need not
bear the burden of provincialism.

Paul Schimmel, "Into the Maelstrom: L.A. Art
at the End of the Century," in Catherine Gudis,
ed., *Helter Skelter: L.A. Art in the 1990s*, The
Museum of Contemporary Art, Los Angeles, 1992.

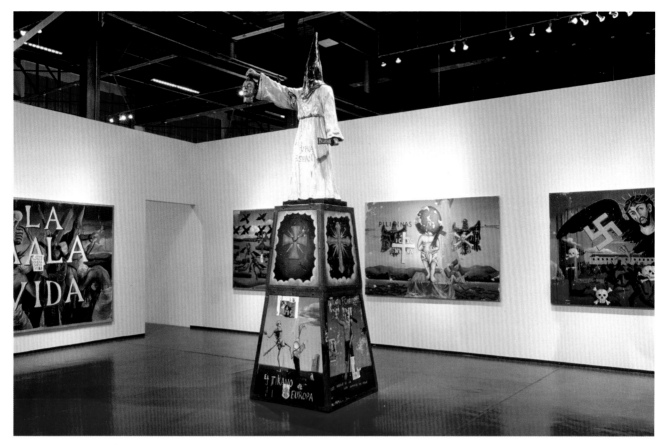

Installation by Manuel Ocampo

extremist politics. The aim seemed to be to strike as many nerves and social taboos as possible. Schimmel himself wrote that none of the art on display had "do-gooder" intentions related to improving political life or presenting solutions to social problems. Instead, the selections were intentionally decadent, and exemplified a demoralizing and obscene state of mind.

Accompanying the exhibition was a book with 10 new essays on the subject of the political and social history of Los Angeles and the cultural movement known as LA Noir, upon which Helter Skelter drew heavily. It was one of the most talked-about shows of the year. There were strong responses from critics, many of them negative. As the *New York* *Times*'s Michael Kimmelman put it, Helter Skelter posed as a "substantial and challenging" exhibition when it really only expressed a kind of "adolescent nihilism." It has become iconic, however, since it brought together an impressive number of talented artists and cemented LA's status as one of the world's most creative and important cities in the visual arts.

Installation view

Exhibition Title
Helter Skelter:
L.A. Art in the 1990s

Organizer
The Museum of
Contemporary Art,
Los Angeles

Curator
Paul Schimmel

Dates
January 26 – April 26, 1992

Location
The Museum of
Contemporary Art,
Los Angeles, California, USA

Publication
Catherine Gudis, ed., *Helter
Skelter: L.A. Art in the 1990s*,

The Museum of Contemporary
Art, Los Angeles, 1992

Artists
Chris Burden
Meg Cranston
Victor Estrada
Llyn Foulkes
Richard Jackson
Mike Kelley
Liz Larner

Paul McCarthy
Manuel Ocampo
Raymond Pettibon
Lari Pittman
Charles Ray
Nancy Rubins
Jim Shaw
Megan Williams
Robert Williams

Paul McCarthy, *The Garden*, 1991–92

Traffic

January 26 – March 24, 1996
CAPC Musée d'Art Contemporain,
Bordeaux, France

Peter Land, *Pink Space*, installation, 1995

All of the 30 artists brought together for the 1996 exhibition Traffic, despite the great diversity of their approaches, had an interest in common: activating relationships between people. The works they made for the show were platforms for the viewer to become a participant in the creative process—to transcend the role of passive visual consumer.

Traffic was curated by Nicholas Bourriaud at the CAPC Musée d'Art Contemporain in Bordeaux, France. Bourriaud—whose seminal book *Relational Aesthetics*, published after the exhibition opened, became the authoritative definition of that strand of art—organized the exhibition as an experiment in thinking about art as a form of social interaction. He reflected 10 years later: "It was one of those moments when an emerging aesthetic paradigm took form and became visible, when an artistic generation was shaped."

The venue was an old warehouse building that had been converted into a gallery, which meant that there was a great deal of open space at Bourriaud's disposal. Some works served as physical and metaphorical platforms with which the audience could engage. Others documented relational situations that the artists had enacted in advance of the opening of the show. This documentation took different forms; viewers were confronted with everything from large pink sculptures to a multitude of videos. The artist Rirkrit Tiravanija, for example, displayed dirty dishes left over from past suppers that he had organized. The work was the residue, or an index, of past relational encounters.

Bourriaud wanted Traffic to expand the definition of what contemporary art might entail, and he situated the artists as carrying avant-garde traditions into the 1990s, but critics remained skeptical. "Traffic and Bourriaud's concept of 'relationality,'" wrote *frieze* critic Carl Freedman, "were just too unspecific to be capable of defining a new art, especially when so many of the works did little to support the exhibition's premise."

Despite the skepticism, Traffic marked a turning point in contemporary art, and relational aesthetics became a dominant practice that remains influential today. The project helped Bourriaud concretize some of the ideas that he later published in his book; the curatorial effort tested the book's ideas in practice.

Exhibition Title	**Location**	Jes Brinch /	Carsten Höller
Traffic	CAPC Musée d'Art	Henrik Plenge Jakobsen	Pierre Huyghe
	Contemporain,	Angela Bulloch	Peter Land
Organizer	Bordeaux, France	Maurizio Cattelan	Miltos Manetas
CAPC Musée d'Art		Andrea Clavadetscher /	Gabriel Orozco
Contemporain,	**Publication**	Eric Schumacher	Jorge Pardo
Bordeaux	Nicolas Bourriaud,	Honoré d'O	Philippe Parreno
	Traffic, CAPC Musée d'Art	Liam Gillick	Jason Rhoades
Curator	Contemporain, Bordeaux,	Dominique Gonzalez-Foerster	Christopher Sperandio /
Nicolas Bourriaud	1996	Douglas Gordon	Simon Grennan
		Jens Haaning	Rirkrit Tiravanija
Dates	**Artists**	Lothar Hempel	Xavier Veilhan
January 26 –	Vanessa Beecroft	Christine Hill	Gillian Wearing
March 24, 1996	Henry Bond	Noritoshi Hirakawa	Kenji Vanobe

Philippe Parreno, *Werktische*, installation, 1995

Installation view with Liam Gillick, *(The What If? Scenario) Dining
Table*, 1996 and *(The What If? Scenario) Discussion Zone*, 1996

Vanessa Beecroft, VB18, performance, 1996

Sensation: Young British Artists from the Saatchi Collection

September 18 – December 28, 1997
Royal Academy of Arts, London, UK,
and touring

Sensation: Young British Artists from the Saatchi Collection carried out the self-fulfilling prophecy of its title, stirring up the public and critics alike. It showcased approximately 90 works by 42 young artists, known collectively as the Young British Artists, or YBAs. Many were members of a tight-knit group of friends who had recently graduated from Goldsmiths College, London. The commercial successes of the YBAs had by this time far exceeded what might otherwise have been expected, given their relatively young age, due to the fact that the art collector Charles Saatchi, by becoming their chief patron, had focused massive international attention upon them. Saatchi, an infamous advertising magnate (known for his campaigns for Britain's Conservative party) and a voracious contemporary art collector, joined forces with curator Norman Rosenthal to select for this show some of his favorite works from his massive personal collection, which then numbered approximately 1,500 pieces.

Sensation was presented at the Royal Academy of Arts in London in 1997. It drew record attendance for the venue, with more than 300,000 visitors over the course of the show. It then traveled to the Hamburger Bahnhof in Berlin in 1998, and to the Brooklyn Museum in 1999. The work encompassed a variety of styles and artistic approaches, but all, according to Rosenthal, had "public resonance" because of the young artists' "totally raw and radical attitude to realism, or rather to reality and real life itself." Many of the artists in Sensation overtly referenced previous art developments, used shock tactics, applied (often black) humor, and challenged orthodox views—so much so that the show caused heated controversies in the media and sparked protests by all types of groups on both the left and the right. One of the biggest reactions was to Chris Ofili's painting of the Virgin Mary that incorporated elephant dung.

Many religious groups and even New York City's mayor, Rudolph Giuliani, called the show indecent and sought to close it down. Others found offensive Saatchi's conspicuous treatment of emerging artists as tradable commodities, and suspected that Sensation was just a money-making machine; Saatchi was known to routinely buy a young artist's work to heighten his or her profile and then immediately sell it for a much higher price. For better or worse, this is the art market that exists today, and it is mostly attributable to Saatchi, who has recently started to distance himself from some of his past methods. Even though Sensation was the show that brought the YBAs to popular attention, it has been called the beginning of the end of the phenomenon. What started with the radical Freeze in 1988 had by 1997 become an institutionalized exercise in market speculation.

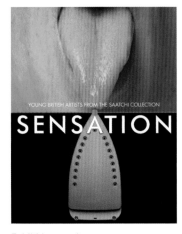

Exhibition catalogue

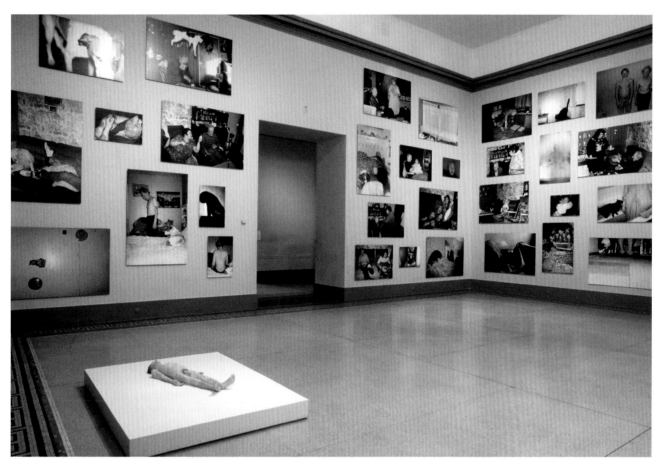

Installation view with Ron Mueck, *Dead Dad*, 1996–97

Following pages: Rachel Whiteread,
Untitled (One Hundred Spaces), 1995

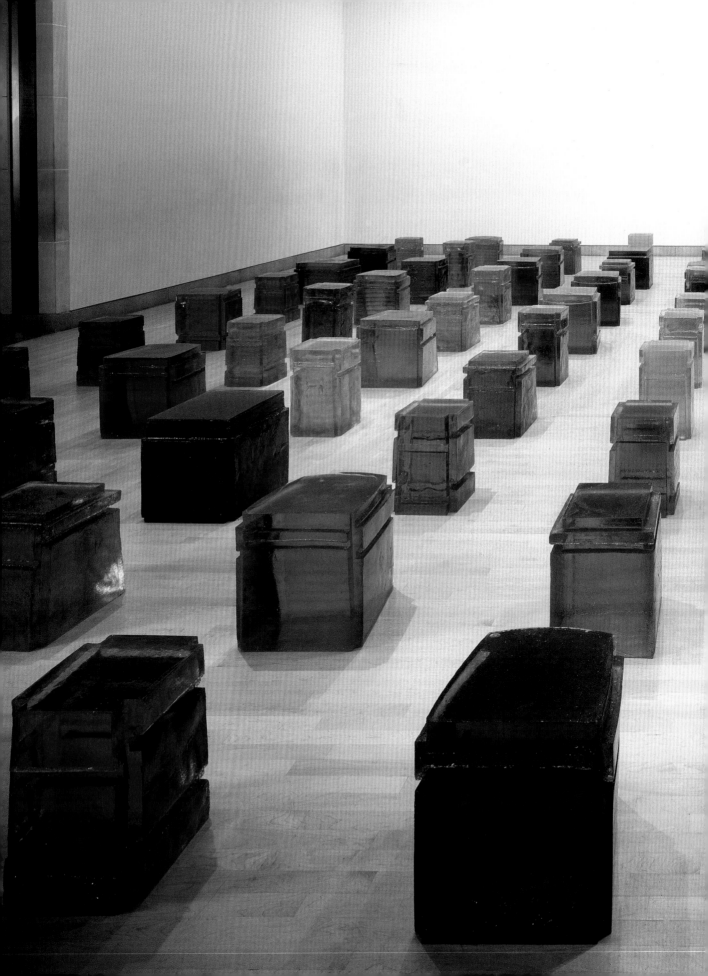

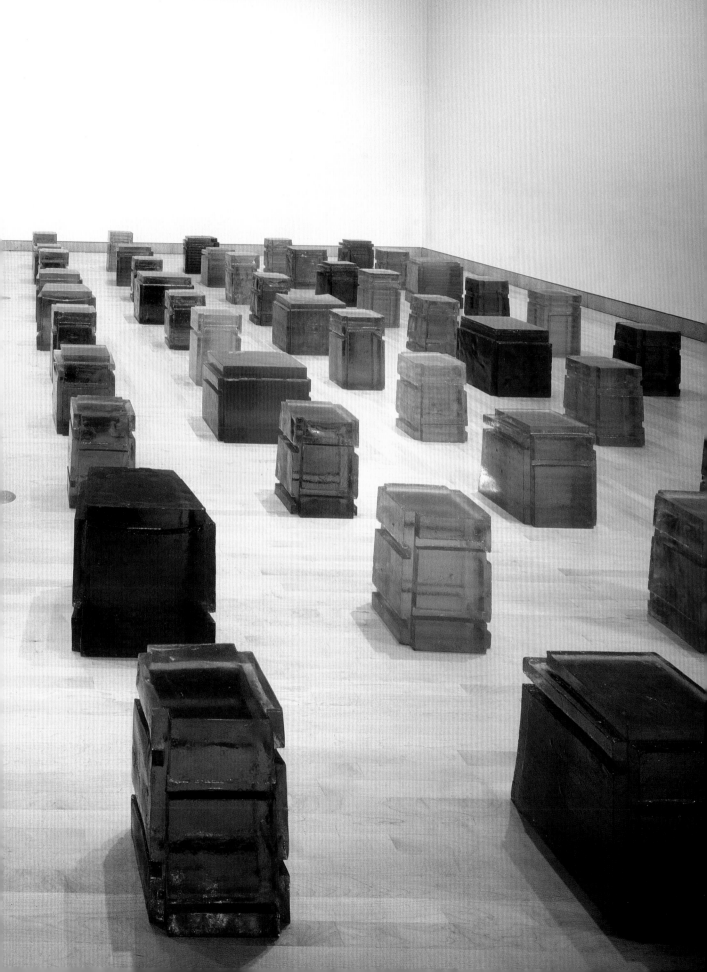

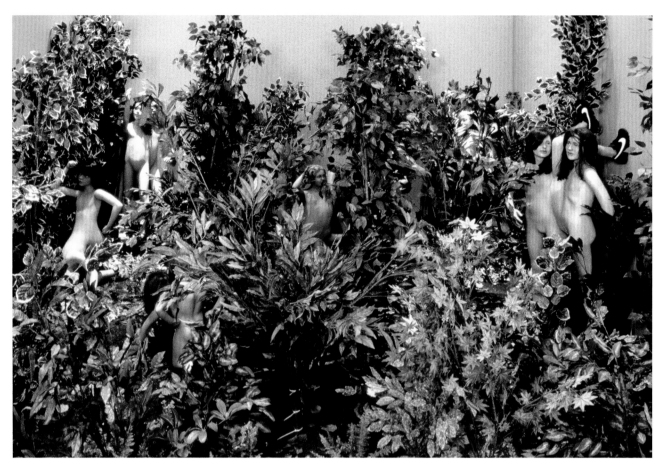

Jake and Dinos Chapman, *Tragic Anatomies: Cunt Chops*, 1996

Exhibition Title
Sensation: Young British Artists
from the Saatchi Collection

Curators
Norman Rosenthal
Charles Saatchi

Dates
September 18 –
December 28, 1997

Location
Royal Academy of Arts,
London, UK

Tour Locations and Dates
Hamburger Bahnhof, Berlin,
 Germany, September 30,
 1998 – January 30, 1999
Brooklyn Museum, New York,
 USA, October 2, 1999 –
 January 9, 2000

Publication
Brooks Adams, Lisa Jardine,
Martin Maloney, Norman
Rosenthal, and Richard Shone,
with photography by Johnnie
Shand Kydd, *Sensation: Young
British Artists from the Saatchi
Collection*, Thames & Hudson
in association with the Royal
Academy of Arts, London, 1997

Artists
Darren Almond
Richard Billingham
Glenn Brown
Simon Callery
Jake & Dinos Chapman
Adam Chodzko
Mat Collishaw
Keith Coventry
Peter Davies
Tracey Emin
Paul Finnegan

Mark Francis
Alex Hartley
Marcus Harvey
Mona Hatoum
Damien Hirst
Gary Hume
Michael Landy
Abigail Lane
Langlands & Bell
Sarah Lucas
Martin Maloney
Jason Martin
Alain Miller
Ron Mueck
Chris Ofili
Jonathan Parsons
Richard Patterson
Simon Patterson
Hadrian Pigott
Marc Quinn
Fiona Rae
James Rielly
Jenny Saville

Yinka Shonibare
Jane Simpson
Sam Taylor-Wood
Gavin Turk
Mark Wallinger
Gillian Wearing
Rachel Whiteread
Cerith Wyn Evans

Chris Ofili, *The Holy Virgin Mary*, 1996

Freestyle

April 28 – June 24, 2001
The Studio Museum in Harlem, New York, USA,
and touring

Eric Wesley, *Kicking Ass*, 2000

Freestyle was a 2001 exhibition at The Studio Museum in Harlem, New York, curated by Thelma Golden, who, prior to her appointment at The Studio Museum, had been a curator at the Whitney Museum of American Art. Freestyle subsequently traveled to the Santa Monica Museum of Art in California. All of the 28 participants in the exhibition were young, emerging African American artists from the United States. They were working in multiple media; painting was dominant, but there were several video and film works, photographs, and sculptural pieces.

Golden was interested in creating a show on black artists in response to their underrepresented status in museums, galleries, and art-history books. The multicultural turn in the 1980s and 1990s did a great deal to open up the art world to minority artists and histories, a change that directly inspired Golden in organizing Freestyle. She described the exhibition as representing a "post-black" phase, in the sense that the artworks themselves could not be reduced to speaking for some kind of homogenous "black" identity. She intended the term "post-black" simultaneously to negate and affirm the notion of blackness. As she wrote in the catalogue, the artists are "adamant about not being labeled 'black' artists, though their work was steeped, in fact deeply

interested, in redefining complex notions of blackness." Hence, the main intention was to problematize and open up the terms that constituted black identity and culture by using some of the strategies set by those terms against themselves.

The show had no explicit theme, but all the artists approached their art with a certain cultural understanding that brought their diverse practices together coherently (for example, dealing with issues such as racism, hip-hop, otherness, and social justice). Even though many of the topics were politically heavy, humor and satire lightened the mood of the exhibition. Throughout, Golden was intent on focusing on the differences and individuality of the artworks, in much the same way as improvised freestyling in hip-hop is, in Golden's words, a "relentless and unbridled expression of the self."

Exhibition Title
Freestyle

Organizer
The Studio Museum in Harlem,

Curator
Thelma Golden

Dates
April 28 – June 24, 2001

Location
The Studio Museum in
Harlem, New York, USA

Tour Locations and Dates
Santa Monica Museum of Art,
California, USA, September 28
– November 18, 2001

Publication
Thelma Golden, ed., *Freestyle*,
The Studio Museum in Harlem,
New York, 2001

Artists
Laylah Ali
John Bankston
Sanford Biggers
Mark Bradford

Louis Cameron
Rico Gatson
Deborah Grant
Kojo Griffin
Adler Guerrier
Trenton Doyle Hancock
Tana Hargest
Kira Lynn Harris
David Huffman
Jerald leans
Rashid Johnson
Vincent Johnson
Jennie C. Jones
Arnold J. Kemp
Dave McKenzie

Julie Mehretu
Adia Millett
Kori Newkirk
Camille Norment
Senam Okudzeto
Clifford Owens
Nadine Robinson
Susan Smith-Pinelo
Eric Wesley

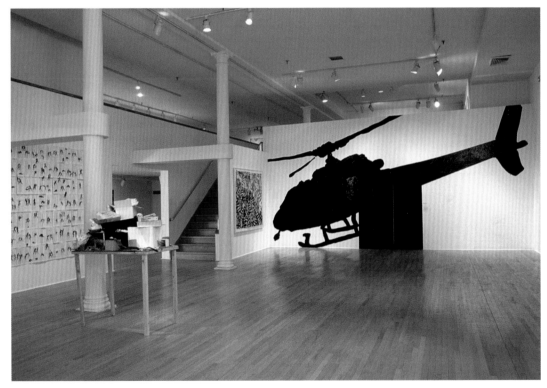

Installation view

History

Inside the
Visible:
An Elliptical
Traverse of 20th
Century Art in,
of, and from
the Feminine

Reconsidering
the Object
of Art:
1965–1975

Out of Actions:
Between
Performance
and the Object,
1949–1979

Global
Conceptualism:
Points of Origin,
1950s–1980s

WACK!
Art and the
Feminist
Revolution

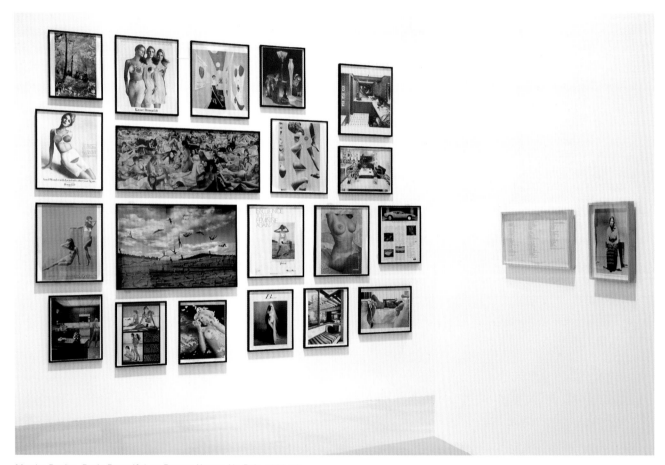

Martha Rosler, *Body Beautiful, or Beauty Knows No Pain*, 1966–72
(left) and Faith Wilding, *Waiting*, 1972 (right), installation view from
WACK! Art and the Feminist Revolution, The Geffen Contemporary at
The Museum of Contemporary Art, Los Angeles, California, USA, 2007

History

This group of exhibitions took a long view of 20th-century art history, looking at a few of the many developments that derived from post-World War II art in Western Europe and the United States, and occasionally further afield. These movements included Conceptualism, performance, feminism, and others. Reconsidering the Object of Art, curated by Ann Goldstein and Anne Rorimer for the Museum of Contemporary Art, Los Angeles, in 1995, examined the legacy of Conceptualism from 1965 to 1975. Another exhibition in 1999 looked at Conceptualism and its legacy from a broad international perspective: Global Conceptualism: Points of Origin, 1950s–1980s was a touring show organized by the Queens Museum of Art that looked into conceptual movements in Asia, Australia, Eastern Europe, and Latin America in addition to the Western world. Out of Actions: Between Performance and the Object examined performance as a process and the objects that are left-overs of that process, featuring works made by more than 150 artists in the 30-year period from 1949 to 1979.

Some of the biggest surveys to reconsider movements from the second half of the 20th century focused on traditionally overlooked female artists and the legacy of feminism in artistic practice. Two exhibitions, Catherine de Zegher's Inside the Visible: An Elliptical Traverse of 20th Century Art in, of, and from the Feminine and Connie Butler's WACK! Art and the Feminist Revolution were major leaps forward in the understanding and exposure of female artists of the 20th century. As with Global Conceptualism, the curators were not just responsible for the organization and display of historical work, but were also involved in the rewriting of art history by giving marginalized artists and movements a voice and a story.

Inside the Visible: An Elliptical Traverse of 20th Century Art in, of, and from the Feminine

April 16, 1994 – May 28, 1995
Béguinage of Saint-Elizabeth, Kortrijk, Belgium
and touring

Inside the Visible: An Elliptical Traverse of 20th Century Art in, of, and from the Feminine was curated by Catherine de Zegher and included more than 250 works by 37 international female artists. Of these, only a handful were well-known; de Zegher gave priority to artists of the "margins" who had helped shape the history of 20th-century modern art, but had as yet received little recognition from museums.

Seeking to problematize the stark categories of "male" and "female," de Zegher developed the exhibition with the aim of moving beyond what she called the "artificiality of oppositional thinking," instead using the philosophies of deconstruction, feminism and post-structuralism as the theoretical grounding for her curatorial approach. Selecting a variety of artists from different time periods and countries, she proposed constellations of historical "fragments" related to the social, the political, and the economic. The chronological moments

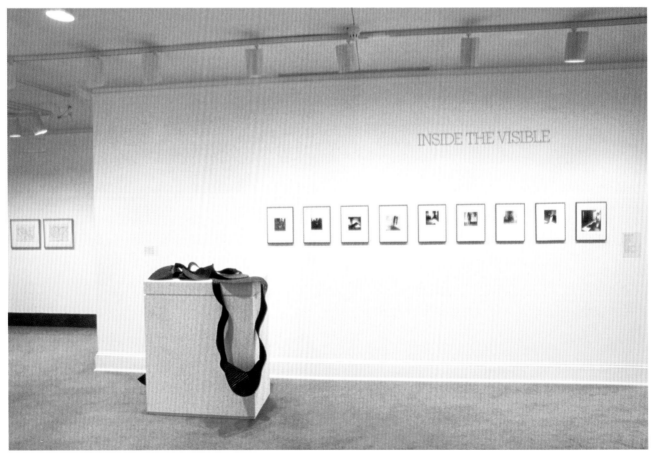

Installation view from the exhibition's tour to the National Museum of Women in the Arts, Washington, DC, USA, 1996

Exhibition Title
Inside the Visible: An Elliptical
Traverse of 20th Century Art
in, of, and From the Feminine

Honorary Exhibition Title
Cultural Ambassador of
Flanders (name granted
by the Flemish Government)

Organizer
Kanaal Art Foundation

Curator
Catherine de Zegher

Dates
April 16, 1994 – May 28, 1995

Location
Béguinage of Saint-Elizabeth,
Kortrijk, Belgium

Tour Locations and Dates
Institute of Contemporary
Art, Boston, USA,
January 31 – May 12,
1996
National Museum of
Women in the Arts,
Washington, DC, USA,
June 15 – September 15,
1996
Whitechapel Gallery,
London, UK, October 11
– December 8, 1996

Publication
Catherine de Zegher, ed.,
*Inside the Visible: An
Elliptical Traverse of 20th
Century Art in, of, and
From the Feminine*, MIT
Press, Cambridge,
Massachusetts, 1996

Artists
Louise Bourgeois
Claude Cahun
Emily Carr
Thesesa Hak Kyung Cha
Lygia Clark
Hanne Darboven
Lili Dujourie
Ellen Gallagher
Gego
Mona Hatoum
Nathalie Hervieux
Eva Hesse
Susan Hiller
Hannah Höch
Ann Veronica Janssens
Katarzyna Kobro
Yayoi Kusama
Bracha Lichtenberg Ettinger
Anna Maria Maiolino
Agnes Martin
Ana Mendieta

Avis Newman
Carol Rama
Martha Rosler
Charlotte Salomon
Mira Schendel
Lynn Silverman
Nancy Spero
Jana Sterbak
Sophie Taeuber-Arp
Nadine Tasseel
Ana Torfs
Joëlle Tuerlinckx
Cecilia Vicuña
Maria Helena Vieira da Silva
Carrie Mae Weems
Francesca Woodman

on which she focused were the 1930s–40s, the 1960s–70s, and the 1990s. The floor plan was organized into four sections, titled "Parts of/for," "The Blank in the Page," "The Weaving of Water and Words," and "Enjambment: La donna è mobile," in order to reflect poetically on historical classification systems, creating a thematic web that spoke to each moment. The sections did not lead the viewer around in a linear, narrative-like fashion, but rather converged at the center, allowing for a multiplicity of possible paths through the show. Nor were the sections organized chronologically. Rather, they juxtaposed art of different historical eras, locations, and media in a way that supported the thematic associations.

Inside the Visible first showed in 1994 at the Béguinage of Saint-Elizabeth in Kortrijk, Belgium, as a response to a series of 12 shows held there the year before. The site, significantly, was originally a 13th-century quasi-religious housing arrangement for females who opted to live an existence free of men. The exhibition traveled to two venues in the United States—the Institute of Contemporary Art in Boston and the National Museum of Women in the Arts in Washington, DC—and to the Whitechapel Gallery in London,

UK. Inside the Visible was well received for its challenging subject matter and comprehensive nature. Its alternative history of 20-century art effectively pushed forward the legacy of female artists during this time, giving them added visibility and opening up their work for consideration and debate on a larger scale.

Installation view from the exhibition's tour to the National Museum of Women in the Arts, Washington, DC, USA, 1996

Reconsidering the Object of Art: 1965–1975

October 15, 1995 – February 4, 1996
The Museum of Contemporary Art, Los Angeles,
California, USA

The years 1965 to 1975 were a major moment in contemporary art; not since the early 20th century had art undergone such a drastic questioning of its own meaning and its path forward. The exhibition Reconsidering the Object of Art: 1965–1975 offered a comprehensive exposé of various artists who challenged the form, function, and meaning of art over the course of that decade. Curated by Ann Goldstein and Anne Rorimer and held at The Museum of Contemporary Art, Los Angeles, in 1995–96, it included 55 artists from the United States, Canada, and Europe. A notable similar exhibition, L'Art conceptual: Une perspective, had taken place six years earlier at the Musée d'Art Moderne de la Ville de Paris. Reconsidering the Object of Art was much richer and more comprehensive, however, with 18 more artists on its roster.

The exhibition was not chronologically or thematically organized. Since many of the conceptual works were performative and meant to be time- and site-specific, the curators chose not to re-create them, and instead displayed relics and documentation related to them. They also relied heavily on text placards throughout the space to provide information about the works and their historical context. Overall, the show was text-heavy, since much Conceptual art, like Lawrence Weiner's large texts on walls, or John Baldessari's texts on canvases, incorporated language.

Hans Haacke, Adrian Piper, and Sol LeWitt protested the sponsorship of the show by Philip Morris, the gargantuan tobacco company. However, while Piper and LeWitt insisted on withdrawing their works from the show altogether, Haacke's piece stayed in, with his typed petition tacked onto the wall beside it. Critics, for their part, were mostly satisfied with the exhibition, although some commented on the exclusion of certain key Conceptual artists.

The association of Conceptual Art with the primacy of the idea, in some cases to the point of the elimination of a physical art object, does represent a key strategy.

Making use of non-art forms and systems drawn from the conventions of everyday life, and of diverse disciplines such as anthropology, philosophy, and literature, the resulting works were pointedly removed from the traditional object of art.

Ann Goldstein and Anne Rorimer, in *Reconsidering the Object of Art: 1965-1975*, Museum of Contemporary Art, Los Angeles, 1995.

Exhibition Title
Reconsidering the Object
of Art: 1965–1975

Curators
Ann Goldstein
Anne Rorimer

Dates
October 15, 1995 –
February 4, 1996

Location
The Museum of Contemporary
Art, Los Angeles, California,
USA

Publication
Ann Goldstein and Anne
Rorimer, eds., *Reconsidering
the Object of Art: 1965–1975*,
MIT Press, Cambridge,
Massachusetts, and The
Museum of Contemporary
Art, Los Angeles, 1995

Artists
Vito Acconci
Bas Jan Ader
Giovanni Anselmo
Eleanor Antin
Art & Language
Michael Asher
David Askevold
John Baldessari
Robert Barry
Lothar Baumgarten
Bernd & Hilla Becher
Mel Bochner
Marcel Broodthaers
Stanley Brouwn
Daniel Buren
Victor Burgin
André Cadere
James Coleman
Hanne Darboven
Jan Dibbets
Peter Downsbrough
Ger van Elk
Morgan Fisher
Gilbert & George

Dan Graham
Hans Haacke
Douglas Huebler
Joan Jonas
Stephen J. Kaltenbach
On Kawara
John Knight
Joseph Kosuth
Christine Kozlov
David Lamelas
William Leavitt
Sol LeWitt
Richard Long
Tom Marioni
Gordon Matta-Clark
N.E. Thing Co.
Bruce Nauman
Maria Nordman
Dennis Oppenheim
Blinky Palermo
Giulio Paolini
Adrian Piper
Yvonne Rainer
Allen Ruppersberg
Edward Ruscha

Robert Smithson
Michael Snow
Niele Toroni
William Wegman
Lawrence Weiner
Ian Wilson

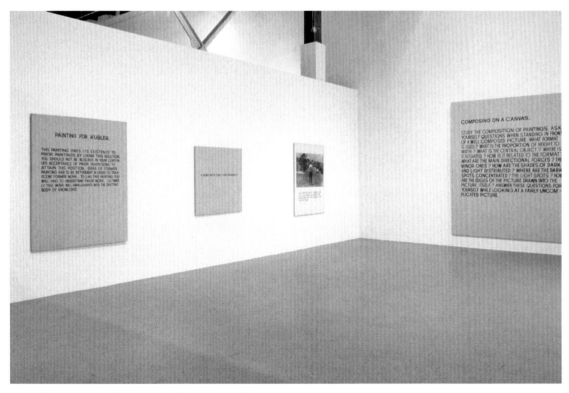

Installation view with John Baldessari (left to right), *Painting for
Kubler*, 1967–68, *A Work with Only One Property*, 1967–68, *The
Spectator is Compelled...*, 1967–68, and *Composing a Canvas*,
1967–68. (Reconsidering the Object of Art: 1965–1975, 1995–96.
Photo courtesy of The Museum of Contemporary Art, Los Angeles)

Out of Actions: Between Performance and the Object, 1949–1979

February 8 – May 10, 1998
The Museum of Contemporary Art,
Los Angeles, California, USA,
and touring

Since performance art is usually ephemeral, few people actually get to see the work live. For most, it is a secondhand experience, apprehended later via documentation, relics, or indexes. The international traveling exhibition Out of Actions: Between Performance and the Object, 1949–1979 was an attempt to convey how performance art, as a process, takes form via objects, whether the objects are planned sketches or documentation of the event. As the curatorial statement noted, the goal was to provide viewers with an understanding of the relationship between action, performance, and the creative process, covering three decades of the postwar era and featuring more than 150 artists from around the world.

Out of Actions was curated by Paul Schimmel together with an international advisory team. It was originally organized and shown at the Museum of Contemporary Art, Los Angeles, in 1998, and over the next year it traveled around the globe to MAK—Austrian Museum of Applied Arts, Vienna; Museu d'Art Contemporani, Barcelona; and Museum of Contemporary Art, Tokyo. It featured numerous media and all kinds of documents, from publications to drawings, photography, film, and video. A special emphasis was given to the early

history of performance and process art and how this work emerged out of more traditional, object-based forms such as painting and sculpture. As Schimmel stated, "It is really not a performance show—that's one thing I was completely clear on."

Although the main focus was on artists from America, Europe, and Japan, overall the presentation was fairly comprehensive, with much attention also given to Latin American performance art, which was and still is relatively unknown to Western audiences. The Japanese group Gutai was also largely unknown in the West, so its inclusion in the exhibition deepened the history depicted.

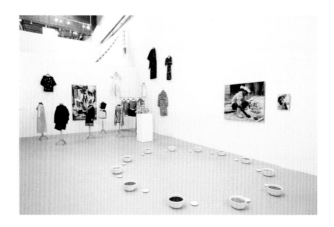

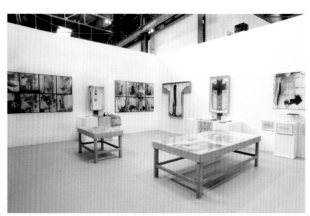

Installation views of the exhibition (above) and of works by Herman Nitsch (below). (Out of Actions: Between Performance and the Object, 1949–1979, 1998, The Museum of Contemporary Art, Los Angeles. Photos by Brian Forrest)

Exhibition Title
Out of Actions: Between Performance and the Object, 1949–1979

Curators
Paul Schimmel with an international advisory team

Dates
February 8 – May 10, 1998

Location
The Museum of Contemporary Art, Los Angeles, California, USA

Tour Locations and Dates
MAK—Austrian Museum of Applied Arts, Vienna, Austria, June 17 – September 6, 1998
Museu d'Art Contemporani, Barcelona, Spain, October 15, 1998 – January 6, 1999
Museum of Contemporary Art, Tokyo, Japan, February 11 – April 11, 1999

Publication
Paul Schimmel, ed., *Out of Actions: Between Performance and the Object, 1949–1975*, Thames & Hudson, London, and The Museum of Contemporary Art, Los Angeles, 1998

Artists
Marina Abramović / Ulay
Vito Acconci
Genpei Akasegawa
Laurie Anderson
Eleanor Antin
Rasheed Araeen
Mowry Baden
Artur Barrio
Joseph Beuys
Jerzy Beres
Mark Boyle / Joan Hills
George Brecht
Stuart Brisley

Stanley Brouwn
Robert Delford Brown / Rhett Delford Brown
Günter Brus
Chris Burden
James Lee Byars
John Cage
Marc Camille Chaimowicz
Lygia Clark
Pinchas Cohen Gan
Guy de Cointet
Collective Actions Group
Houston Conwill
Paul Cotton
Coum Transmissions
Jim Dine
John Duncan
Benni Efrat
Felipe Ehrenberg
Roberto Evangelista
VALIE EXPORT
Robert Filliou
Rose Finn-Kelcey
Sherman Fleming
Lucio Fontana
Terry Fox
Howard Fried
Rose Garrard
Gideon Gechtman
Jochen Gerz
Gilbert & George
Alberto Greco
Ion Grigorescu
Victor Grippo
Red Grooms
Guerilla Art Action Group
David Hammons
Al Hansen
Maren Hassinger
Lynn Hershman
Hi Red Center
Dick Higgins
Tatsumi Hijikata
Susan Hiller
Rebecca Horn
Tehching Hsieh
Joan Jonas
Kim Jones
Michel Journiac
Akira Kanayama
Tadeusz Kantor

Allan Kaprow
Tina Keane
Mike Kelley
Jurgen Klauke
Yves Klein
Billy Kluver
Milan Knizak
Alison Knowles
Komar & Melamid
Jannis Kounellis
Shigeko Kubota
Tetsumi Kudo
Marcos Kurtycz
Yayoi Kusama
Suzanne Lacy / Leslie Labowitz
John Latham
Jean-Jacques Lebel
Carlos Leppe
Lea Lublin
Paul McCarthy
George Maciunas
Bruce McLean
Leopoldo Maler
Piero Manzoni
Tom Marioni
Cusi Masuda
Georges Mathieu
Gordon Matta-Clark
David Medalla
Cildo Meireles
Ana Mendieta
Gustav Metzger
Marta Minujin
Jan Mlčoch
Linda Montano
Charlotte Moorman
Robert Morris
Otto Muehl
Saburo Murakami
Natsuyuki Nakanishi
Bruce Nauman
Paul Neagu
Senga Nengudi
Joshua Neustein
Hermann Nitsch
Hélio Oiticica
Claes Oldenburg
Yoko Ono
Orlan
Raphael Ortiz

Lorenzo Pace
Nam June Paik
Gina Pane
Lygia Pape
Ben Patterson
Nick Payne
Adrian Piper
Michelangelo Pistoletto
Jackson Pollock
William Pope L.
Yvonne Rainer
Robert Rauschenberg
Carlyle Reedy
Faith Ringgold
Klaus Rinke
Ulrike Rosenbach
Dieter Roth
Zorka Ságlová
Niki de Saint Phalle
Alfons Schilling
Tomas Schmit
Carolee Schneemann
Rudolf Schwarzkogler
Bonnie Sherk
Shozo Shimamoto
Ushio Shinohara
Kazuo Shiraga
Barbara T. Smith
Daniel Spoerri
Stelarc
Petr Stembera
Barbara Steveni
Wolfgang Stoerchle
Jiro Takamatsu
Atsuko Tanaka
Mark Thompson
Jean Tinguely
Rasa Todosijevic
Kerry Trengrove
Ben Vautier
Wolf Vostell
Franz Erhard Walther
Peter Weibel
Franz West
John White
Robert Whitman
Hannah Wilke
Emmett Williams
Yippies
La Monte Young
Zaj Group

Global Conceptualism: Points of Origin, 1950s–1980s

April 28 – August 29, 1999
Queens Museum of Art, New York, USA,
and touring

Installation view from the exhibition's tour to MIT List Visual Arts Center, Cambridge, Massachusetts, USA, 2000

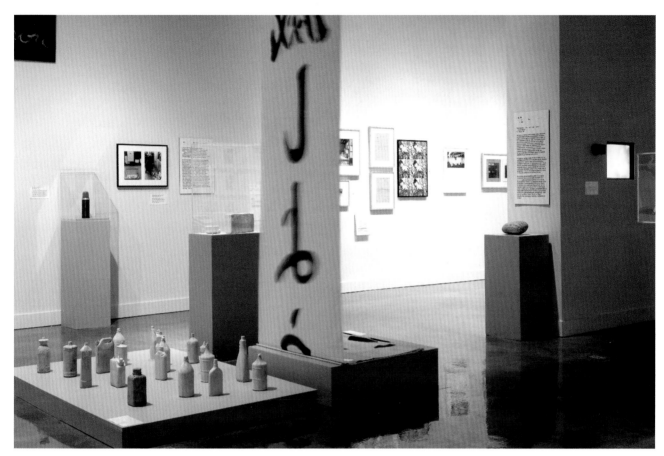

The Japanese and Eastern European section of the exhibition's tour to MIT List Visual Arts Center, Cambridge, Massachusetts, USA, 2000

Global Conceptualism: Points of Origin, 1950s–1980s featured over 200 works by more than 140 international artists. It was directed by Jane Farver, Luis Camnitzer, and Rachel Weiss, and also included 13 other essayists and curators. First organized and exhibited at the Queens Museum of Art, New York, in 1999, it traveled over the following two years to the Walker Art Center in Minneapolis, the Miami Art Museum, and the MIT List Visual Arts Center in Cambridge, Massachusetts.

Global Conceptualism was intended as a survey of the diverse approaches that have been taken toward Conceptual art—art in which the formation and representation of an idea takes primacy over its material attributes. A wide variety of media, demonstrating varying degrees of dematerialization, were on display, including but not limited to photography, video, film, books, sculptures, and paintings. Often, what visitors saw was some form of documentation of an art process rather than a

discrete object. The curators also contextualized the rise of Conceptual art in political terms, explaining the intention of many of the artists to make work that would serve as a vehicle for dissent, enabling a break with traditional understandings of what was considered "acceptable" art—or even "art" at all.

The exhibition was organized into regional sections and bifurcated into two chronological periods: circa 1950 to 1973 in Japan, Western Europe, Eastern Europe, Latin America, North America, Australia, and New Zealand; and 1973 to the late 1980s in the Soviet Union, Africa, South Korea, mainland China, Taiwan, and Hong Kong. Conceptual art is mostly associated with American and British artists, and Global Conceptualism sought to challenge this widely held assumption by including numerous international manifestations of Conceptualism that developed independently of Western practices. Many of the artists and art groups in the show were not widely known in the United States at the time.

Installation view of two-dimensional works from the exhibition's tour to MIT List Visual Arts Center,
Cambridge, Massachusetts, USA, 2000

Installation view from the exhibition's tour to MIT List Visual Arts Center, Cambridge, Massachusetts, USA, 2000

Exhibition Title
Global Conceptualism:
Points of Origin, 1950s–1980s

Organizer
Queens Museum of Art

Project Directors
Luis Camnitzer
Jane Farver
Rachel Weiss

Curators/Essayists
Stephen Bann
László Beke
Okwui Enwezor
Claude Gintz
Gao Minglu
Apinan Poshyananda
Mari Carmen Ramírez
Terry Smith
Chiba Shigeo
Sung Wan-Kyung
Reiko Tomii
Margarita Tupitsyn
Peter Wollen

Dates
April 28 – August 29, 1999

Location
Queens Museum of Art,
New York, USA

Tour Locations and Dates
Walker Art Center, Minneapolis,
 USA, December 19, 1999 –
 March 5, 2000
Miami Art Museum, Miami,
 USA, September 15 –
 November 26, 2000
MIT List Visual Arts Center,
 Cambridge, Massachusetts,
 USA, October 24 –
 December 31, 2000

Publication
Luis Camnitzer, Jane Farver,
and Rachel Weiss, eds., *Global
Conceptualism: Points of Origin,
1950s–1980s*, Queens Museum
of Art, New York, 1999

Artists
1,000-Yen Note Incident
 Discussion Group
Marina Abramović
Akasegawa Genpei
Giovanni Anselmo
Eleanor Antin
Billy Apple
Shusaku Arakawa &
 Madeline Gins
Art & Language
John Baldessari
Artur Barrio
Peter Bartoš
Gordon Bennett
Bikyōtō
Alighiero e Boetti
Oscar Bony
Willem Hendrik Adriaan Boshoff
Frédéric Bruly Bouabré
Marcel Broodthaers
Stanley Brouwn
Daniel Buren
Victor Burgin
Ian Burn
André Cadere
Waltércio Caldas
Antonio Caro
Ricardo Carreira
Theresa Hak Kyung Cha
Chang Chaotang
Choi Byung-Soo
Lygia Clark
Collective Actions Group
Carol Condé & Karl Beveridge
Eduardo Costa
Philip Dadson
Hanne Darboven
Guy Debord
Antonio Dias
Jan Dibbets
Braco Dimitrijević
Miklós Erdély
Luciano Fabro
León Ferrari
Stano Filko
Hollis Frampton
Harry Gamboa, Jr.
Kendell Geers
Geng Jianyi
Gorgona Group
Alberto Greco

Víctor Grippo
Grup de Treball
Wenda Gu
Hans Haacke
Tibor Hajas
Preston Heller
Hikosaka Naoyoshi
Hori Kosai
Huang Huacheng
Huang Yong Ping
Huang Yung-Sung
Douglas Huebler
Robert Huot
Roberto Jacoby
Jozef Jankovič
Ilya Kabakov
Tadeusz Kantor
Kashihara Etsutomu
On Kawara
Mary Kelly
Peter Kennedy
Kim Bong-Joon
Kim Dong-Won
Kim Yong-Min
Kim Yong-Tae
Yves Klein
Július Koller
Komar & Melamid
Rachid Koraïchi
Joseph Kosuth
Christine Kozlov
Labor Newsreel
Laboratoire Agit-Art
David Lamelas
Sol LeWitt
Lucy Lippard
Lee Lozano
Ana Lupaş
M Group
János Major
Antonio Manuel
Piero Manzoni
Matsuzawa Yutaka
Cildo Meireles
Juraj Meliš
Andrew Menard
Mario Merz
Boris Mikhailov
Alex Mlynárčik
Irina Nakhova
Paul Neagu
Nomura Hitoshi

Oho
Hélio Oiticica
Yoko Ono / John Lennon
Roman Opalka
Giulio Paolini
Park Bul-Dong
Mike Parr
Gyula Pauer
Malcolm Payne
Claudio Perna
Adrian Piper
Liliana Porter
Mel Ramsden
Robert Rehfeldt
Gerhard Richter
Józef Robakowski
Martha Rosler
Michael Snow
Song Yongping
Petr Štembera
Sung Neung-Kyung
Tamás Szentjóby
Tang Song
Yasunao Tone
Endre Tót
Vincent Trasov (Mr Peanut)
Goran Trbuljak
Tucumán Arde
Wei Guangqing
Lawrence Weiner
Joyce Wieland
Gil J. Wolman
Wu Shan Zhuan
Xiao Lu
Xu Bing
Danny Ning Tsun Yung
Zhang Peili

WACK! Art and the Feminist Revolution

March 4 – July 16, 2007
The Geffen Contemporary at The Museum of
Contemporary Art, Los Angeles, California, USA,
and touring

WACK! Art and the Feminist Revolution was a
2007 exhibition at The Geffen Contemporary at
The Museum of Contemporary Art, Los Angeles.
The show was curated by Cornelia Butler and
included 120 artists and artist groups from 21
different countries. WACK! was the first international
survey of artworks that emerged out of the feminist
art movement between 1965 and the 1980s. It aimed
to make visible how feminist art—not just in the
United States, but internationally—created a sea
change in the way art production has been seen
and understood since. The focus was also on
the intersection of art and artworks with the
sociopolitical feminist movement that started in
the 1960s. Works made before this were also on
view, as examples of a proto-feminist impulse, thus
providing a fuller history of feminist art and culture.
The exhibition required eight years of organizing
and planning, due to its comprehensive scope.

The title, WACK!, was meant to look like an acronym,
referring to feminist groups that formed in the 1960s
and 1970s. Works in many media were included, but
photography, video, film, and performance were
dominant. It was not curated chronologically, but
rather thematically, to highlight important facets
of feminist art practice. There were 20 such subjects
dividing up the show, ranging from formal
aesthetic issues through themes of the female
body to politics and history. Not all of the art was
necessarily feminist per se (such as the portraits
by Alice Neel); Butler was interested in showing
how people who were not explicitly card-carrying
feminists still influenced the movement.

The exhibition traveled the following year, showing
at the National Museum of Women in the Arts in
Washington, DC; P.S.1 in Long Island City, New York;
and the Vancouver Art Gallery. Overall, the critical
reception was positive: the exhibition was lauded
for its breadth and diverse representation of the
feminist art movement.

> WACK! Art and the Feminist
> Revolution is predicated on
> the notion that gender was and
> remains fundamental to culture
> and that a contemporary
> understanding of the feminist
> in art must necessarily look
> to the late 1960s and 70s.
>
> Lisa Gabrielle Mark and Cornelia Butler in *WACK!:
> Art and the Feminist Revolution*, The Museum of
> Contemporary Art, Los Angeles, and MIT Press,
> Cambridge, Massachusetts, 2007.

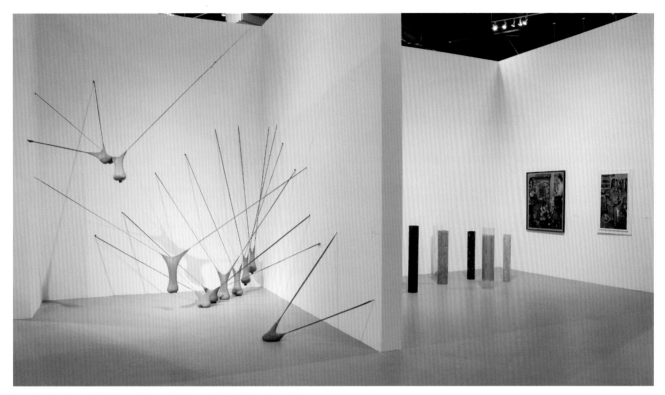

Installation view with Senga Nengudi, *I*, 1977 (left), Carla Accardi, *Rotoli*, 1966–72 (center right), and Jacqueline Fahey, *Christine in the Pantry*, 1972 and *Sisters, Communing*, 1974 (right)

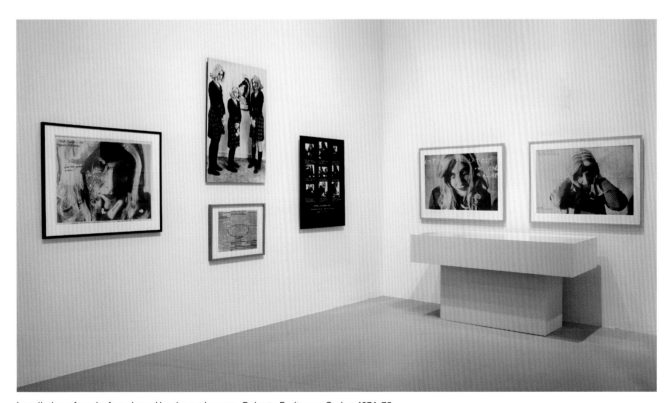

Installation of works from Lynn Hershman Leeson, *Roberta Breitmore Series*, 1974–78

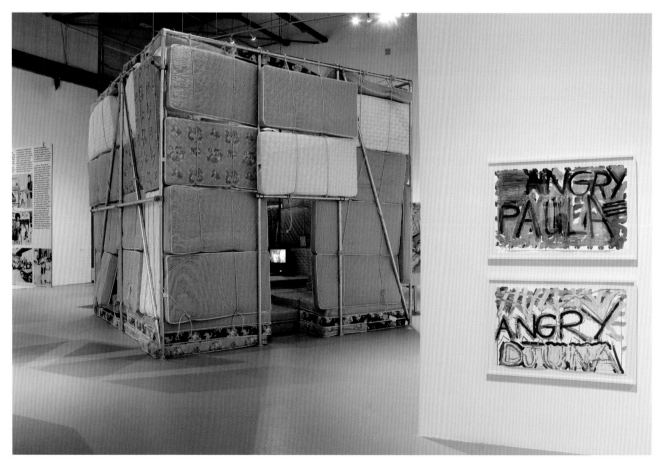

Installation view with Louise Fishman, *Angry Paula,* 1973, and *Angry Djuna*, 1973

Alexis Hunter
Mako Idemitsu
Sanja Iveković
Joan Jonas
Kirsten Justesen
Mary Kelly
Joyce Kozloff
Friedl Kubelka
Shigeko Kubota
Yayoi Kusama
Ketty La Rocca
Suzanne Lacy
Suzy Lake
Maria Lassnig
Léa Lublin
Lee Lozano
Lesbian Art Project
Anna Maria Maiolino
Mónica Mayer
Ana Mendieta
Annette Messager

Marta Minujín
Nasreen Mohamedi
Linda M. Montano
Ree Morton
Laura Mulvey /
 Peter Wollen
Alice Neel
Senga Nengudi
Ann Newmarch
Lorraine O'Grady
Pauline Oliveros
Yoko Ono
ORLAN
Ulrike Ottinger
Gina Pane
Catalina Parra
Ewa Partum
Howardena Pindell
Adrian Piper
Sylvia Plimack Mangold
Sally Potter

Yvonne Rainer
Ursula Reuter Christiansen
Lis Rhodes
Faith Ringgold
Ulrike Rosenbach
Martha Rosler
Betye Saar
Niki de Saint Phalle
Miriam Schapiro
Mira Schendel
Carolee Schneemann
Joan Semmel
Bonnie Sherk
Cindy Sherman
Katharina Sieverding
Sylvia Sleigh
Alexis Smith
Barbara T. Smith
Mimi Smith
Joan Snyder
Valerie Solanas

Annegret Soltau
Nancy Spero
Spiderwoman Theater
Lisa Steele
Sturtevant
Cosey Fanni Tutti
Mierle Laderman Ukeles
Cecilia Vicuña
June Wayne
"Where We At"
 Black Women Artists
Colette Whiten
Faith Wilding
Hannah Wilke
Francesca Woodman
Nil Yalter
Zarina

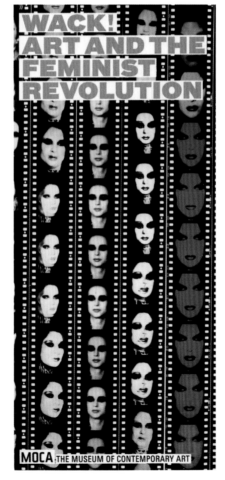

Exhibition announcement card

Talking about Exhibitions

Carolyn Christov-Bakargiev

Independent curator and writer, Rome and New York

Massimiliano Gioni

Associate Director and Director of Exhibitions
at the New Museum, New York

Mary Jane Jacob

Professor and Director of Exhibitions
at the School of the Art Institute of Chicago

Maria Lind

Director of the Tensta Konsthall, Stockholm

Jessica Morgan

Daskalopoulos Curator,
International Art at Tate Modern, London

Hans Ulrich Obrist

Co-director of Exhibitions and Programs and Director
of International Projects at the Serpentine Gallery, London

Adriano Pedrosa

Independent curator and writer, São Paulo

in conversation with

Jens Hoffmann

Jens Hoffmann: Curating has dramatically changed over the last two decades, becoming an increasingly creative and perhaps even artistic undertaking. What do you understand the term "curatorial innovation" to mean?

Hans Ulrich Obrist: Alteration? Change? Novelty? Introduction? Departure? Variation? Innovation means a new way, or a new process, of doing something. New practices. We only remember exhibitions that invent new rules of the game.

Maria Lind: I think curatorial innovation is about developing ways of working with art in order to underline and enhance the potential of that art. Sometimes it also involves evoking something hitherto unexplored within the work. This means that the curator's choice of works, format of presentation, context, timing, and mediation are essential. And more essential than anything else is the way these components are combined in order to challenge the cultural status quo, however discreetly.

Mary Jane Jacob: Curatorial innovation is about making connections—putting things together in a way that makes an opening for thought and experience. It is about curating with an intent rooted in an occasion and a concern that drives the pursuit. Working with the unknown is essential to innovation, and if you're comfortable in that unstable place where innovation happens, you can also be open to where others take the curatorial question. The result can be great, or it can be a brave attempt, but it will inevitably be innovative.

Massimiliano Gioni: Ultimately, I'd say that I want to make shows that I haven't seen before. I want to make shows simply because they haven't previously existed. To be frank, I'm not so sure I think in terms of innovation. "Revolution" perhaps would be a more appropriate term, even though it has romantic associations and sounds overly ambitious. I mean "revolution" in the sense of a paradigm shift. Ideally, it's about expanding the territory and pointing to artists and artworks that we believe are worth thinking about. When I'm working on an exhibition, I find myself thinking not so much about innovating, but more about enriching my own vocabulary and widening the definition of what an exhibition can look like or do. And, of course, I try to provide resources—economic, or just practical or intellectual—to empower the work of artists, and to try and push the artist and the artwork to be simultaneously themselves and something completely different.

Carolyn Christov-Bakargiev: I understand your term "curatorial innovation" to mean new ways of presenting art, new ways of working with artists and making art with them, and new ways of thinking through the symbolic underpinnings and meanings in exhibitions and art projects insofar as

they're culturally meaningful. But I must add that I see the term "curatorial" declining in usage in artistic practice, even as it becomes more common in the media and the world at large.

Lind: The word "innovation" has a problematic side as well, in that it so often ends up meaning experimentation for the sake of experimentation, which leads to what I call "curatorial pirouettes," or formalist exercises that are really all about the curator. Far more interesting is to take art seriously enough to want to explore its potential in sensitive and intelligent ways, and carefully consider how art in general, and curated projects in particular, sit within culture.

Jessica Morgan: I agree that innovation for innovation's sake is not really of sustainable interest. Constant "progress" doesn't always make things better. Innovation is useful when we invent not only new forms of display, but also, more fundamentally, new structures that change working practices and our understanding of history. This could include novel ways of curating through new forms of collaboration or communication (across genre, chronology, disciplines) and a radical approach to prescribed histories of art and culture.

Adriano Pedrosa: Above all, it's important to respond to the needs and transformations of contemporary art production, dissemination, and discussion, as well as the specificities of the context—the institution, the city, the venue one's working with, and their respective histories. A format considered innovative in one context might be already established in another, or vice versa. I don't think curatorial innovation—simply bringing something new to curatorial history—should be an end in itself. It must also be relevant, complex, responsive to a particular context. Often when one looks at certain projects—not just exhibitions—and analyzes what's been done, it's clear how certain parameters or approaches have become ossified. And as one questions them, one innovates.

Obrist: The current vogue for the idea of curating stems from a feature of modern life that it is impossible to ignore: the incredible proliferation of ideas, information, images, disciplinary knowledge, and material products. This is hard to overstate. Every 48 hours humanity generates as much new data as was created between the origin of recorded history and 2003. And this is only the leading edge of a larger change that has been occurring for 100 years: the shift from industrial production to advanced consumer economies. Today we're awash with cheaply produced objects to a degree that would have been difficult to imagine a century ago. The result, arguably, has been a shift in the ratio of importance between *making* objects and *choosing* them. This risks producing a kind of speculative bubble in the value attached to the idea of curating, which should be resisted.

Hoffmann: I'd be curious to hear all of you speak a bit more about the changes in curating. How has exhibition making changed in the last two decades? And why has it changed?

Jacob: This question is insightful. In contrast to Hans Ulrich's view, I believe that an exhibition is now a practice of *making*. Exhibitions are no longer so much about selecting or organizing, but making. What is it to make? It is to bring into being. This is a process of many dimensions: physical, human, intellectual, political, ethical, spiritual, and more. Back when curating was about picking artworks and arranging them, employing the skills of connoisseurship and scholarship, taste ruled. Then it all got messier. More people got in on the act. More kinds of institutions and spaces (and non-spaces) emerged for exhibitions and with this, happily, what an exhibition *is* was cracked wide open—and that brought in innovation as a benchmark.

Pedrosa: The last two decades have also witnessed an extraordinary rise in interest in contemporary art and therefore exhibitions. An art circuit that was rather small and specialized up until the 1980s has now become global and widespread. This was made possible through the internet and cheap travel, which have allowed many more people to look at art. More importantly, what was quite a Eurocentric, Northern Atlantic art circuit now encompasses many other territories, particularly in Asia, the Middle East, North Africa, and Latin America, not just in terms of art production, but also in terms of curatorial practice. Twenty years ago, a publication such as this one would be unlikely to include an exhibition that occurred outside Europe or the United States. In a context that's so wide, populous, and complex, the work of the curator as an editor and a mediator between art, artists, institutions, the media, and the public from many different regions, generations, and points of view has become more crucial. And I should add that there is no single model or approach to navigate this scenario. Indeed, there are many of them, and it's healthy to promote that diversity.

Obrist: It's also healthy to maintain some skepticism about the limits of the concept of curating, rather than pretend that *every* choice *everyone* makes is a form of curating. That most people today act as curators of experience and information doesn't mean everyone is a curator. If that were true, then the term would have expanded beyond any useful meaning. Curating is a profession with a specific history. But the lessons of the profession may be of greater use now than in previous eras. When new cultural formations appear, they tend to use fragments of already-obsolete forms. Therefore, I believe the future of exhibition making will deploy devices we once knew but have perhaps forgotten about.

Morgan: I agree. Every "innovation" that we might perceive now has in fact already been established for many years and in most cases for almost a century.

Fundamentally, I don't think that exhibition making has changed at all in the last two decades. The shifts that have impacted exhibition making (as indeed they've affected every aspect of society) are the development of a global economy, the rapidly increased pace of global communication, mass migration, and the social and environmental issues that have accompanied all of this. As Adriano says, we now have a vastly increased global dimension of the art world and the development of artistic careers, curators, and art centers in areas previously considered peripheries.

Christov-Bakargiev: I think exhibitions as "exhibitions" were more relevant 20 years ago than today. Nowadays, there's so much urgency to address conflict, inequalities, debt, lack of freedom, the ecological crisis, and the consequences of cognitive capitalism in the digital age that fundamental research in both artistic and curatorial practice seems more important than simply exhibition making.

Gioni: To paraphrase the title of a successful magazine on curating, we live in an age of extreme exhibitionism. And that of course puts more and more pressure on artists and exhibition organizers to rethink what exhibitions are. This pressure can lead not only to what Maria calls "curatorial pirouettes" but also to an excess of self-reflexivity, a sort of onanistic practice. Having said that, I can't pretend that I'm critical of the explosion of contemporary art exhibitions, not only because I make a living out of them, but also because ultimately I think an exhibition is a format that can be constantly transformed and renovated, and that the more chances we have to do that, the better.

Obrist: The global forces that are effective everywhere are indeed also effective in art. The growing number of biennials and exhibitions all over the world has led to, on the one hand, a more diverse art world and many new experiments, but on the other hand also to the danger that the homogenizing forces of globalization will affect the art world. Édouard Glissant, in my view, provides a great curatorial toolbox for the 21st century, since his writings show us a way of escaping this threat. The metaphor of the Antillean archipelago is important for Glissantian thought: it has no center but consists of a string of different islands and cultures. The exchange that takes place among them allows each to preserve its own identity. "Archipelic" thought, which endeavors to do justice to the world's diversity, forms an antithesis to "continental" thought, which makes a claim to absoluteness and tries to force its worldview on other countries. Particularly in the case of my co-productions that have toured worldwide, we tried to create an oscillation between the exhibition and the respective venue. The exhibition changed places, but each place also changed the exhibition. There were continual feedback effects between the local and the global. It's key to react to circumstances in such a way as to produce differences, rather than assimilation.

Lind: For me, the most significant development in the last 20 years is that other formats besides exhibitions, such as discursive events, commissioning projects outside designated exhibition spaces, and film screenings, have become more common and more influential. Like painting, exhibition making has gone from a hegemonic to a more naturalized and appropriate position, sharing territory with many others.

Gioni: For me, a crucial question is the relationship between contemporary art and entertainment, which has become extremely complex, and needs to be constantly readdressed and revaluated.

Morgan: Yes, the vast expansion of the culture industry has resulted in a wider interest in the consumption of fine art and its value as entertainment, impacting the scale as well as the types of exhibitions made. The escalating economy of the art market and the closer ties between the worlds of fashion and art have also (largely negatively) impacted exhibition making.

Christov-Bakargiev: I tend to see the intense aggregation of bodies and embodied persons making or attending exhibitions as a positive thing. It turns the exhibitions into sites of resistance to the disembodied self of the digital age.

Jacob: I can think of another, again more positive, aspect of what you're all speaking of: the shift we've witnessed toward the primacy of the audience. This often gets buried in institutional art-speak, but it's dear to my heart. In the last two decades, the audience has become the protagonist. Sometimes this consideration involves overt connections or collaborations with the viewer. Sometimes it's a negotiation among constituencies or the engagement of visitors who are ready to have a two-way conversation. Sometimes we as curators advocate for *their* voice, *their* hand, and sometimes we call for this process itself to be proclaimed as the location of the art. But it's more than this, because the viewer is ever-present, and because the process in which the audience participates is one that extends the *making*, which I mentioned before as a crucial term, and keeps it going in vital ways. We have yet to fully acknowledge the more nuanced ways in which this relationship plays out.

Hoffmann: Where do you see exhibition making, and curating, going in the years to come?

Christov-Bakargiev: I see exhibitions becoming forms of philosophical enquiry, forms of living, experiments with different temporalities and refusals of synchronicity, simultaneity, speed, even the temporary exhibition itself. I see artists and curators participating actively in plans and programs that

are directly affecting the real world, in some cases developing forms of self-government in the real world.

Jacob: I think curators will play an increasing role in the process of art making. More and more, I feel it's the *process* that I'm curating, taking care of, and keeping open in order for art to happen. The orbit of curating has widened, so I'd hope that the alliances made with arts professionals with whom we share our practice, especially educators, will be sustained and grow. I hope that joining at times with those in other disciplines will continue to create a rich terrain of discourse and practice. And I hope that the understanding of context at which we've arrived will mean that audiences and others outside our profession will stay a part of the equation.

Obrist: I'm often asked about the future of curating, but I don't think we can speculate on it without knowing the future of art. Only artists can tell us about the future of art, so I always ask artists to talk about the future. But one thing that has definitely changed in my practice over the last 20 years is that besides curating space, I've become more and more focused on curating time. Two decades ago I often experimented with alternative spaces in which to work, the guiding principle being art that pops up where you expect it least. Lately I've also begun to see my practice attaining temporal dimensions: 24- or 48-hour events where artists, scientists, architects, musicians, choreographers, and so on are given time to explore a concept. Exhibitions in the years to come should be a way to resist the pressures toward an ever-more-uniform experience of time and space. Curating must follow art.

Pedrosa: Curatorial practice must follow not only artistic practice, but also the transformation of institutions, the public, and the media. I'm a curator, not a futurologist, but hopefully we'll see the development of different models and formats of exhibition projects, with more singular and dissonant voices that challenge the norm, as opposed to monolithic trends or styles in which all curators and institutions work with the same model and canon. It's fundamental to support curatorial diversity, so that the increase in interest in contemporary art doesn't automatically translate into "massification."

Morgan: I also fear that exhibition making is becoming increasingly institutionalized. There are fewer independent curators, and large-scale independent exhibitions such as biennials are increasingly professionalized. A positive result of this is that large institutions can enable the research and scholarship (time, expertise, and funding) for new thinking. A negative impact is the concomitant dependency of institutions on private funding and the resultant movement in the direction of commercial interests and entertainment "returns" over experimentation and innovation.

Pedrosa: It is rather sad to see how at times biennials, museums, collections, and galleries seem to be seeking the same type of artworks, and how they create a certain fashion or hype around certain artists that doesn't add much to the understanding of the complexities and subtleties of the work. We live in a time where everything is produced and consumed so rapidly. Art should be more enduring than the wink of a Twitter feed.

Morgan: Collections are also curated bodies of art, and here, I think, there's a vast amount of curatorial work that could take place in the years to come. Too many collections are based on the market forces of the day, and, as the collection is the heart of the institution, it needs to develop a character and individuality that will ultimately be the bedrock of that site. There's no better way to achieve a permanent alteration in the history of art and culture than through the manifestation of new arguments in the permanent collection (rather than the temporary exhibition), and I hope to see much innovation taking place in this area in the coming years.

Jacob: I think that as we increasingly engage curatorial practice within a wider conceptual and physical frame, a lot more connections will be made, and with this, the relevancies between exhibition making and the circumstances in which we live will be felt. We as curators also find our own connections in the practice of making exhibitions over place and over time. Because it's never just about an exhibition—there's always a deeper investment—hence, a show can have a greater life. Over time, this can become one and the same with one's life: that is, a vocation. And there are values at stake here. (I don't mean solely *interests*, and I'm not evoking a moralist meaning.) Curatorial values are at the core of the vision that drives exhibition making, and are embodied in what matters to us as curators. As we've seen in recent decades—and will no doubt continue to see in the future—the realm of curating is nowadays as wide as art itself.

Hoffmann: To conclude our discussion, I would like to summarize briefly the outcome of a number of conversations I have had recently about the selection of exhibitions for this book. While on a trip to Australia and New Zealand, I was confronted with the question as to whether I feel that my selection is overall very Western-centric, despite the fact that there are exhibitions from across the globe included in the book, as well as exhibitions that showcase art and ideas from many parts of the world. When faced with this question, I realized that the act of nominating a number of exhibitions based on how they have influenced curatorial practice or how they have displayed "curatorial innovation" is itself a rather Western-centric notion. I did not select them purely for their curatorial innovation, but also for the way that they reflected artistic innovation, and this approach does, I suppose, come from a very Western way of thinking about curating, perhaps connected to a somewhat old-fashioned idea of the European avant-garde with

its constant longing for artistic, intellectual, and political progress. The history of exhibitions in Australia or other places might be based on very different criteria because of the cultural histories of those places, and would therefore likely be developed according to a very different relationship between art and curating. For instance, one curator whom I met in Auckland is currently studying the history of exhibitions of Maori art in New Zealand, specifically how these have changed over the past five decades with regard to display and cultural mediation. I think it is very important to keep such differences in mind when reading this book. Try as we might, it is inevitably difficult for curators completely to move away from their own traditions. But I believe that if we accept, and remain constantly aware of, our curatorial subjectivities and the cultural contexts from which they arise, we can continue to curate truly forward-thinking international shows in ways that are sensitive, insightful, and exhilarating for the viewing audience.

Further Reading

Bruce Altshuler, *The Avant-Garde in Exhibition: New Art in the 20th Century*, University of California Press, Berkeley, 1998

Bruce Altshuler, *Salon to Biennial: Exhibitions That Made Art History, Volume I: 1863–1959*, Phaidon Press, London, 2008; *Biennials and Beyond: Exhibitions That Made Art History, Volume II: 1962–2002*, Phaidon Press, London, 2013

Gail Anderson, *Reinventing the Museum: Historical and Contemporary Perspectives on the Paradigm Shift*, AltaMira Press, Berkeley, 2004

Tony Bennett, *Birth of the Museum: History, Theory, Politics*, Routledge, London 1995

Beatrice von Bismarck, Jörn Schafaff, and Thomas Weski, eds., *Cultures of the Curatorial*, Sternberg Press, Berlin, 2012

Nicolas Bourriaud, *Relational Aesthetics*, Les presses du réel, Dijon, 1998

Marcia Brennan, *Curating Consciousness: Mysticism and the Modern Museum*, MIT Press, Cambridge, MA, 2010

Sarah Chaplin and Alexandra Stara, eds., *Curating Architecture and the City*, Routledge, London, 2009

Sarah Cook and Beryl Graham, *Rethinking Curating: Art after New Media*, MIT Press, Cambridge, MA, 2010

James Cuno, ed., *Whose Muse?: Art Museums and the Public Trust*, Princeton University Press, Princeton 2006

Douglas Crimp, *On the Museum's Ruins*, MIT Press, Cambridge, MA, 1995

Claire Doherty, ed., *Situation*, MIT Press, Cambridge, MA, 2009

Carol Duncan, *Civilizing Rituals: Inside Public Art Museums*, Routledge, London, 1995

Exhibition Histories (series), Afterall Books, London, 2010–ongoing

Elena Filipovic, Marieke van Hal, Solveig Ovstebo, eds., *The Biennial Reader*, Hatje Cantz, Ostfildern-Ruit, 2010

Viv Golding and Wayne Modest, eds., *Museums and Communities: Curators, Collections and Collaboration*, Bloomsbury, London, 2013

Zoe Gray, Miriam Kathrein, Nicolaus Schafhausen, Monika Szewczyk, and Ariadne Urlus, eds., *Rotterdam Dialogues: The Critics, The Curators, The Artists*, Witte de With Publishers, Rotterdam, 2010

Reesa Greenberg, Bruce W. Ferguson, and Sandy Nairne, eds., *Thinking About Exhibitions*, Routledge, London, 1996

Jens Hoffmann, ed., *Ten Fundamental Questions of Curating*, Mousse Publishing, Milan, 2013

Selma Holo and Mari-Tere Alvarez, eds., *Beyond the Turnstile: Making the Case for Museums and Sustainable Values*, AltaMira Press, Berkeley, 2009

Grant Kester, *Conversation Pieces: Community and Communication in Modern Art*, University of California, Berkeley, 2004

Joasia Krysa, ed., *Curating Immateriality: The Work of the Curator in the Age of Network Systems*, Autonomedia, New York, 2006

Carin Kuoni, ed., *Words of Wisdom: A Curator's Vade Mecum*, Independent Curators International, New York, 2001

Miwon Kwon, *One Place After Another: Site-Specific Art and Locational Identity*, MIT Press, Cambridge, MA, 2004

Steven D. Lavine, *Exhibiting Cultures: The Poetics and Politics of Museum Display*, Smithsonian Books, Washington, DC, 1991

Amy K. Levin, ed., *Gender, Sexuality and Museums: A Routledge Reader*, Routledge, London, 2010

Maria Lind, ed., *Performing the Curatorial Within and Beyond Art*, Sternberg Press, Berlin, 2012

Maria Lind, *Selected Maria Lind Writing*, Sternberg Press, Berlin, 2010

Sharon MacDonald, ed., *A Companion to Museum Studies*, Wiley-Blackwell, Oxford, 2010

Paula Marincola, ed., *Curating Now: Imaginative Practice/Public Responsibility*, Philadelphia Exhibitions Initiative, Philadelphia, 2002

Paula Marincola, ed., *What Makes a Great Exhibition?*, Reaktion Books, London, 2007

Jean-Paul Martinon, *The Curatorial: A Philosophy of Curating*, I.B. Tauris, London, 2013

Brian O'Doherty, *Inside the White Cube: The Ideology of the Gallery Space*, University of California Press, Berkeley, 2000

Paul O'Neill, *The Culture of Curating and the Curating of Culture(s)*, MIT Press, Cambridge, MA, 2012

Paul O'Neill, ed., *Curating Subjects*, Open Editions/Occasional Table, London, 2007

Paul O'Neill and Mick Wilson, eds., *Curating and the Educational Turn*, Open Editions/De Appel Arts Center, London and Amsterdam, 2010

Hans Ulrich Obrist, *A Brief History of Curating*, JRP Ringier, Zurich, 2008

Hans Ulrich Obrist and April Lamm, ed., *Everything You Always Wanted to Know About Curating* But Were Afraid to Ask, Sternberg Press, Berlin, 2011

Ross Parry, ed., *Museums in a Digital Age*, Routledge, London, 2009

Christiane Paul, ed., *New Media in the White Cube and Beyond: Curatorial Models for Digital Art*, University of California Press, Berkeley, 2008

The Producers: Contemporary Curators in Conversation (series), Baltic Centre for Contemporary Art, Gateshead, 2000–ongoing

Steven Rand and Heather Kouris, eds., *Cautionary Tales: Critical Curating*, apexart, New York, 2007

Judith Rugg and Michele Sedgwick, eds., *Issues in Curating Contemporary Art and Performance*, Intellect Ltd, Bristol, 2012

Kitty Scott, ed., *Raising Frankenstein: Curatorial Education and its Discontents*, Koenig Books, Cologne, 2011

Terry Smith, *Thinking Contemporary Curating*, Independent Curators International, New York, 2012

Terry Smith, Okwui Enwezor, and Nancy Condee, eds., *Antinomies of Art and Culture: Modernity, Postmodernity, Contemporaneity*, Duke University Press, Durham, NC, 2008

Mary Anne Staniszewski, *The Power of Display: A History of Exhibition Installations at the Museum of Modern Art*, MIT Press, Cambridge, MA, 2001

Carolee Thea, *On Curating: Interviews with Ten International Curators*, Distributed Art Publishers, New York, 2009

Melanie Townsend, ed., *Beyond the Box: Diverging Curatorial Practices*, The Banff Center Press, Banff, Alberta, 2003

Barbara Vanderlinden and Elena Filipovic, eds., *The Manifesta Decade: Debates on Contemporary Art Exhibitions and Biennials in Post-Wall Europe*, MIT Press, Cambridge, MA, 2001

Gavin Wade, ed., *Curating in the 21st Century*, New Art Gallery Walsall, 1999

Alan Wallach, *Exhibiting Contradiction*, University of Massachusetts Press, Amherst, 1998

Peter Weibel and Andrea Buddensieg, eds., *Contemporary Art and the Museum: A Global Perspective*, Hatje Cantz, Ostfildern-Ruit, 2007

Stephen E. Weil, *Making Museums Matter*, Smithsonian Books, Washington, DC, 2002

Marcella Wells, Barbara H. Butler, and Judy M. Koke, *Interpretive Planning for Museums: Integrating Visitor Perspectives in Decision-Making*, Left Coast Press, Walnut Creek, 2012

Picture Credits

(*l*) = left, (*r*) = right, (*a*) = above, (*c*) = center, (*b*) = below

pp.2–3 Fundación/Colección Jumex, Mexico. Courtesy Fundación/Colección Jumex, Mexico. © Fundación/Colección Jumex, photo La Colección Jumex, Mexico; p.4 Courtesy Galerie Barbara Weiss, Berlin, photo Roman Mensing/artdoc. de; p.7 (*l*) Rosângela Rennó, *Guerrero* portrait from the *United States* series, 1997, installation view from inSITE97, various sites in San Diego, USA, and Tijuana, Mexico, 1997. Courtesy inSITE. © Rosângela Rennó, photo Eduardo Zepeda; p.7 (*ar*) Installation view, The Brooklyn Museum Collection: The Play of the Unmentionable, The Brooklyn Museum, New York, USA, 1990. Brooklyn Museum Archives. Records of the Department of Painting and Sculpture: Exhibitions. The Brooklyn Museum Collection: The Play of the Unmentionable (Joseph Kosuth). [09/27/1990– 12/31/1990]. Courtesy the artist and Sean Kelly Gallery. © Joseph Kosuth, Ken Schles, and the Brooklyn Museum, photo Ken Schles; p.7 (*br*) Liam Gillick, *Big Conference Centre Limitation Screen*, 1998, and *Big Negotiation Screen*, 1998 (center), and Sylvie Fleury, *Spring Summer 2000*, 2000, installation (right), installation view from What If: Art on the Verge of Architecture and Design, Moderna Museet, Stockholm, Sweden, 2000. Courtesy Liam Gillick, Moderna Museet, and Casey Kaplan Gallery, New York, and courtesy Sylvie Fleury and the Moderna Museet; p.8 (*al*) Yinka Shonibare, *Victorian Philanthropist's Parlour*, 1996–97, installation view from the 2nd Johannesburg Biennial: Trade Routes – History and Geography, Johannesburg and Cape Town, South Africa, 1997. Copyright the artist. Courtesy the artist, Okwui Enwezor, Stephen Friedman Gallery, London, and James Cohan Gallery, New York, photo Werner Maschmann; p.8 (*bl*) Robert

Kuśmirowski, *Wagon*, 2006, installation view from the 4th Berlin Biennial for Contemporary Art: Of Mice and Men, KW Institute for Contemporary Art and various sites along Augustrasse, Berlin, Germany, 2006. Private Collection, Kortrijk, Belgium. Courtesy the artist, Foksal Gallery Foundation, Warsaw, and Johnen Galerie, Berlin, photo Uwe Walter; p.8 (*r*) Henrietta Lehtonen, *Cafeteria and Park Island*, 1994, installation view from This is the Show and the Show is Many Things, Museum of Contemporary Art, Ghent, Belgium, 1994. Courtesy SMAK, photo by Dirk Pauwels; p.9 (*al*) Los Jaichackers (Julio Morales and Eamon Ore-Girón), *Migrant Dubs*, 2008, installation view from Phantom Sightings: Art After the Chicano Movement, Los Angeles County Museum of Art, California, USA, 2008. Courtesy the artists and Los Angeles County Museum of Art, digital image © 2013 Museum Associates/LACMA, licensed by Art Resource, New York; p.9 (*bl*) Philippe Parreno, *No More Reality*, 1991, installation view from No Man's Time, Centre National d'Art Contemporain— Villa Arson, Nice, France, 1991. © Jean Brasille/Villa Arson; p.9 (*r*) Martha Rosler, *Body Beautiful, or Beauty Knows No Pain*, 1966–72 (left) and Faith Wilding, *Waiting*, 1972 (right), installation view from WACK! Art and the Feminist Revolution, The Geffen Contemporary at The Museum of Contemporary Art, Los Angeles, California, USA, 2007. The Geffen Contemporary at The Museum of Contemporary Art, Los Angeles, 2007. Courtesy the Museum of Contemporary Art, Los Angeles; p.10 Dimitrijević: Collection Eric Fabre, Bruxelles. Photo courtesy Centre Pompidou and the artist; p.17 © Estate of Mike Kelley. All rights reserved. Courtesy Mike Kelley Foundation for the Arts and Museum of Modern Art, Vienna (MUMOK); p.20 Courtesy inSITE. © Rosângela Rennó, photo Eduardo Zepeda; p.22 Courtesy The Modern Institute/Toby Webster Ltd,

Glasgow. Collection LWL-Landesmuseum, Münster, photo Roman Mensing/artdoc. de. Courtesy of Mike Kelley Foundation for the Arts © Estate of Mike Kelley. All rights reserved; p.23 (*a*) Courtesy The Modern Institute/Toby Webster Ltd, Glasgow. Collection LWL-Landesmuseum, Münster, photo Roman Mensing/artdoc. de; p.23 (*b*) Photo Thorsten Arendt/artdoc.de; p.24 Courtesy the artist, Foksal Gallery Foundation, Warsaw, and neugerriemschneider, Berlin, photo Roman Ostojic/ artdoc.de; p.26 Exhibition guide, Places with a Past: New Site-Specific Art in Charleston, 1991. Courtesy the artist and Spoleto Festival, USA; p.27 Courtesy Spoleto Festival, USA, photo John McWilliams; pp.28–29 Courtesy L&M Arts, Venice, CA, the artist, and Spoleto Festival, USA, photo John McWilliams; p.31 Courtesy Spoleto Festival, USA, photo John McWilliams; p.33 (*a*) Courtesy inSITE, the artist and David Zwirner, New York/ London, photo Francis Alÿs; p.33 (*b*) Courtesy inSITE, the artist and David Zwirner, New York/ London, photo Francis Alÿs; p.35 Courtesy inSITE, photo inSITE. Artwork © 2005 Mark Bradford; p.36 Courtesy inSITE, photo Alfredo de Stefano; p.38 Edition 1/7. © Alighiero Boetti, by SIAE/DACS, 2014. Courtesy Fondazione Alighiero e Boetti, Rome, and Sonsbeek International Sculpture Exhibition; p.39 Collection of the Kröller-Müller Museum, Otterlo, photo M. Bałka. Courtesy of Sonsbeek International Sculpture Exhibition; p.40 Courtesy the artist, Galerie In Situ Fabienne Leclerc, Paris, Tanya Bonakdar Gallery, New York, and Sonsbeek International Sculpture Exhibition; p.41 Courtesy of Sonsbeek International Sculpture Exhibition, © Yves Paternoster; p.42 (*a*) Courtesy Mary Jane Jacob, photo John McWilliams; p.42 (*b*) Exhibition catalogue, Culture in Action, 1993, courtesy Mary Jane Jacob; p.43 Courtesy Mary Jane Jacob, photo Antonio Perez Photo,

Chicago; p.44 Courtesy Mary Jane Jacob, photo Iñigo Manglano-Ovalle; p.45 (*al*) Courtesy Mary Jane Jacob; p.45 (*ar*) Courtesy Mary Jane Jacob; p.45 (*cr*) Courtesy Mary Jane Jacob; p.45 (*b*) Courtesy Mary Jane Jacob; p.45 (*cl*) Courtesy Mary Jane Jacob; p.46 Courtesy Mary Jane Jacob, photo John McWilliams; p.47 Courtesy Mary Jane Jacob, photo John McWilliams; p.48 Courtesy U.S. Biennial, Inc., photo Brad Edelman; p.49 (*a*) Courtesy U.S. Biennial, Inc., photo John d'Addario; p.49 (*b*) Exhibition catalogue, Prospect.1 New Orleans, 2008–9, Courtesy U.S. Biennial, Inc.; p.50 Courtesy U.S. Biennial, Inc., photo John d'Addario; p.51 Courtesy U.S. Biennial, Inc., photo John d'Addario; p.54 Brooklyn Museum Archives, Records of the Department of Painting and Sculpture: Exhibitions. The Brooklyn Museum Collection: The Play of the Unmentionable (Joseph Kosuth). [09/27/1990–12/31/1990]. Courtesy the artist and Sean Kelly Gallery. © Joseph Kosuth, Ken Schles, photo Ken Schles; p.57 Photo Ed Woodman; p.58 Photo Ed Woodman; p.59 Photo Ed Woodman; p.60 Courtesy Brooklyn Museum. Brooklyn Museum Archives, Records of the Department of Painting and Sculpture: Exhibitions. The Brooklyn Museum Collection: The Play of the Unmentionable (Joseph Kosuth). [09/27/1990–12/31/1990]. Courtesy the artist and Sean Kelly Gallery. © Joseph Kosuth, Ken Schles, and the Brooklyn Museum, photo Ken Schles; p.61 Courtesy Brooklyn Museum. Brooklyn Museum Archives. Records of the Department of Painting and Sculpture: Exhibitions. The Brooklyn Museum Collection: The Play of the Unmentionable (Joseph Kosuth). [09/27/1990–12/31/1990]. Courtesy the artist and Sean Kelly Gallery. © Joseph Kosuth, Ken Schles, and the Brooklyn Museum, photo Ken Schles; p.62 (*a*) Photo courtesy the artist and Pace Gallery, © Fred Wilson, courtesy Pace Gallery; p.62 (*b*) Photo courtesy the artist and Pace Gallery, © Fred Wilson,

courtesy Pace Gallery; p.63 (*a*) Photo courtesy the artist and Pace Gallery, © Fred Wilson, courtesy Pace Gallery; p.63 (*b*) Photo courtesy the artist and Pace Gallery, © Fred Wilson, courtesy Pace Gallery; p.64 Photo courtesy the artist and Pace Gallery, © Fred Wilson, courtesy Pace Gallery; p.65 Photo courtesy the artist and Pace Gallery, © Fred Wilson, courtesy Pace Gallery; p.66 (*a*) Installation, Collection of The Museum of Contemporary Art, Los Angeles, purchased with funds provided by The Frederick R. Weisman Art Foundation, Los Angeles. Photo Thomas Griesel, The Museum of Modern Art, New York, courtesy the Museum of Modern Art, New York, the artist, and Galerie In Situ Fabienne Leclerc, Paris, ©The Museum of Modern Art/Licensed by SCALA/Art Resource, NY; p.66 (*b*) Installation, Collection of The Museum of Contemporary Art, Los Angeles, purchased with funds provided by The Frederick R. Weisman Art Foundation, Los Angeles. Photo Thomas Griesel, The Museum of Modern Art, New York, courtesy the artist and Tracy Williams, Ltd, ©The Museum of Modern Art/Licensed by SCALA/Art Resource, NY; p.67 Collection of The Museum of Contemporary Art, Los Angeles, purchased with funds provided by The Frederick R. Weisman Art Foundation, Los Angeles. Photo Thomas Griesel, courtesy the artist and Galerie In Situ Fabienne Leclerc, Paris, ©The Museum of Modern Art/Licensed by SCALA/Art Resource, NY; p.68 (*a*) Photo © Museum Moderner Kunst Stiftung Ludwig Wien/Lena Deinhardstein, © Estate of Mike Kelley. All rights reserved. Courtesy Mike Kelley Foundation for the Arts and Museum of Modern Art, Vienna (MUMOK); p.68 (*b*) Photo © Museum Moderner Kunst Stiftung Ludwig Wien/Lena Deinhardstein, © Estate of Mike Kelley. All rights reserved. Courtesy Mike Kelley Foundation for the Arts and Museum of Modern Art, Vienna (MUMOK); p.72 Courtesy Liam Gillick, Moderna Museet, and Casey Kaplan Gallery, New York,

and courtesy Sylvie Fleury and the Moderna Museet; p.75 (*al*) Exhibition catalogue, High & Low: Modern Art and Popular Culture, 1990–91, ©The Museum of Modern Art/Licensed by SCALA/Art Resource, NY; p.75 (*ar*) Courtesy of The Museum of Modern Art, New York, photographer Mali Olotunji, The Museum of Modern Art, New York, USA, ©The Museum of Modern Art/Licensed by SCALA/Art Resource, NY; p.75 (*b*) Courtesy of The Museum of Modern Art, New York, photographer Mali Olotunji, The Museum of Modern Art, New York, USA, and McKee Gallery, New York ©The Museum of Modern Art/Licensed by SCALA/Art Resource, NY; p.76 Collection Yale University Art Gallery, gift of Colossal Keepsake Corporation, © 1969 Claes Oldenburg. Courtesy of The Museum of Modern Art and the artist. Photographic archive, The Museum of Modern Art, New York. Digital image ©The Museum of Modern Art/Licensed by SCALA/Art Resource, NY; p.77 Courtesy of The Museum of Modern Art, New York, photographer Mali Olotunji, The Museum of Modern Art, New York, USA, ©The Museum of Modern Art/Licensed by SCALA/Art Resource, NY; p.79 (*a*) Courtesy Hans Ulrich Obrist and the artist; p.79 (*b*) Exhibition catalogue, Cities on the Move: Contemporary Asian Art on the Turn of the 21st Century, 1997–98; p.80 Courtesy Hans Ulrich Obrist and the artist; p.83 (*a*) Courtesy Armin Linke and the artist, photo Armin Linke, © Armin Linke, 1999; p.83 (*b*) Courtesy Armin Linke, the artist, and Air de Paris, Paris, photo Armin Linke, © Armin Linke, 1999; p.84 Boxed exhibition publication designed by Pae White, What If: Art on the Verge of Architecture and Design, 2000, courtesy Maria Lind, Pae White and Moderna Museet, Stockholm; p.85 Courtesy Moderna Museet, Stockholm, the artist and 303 Gallery, New York; p.86 (*bl*) Courtesy Moderna Museet, Stockholm; p.86 (*ar*) Courtesy Moderna Museet, Stockholm; p.87 Courtesy Moderna Museet, Stockholm;

p.89 Photography by Tate Photography ©Tate, London 2013; p.90 Photography by Tate Photography ©Tate, London 2013; p.91 Exhibition catalogue, Century City: Art and Culture in the Modern Metropolis, 2001, Tate, London; p.94 Copyright the artist. Courtesy the artist, Okwui Enwezor, Stephen Friedman Gallery, London, and James Cohan Gallery, New York, photo Werner Maschmann; p.97 Courtesy Centre Pompidou and the artist; p.98 Courtesy Centre Pompidou; p.100 Courtesy the artist, Luhring Augustine, New York, and Dan Cameron; p.101 © Studio Wim Delvoye, © Javier Campano, courtesy Dan Cameron; p.102 © Huang Yong Ping, photo courtesy Okwui Enwezor, photo Werner Maschmann; p.103 Courtesy Wenda Gu; p.105 Courtesy the artist, Jack Shainman Gallery, New York, and Okwui Enwezor, photo Werner Maschmann; p.106 Courtesy Okwui Enwezor; p.107 Courtesy Okwui Enwezor and Galleria 111, Lisbon, Portugal; p.108 Collection of Ninah and Michael Lynne, © the artist, courtesy the artist and Okwui Enwezor; p.109 Courtesy the artist and Okwui Enwezor; p.110 Collection Tropenmuseum, Amsterdam, courtesy Okwui Enwezor, photo Werner Maschmann; p.111 Courtesy the artist and Okwui Enwezor; p.112 Tobreluts: Courtesy the Deborah Colton Gallery, Houston, and Moderna Museet, Stockholm. Thiel: ©VG Bild-Kunst, Bonn. Courtesy Moderna Museet, Stockholm, and Sean Kelley Gallery, New York; pp.114–15 Courtesy Moderna Museet, Stockholm and the artist; p.118 Private Collection, Kortrijk, Belgium, courtesy the artist, Foksal Gallery Foundation, Warsaw, and Johnen Galerie, Berlin, photo Uwe Walter; p.120 Courtesy Manifesta, photo Roman Mensing/artdoc.de; p.123 (*l*) Courtesy Manifesta, the artist and the Kerstin Engholm Gallery, Vienna, photo Bernd Bodtländer; p.123 (*r*) Exhibition catalogue, Manifesta 9: The Deep of the Modern, 2012, courtesy Manifesta; p.124 Courtesy Manifesta, the artist and Marian Goodman Gallery,

New York, photo Roman Mensing/artdoc.de; p.126 (a) Courtesy the artist and documenta Archiv, Kassel, Ryszard Kasiewicz / © documenta Archiv; p.126 (b) Courtesy the artist and documenta Archiv, Kassel, Ryszard Kasiewicz / © documenta Archiv; p.128 (l) Courtesy Adriano Pedrosa, Fundação Bienal de São Paulo, Kurimanzutto, and the artists, photo Juan Guerra; p.128 (r) Courtesy Adriano Pedrosa and Fundação Bienal de São Paulo, photo Juan Guerra; p.129 Courtesy Adriano Pedrosa, Fundação Bienal de São Paulo, Kurimanzutto, and the artists, photo Juan Guerra; p.130 Courtesy Adriano Pedrosa, Fundação Bienal de São Paulo, and the artist, photo Juan Guerra; p.132 (b) Courtesy of the artist, Regen Projects, Los Angeles, and documenta Archiv, Ryszard Kasiewicz / © documenta Archiv; p.132 (a) Courtesy of the artist and documenta Archiv, Ryszard Kasiewicz / © documenta Archiv; p.134 Collection Dia Art Foundation, New York, photo © Blaise Adilon, artwork © Bridget Riley 2013, all rights reserved, courtesy Karsten Schubert, London, and Biennale de Lyon; p.136 Exhibition catalogue, 7th Lyon Biennial: C'est arrivé demain (It Happened Tomorrow), 2003–4, courtesy Biennale de Lyon; p.137 © Blaise Adilon, courtesy Biennale de Lyon, Galerie Hauser & Wirth, Zurich/London, Luhring Augustine, New York, Pinault Collection, the Mike Kelley Foundation for the Arts, and the McCarthy Studio, artwork © Estate of Mike Kelley, all rights reserved; p.138 Collection Fondazione Sandretto Re Rebaudengo, Turin, courtesy the artist, Galerie Hauser & Wirth, Zurich/London, Trussardi Foundation, KW Institute for Contemporary Art, Berlin, and Berlin Biennale for Contemporary Art, photo Uwe Walter; p.139 Photo © Aneta Grzeszykowska, courtesy Raster, Warsaw. Card courtesy Trussardi Foundation, KW Institute for Contemporary Art, Berlin, and Berlin Biennale for

Contemporary Art; p.140 Courtesy the artist, Sies + Höke, Düsseldorf, Trussardi Foundation, KW Institute for Contemporary Art, Berlin, and Berlin Biennale for Contemporary Art, photo Uwe Walter; p.141 Courtesy the artist, Trussardi Foundation, KW Institute for Contemporary Art, Berlin, and Berlin Biennale for Contemporary Art, photo Uwe Walter; p.142 Courtesy the artist, Marian Goodman Gallery, New York, Betty & George Woodman, New York, Trussardi Foundation, KW Institute for Contemporary Art, Berlin, and Berlin Biennale for Contemporary Art, photo Uwe Walter; p.143 (l) Courtesy Trussardi Foundation, KW Institute for Contemporary Art, Berlin, and Berlin Biennale for Contemporary Art, © Nathalie Djurberg, still from Viola, 2005, courtesy Zach Feuer Gallery, New York; p.143 (r) Courtesy Trussardi Foundation, KW Institute for Contemporary Art, Berlin, and Berlin Biennale for Contemporary Art; p.144 Courtesy the artist and Galerie Buchholz, Cologne/Berlin; p.145 Courtesy the artist; p.146 Courtesy the artists, Galerie Buchholz, Cologne/Berlin, and International Istanbul Biennial; p.147 Courtesy the artist and International Istanbul Biennial; p.148 Courtesy the artist, Catriona Jeffries Gallery, Vancouver, and documenta Archiv, Kassel, Ryszard Kasiewicz / © documenta Archiv; p.149 Courtesy the artist, Catriona Jeffries Gallery, Vancouver, and documenta Archiv, Kassel, Ryszard Kasiewicz / © documenta Archiv; p.150 (a) Courtesy the artist and documenta Archiv, Kassel, Ryszard Kasiewicz / © documenta Archiv; p.150 (b) Courtesy documenta Archiv, Kassel, Ryszard Kasiewicz / © documenta Archiv; p.154 Courtesy the artist and SMAK, photo Dirk Pauwels; p.157 Courtesy the Estate of Jason Rhoades, SMAK, Hauser & Wirth, and David Zwirner, photo Dirk Pauwels; p.158 Courtesy the artist and SMAK, photo Dirk Pauwels; p.159 Courtesy SMAK, photo Dirk Pauwels; p.160 (a) Courtesy the artist and Hans

Ulrich Obrist; p.160 (c) Courtesy Independent Curators International, New York, and the artist; p.161 Cover to do it: the compendium, 2013, courtesy Independent Curators International, New York; p.163 Courtesy Independent Curators International, New York, Eugenia González and Agustina Rodríguez; p.164 (a) Courtesy the artist. Photo Poul Buchard/ Brøndum & Co., NowHere, vol. 2, Louisiana Revy, exhibition catalogue, Louisiana Museum of Modern Art, Humlebæck, Denmark; p.164 (b) Courtesy the artist and Victoria Miro, London, © Chris Ofili. Photo Poul Buchard/Brøndum & Co., NowHere, vol. 2, Louisiana Revy, exhibition catalogue, Louisiana Museum of Modern Art, Humlebæck, Denmark; p.167 Courtesy La Biennale di Venezia, La Biennale di Venezia—Archivio Storico delle Arti Contemporanee, and Air de Paris, Paris, photo Giorgio Zucchiatti; p.169 Courtesy the artist; p.172 (a) Courtesy Amilcar Packer, Galeria Joan Prats, Galeria Luisa Strina, São Paulo, and Fundação Bienal São Paulo; p.172 (b) Exhibition poster, 28th São Paulo Biennial: In Living Contact, 2008, designed by Angela Detanico and Rafael Lain, courtesy Fundação Bienal São Paulo and Galeria Vermelho, São Paulo; p.173 Courtesy Amilcar Packer; p.174 All images courtesy Fundação Bienal São Paulo; p.175 Courtesy of Amilcar Packer and Galeria Luisa Strina, São Paulo; p.176 Fundación/ Colección Jumex, Mexico. Courtesy Fundación/Colección Jumex, Mexico. © Fundación/ Colección Jumex, photo La Colección Jumex, Mexico; p.178 Fundación/Colección Jumex, Mexico. Courtesy Fundación/ Colección Jumex, Mexico. © Fundación/Colección Jumex, photo La Colección Jumex, Mexico; p.179 Fundación/ Colección Jumex, Mexico. Courtesy Fundación/Colección Jumex, Mexico. © Fundación/ Colección Jumex, photo La Colección Jumex, Mexico; p.182 Courtesy the artists and Los Angeles County Museum of Art, digital image © 2013 Museum Associates/LACMA, licensed by

Art Resource, New York; p.184 Courtesy the artist and the Simon Preston Gallery, New York; p.185 © Kiki Smith, courtesy the artist, Whitney Museum of American Art, and Pace Gallery; p.186 University of California Berkeley Art Museum and Pacific Film Archive; p.187 All images courtesy Lawrence Rinder and University of California Berkeley Art Museum and Pacific Film Archive; p.188 Courtesy the artist and University of California Berkeley Art Museum and Pacific Film Archive; p.190 Courtesy Adriano Pedrosa and the artist, photo Everton Ballardin; p.191 Courtesy Adriano Pedrosa and Kurimanzutto, photo Everton Ballardin; p.192 (a) Courtesy International Istanbul Biennial; p.192 (b) Courtesy International Istanbul Biennial; p.193 Courtesy International Istanbul Biennial, Churner and Churner, New York, photo Natalie Barki; p.194 Courtesy the artist and International Istanbul Biennial, photo Natalie Barki; p.195 (l) Courtesy International Istanbul Biennial; p.195 (r) Courtesy International Istanbul Biennial; p.196 Courtesy the artists and Los Angeles County Museum of Art, digital image © 2013 Museum Associates/LACMA. Licensed by Art Resource, New York; pp.198–99 Courtesy Los Angeles County Museum of Art, digital image © 2013 Museum Associates/LACMA. Licensed by Art Resource, New York; p.202 Courtesy the artist, Villa Arson, Nice, and Air de Paris, Paris, © Jean Brasille/Villa Arson; p.204 (a) Courtesy the artist and Villa Arson, Nice, © Jean Brasille/ Villa Arson, © Johan Muyle; p.204 (b) Courtesy the artist, Villa Arson, Nice, and Air de Paris, Paris, © Jean Brasille/Villa Arson; p.205 Courtesy the artists, Villa Arson, Nice, and Margo Leavin Gallery, Los Angeles, © Jean Brasille/Villa Arson, © Allen Ruppersberg; p.206 Courtesy the artist, The Museum of Contemporary Art, Los Angeles, and Gagosian Gallery, Beverly Hills, photo Chris Burden, © Nancy Rubins; p.207 Courtesy Tyler Rollins Fine Art, New York, and the Museum of Contemporary Art, Los

Angeles; p.208 Courtesy The Museum of Contemporary Art, Los Angeles; p.209 Private collection, courtesy the artist, Hauser & Wirth, and Courtesy of the Museum of Contemporary Art, Los Angeles; p.210 Courtesy the artist, CAPC, Bordeaux, and Galleri Nicolai Wallner, Copenhagen, © DMB, photo Frédéric Delpech; p.211 Courtesy the artist, CAPC, Bordeaux, and Air de Paris, Paris, © DMB, photo Frédéric Delpech; p.212 © DMB, photo Frédéric Delpech, courtesy the artist, Maureen Paley, London, and CAPC Bordeaux; p.213 Courtesy the artist, Galleria Massimo Minini, Brescia, Italy, and CAPC, Bordeaux, © DMB, photo Frédéric Delpech; p.214 Exhibition catalogue, Sensation, 1997, courtesy Thames & Hudson, London; p.215 Collection Stefan T Edlis, courtesy the Brooklyn Museum and Hauser & Wirth. Brooklyn Museum Archives, Records of the Department of Painting and Sculpture: Exhibitions, Sensation: Young British Artists from the Saatchi Collection [10/02/1999–01/09/2000]; pp.216–17 Courtesy the artist, the Brooklyn Museum and Luhring Augustine, New York. Brooklyn Museum Archives, Records of the Department of Painting and Sculpture: Exhibitions, Sensation: Young British Artists from the Saatchi Collection [10/02/1999–01/09/2000]; p.218 Courtesy the artists, the Brooklyn Museum and White Cube, London. Brooklyn Museum Archives, Records of the Department of Painting and Sculpture: Exhibitions, Sensation: Young British Artists from the Saatchi Collection [10/02/1999–01/09/2000]; p.219 Courtesy the artist, the Brooklyn Museum and Victoria Miro, London, © Chris Ofili. Brooklyn Museum Archives, Records of the Department of Painting and Sculpture: Exhibitions, Sensation: Young British Artists from the Saatchi Collection [10/02/1999–01/09/2000]; p.220 Photo Josh White, courtesy International Art Objects Galleries, Los Angeles, the

artist and The Studio Museum, Harlem, New York; p.221 Courtesy The Studio Museum, Harlem, photo Adam Reich; p.224 Courtesy the artists and The Museum of Contemporary Art, Los Angeles; p.226 Courtesy the National Museum of Women in the Arts, Washington, DC; p.227 Courtesy the National Museum of Women in the Arts, Washington, DC; p.229 Courtesy the artist and The Museum of Contemporary Art, Los Angeles; p.230 (a) Courtesy the Museum of Contemporary Art, Los Angeles, photo Brian Forest; p.230 (b) Courtesy the Museum of Contemporary Art, Los Angeles, photo Brian Forest; p.232 Courtesy Jane Farver; p.233 Courtesy Jane Farver; p.234 (a) Courtesy Jane Farver; p.234 (b) Courtesy Jane Farver; p.237 (a) Courtesy the artists and the Museum of Contemporary Art, Los Angeles; p.237 (b) Courtesy the artists and The Museum of Contemporary Art, Los Angeles; p.238 Courtesy the artists and The Museum of Contemporary Art, Los Angeles; p.239 Exhibition announcement card, WACK!, featuring Katharina Sieverding, Transformer, 1973.

Acknowledgments

Jens Hoffmann would like to thank the following individuals without whose support and inspiration this book could never have been made: John Baldessari, Maurice Berger, Ritsaert ten Cate, Lynne Cooke, Philip Dodd, Okwui Enwezor, Claire Fitzsimmons, RoseLee Goldberg, Dominique Gonzalez-Foerster, Claudia Gould, Chelsea Haines, Sophia Hoffmann, Mary Jane Jacob, Dane Jensen, Jacky Klein, Luisa Lambri, Maria Lind, Micki Meng, Marsha Miro, Jessica Morgan, Hans Ulrich Obrist, Adriano Pedrosa, Ross Sappenfield, Tino Sehgal, Tom Stromberg, Joanna Szupinska-Myers, Lindsey Westbrook, Celia White, Vincent Worms. With special thanks to Luisa Lambri for all that she does.

Index